"An absolutely stunning story, and a stunningly beau
told by a terrific writer, gifted thinker, and accomplis
Maureen O'Connell's new book tells the tale of how Philadelphia's Mural
Arts Program successfully brought together artists, community activists,
inner-city neighborhood residents, churchgoers, scholars, pastors, and
simple lovers of art to spread a message of social justice, tolerance, and, in
the end, love. Far beyond a simple neighborhood 'beautification' program,
O'Connell shows how art advanced an idea of justice and peace, deepened
a people's appreciation for their own dignity, and invited 'outsiders' into
the vibrant life of the inner city. How can art transform a culture? How can
a mural help someone understand God? How can paint lead to fellowship?
Read this superb book and discover how."

—James Martin, SJ
Author of *The Jesuit Guide to (Almost) Everything*

"A beautiful and brilliant book about the ways that art making can build and
sustain communities while promoting justice and restoring pride. O'Connell
vividly delineates the intersections of truth-telling and trust-building in the
process of making and viewing public artworks."

—Robin Jensen
Luce Chancellor's Professor of the History
of Christian Art and Worship, Vanderbilt University

"This is a deeply moving and thought-provoking exploration of the
transformative role of art in public life. It is also a plea to take the aesthetic
seriously in the search for justice. O'Connell shows that theological and
ethical reflection takes place not just in books and classrooms but also on the
walls and streets of our cities, revealing how beauty and justice are living
realities. What an eye-opening work from this gifted scholar!"

—Susan A. Ross, Ph.D.
Professor of Theology and Faculty Scholar Chair,
Department of Theology, Loyola University Chicago

"This book is a celebration of the power of murals and the passion of those
who create them. It is a carefully researched look at the Philadelphia murals
seen through a theological lens. The author brings an enthusiasm and
knowledge to her unique perspective that invites readers and viewers to see
and understand these collaborative, community-centered murals as models
for an art that has the potential to create social transformation."

—Janet Braun-Reinitz
Co-author of *On The Wall: Four Decades of Community
Murals in New York City*

If These Walls Could Talk

*Community Muralism
and the Beauty of Justice*

Maureen H. O'Connell

Foreword by Jane Golden,
Executive Director, Mural Arts Program

LITURGICAL PRESS
Collegeville, Minnesota

www.litpress.org

1	2	3	4	5	6	7	8

Library of Congress Cataloging-in-Publication Data

O'Connell, Maureen H.
 If these walls could talk : community muralism and the beauty of justice / Maureen H. O'Connell ; foreword by Jane Golden.
 pages cm
 Includes bibliographical references and index.
 ISBN 978-0-8146-3340-3 — ISBN 978-0-8146-3404-2 (e-book)
 1. Street art—Pennsylvania—Philadelphia. 2. Mural Arts Program (Philadelphia, Pa.) 3. Community arts projects—Pennsylvania—Philadelphia. 4. Art and society—Pennsylvania—Philadelphia. 5. Religion and social problems—Pennsylvania—Philadelphia. I. Title.

ND2638.P48O28 2012
751.7'30974811—dc23 2012007806

For Corinne and Thomas,
in thanks for their unfailing sisterly and brotherly love
and for Philadelphians who dare to believe
that beauty will save the world

Contents

Acknowledgments

Community muralists will tell you that any project worth its salt is really about the process behind the paint and not the final product on the wall. I have found the same to be true of this book about community muralism. These pages are the end product of a multiyear process of personal discovery, both in a city and a religious tradition with which I thought I was pretty familiar. Since my guides were community members and their visions, my epiphanies have been tremendous. I've tried to capture them, albeit with words, in these pages.

I am grateful to the Society for the Arts in Religious and Theological Studies for an initial seed grant through their Luce Faculty Fellowship program in 2006–7, with special thanks to Kimberly Vrudny for encouraging me to apply. A Christian Faith and Life Grant through the Louisville Institute as well as a Faculty Fellowship from Fordham University funded an important year of research in 2008–9. The Wabash Center for Teaching and Learning in Theology and Religious Studies provided crucial funding for summer writing in 2010. My department chair, Terry Tilley, proved to be a tireless champion of my work here and helped me secure subventions from various sources at Fordham to cover the costs of incorporating so many images into the final product, as did a generous gift from Mr. and Mrs. Stephen E. Bepler.

Amy Johnston, information and special events specialist with Philadelphia's Mural Arts Program, was absolutely invaluable to me when it came to getting in touch with muralists and community members, most notably Jane Golden, and in handling various details in the final stages of production. Among the artists I have been fortunate to come to know through this process, Eric Okdeh, Shira Walinsky, and Joe Brenman stand out as three remarkable individuals who warmly welcomed me into the communities with which they worked and helped me ground my own creative project in the stories and visions of real people.

Since I am no urban historian, I am grateful to Michael Clapper, who is both a Philadelphia historian and a dear friend, for his counsel in the first section of this book. Likewise, I attribute my desire to continue to

heighten white racial consciousness to the wisdom of several friends and colleagues, including Alex Mikulich of the Jesuit Social Research Institute in New Orleans, Laurie Cassidy in the Religious Studies Department at Marywood University, and my colleagues in the Dorothy Day Center for Service and Justice at Fordham University. A two-day workshop, "Undoing Racism," with the People's Institute for Survival and Beyond gave me the language and tools I needed in order to see racism at work in my family history as well as in the world's largest public art gallery.

Hans Christoffersen at Liturgical Press deserves considerable thanks for taking a chance on an art book in an uncertain market, and Lauren L. Murphy and Julie Surma gave my words and images special attention. Two graduate students at Fordham—Christine McCarthy and Matthew Briel—gave me feedback at critical points in the creative process.

A special thanks goes to Donna Freitas, my friend and in many ways my agent, whose exuberant enthusiasm for this project at every stage—from initial proposal to final layouts—relentlessly emboldened me to write the book *I* wanted to write and in the way *I* wanted to write it. My mother, Kathleen, was my wingman on many a mural hunt throughout neighborhoods in Philadelphia, many of them old family haunts. She and my father, George, have basically operated a shuttle service between my childhood home and the Trenton Transit Center for the past six years. I could not have done this work without their loving support. And in the end, I blame my sister, Corinne, for turning me on to the Philadelphians who are the muse for this project and, ultimately, continue to rescue me from the ivory tower of academia. Her sisterly love of folks in disadvantaged communities—their resilience, their creativity, their passion for justice for all people—is my touchstone for the reign of God.

Foreword

The Effect of Public Art on the Social Fabric of Communities

Murals are, more often than not, pictorial representations of memories, dreams, heroes, and aspirations. In Philadelphia, they are also an iterative, if incomplete, visual map of human experience in our city's neighborhoods—and particularly in those that have seen the ills of poverty, disinvestment, drugs, and violence. Whether the imagery is simple or complex, a mural is a synthesis of individual and collective experience and a testament to the power of artists and community members to understand and represent what's important to them. Creating a mural is often a complicated civic and creative process, one that begins long before an artist prepares a design and that endures well beyond the mural's dedication.

In an early version of the Mural Arts Program (then working under the aegis of the Philadelphia Anti-Graffiti Network), our small band of artists and former graffiti writers would drive our ancient city sedan into a disenfranchised neighborhood only to be greeted with skepticism. We would ask them if they wanted a mural, and they would knit their brows and reply, "We've never seen anyone from the city coming in to offer us any kind of service, much less a big painting."

As we worked with those first groups of community members to reconsider how a mural could make a difference on their block, and they puzzled about what kind of image they wanted, it slowly registered on us what we were really offering—and asking. We initially assumed that these groups of neighbors saw themselves as a community, but, surrounded as they were by a landscape of vacant buildings and empty lots, abandoned cars and fragmented families, community action was a concept that was difficult to imagine. Moreover, they saw their neighborhoods as having fallen through the cracks, long since deemed unworthy of the attention of city government. Some very determined

community members, however, recognized the power of a symbolic social action to spur actual change.

We were able to tap into something formidable. Our presence on those blocks over weeks and months while erecting scaffolding and painting on those blocks, even with our minimal supplies and equipment, slowly began to alter perceptions beyond those leaders. A mural became a rallying point—eventually sparking a mini-revolution of rising expectations. The modest physical change in a community afforded by two- and three-story paintings began to drive attitudinal changes—about collective voice, pride, and power. Early on, the evidence was modest: building owners would begin to remove the trash that had accumulated in front of blank or "tagged" walls, stoop-sitting residents would quietly keep a close eye on anyone out to "tag" their new mural, block captains found a few more volunteers on cleanup days, and neighbors who had launched community gardens sought us out to create murals that honored their heroes as well as their religious and cultural traditions.

As local leaders began to see the power of murals to represent their values and hopes—to capture memory, to mine the rich social imagery

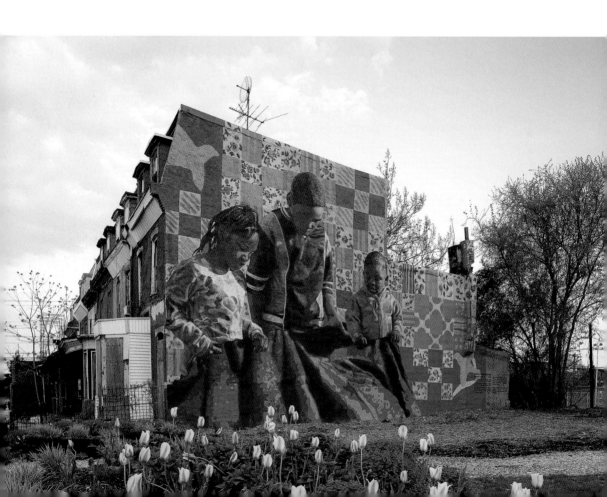

that lies beneath the surface, and to spur social action to reclaim communities—murals became emblematic of a newfound agency. To this day, the demand for murals far outstrips the Mural Arts Program's ability to respond.

After twenty-seven years, Mural Arts' canvases have both proliferated and expanded in scale. Stakeholder groups have grown from clusters of neighbors to entire city departments, transit systems, and citywide dialogues. The scale and visual impact of murals have grown, the process by which a mural takes shape is increasingly layered, and the Mural Arts organization has expanded its reach into correctional facilities, social service agencies, and Philadelphia public school campuses, but our goals for the people we work with are constant: to give them voice, to offer our creative and organizational resources in their service, and to transform how they see themselves and their communities. When we inquire of community members what is important to them and ask them to mine the range of their experience, whether painful, troubled, or triumphant, for images, we demonstrate our faith in the authenticity of their voices and our belief in their right to be seen and heard.

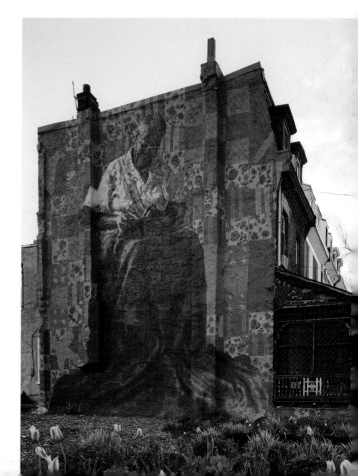

◄ *Holding Grandmother's Quilt*,
Donald Gensler, 2004,
© Philadelphia Mural Arts Program.
►

With interest in murals growing in Philadelphia, we often find that our work with stakeholders must span groups who have very different perspectives on truth and history, personal and collective. Brokering such differences is a level of responsibility that challenges us as well as those who are drawn into the process. Working with inmates and victims together on a single Restorative Justice project tests the honesty of everyone involved. And, in our Porchlight Initiative program, when we ask people grappling with addiction to understand—and express— what they are responsible for and what they are not, we often test their long-held self-perceptions and behaviors. Our work becomes as much about truth and reconciliation as about art, but in the end, the art itself becomes a powerful sign, not only of the artist's skill, but of the will of the entire community to dig deep and wrestle with its own capacity to grow and change.

Jane Golden
Executive Director
Mural Arts Program
Philadelphia
January 2012

Introduction

*"Community art can knit people together in a way that other things
can't. It has this ability to build consensus and to challenge people who
think collectively for the greater good."*

—Jane Golden, "A City Uses Murals to Bridge Difference,"
The New York Times, 6 October 2008

I recently walked the longest four hundred yards of my life. After
checking in at the front desk of a sprawling facility in the midst of Phila-
delphia's equally sprawling "ex-burbs," I made my way down a bustling
corridor toward a studio where I was to observe a meeting among a
group of artists and the folks who commissioned them to complete a
piece for their sacred space. Sounds rather ordinary, I know. So what
made that relatively short distance seem so long?

For one, the front desk was a security checkpoint with armed guards
and sets of sliding gates that opened incrementally, the forward gates
opening only after those behind me had slid shut. In addition, the artists
were a dozen inmates, many of them lifers, with DOC (Department of
Corrections) stamped in white on the backs of their brown jumpsuits.
And the "studio" was nothing more than a big table in the farthest cor-
ner of the auditorium at the State Correctional Institution at Graterford,
the largest maximum-security prison in Pennsylvania and among the
ten largest such facilities in the country. Hence, the long quarter mile
between that space and the initial checkpoint.

But it wasn't just the physical distance I put between myself and
"the outside" that struck me. Far more unsettling was the intellectual
and emotional terrain I traversed in that sixty-minute meeting. As I
listened to inmates explain the images that comprised the design for a
three-story mural that they would paint with congregants from Bible
Way Baptist Church in West Philadelphia—a mural that these artists
would paint on "the inside" in that prison auditorium but never see

installed on "the outside" in the heart of a community with which some were very familiar—I had a series of epiphanies that dramatically deepened my understanding of urban poverty and theological aesthetics in ways that intellectual reflection or textbook learning could not. The beauty of the passion of the people around that table in the heart of the Commonwealth of Pennsylvania's prison-industrial complex—reflected in the inmates' commitment to the project and to the young people they hoped to reach, in the willingness of that congregation to practice forgiveness in such a public and prophetic way, and in the way that all gathered there imagined with each other—was even more arresting than the design they proposed at that meeting and the piece, *From Behind the Mask* (Eric Okdeh, 2009), they have since completed.

In this book I expound on this and several other epiphanies I have had in my encounters with the people and images associated with Philadelphia's community muralism movement. This groundswell of public art, now more than twenty-five years old, is transforming once-blighted city spaces into the largest public art gallery on the planet. The City of Brotherly Love, from time to time the murder capital of the world, is now also "Mural Capital of the World."

Philadelphia's walls are talking. Like storytellers in many cultures, they regale citizens with fantastic tales of the past—of fabled ancestors, of journeys of passage both voluntary and involuntary, of the pains of birthing a nation and surviving in a flatlined postindustrial economy. Like a poet laureate of the city, Philadelphia's murals lyrically proclaim the hidden fears, deepest longings, stubborn demands, and resilient dreams of the current generation of William Penn's "holy experiment." Like the ancient prophets, they resolutely speak truth to power, making plain hidden injustices, promises unfilled and covenants broken, and futures yet to be attained. And like the sacred texts of many faith traditions, they compellingly reveal the mystical and practical wisdom of encounters with the Divine in a particular place and time in human history.

And they do all of this without words.

Instead, larger-than-life images now cover more than thirty-five hundred of Philadelphia's walls and nonverbally articulate the catchphrases, conversations, mission statements, and wish lists of neighborhoods, civic associations, social service agencies, nonprofits, and faith communities across the city. Vibrant portraits of schoolchildren and block captains showcase the real people who inhabit different neighborhoods of the city. Arresting renderings of great-grandmothers' memories and young mothers' hopes illuminate the pride and anxiety of the

matriarchs of these communities. Lush landscapes of the Caribbean bring the beauty of home to a new neighborhood. Fanciful vignettes capture daily life on the block, and powerful memorials pay tribute to those who live and have lost their lives there. And a variety of religious symbols interrupt the secularism of the streets that were once the historic laboratory of one of America's oldest experiments in religious tolerance.

Various and often disparate members of civil society come together to create these wall-sized images that can run the length of a city block or rise many stories high. Police officers and inner-city youth, incarcerated felons and victims of crime, members of a North Philadelphia mosque and a suburban synagogue, new African immigrants to the neighborhood and its long-standing African American residents, delinquent juveniles and neighbors impacted by crime, white muralists and communities of color come together in the context of a creative process that ultimately changes the community members even more radically than the wall onto which they paint their ideas. Furthermore, they create these images through an elaborate dialogical process that begins with individual verbal self-expression, cultivates the common ground of shared experiences and visions, and culminates in a collectively designed and painted mural that is displayed on a wall of the community's choosing in the neighborhood itself.

Through this art, people who are frequently excluded from or ignored in public debate or political processes express themselves in unexpected spaces around the city—on walls in front of empty lots or prison yards, on libraries or hospitals, on Buddhist temples and Pentecostal churches, on pedestrian overpasses and interstate underpasses, on blighted row homes and abandoned warehouses. Citizens at large—natives and visitors alike—are beginning to listen to what these images, and, more important, the people who created them, have to say. The art of the city's marginalized neighborhoods and communities guarantees that nonviolent conflict resolution, support for recovery from addiction, prisoner rehabilitation and reentry programs, equitable funding for public education, safety and health, racial harmony, parks and green space, care for the elderly and disabled, and religious tolerance remain central talking points in civic dialogue about what the good life in Philadelphia entails and how its residents ought to go about cultivating it. These images have the potential to transform the "City of Brotherly Love" into the "City of Just Love."

Relying on the perspective of the storytellers who come together to create this art, I examine several of Philadelphia's paradigmatic faith-based community murals, as well as the personal narratives of those

associated with their creation, in order to explore four important contributions that this urban and religious public art makes to the evolving relationship between creating beautiful things and living in right relationship with others in postindustrial urban centers. This book explores why communities in inner-city Philadelphia—whether those affiliated with a particular faith or house of worship or those who live in certain neighborhoods—create larger than life religious imagery to proclaim in unprecedentedly public ways their self-understandings, memories of the past, and visions of the future. It also examines the way this art functions in these communities, as well as in larger public discourse about problems facing every city in America.

But I also consider implications of this most democratic expression of public art on our "God talk," the most basic definition of theology. All of these images are more effective than words in speaking to aspects of the human experience that all persons share: the basic human desire to know and own our past, the freedom to construct a meaningful life in the present, and the capability to dare to dream of a different future. Philadelphia's murals have something to say to those concerned with the relationship between theology and the arts, or between aesthetics and faith, or between beauty and justice. Each of the city's more than thirty-five hundred murals can contribute in some fashion or another to the conversation about the beautiful and the good that began without words on cave walls in France more than thirty thousand years ago and continues today.

I consider four components of every mural—the sociohistorical context in which they are exhibited, the pieces themselves, those who create them, and those who interpret them—in order to call our attention to a kind of beauty that seeks after social change, or in other words, the largely unexplored relationship between theological aesthetics and ethics. Community muralism, a unique contribution of artistic expression outside the purview of "high" or "institutional" art, provides an arresting resource for understanding more clearly what's going on in American cities, as well as a viable response that offers creative alternatives to old problems. In these murals and, more important, in the communities who create them, we find innovative interpretations of who or what God is or what it means to be human in the midst of neighborhoods that are forgotten or ignored.

Community muralism offers a new trajectory for theological aesthetics that more clearly develops the relationship between aesthetics and ethics, particularly in contexts of urban poverty. It calls our attention to inner-city neighborhoods as rich theological "sites" that lift up the

often-ignored reality of urban poverty and privileges the wisdom of people living with dignity despite social pressures to the contrary. In turn, these images call for integrating the imagination into the various methods of Catholic moral theology and social ethics. The murals irrefutably expose the relationship between beauty or aesthetics and ethics, since the beauty of this art lies not only in its content and the reactions it evokes (aesthetics) but also in the types of relationships it fosters among those who create it and those who encounter it (ethics). Community muralism presents a compelling model of art that creates social transformation. To date, this model is unexplored in both the arts and in ethics. Murals serve as compelling examples of a visible religion that makes literal and figurative space for religious expression of and engagement with social justice issues in the midst of a secular age and a secular city.

Frank Burch Brown notes that "the special gift of art is not doctrinal precision, conceptual clarity, or the ability to 'think straight' but rather to explore fictively, metaphorically, and experientially what formal theology cannot present or contain."[1] Philadelphia's more than thirty-five hundred wall-sized canvases—in ghettos and schools, on mosques and in jails, in courthouses and along overpasses—illustrate the way in which the arts can help us to travel the emotional, intellectual, and relational distance between the seemingly inescapable problems of urban poverty and as of yet unexplored solutions. If my experience with artists and community members at Graterford prison is any indicator, that distance may not be as far as we think.

1. Frank Burch Brown, *Religious Aesthetics: A Theological Study of Making Meaning* (Princeton, NJ: Princeton University Press, 1989), 167.

Part One

Philadelphia
Spaces and Stories

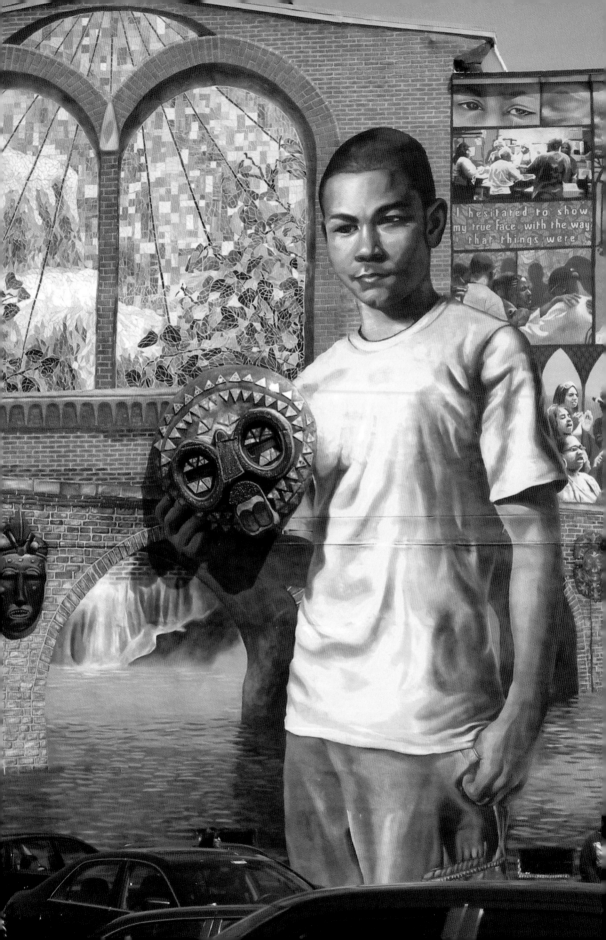

I hesitated to show my true face with the way that things were

From Behind the Mask

Every summer congregants of the Bible Way Baptist Church at Fifty-Second and Master in West Philadelphia put on a Love Fest for the neighborhood. There's live music, dancing and food for the adults, and face painting and a moon bounce for the kids. The fair is an integral part of the faith community's identity and outreach, a time to celebrate what the church is doing to try to heal and revitalize the neighborhood and to welcome new members. In 2007, a few muralists from Philadelphia's Mural Arts Program (MAP) were in the mix at Love Fest at the invitation of a young congregant who had worked with them in a summer painting project examining public safety. An idea took hold, and it wasn't just because Bible Way boasts an ideal three-story wall facing a busy street and a mural by one of the city's first muralists, *Three Graces: Community, Spirituality, and Tragedy* (Parris Stancell, 1998). Far more crucial was the congregation's willingness to imagine what their Love Fest might mean in terms of welcoming ex-offenders back to the community—and to do that imagining along with lifetime inmates in the State Correctional Facility at Graterford and adjudicated youth in two residential programs.

The following summer, Love Fest at Bible Way had an added dimension: painting and poetry workshops for congregants and neighbors to help them keep pace with kids whose creativity had been unleashed in a series of similar visual arts and poetry workshops MAP conducted at the church as well as in two juvenile detention centers, St. Gabriel's Hall and Vision Quest. In those sessions, the theme of masks had started to emerge, in part through students' engagement with a poem, "We Wear the Mask," originally written by African American poet Paul Laurence Dunbar in 1913. They worked with clay to make their own masks, elements of which

lead muralist Eric Okdeh incorporated into the design of the mural. For the adults, the healing work that Bible Way does for its congregants—prayer circles, healing circles, and worship—provided an important muse. The spirit of Love Fest continued into November, when Bible Way hosted painting days for congregants and neighbors to paint sections of the mural on parachute paper that would later be adhered to the wall. They also sculpted the relief of a mask seven feet in diameter that extends a foot and a half from the wall's surface and is cradled in the arms of the mural's most prominent image, a young boy who worked on the project, pictured in a vibrant yellow shirt. Okdeh incorporated a mosaic dimension to capture the soft light of a setting sun streaming through stained-glass windows. So the two themes—masks and healing—come together in *From Behind the Mask* (Eric Okdeh, 2009), which invites reflection on the risks we must take to acknowledge how we perceive and misperceive others, as well as to allow others to see our true selves.

"This mural is something that will make people ask a question: What is that? What does it mean?" explains Robert Rogers, a former pastor at Bible Way, who attended several community meetings in September and October at Graterford to discuss possible designs with lifetime inmates who worked with Okdeh. Inmates also painted portions of the piece within the walls of the prison. "This gives us a chance to have a conversation about spiritual things and real people with real needs because of what God has done in our lives."

Rogers notes that the entire mural process complements the mission of the congregation to practice a "discipleship that meets real and felt needs." It also reflects one of his basic mantras attributed to Francis of Assisi: "Preach the gospel and sometimes use words." He also hopes it will invite people to see what's going on in the neighborhood, particularly in lives of prisoners and ex-offenders, both adult and juvenile, who worked on the mural "in different lights."

"My people are destroyed by a lack of knowledge," he explains of the public's wariness of engaging with ex-offenders. "I deprive myself of what you could bring to me. Ex-offenders have stories to tell and testimonies to share. Our community needs to know these things. Who better to tell somebody to be obedient to God? Who better to explain the story of Moses' reluctance to obey God, for example? They are experts about that story because they didn't read it in a book. They lived it."

"I believe we can know ourselves," said Zafir, one of the Graterford muralists, in regard to the mural's image of a woman standing in the middle of a bridge and peering into a pool of water. "And it's not about individual pathology; it is also a social pathology. And the mirror is a central tool for that revolution."

Painting a Healing Love Fest

The story and images of *From Behind the Mask* invite reflection on how citizens in metropolitan areas such as Philadelphia perceive one another and the ways in which the masks we wear—whether those we construct for ourselves or those constructed for us by others—cover the true face of urban poverty, obscuring its complex causes and preventing us from alighting upon new solutions. Murals like *From Behind the Mask*, therefore, become mirrors through which we can more clearly face the personal and social pathologies of concentrated poverty. But perhaps more important, if we take the risk to remove our own masks and stand as our true selves before these images, we might see facets of what it means to be human that we might otherwise miss reflected in spaces we might otherwise avoid.

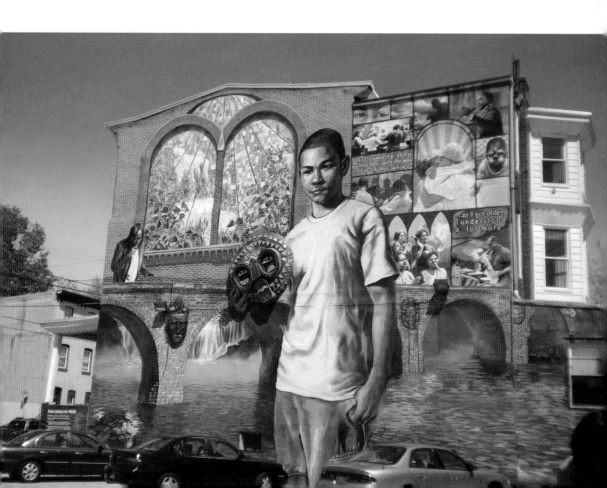

Chapter One
Spaces, Stories, and Method

Painted on a halfway house for female ex-offenders on the corner of Thirteenth and Erie in North Philadelphia, *Forgiveness* (Eric Okdeh, 2007; see p. 5) is clearly visible from the intersection of Broad and Erie, a block to the west. At the turn of the twentieth century, Broad and Erie was the socioeconomic anchor of "Nicetown," named for the Neisse family who first settled this part of the city through a land grant from William Penn in the 1680s and what urban sociologist Loïc Wacquant would call a "ghetto of opportunity." The social networks and institutions of mostly second-generation Irish immigrants who made up a third of Philadelphia's population by 1900 created a sense of cohesion in these neighborhoods and formed residents in socially mobile dispositions and practices. There was plenty of work, mostly in construction and domestic labor in the mansions farther north on Broad Street, as well as with Midvale Steel, which employed seventy-three hundred Philadelphians in its heyday in 1919, a number that would drop by more than six thousand before it closed in 1970.

The American roots of my family lie—figuratively and literally—in Nicetown soil. In fact, both sets of great-grandparents on my mother's side more than likely passed by the wall that would eventually display *Forgiveness* during their Sunday "strolls along the Avenue." My mother's maternal grandparents, Belinda Dempsey and Edward Hargadon, indicated Nicetown addresses as their final destinations upon their independent departures from Counties Mayo and Sligo, since they had social ties in this "ghetto of opportunity." More than likely, among these connections were the family of my mother's paternal great-grandparents, William and Mary (née Smith) Gallagher, who had lived and worked in Nicetown since their arrival in Philadelphia in 1860s, where William was employed in construction. Belinda and

Edward met in Nicetown, married at the big Jesuit Gesu Church on Girard Avenue on the other side of Broad, and baptized their eight children, my grandmother the only girl among them, in the neighborhood church, St. Stephen's, just a block north of *Forgiveness* on Broad. They ran a bar and boarding house at 1313 Erie Avenue, again, not far from today's mural, where they more than likely served Midvale Steel workers and the newest arrivals from Ireland. William and Mary Gallagher's grandson, William, eventually married Belinda and Edward Hargadon's only daughter and my grandmother, Catherine. Bernard and Isabell (née Kennedy) Gallagher (parents to William) and many other Gallaghers are buried in Nicetown—in the New Cathedral Cemetery at Second and Butler. Perhaps as a foretelling of my mother's family's eventual northern migration out of the city in the late 1940s, Belinda and Edward are buried in the Frankford section of Northeast Philadelphia, in a plot in St. Raymond's Cemetery that they purchased on a Sunday drive to the "country."

Today, *Forgiveness* looks out on quite a different reality. What was once a ghetto of opportunity—replete with familial and social networks, viable employment, locally owned businesses, and home ownership—quite rapidly became a "ghetto of last resort" in the decades following the Second World War. When I stand before this mural, in the midst of space that was home to people for whom I am named, my family's connection to the neighborhood's eventual deterioration becomes as palpable to me as our connection to its earlier successes. Like most white Philadelphians, stories of communal demise with sinister plot lines shaped by unearned privileges and racism are not as familiar to me as tales of individual success with the tropes of personal hard work and sacrifice. Although we will consider its content in the fourth section, it is the sociospatial location of *Forgiveness* in what Wacquant would call a "hyper-ghetto of last resort" that makes murals indispensible for understanding the complex dynamics of concentrated poverty and suburban whites' connections to the people who continue to eke out a meaningful life in these spaces. Murals lure hundreds of people like me back into neighborhoods haunted by memories of our earliest American relatives and scarred by their personal and collective choices to protect the interests of certain members of future generations, like me, at the expense of others. The practices associated with mural making, as well as the values they prophesy, foretell of a new story that citizens of the metro area might share. Standing before *Forgiveness*, I have no choice but to do my theology from this place where the past merges with the present in wall-sized visions of the future.

Murals and Constructive Theology

Community murals underscore that theology, in the words of Catholic theologian Terrence Tilley, "is a communicative practice of constructing a way to live out a tradition faithfully." In other words, invoking the words of Gordon Kaufman, murals serve as tools that help us to construct imaginatively "a comprehensive and coherent picture of humanity in the world under God" through which we can better see human existence and understand, criticize, and reconstruct the central beliefs and symbols of our faith traditions in a way that better orients us to God, to each other, and to justice.

This constructive approach to theology examines the practices of communities in order to understand how these activities reflect patterns of intellectual belief or truth claims around classical theological themes such as God, Trinity, Jesus, salvation, or church. It relies on practices to evaluate the validity of theological beliefs and claims according to the embodied, lived, and concrete relational activities of the community of believers, paying particular attention to the sites or, as Serene Jones and Paul Lakeland say, the "theological geographies" where these constructive practices occur, since particular situations give rise to certain questions of faith and resources for answering those questions. Tilley suggests that a constructivist theological method creates a new "local theology" from the doctrinal wisdom of the past and experiential wisdom of the present community in particular contexts. This method creates something new out of the tradition and contemporary contexts. Rather than focus only on the *content* of tradition, or the objective "stuff" that gets carried forward through the generations and whether or not it has been correctly appropriated in the current context (first-order theology), or the experiences of those who carry this content from one generation to the next (second-order theology), the constructivist method also considers the *process* of tradition or the orienting ideas and practices that carry the content forward and bolster its relevance in the lived experiences of the community (third-order theology). *How* we practice our faith, or our active faith commitments, is equally as important as *what* we believe, or the content of our faith convictions.

This constructive approach seems almost unavoidable, particularly when humanly created beauty or experiences of it become a focal point of our theological reflection. The stories that gave rise to *From Behind the Mask*, and the creative practices that brought this vision into being and continue to be incarnated in neighbors for whom this image offers meaning and identity, for example, underscore the fact that murals created by faith communities and those that have religious imagery

function as "theological texts" for folks in and beyond the communities where they reside. They offer a figurative and literal locus of theological reflection, embody religious practices, and serve as a touchstone for moral conversion and action. We might also consider community murals "visual doctrines" that attempt to explain the central beliefs of the faith traditions of the communities that create them—beliefs about God, humanity, salvation, and redemption. Like most religious art, murals represent a particular community's attempt to transcend the limitations of words, whether written or spoken, in order to proclaim the beliefs that define them in innovative ways, to explain the transcendent, and to motivate personal and collective commitment to a set of values that these communities have identified as life-sustaining. Invoking Jones and Lakeland, we might approach them as "collectively rendered maps," a metaphorical way of understanding doctrine that guides us through the complex terrain of faith as it unfolds in the theologically forgotten site of urban poverty, guiding us to new insights and practices.

The constructivist theological method is one of discovery. We unearth new insights about the tradition, as well as new perspectives on our current reality in the process of lifting up new faith claims and new ways of examining them. This method underscores the active nature of Catholic faith and theology—a faith tradition and the theological concepts that stem from it are not self-contained units of knowledge that we passively receive but rather dynamic ways of meaning making that we actively construct anew in ever-changing contexts and circumstances. In fact, Kaufman sees constructive theologians as artists since "the activity of imaginative unifying and ordering in which he or she is engaged is to some extent controlled by aesthetic considerations of harmony and balance, consistency and contrast." For similar reasons, sociologist of religion Robert Wuthnow sees artists as theologians, particularly if "theology is the practice of drawing connections between religious truths and contemporary cultural concerns." Eva Cockcroft, a New York City muralist often considered the mother of the mural movement in the United States, echoes this when she notes that muralists "believe that correct ideas do not fall from the skies, nor can they simply be appropriated from scholastic studies. Correct ideas emerge from, are tested and proven in social practice." New sites of theological reflection and the constructivist method remind us of the moral imperative to be creatively engaged in the world where God is at work and to participate in the ongoing work of the tradition. When engaged via a constructive method, murals ask how we can fully understand the imperative of neighbor love, the radical equality of the kingdom of God,

or the comprehensiveness of the common good if we do not perceive these concepts from the perspectives of those struggling to survive in the midst of urban blight.

Murals as Theological Sites

A few distinguishing characteristics make murals an ideal "site" for theological construction. Foremost among them is the fact that the geographical location of these images cannot be separated from their content. They arise out of the very territory of human experience and beliefs they are attempting to map, and so to that end their content does not make sense without an equal awareness of their context. Certainly, art regularly reflects the historical, social, economic, cultural, and religious contexts of both artists and audience. Nevertheless, the relationship between artistic content and socioeconomic context is amplified in community murals. Images such as *From Behind the Mask* cannot be encountered in isolation from the cultural milieu in which they are created. They do not hang in quiet galleries disconnected from the particularities out of which they arose or the conditions to which they respond. Rather, they herald their messages in the clamor of noisy street corners, splash their color in the middle of blighted blocks, lay out their visual oases in bustling transportation centers, and open their vistas inside prison yards in a way that creates images that are *lived in*, since they incarnate human experience in these places, and are *lived by*, since they orient those who move in and out of these spaces to a sense of meaning and a vision of the good.

This intrinsic connection between content and context pulls theologians, art historians, and the general public into unexplored spaces in American cities and into conversation with people whose contributions to the constructive endeavor of building theology have been largely ignored by the dominant culture. Where many forms of public art are often exhibited in the well-traversed spaces commonly associated with civic life—town halls, courthouses, the commons, commercial districts, libraries, historic sites, community centers, university campuses—community murals adorn walls in neighborhoods often dislocated from civic life and where residents have been ignored or misunderstood by the wider society. In the case of Philadelphia, the fifth largest and seventh poorest city in the United States, this means that a significant number of the murals reside in neighborhoods of "concentrated poverty," where residents are trapped by centripetal forces of hyper-segregation, high levels of unemployment and violence, and low levels of education and

access to health care. Murals become sites where we can recognize how space impacts the ways in which we experience our lives and build social relationships. They force us to take space into consideration when we start to strategize about how to respond to the injustices of concentrated urban poverty.

Finally, murals are sites where we discover the practices that sustain life in community and faith in the midst of poverty. To some extent, they invoke memories of the resilience of the African American spirit formed under the weight of dehumanizing oppression that predates the nation's founding in Philadelphia and subsequent generations of discrimination and violence. As we will see in chapters that follow, many of Philadelphia's murals visually capture fundamental characteristics of black spirituality: the unity of the secular and the sacred, an emphasis on individual sufferings that are gathered into the community and collectively resisted; a focus on Scripture and a dialogical experience with the Word; depictions of an immanent God who is experienced in people's lives through bodily engagement with the Spirit; a sense that worship and the sacred cannot be contained in the physical church but rather in the corporeal body of Christ; and hope in a powerfully transcendent God who seeks liberation for suffering people. With an eye for these spiritual elements, we begin to understand how murals cultivate a variety of practices associated with the power of memory, the agency of storytelling, and the inherent freedom of dreaming. To that end, murals are visual recipes for being good neighbors in specific communities that cook up "social capital" or the network of meaningful relationships that fortify people in these neighborhoods. Storytelling, deep listening, imagining, humility, and consensus building transform these sites into constructive spaces of contact among communities—both among the members of the community who create these images as well as with folks from outside communities who venture into otherwise bypassed communities in order to experience this art firsthand. These practices of urban neighbor love, in addition to being increasingly rare occurrences in American culture in general, are compelling not only for "constructing meaningful theological concepts, images and perspectives" but also for their ability, as Kaufman puts it, to "help move us and our world forward toward a more profound humanization."

Murals are "placemakers" for religious traditions that make them relevant in building more just metropolitan communities. As theological texts constructed on particular sites that give rise to new practices for doing both theology and beauty, community murals offer examples of what Alejandro García-Rivera identifies as a "living theology" and

"living aesthetics" in both theology and the arts. He notes that living theology depends on the arts to explain and breathe life symbolically, imaginatively, and more effectively into the "knotty doctrinal issues" that a "textbook" approach to theology attempts to inculcate, often at the risk of losing sight of what these doctrines mean in the lives of real people. Likewise, the arts depend on theology to protect the sense of mystery and wonder that "textbook aesthetics" often too easily explain away at the risk of making art a privatized and "self-conscious dialogue with itself." The rich imagery of Philadelphia's community murals offers new ways to think about a host of "knotty doctrinal issues" around human rights, racism, mass incarceration and the death penalty, HIV/AIDS, religious pluralism, and secularization. Therefore, as visual theological texts, murals construct theology using the traditions in inner-city neighborhoods. These traditions bring new colors, nuanced shading, texture, and depth to what can at times be an all too familiar theological pallet as well as to the seemingly unchangeable circumstances of concentrated poverty where nothing new seems possible.

Theological Aesthetics "from Below"

As a distinctively democratic expression of public art, both in the geographic scope of their exhibition and the organic nature of their creation, Philadelphia's community murals bring distinct characteristics to theological aesthetics. Community muralism demands that we incorporate the *process* of mural making and the socioeconomic *context* of this art into more traditional aesthetic and theological assessments of its actual content as well as the methods we employ to perceive and evaluate it and its transformative power. These features contribute several practical developments to the relationship between theological reflection and artistic expression.

Community murals point toward a theological aesthetics "from below." Characteristics of any systematic theology "from below"—Christology, ecclesiology, and anthropology—include a distinct emphasis on the organic and dynamic rather than the authoritative and immutable nature of religious belief and theological reflection. Belowness attends to the collective experiential wisdom of persons in concrete contexts rather than appeals to external authorities or universal truths. It understands that the human capacity for reason is informed by historical consciousness as much as by appeals to abstract or cognitive truth claims and supports an evolving and dynamic approach to transcendentals such as truth and beauty as opposed to more classic and immutable

articulations. It emphasizes social encounters with God in horizontal relationships in salvation history and in the contemporary reality, not merely in privately vertical relationships that long for personal salvation. And it underscores the importance of shaping communal identity and practice from the ground up rather than from the top down.

Community murals cultivate this type of "from belowness" in theological aesthetics. They expand scholarly examination beyond the geographical, epistemological, and aesthetic confines of "high" or "institutional art" that reflect the theological and artistic sensibilities of those privileged enough to participate in it and those who have traditionally determined what counts as theological or beautiful. Murals privilege the experiential wisdom and artistic sensibilities of the people of the streets: mothers, schoolchildren, teachers, high school students, faith communities, recovering drug addicts, and law enforcement officers. Their images emerge from the collective consciousness of communities before they are painted, and as a result of the organic process of their creation they provocatively reveal the human faces of social injustices that we tend to think about in conceptual or statistical terms. Murals nonverbally articulate communities' encounters with the Divine in particular contexts of the neighborhood without necessarily depending on appeals to universal creeds, doctrines, or holiness codes. And murals arise from practices that reflect these communities' self-understandings and ways of engaging in the world.

This "belowness" stands in contrast to at least three aspects of traditional theological aesthetics: *who* creates religious art and interprets its theological significance; *what* context this art arises from and, as a result, *what* counts as religious imagery; and *how* this art is created and functions in the life of faith communities. Exploring these three interruptions in the content of inner-city murals expands the parameters of theological aesthetics and deepens our understanding of the relationship between beauty and justice, one of the primary aspects of theological aesthetics.

First, much of this art is done by people on the margins of already marginalized urban communities. Among the thousands of Philadelphians who have painted murals, the movement also includes incarcerated felons or prisoners seeking to reenter society, adjudicated youth, recovering addicts, congregants of storefront churches, and families of victims and perpetrators of crime. Integrating these persons into our evaluations of the creation, interpretation, and transformative power of art corrects the cultural, gender, and political biases inherent in historical and even contemporary theological aesthetics, given its almost exclusive reliance on Euro-American or white and masculine perspec-

tives. Community murals, therefore, address concerns of scholars such as Susan Ross and bell hooks who note that while women—particularly women of color—are often considered beautiful objects or subject to externally imposed expectations of beauty, rarely are they recognized as paradigmatic subjects of art or primary subjects engaged in defining what constitutes beauty. They interrupt what bell hooks identifies as the "Euro-centric gaze" that "commodifies, accommodates and celebrates." Community muralism moves art from the elite to the street, so to speak.

More important, since the memories, emotions, and imaginations of these persons are the muse and material for the art, community members become the privileged insiders and experts who explain the significance of their creation to the wider community. Mural making and the images in community murals empower people who have been misrepresented in the arts, denied meaningful access to the arts, and denied authentic imaginative expression and creativity. They become critical subjects of art rather than mere objects of art, and as such, they become active subjects in creating a more just society rather than mere objects of social charity.

The *what* of this art, or its visual content, interrupts traditional venues and symbols for religious self-expression, as well as the self-understandings of many believers. Because they live and create on the margins of society, the people who paint community murals acutely experience, analyze, and respond to a variety of "signs of the times" that may be foreign to artists who work in the sanctuary of studios or within the parameters of the art industry, as well as to those who encounter art in galleries, museums, or private collections. The content of their murals is shaped by the experiential wisdom of the difficulties and blessings in their ongoing struggle for justice. This, in turn, influences their analysis of social problems and enables them to offer alternatives to mainstream evaluations so frequently dominated by the perspective or location of white privilege. These privileges often blind us to the injustices that dominate others' existence—radical social inequality, discrimination, double standards, intolerance, racial profiling—as well as to our implications in them. In addition, since these communities are often denied access to mainstream channels of communication—written, verbal, and nonverbal—in the secular and religious spheres, the images they create bring imaginative, emotional, and provocative perspectives to frequently debated and well-argued social justice problems facing urban communities. This too interrupts the prevailing logic of white privilege, often characterized by autonomous, distanced, and disembodied rationality, appeals to law and order and preference for reward and

punishment models of moral development, and a distrust of emotional or experiential intelligence.

A three hundred–foot wall with four oversized sets of eyes raises self-awareness of privilege and social responsibility (*All Join Hands: The Visions of Peace*, Donald Gensler, 2006; see p. 106), a crucified black Christ offers new insights into the dangers of challenging the drug market (*Born Again*, Cliff Eubanks, 2000; see p. 178), a wheel of life underscores the cyclical nature of immigration (*The Journey: Viet Nam to the United States*, Shira Walinsky, 2007; see p. 232), and a mask reminds us of the ongoing demand for conversion to more authentic selves (*From Behind the Mask*, Eric Okdeh, 2009; see p. 5). Moreover, these same images illuminate possible solutions to problems facing urban communities that persons living in these spaces have identified for themselves and that others on the outside do not perceive, or choose to ignore: the celebration of ancestors and community anchors, a persistent and resilient hope that a better future is possible, a fierce commitment to children, and a confidence that a life of faith can be integrated into life in the neighborhood. Zafir, a muralist and incarcerated prisoner in Pennsylvania's largest prison, notes, "We are having our voices through our art." One of his fellow muralists agrees and rhetorically asks, "How do we change attitudes? We keep painting. We just keep painting."

The content of these images suggests that if debate and moral argument about the problems of poverty were sufficient, we would have solved these entrenched injustices long ago. Rather, we need new approaches that emphasize the transformative power of the imagination and risk new ways of being in relationship with each other. Murals illuminate the inherently oppressive blind spots in the moral or ethical vision of even the most well-intentioned or compassionate outsiders who want to build a more just society. They identify and then resist what Bryan Massingale has identified as the source of racism within the Catholic tradition, namely, "the pervasive belief that European aesthetics, music, theology, and persons—and these only—are standard, normative, and truly 'Catholic.'"

Finally, when we consider *how* murals are created, we realize that the beauty of this art often lies in the process of muralism more so than in the images themselves. This is a significant shift in emphasis for theological aesthetics. For instance, most public art is generally commissioned by a public or private entity and created by a particular artist who often has little connection to the public space in which the work is ultimately exhibited. Similarly, religious art—from church buildings to icons—is often commissioned by persons in positions of authority and

frequently created by an artist outside of the community itself. When it comes to murals, neighbors and community members commission professional muralists to work closely with them in creating community murals. The professional artist is beholden to the collective vision of the community at every stage of the mural-making process—from initial community brainstorming meetings to the final design. And that design depends on the consensus of the community—an agreement that is best reached through an intentional process of building relationships of openness, trust, and collective imagination. This visual preferential option for the community, as well as the dialogical process that sparks the community's creative ideas, offers concrete and embodied examples of the relationship between beauty and justice.

For example, community meetings can cultivate creative, moral, and political agency as neighbors collectively select the appropriate wall, hash out possible themes and imagery, assess initial designs, build consensus around a final image, paint, and plan a dedication ceremony. These practices often concretely incarnate the vision that neighbors hope to capture in their murals. For example, images of forgiveness empower young people to risk forgiving others, images of landscapes seed community gardens, images of deep personal joy stave off the darkness that feeds addiction, images of community pride stoke civic responsibility, and images of an immanent God make God present in the neighborhood. Therefore, community murals illuminate the relationship between aesthetics and ethics through praxis; beauty and the good are no longer abstract concepts but rather lived practices that support justice and living in right relationship with others.

Given that community muralism introduces new participants, content, and processes to theological aesthetics, we can recognize community murals in Philadelphia as emerging "religious classics," in David Tracy's sense of the term. Community murals create arresting, interruptive, and potentially transformative dialectical experiences that reveal and conceal reality; pose questions that invite deeper reflection; and challenge limited interpretations of our social reality, expectations of what it means to be human, or notions of God. Given the importance of the collaborative process of their creation, as well as the context in which they are exhibited, community murals may be one of the most authentic expressions of a religious classic as Tracy explains it, since they are not primarily texts but rather liberating "events" wherein "the actions of whole peoples whose disclosive, ignored, forgotten, despised story is at last being narrated and heard in ways which might transform us all."

Chapter Two

The Ghetto as Symbol

Many of the exhibits in the world's largest outdoor visual art gallery are in neighborhoods of concentrated poverty, what Americans commonly call "the ghetto." Demographically, the ghetto refers to geographic tracts where the US Census Bureau indicates that 40 percent or more of the residents live below the national poverty line; more than 80 percent are of the same ethnicity, most often African American or Latino; a majority are un- or underemployed and hold a GED as their terminal degree. The origins and sustenance of today's ghetto are complex. Loïc Wacquant identifies a variety of top-down practices of "ethnoracial closure and control" that have created the contemporary ghetto: mass unemployment in a postindustrial economy, a withdrawal of public services over the last sixty years, conscientious commitments against public and private investment in the future of these places, and the political and economic commitments of the prison-industrial complex. Michael Katz and Mark Stern identify "screens" in employment, education, housing, and health care that "filter African Americans into more or less promising statuses, progressively dividing them along lines full of implications for their economic futures." Kevin Kruse and Thomas Sugrue highlight the detrimental impact of the "suburban ascendency" that began in the 1950s on inner-city populations: reinscribing impermeable racial and economic boundaries; siphoning human, economic, political, and ecological resources; and shifting the epicenter of public welfare and social capital away from cities. William Julius Wilson names a variety of cultural "pathologies" or dispositions and practices that develop among long-term residents of these marginalized places as a result of structural injustices that further isolate them from the common good: high rates of truancy and teen pregnancy, declining marriage rates, joblessness, participation in the informal economy, and suspicion of achievement as it is defined by the dominant culture.

Stepping out from behind Our Masks

Understanding chronic urban poverty is a difficult but necessary task in order to interpret content of murals in these neighborhoods accurately. We need to unmask the external, internal, and symbolic contours of these spaces that in turn shape but in no way determine the people who paint murals in them. For outsiders, an accurate interpretation of the sociospatial reality of the ghetto requires unmasking its historical, economic, political, and cultural roots in order to make evident the way this symbol has hijacked effective ethical reflection on and responses to concentrated urban poverty and denied residents of poor neighborhoods the opportunity to shape their own identities and destinies. The misappropriation of this symbol has saddled them, instead, with the burden of being the primary causes and problem solvers of the conditions that shape their existence. That few theologians or Christian ethicists, and far fewer art historians, have made the urban poor or conditions in American inner cities a focal point of their scholarship makes this unmasking work difficult to do.

In addition, an either/or approach to urban poverty has dominated public rhetoric and policy when it comes to diagnosing the symptoms of and treatment for concentrated poverty. This too does little to expose the causes of and responses to urban poverty. Since it became a focal point of political and academic reflection in the 1960s, we have tended to conclude that poverty is *either* caused by structural inequalities (in education, employment, affordable housing, public works, and health care) *or* a result of cultural factors (familial approaches to learning, attitudes about work, ethos around home ownership, or personal commitments to health). Combating poverty is the responsibility of *either* the government *or* individual poor persons. Responding to poverty *either* involves justice that remedies structural inequities *or* requires charity that meets the needs they cause. Ending poverty requires *either* providing the poor with the basic things they lack as the result of structural inequities *or* providing the moral guidance to assist them in making decisions that can radically change their economic situation.

Neither the strictly structural mask nor the exclusively cultural one that scholars, politicians, and everyday citizens unknowingly wear when facing concentrated poverty is particularly helpful, since both obscure the mutual dependence between social structures and cultural practices—within and outside of ghettos—that perpetuate conditions of urban poverty. Whether politicizing or moralizing poverty, we fail to humanize it. We forget that the urban poor are not an exotic "other" or a problem that needs to be solved. We forget to ask what it means

for human beings to flourish, why some are able to flourish more easily and heartily than others, and what interventions might be appropriate to increase the prospects of flourishing for as many people as possible. What's more, Wacquant notes that precisely because this approach to poverty fails to interrogate the relationship of scholars and policy makers to the urban poor or the supposed neutrality of our academic gaze that shapes our evaluation of it, this dichotomous approach fails to draw important connections between unearned privilege and the lack of privilege, between excess and scarcity, between invisible safety nets along the pathways of social mobility and obvious roadblocks, between the lifestyle choices of the middle-class suburbanites and those of the inner-city poor. All of this is to say that stepping out from behind the either/or mask in order to understand the historical and socioeconomic contexts of many of Philadelphia's thirty-five hundred concrete canvases will not be a straightforward or easy task.

The Ghetto as a Socially Constructed Symbol

Approaching the ghetto as a symbol, however, is a distinct contribution that theology—and even more so theological aesthetics—can make to the process of unmasking the reality of today's urban ghetto in order to be more effective in our responsibility to folks who live in them. Symbols are the language of theology, since any talk of God can only be couched in symbols, and the arts continually reveal new interpretations of symbols, sustaining the very mystery to which they point. Obviously, our construction and use of symbols is not limited to engagement of the divine. We rely on symbols to construct frameworks of meaning, understand what is happening in our lives, and express ourselves. When we consider the ghetto as a socially constructed symbol we can begin to unpack the factors that gave rise to the social construction of this space in the first place, and to recognize the way that this symbol functions in our public discourse and commitments to justice in metropolitan areas.

The symbol of the American ghetto has been constructed by economic, political, social, and cultural factors since the inception of American cities like Philadelphia, but particularly in the decades following the Second World War. This symbol is invoked by those who live outside of the ghetto in order to shape personal and public attitudes about and commitments to the people who live within them. Wacquant notes that ghettos symbolize territories of social stigma and public scorn "where only the rejects of society could bear to dwell," places unworthy

of public or private investment. In fact, when thinking symbolically of the ghetto, he invokes the image of a two-headed hydra—"personified, on the masculine side, by the defiant and aggressive 'gang banger' and, on the feminine side, by the dissolute and passive 'welfare mother'"— that threatens the personal security and moral values of the wider society. Theology and the arts have done little to contest overwhelming negative symbols of the ghetto like this one, denying agency to those who live in this space and justifying suburban dismissal of them. And yet, this seems a particularly fitting approach for theology in light of the fact that the images painted on sacred walls throughout ghettos in Philadelphia function symbolically, calling attention to the social construction of space and offering alternative ways of understanding life in these places that stem from neighbors' attempts to make meaningful lives, participate more fully in their social reality, and communicate that meaning to wider community. As new symbols of the ghetto, murals function for people who live there—as visual collective memories that refuse to let go of forgotten strains of history, as visual identity that reclaims space and lives as meaningful, as performative resistance to the dominant culture, and as moral agency in the midst of the pressures of poverty. Murals also function in communities outside of the ghetto—as interruptions of the status quo, as alternative interpretations of city life, as pricks of moral conscience, as invitations to a more interdependent way of being.

In what follows, I use a combination of community murals that appear throughout the book. I selected these murals to present the economic, political, and demographic facets of the symbol of the ghetto since World War II, by virtue of their sociospatial locations and the things that happened in these spaces and to the people who have moved through them, including members of my own family, so that we might better understand the content of the murals exhibited there.

Economic Conditions:
From Industrial Boom to Post-Industrial Rust

From the time it was built in the nineteenth century until its massive mural makeover in 2006, the five-story brick building on the northeast corner of Germantown Avenue and Jefferson Street that is now home to *Doorways to Peace* (Joe Brenman and Cathleen Hughes, 2004; see p. 223) would have been entirely unremarkable in its North Philadelphia neighborhood. Before the Al-Aqsa Islamic society purchased the structure in 1991, the building was a furniture manufactory that would have

been hard to distinguish from the nearly nine thousand factories built during the height of Philadelphia's industrial boom from 1860 to 1930. During those heady decades the city was the world's largest producer of nondurable goods, and the building at 1501 Germantown Pike would have been ideally situated to serve the various ethnic communities and markets along one of the oldest thoroughfares in the country, connecting villages and textile and grain mills in the north and the west with the manufactories and financial institutions in the center of the city. What's more, the nearly fifty piers and docks in one of the busiest ports along the eastern seaboard through most of the twentieth century, surpassed only by New York City, would have been close at hand, exporting goods such as furniture and importing laborers from Europe who made up nearly a third of the city's population at the peak of immigration to Philadelphia in 1870.

By the late 1950s, when the production of nondurable goods like furniture had relocated to the American South and eventually to the global south, 1501 Germantown would have blended in with the other skeletons of Philadelphia's industrial age that still haunt its postindustrial landscape. Today, Germantown Avenue connects the dots between the toniest and grittiest neighborhoods within the city limits. The previous lives of the current home of the Al-Aqsa Islamic Center and hundreds of former industrial buildings like it are all that is left of Philadelphia's days as "Workshop to the World." Track the demise of the industriousness they housed and you'll begin to understand social implications of living among and painting on the old industrial walls of the "Manufacturing Mausoleum of the World."

Dramatic changes in the American economy in the twentieth century dictated the boom and bust of most cities in the east. Katz notes that by the 1970s the economies of many American cities shifted from the production of goods or manufacturing that relied on physical capital to the production of services such as finance or insurance that relied on human capital. The former offered stable employment and viable wages to the majority of city residents, and the social capital these workers generated built and sustained urban neighborhoods for nearly two centuries. The latter reserved economic growth for those with higher levels of education and invested the financial and social capital they generated into the physical and social infrastructure of either suburban office parks or downtown financial districts. The shift to the production of human services herded blue-collar workers into the service sector where their work continues to be undervalued by low-paying jobs, limited benefits such as health care or pensions, and obstacles to unionization.

This transition from industry was particularly dramatic in Phila-
delphia, whose economy had been anchored in the production of
nondurable goods since the earliest days of the colony. The peak of
production—from 1860 to 1930—coincided with influx of European im-
migrants who were immediately absorbed into neighborhoods shaped
by ethnicity and the types of goods produced in them. Neighbors could
step out of their row houses—adjoined single-family dwellings that
became the standard residential structure in Philadelphia by 1800 and
were built at a rate of six thousand a year at the peak of the industrial
boom—and walk to work in one of the nine thousand factories or mills,
or the twenty-one shipping docks or twenty-three piers that provided
the economic and social anchor for their neighborhoods. Nearly 40
percent of those laborers worked in textile factories of some sort in
1930—hosiery, wool, carpets, upholstery—as compared with 19 percent
of textile workers nationwide.

But all of that industriousness came to a grinding halt when work
for many Philadelphians, in the words of William Julius Wilson, quite
literally disappeared. Although they served as economic anchors in
their North, West, and South Philadelphia neighborhoods, companies
producing nondurable goods followed cheap labor, first to the American
South and eventually to the global south. In Philadelphia, manufacturing
involved 39 percent of the workforce in 1920 but only 21 percent by 1984.
Between 1947 and 1986, 79 percent of the textile jobs disappeared.

And with the disappearance of work, so too vanished the material
and intangible benefits of steady employment: the financial and per-
sonal security that comes with health care, unemployment insurance,
disability insurance, pension funds; the sense of personal empowerment
and dignity that accompanies the ability to meet familial and social ob-
ligations; the creation of intergenerational wealth in the form of savings
accounts, retirement funds, and home ownership. From 1970 to 1980 the
number of Census Bureau tracts of concentrated poverty in Philadel-
phia, as well as in the adjoining counties of Camden and Chester, grew
from eight to forty-four—making Philadelphia the worst of the nation's
largest fifty cities in terms of economic deprivation in 1980.

The resurgence in the economy in the last decade of the twentieth
century and the first five years of the new millennium generated wealth,
but only for some. For example, Katz reports that in 1979 the average
income of the top 5 percent of families was 11.3 times that of the lowest
20 percent; by 2005 that ratio had jumped to 20.9. And while the national
employment rate increased 25 percent between 1991 and 2001, it grew
only 3 percent in "older central cities" such as Philadelphia, evidence of

the suburban preferences of most metropolitan employers and residents. Moreover, this wealth is increasingly concentrated in communities with close proximity to communities of concentrated poverty. The end of the twentieth century saw the gentrification of many urban neighborhoods, as some working professionals preferred urban living to life in the suburbs and new financial and technology firms opened up shop in downtown districts. In fact, the global boom in industries connected to human capital has created a new form of "internal colonization" in American cities, since in order to continually grow their bottom line these industries—financial, research and development, and technology—depend on the labor of a low-wage service industry. "The social and labor structures of the American city have thus split into two vastly unequal but intimately linked economies," explains Katz, "intimately linked because only the informal sector can supply the trappings of prosperity that make urban life attractive to the affluent." The combination of these factors ultimately transformed once-viable working class neighborhoods into "reservations for the very poor" or "ghettos of last resort" in the shadows of downtown skyscrapers.

The recession of 2008 only compounded these economic disparities and pulled many families teetering on the edge of poverty into the cycle of economic insecurity. In 2009, the first year the impact of the economic recession could be measured, Philadelphia—a metropolitan area with a twenty-mile radius encompassing five million people (approximately 1.5 million of whom live within the city limits)—lost 97,000 jobs and saw a 50–100 percent increase in Food Stamp participation in more than twenty-five of its state assembly districts (most of them suburban), and foreclosures impacted 10 percent of homeowners.

Political Commitments: Or Lack Thereof

If William Penn (1644–1718) had intended a "greene Country Towne" in his fastidious planning of Philadelphia in the 1680s, then the federal Home Owner's Loan Corporation, a precursor to the Federal Housing Administration, clearly intended a red one by the 1940s. Established in 1934 to refinance thousands of mortgages defaulted on during the Depression, this federal agency dissected American cities into four color-coded zones according to forecasted risks in granting mortgages, projections that were based entirely on racial and ethnic prejudices. This "redlining" appraisal process made whole neighborhoods, like the one where *Steppers* (Calvin Jones, 1996; see p. 90) resides on Twenty-Third Street a few blocks north of Ridge Avenue, ineligible for federally refinanced mortgages,

both for residential and business properties. Redlining, in the words of journalist Buzz Bissinger, planted "the seeds of the city's inevitable destruction," since funneling loans away from certain neighborhoods ensured that no future investment would be made in them. In 1937 the commission divided Philadelphia into twenty-five sections. Fewer than 5 percent received "first-grade designations," coded green, and the federally subsidized mortgages that came with such a designation. South Philadelphia just below Center City, North Philadelphia just above Center City, and much of West and Southwest Philadelphia were outlined in red and received no such funding. This disparity in government allocation of resources—both economic in terms of physical infrastructure and social in terms of schools, parks, and hospitals—caused the rise and fall of certain neighborhoods in metropolitan areas.

A decade later, city residents were again negatively impacted by federal housing assistance made available through the Veterans Administration for GIs returning from World War II. This assistance favored suburban developers, like my maternal grandfather, William Gallagher, who moved my mother's family out of their Nicetown neighborhood in North Philadelphia in 1948 to the then-countryside village of Jeffersonville in Montgomery County where he bought one hundred acres of farmland and built more than two hundred single-family homes. William Gallagher sold the majority of these properties to GIs through mortgage guarantee programs funded by the Veterans Administration, securing my family's long-term financial future as well as the future of Philadelphians, mostly white, who were approved for a mortgage and bought one of the 140,000 homes built in the suburbs between 1946 and 1953. But he also helped to fuel the exodus from the city and threatened the economic integration of city neighborhoods.

Katz notes that as a result of these political commitments, from 1934 to 1972, homeownership increased in America from 44 to 63 percent, but the majority of those homeowners were folks like my grandparents—white urban natives who were able to get mortgages in the HOLC green-lined suburbs. Therefore, the biggest federal incentive for homeownership abandoned poor blacks in neighborhoods that were, from the federal government's perspective, nothing more than containment areas whose redlined status justified further state inaction in public services—from education to recreation—in the decades that followed. Whole populations of Philadelphians were denied the financial and social benefits of homeownership, and the neighborhoods in which they lived were not deemed worthy of federal investment in housing, a legacy that continues today.

Strategies for urban renewal in the 1970s, in the wake of redlining and suburban migration, also exacerbated the conditions of poverty in inner-city neighborhoods. Blighted residential and industrial properties were razed under the direction of the federally subsidized Philadelphia Redevelopment Authority, but the affordable housing stock was not necessarily replenished. And although public housing made available through federal subsidies and the Philadelphia Housing Authority in the 1930s and 1940s was priced in order to accommodate as many people as possible, eventually even the very poor were priced out of these units, leaving them to be housed in densely populated and socially isolated high-rises that became the popular solution to public housing from the 1940s through the 1980s. According to a report out of the University of Pennsylvania for the Philadelphia Affordable Housing Coalition, as of 2000, there were thirty thousand fewer affordable housing units than needed by the more than 30 percent of the city's population who make less than $20,000 a year.

The 1980s did not bring much positive change for the urban poor. Katz identifies three themes that shaped political commitments in this decade: a war on dependency that viewed vulnerability and dependency as a social liability, a devolution in authority that downgraded government responsibility for vulnerable persons and shifted that obligation to the private sector, and a reliance on the logic of free-market economics to shape social policy. The socially and fiscally conservative policies of "Reaganomics" negatively impacted the most vulnerable citizens of cities—the homeless, veterans, HIV/AIDS patients, the mentally ill, crack cocaine users, at-risk youth, and the elderly—by significantly undercutting public funding for the various institutions and agencies that served these populations.

Perhaps the only aberration in the legacy of state inaction in cities can be found in policing and incarceration. Changes in the criminal justice system in the mid-1980s have caused a threefold increase in rates of incarceration in America. As of 2007, the Commonwealth of Pennsylvania ranked among the top ten states with the highest percentage of incarcerated residents. Seventy percent of the inmates in the state's largest maximum-security prison are Philadelphians. In 2007, Philadelphia County had the highest number of inmates in its jails and prisons of any city in the country. Mass incarceration disproportionately impacts poor urban persons and communities: interrupting education; jeopardizing employment opportunities; destabilizing families; and draining public funds for education, recovery programs, recreation, and employment, which are far more effective than imprisonment in

cultivating law-abiding citizens. In 2007 states spent $49 billion on incarceration, up from $11 billion in 1987. In 2010, Pennsylvania spent $2 billion on corrections and is in the process of building four new prisons. The City of Philadelphia requested $231 million for corrections in the 2011 budget. The fact that recidivism rates have remained steady at 75 percent strongly suggests that this is neither an effective form of state action nor a sound investment of public funds.

Demographic Shifts:
Go West! . . . And Northwest! . . . And East!

The American ghetto as we understand it today arose after the dust of two significant migrations in the twentieth century had settled. The Nicetown neighborhood where *Forgiveness* (Eric Okdeh, 2007; see p. 137) resides is one of many spaces in the city that experienced this movement of people. The first was "the Great Migration" of more than one million southern blacks into the northern industrial cities as the result of mechanization in agriculture in the South in the 1920s and 1930s. Between 1910 and 1930, one hundred forty thousand blacks, mostly from Virginia and South Carolina, migrated to Philadelphia; records show that in the summer of 1917, eight hundred arrived each week. In some cases, these new arrivals lived in neighborhoods that were economically if not racially integrated. They offered steady employment, black-owned businesses that were supported by the community, and civic institutions that facilitated communal life. More often than not, however, people of color were forced to settle in already overcrowded South and North Philadelphia neighborhoods.

Shortly after this influx of African Americans arrived in northern cities, the workshop of the world ground to a halt, and their Euro-American neighbors, like my grandparents, moved out. Suburbanization continued to feed the individualism at the heart of the American "Go West!" spirit. "A man could no longer move his family west in search of his own private homestead," remarks Bissinger of this period in Philadelphia history. "But at the very least, he could go ten or fifteen miles in any direction outside the city limits and find his own house on a tidy plot of land."

From 1950 to 1970, more than seven million white Americans left central cities for the suburbs. Boosted by federal mortgage programs and literally transported by an elaborate and extensive highway system financed by the Federal Transportation Department. The economically mobile gained ways out of the city while many urban neighborhoods were dismembered with multilane interstate highways, overpasses that

darkened city thoroughfares, and air and noise pollution that detracted from the quality of life. The suburban population grew by eighty-five million people in that same period. Although people had begun to move to the Philadelphia suburbs as early as 1920, in 1960 the suburbs had absorbed more than half of the region's population and two-thirds by 1980. By 1990 the city had lost four hundred thousand residents and 20 percent of the 1.5 million citizens who remained were living at the poverty level. Employment followed people like my grandparents. By 1980, office and industrial parks, shopping malls, and other suburban employers were providing close to two-thirds of the region's jobs so that by 1990 only one-third of the metropolitan area's jobs actually existed within the city limits.

The processes of suburbanization and the "stake your claim" dispositions, lifestyles, and values of suburban Americans contribute to the ghettoization of American cities. Wilson notes that the relocation of manufacturing and then the service industry to the suburbs in the 1980s and 1990s created a geographical mismatch for low-paid urban workers who rely on public transportation to take them miles from their neighborhoods for minimum wage work.

A third migration in the 1980s of foreign-born immigrants from Latin America, Asia, and Africa—or what Wacquant calls "economic and political satellites of the U.S."—into America's gateway cities, and at rates that far exceeded those of European immigration at the turn of the twentieth century, also impact American cities and the poor who already live there. Wacquant points out that the "new immigrants," as they are called, are channeled into "the very neighbourhoods where economic opportunities and collective resources are steadily diminishing" and are ill-equipped for viable employment in the current economy. The service-sector economy increasingly relies on immigrant laborers, and undocumented immigrants further devalue wages in those industries. As we will see in more detail in the last section, Philadelphia is one of the "re-emerging gateway cities." Immigrants arriving since 1990 make up almost 10 percent of the city's population.

Philadelphia in Black and White

No other city more starkly presents the historical contradiction of slavery in America than Philadelphia, a city that was home to six hundred slaves just a year before the signing of the Declaration of Independence. And no mural captures the legacy of this contradiction more provocatively than *Lincoln's Legacy* (Josh Sarantitis, 2006; see p. 245),

a one-hundred-thousand-square-foot mural and mosaic located just three blocks west of Independence Hall, the hallowed ground where our nation's social contract was birthed. The mural's content is also significant because it reminds passersby of the way in which racism was grafted into America's very being when signatories of the Declaration and the Constitution in Independence Hall refused to acknowledge the full humanity of all persons.

As a reflection of that decision not to abolish slavery, Philadelphia has historically been a racially segregated city. A Quaker visiting Philadelphia in 1841 commented, "There is probably no city in the known world where dislike, amounting to the hatred of the coloured population, prevails more than in the city of brotherly love." Frederick Douglass echoes this: "There is not perhaps anywhere to be found a city in which prejudice against color is more rampant than Philadelphia."

Although Philadelphia was the birthplace of the abolitionist movement and what historian Russell Weigley calls "a mecca for escaping slaves and free Blacks"—thanks to commitments of Quaker Philadelphians who established the American Anti-Slavery Society in 1833 at a time when one in twelve Philadelphians was black—white Philadelphians on the whole did not share their sentiments. The black community bore the effects of their dissatisfaction with abolition. Riots in 1830s, spurred by newly arrived Irish who competed with blacks for housing and "hod carrying" and stevedoring jobs, destroyed property and claimed lives. Blacks were denied access to streetcar suburbs in the city and were concentrated in the Moyamensing neighborhood in the southeast part of the city. Rates of imprisonment were unequal in the nineteenth century as well: in the 1840s, 29 percent of inmates at Eastern State Penitentiary, the nation's first prison, were black, even though they comprised only 7 percent of the population.

Before the turn of the twentieth century, the city's black population was the largest of any northern city, surpassed only by Baltimore, Washington, and New Orleans. Between 1876 and 1896, fifteen thousand Southern blacks arrived and joined the twenty-five thousand already in the city, living mostly in southeastern neighborhoods but gradually being pushed into West Philadelphia with the arrival of European immigrants. These folks were unskilled laborers and domestic workers, as they were denied access to other positions and not permitted to unionize. Housing was also a problem, and white Philadelphians resented blacks who moved beyond their contained neighborhoods.

As immigrant populations began to migrate to northern and western neighborhoods and into the suburbs, Philadelphia's black community began to move in, but often into deteriorating housing stock. A Works

Progress Administration survey of the city in 1939 indicated that 18 percent of housing stock in the city was substandard. Attempts in the 1950s to integrate neighborhoods through public housing developments in various working-class white neighborhoods throughout the city met with vehement opposition and mob scenes in City Hall. In his study of racism and public housing in the city, James Wolfinger notes that these attitudes persist in neighborhoods where competition for jobs and housing is felt most acutely and where the persistent sense that "ethnicity and race play key roles in determining a person's status" still grips the moral imagination.

Religious Conditions:
Quietly Quaker, Charitably Catholic, and Irresponsibly Tolerant

Peaceable Kingdom (Charles Hankin, 2001; see p. 44), in the Fair Hill neighborhood of North Philadelphia, evokes the biblical vision of justice evoked by Isaiah, as well as the legend of William Penn's peace treaty with the Lenape tribe in 1682 under a giant oak on the banks of the Delaware. This iconic scene, depicted in more than one hundred "peaceable kingdom" pieces by Quaker Artist Edward Hicks (1780–1849), still decorates Quaker homes. The mural visually reinterprets that legend and civic virtue of justice, best exemplified through *philia* or the "brotherly love" depicted in the image. It also provides a provocative lens through which to consider how two particular religious sensibilities and commitments that permeated Philadelphia's history, one Quaker and the other Catholic, contributed to the impoverishment of the neighborhood in which the mural now stands.

Quietly Quaker

In 1681, William Penn bequeathed twenty acres north of the city center to George Fox, founder of the Society of Friends, who in turn gave a parcel of the property, which he named Fair Hill, to the Quakers with specific instructions that it be used for a traditional Meeting House for weekly worship and a burial ground. In the 1780s Fox's property was leased to a tenant farmer and eventually purchased, a century later, by a developer. By the turn of the nineteenth century, the parcel came under the auspices of the Green Street Meeting, a more fundamentalist group of Hicksite Quakers who refused to compromise on the principles of simple living and nonviolence. Members of some of Philadelphia's most prominent Quaker families are buried just two blocks from *Peaceable Kingdom*, along with a number of famous Quaker

suffragists and abolitionists: Lucretia Coff Mott (1793–1880), "mother of American feminism" and the Philadelphia Anti-Slavery Society; Mary Ann McClintock (1822–80), one of the delegates at the Seneca Falls convention for women's rights; and Robert Purvis (1810–98), a black Quaker influential in Philadelphia's Underground Railroad. In 1919 the Fair Hill Friends established a weekly meeting and a school in the neighborhood, but by the 1960s few Friends lived in Fair Hill. "In the 1970s and 1980s, the neighborhood continued to deteriorate," explains a newly formed caretaker group associated with the Chestnut Hill Meeting, "making the upkeep of the burial ground increasingly difficult." In fact, *The Philadelphia Weekly* identified an intersection in Fair Hill as one of the top ten drug corners in the city in 2007.

How does the rise and fall of the Fair Hill neighborhood hinge on the religious values of the Society of Friends? Certainly, its rise can be traced to the central tenants of this sect of the English Reformation initiated in the mid-1600s by landed men of the English countryside who pushed the Church of England to return to early Christian values of simplicity and nonviolence. The highest of these was the belief that all persons are equal under God and are capable of mystical union with God through private introspection on the inner light that animates one's life. That most of the early Quakers, including William Penn, were imprisoned in England for these beliefs only made them that much more passionate about incarnating them in Penn's Woods. The Quakers' commitment to equality fostered a tolerance for difference that made Philadelphia the most religious and culturally diverse city in Europe or the Americas at the time of the Declaration of Independence. Their confidence in the experiential wisdom of believers gave Quakerism its distinctively anti-authoritarian and matriarchal character, evidenced by the witness of the women buried in Fair Hill Cemetery. Their sense that the dispositions and practices of the Sermon on the Mount ought to guide personal and social relationships fueled abolitionist and suffragist movements of later Quakers and other religious Philadelphians.

But these same values—of equality, of individualism, and of simple living in accordance with Gospel values—facilitated Fair Hill's demise, since they also cultivated a kind of privatism that came to characterize mainline Quakerism, particularly as prominent Quaker families, like those buried at Fair Hill, increasingly found themselves among the most wealthy and privileged Philadelphians. E. Digby Baltzell notes that an emphasis on radical equality before God may have cultivated religious tolerance, but it also translated into irresponsible tolerance of economic inequality, since one's stature before God was deemed more important

than one's economic status, high or low, in the community. An emphasis on simple living and reflective introspection made Quakers reluctant public and civic leaders and convinced them to segregate their private religious lives from their public relationships. A commitment to sound government needed to build a just society paled in comparison to the commitment to sound families and private businesses.

While the direct influence of Quakers on the rise of the city did not extend long past its colonial period—and Quaker abolitionists were hardly celebrated by antebellum Philadelphia—their values influenced wealthy and privileged Philadelphians for several generations, citizens whom historians have identified as remarkable for what they *did not do* for the city outside of their small cultural circles of affluence. Historian Sam Bass Warner calls Philadelphia a "private city" psychologically and politically guided by values of "privatism," values that protect private family interests as well as private interests in economy. Retreating from society by putting family concerns first, protecting family wealth at the expense of investing in the common good, and insider politics that quietly reinvested wealth in certain communities did much to undermine the common good in Philadelphia.

Charitably Catholic

The Fair Hill neighborhood is also an ideal space to explore the Catholic roots of religious attitudes about and responses to urban poverty in Philadelphia. Historical records indicate that in the late 1880s and 1890s a young Irish immigrant builder, John Loughran, bought plots of land in Fair Hill and began building eight-room houses with porches, i.e., row houses, which rented for $20 or sold for $2,800. It is possible that *Peaceable Kingdom* is painted on one of Loughran's row houses. As a distinctively German neighborhood began to flourish, a ghetto of opportunity so to speak, Loughran also purchased land for the Philadelphia archdiocese in 1889 so Fair Hill Catholics might build a church to match the sacramental and aesthetic sensibility of the community, which was quite distinct from the Irish influence that dominated the diocese. After outgrowing a small church and school, St. Bonaventure's morphed into a Gothic church by 1906 whose spire could be seen for miles.

Both of these building events were not unique to Fair Hill. Historian Charles Morris notes that the Catholic Church was a "big player in real estate markets" both in the city and in the suburbs: in 1903 the church operated 103 schools, and in 1916 they operated fifty more, by which point the number of students in diocesan schools had doubled. But just as the Quakers receded from Fair Hill, so too did the Catholics.

St. Bonaventure's school closed in 1993 with three hundred children enrolled, a majority of whom were Puerto Rican, challenging usual arguments about the declining Catholic population used to justify parish closures. The parish closed not long after. The empty shell of the church—boarded up and fenced off, with its crossless spire looking down on the cemetery, the neighborhood, and *Peaceable Kingdom*—is all that is left of the Catholic Church's presence in the neighborhood.

Again, we have to ask ourselves, how did a neighborhood that had the support of a vibrant Catholic community, able to raise enough financial, social, and human capital to build and sustain an immense church and elementary school, reach a poverty rate of 57 percent as of the 2000 census? And what role did the church and Catholicism play in this transition from ghetto of opportunity to ghetto of last resort?

Philadelphia Catholicism infected citizens with its own strain of privatism that precluded authentic brotherly love. Philadelphia Catholics historically perceived themselves as an embattled and discriminated group, due in no small part to the fact that the vast majority of them were immigrants from Ireland, an ethnic group that was only separated from the lowest rung on the social ladder by free blacks with whom they violently interacted at multiple points in Philadelphia's history. In order to survive and then to flourish, Philadelphia Catholics, like other urban American Catholics, created and maintained a subculture that pervaded every aspect of life and fostered an inward-gazing "take care of your own" mentality. Morris describes the Philadelphia archdiocese as the "most carapaced and separatist in the country," a "state-within-a-state" whose "ghettoized and defensive" populace was run by pastors who acted as "sub-mayors" over an immovable physical infrastructure that anchored social life and parishioners in that neighborhood. Moreover, nostalgia in our postmodern and postconciliar Church for the black-and-white clarity of this thoroughly Catholic era makes it easy to forget the racist attitudes and actions this segregated subculture cultivated and justified. Segregation by ethnicity and therefore by "race," a particularly fluid category for Catholics, was natural. Neighborhoods were not organic and evolving spaces with perforated boundaries but static re-creations of ethnic villages impervious to life outside their invisible walls; the physical structures of the Catholic ghetto were investments in social mobility that had to be protected and denied to outsiders.

Philadelphia Catholics were also preoccupied with raising money to build and then maintain the grand vision of Dennis Cardinal Dougherty (1865–1951), an infamous religious leader in the first quarter of the twentieth century who called himself "God's Bricklayer" and made

Philadelphia home to the "most effective private schooling system" in America, again evidenced by the building of St. Bonaventure and hundreds of churches and schools like it. The financial resources, labor, and materials for this building blitz came from Catholics themselves. Philadelphia Catholics were so focused on the endless fund-raising necessary to support what was going on in their immediate parish communities that they had little awareness of what was going on in the Catholic community across the city, much less the city at large. Nor did they have the financial wherewithal to do anything for other constituencies who may have been in need.

Finally, despite the public efforts of Jesuit labor priests in Philadelphia who supported workers in everything from education to organizing, a pre–Vatican II morality dominated the social ethic of parish precincts of Philadelphia. In short, Catholics sought social stability through charitable works that did not bother to ask *why* people were hungry, or unemployed, or segregated. Moreover, a "theology of charity" encourages affluent Catholics to give of their surplus to those in need, leaving the root causes of poverty unexamined and cultivating attitudes that actually reinforce the very divide charitable works attempt to bridge.

Re-creating a Symbol

From Behind the Mask and other murals like it call us to remove our own masks before we enter into urban spaces in order to consider what has happened to the people who live in them and at the hands of people who have moved through them. The factors that we have considered here—the decline in an industrial economy, the movements of people into and then out of cities, lack of political commitment and investment in inner-city neighborhoods, cultural conditions in the black and white communities, and the religious sensibilities of Quakerism and Catholicism—all have a role to play in the external, internal, and symbolic construction of the ghetto in Philadelphia. To move through these spaces without attention to these sociohistorical dynamics will prevent us from fully understanding art that is being created there and make it possible to continue to mask urban poverty in ignorance, amnesia, and stereotyping. We now turn to murals that reimagine and reconstruct life in these communities.

Bibliography

Introduction

Discussions with prisoners at the State Correctional Facility at Graterford occurred during a design meeting with Bible Way Baptist Church on September 24, 2008.

Chapter One: Spaces, Stories, and Method

My method is informed by Gordon Kaufman's chapter, "Theology at Construction," in *An Essay on Theological Method*, 3rd edition (Atlanta, GA: Scholars Press, 1995), as well as the introductory chapter of Terrence Tilley's *Religious Diversity and the American Experience: A Theological Approach* (New York: Continuum, 2005), and his *The Disciples' Jesus: Christology as Reconciling Practice* (New York: Orbis Books, 2008). See also Serene Jones and Paul Lakeland's *Constructive Theology: A Contemporary Approach to Classical Themes* (Minneapolis: Fortress Press, 2005). In considering the role of the arts in constructive approach I found *Creative Spirituality: The Way of the Artist* by Robert Wuthnow (Berkeley: The University of California Press, 2001), to be helpful, as well as Alejandro García-Rivera's approaches to a lived theological aesthetics in *A Wounded Innocence: Sketches for a Theology of Art* (Collegeville, MN: Liturgical Press, 2003). In order to draw connections between constructive theology and muralism, I turned to Eva Cockcroft's *Toward a People's Art: The Contemporary Mural Movement* (Albuquerque: University of New Mexico Press, 1998), as well as a report by the National Endowment for the Arts on Philadelphia's muralism and "placemaking" by Ann Markusun and Anne Gadwa, "Creative Placemaking, National Endowment for the Arts, 2010," available at http://arts.gov/news/news10/creative-placemaking-general.html.

To construct a theological aesthetics from below, I invoke Karl Rahner, "The Two Basic Types of Christology," *Theological Investigations* 13 (New

York: Seabury Press, 1975), 213–23; and Roger Haight, *Jesus Symbol of God* (New York: Orbis Books, 1999), 28–30; and *Christian Community in History* (New York: Continuum, 2004), 3–27. See also bell hooks, *Art on My Mind: Visual Politics* (New York: The New Press, 1995), as well as Bryan Massingale's comment on Pax Christi's website, http://www .paxchristiusa.org/. David Tracy's proposals regarding the religious classic in his now-classic *The Analogical Imagination: Christian Theology and the Culture of Pluralism* (New York: Crossroad, 1981) are invaluable for my approach to muralism throughout this book.

Chapter Two: The Ghetto as Symbol

For a *historical overview* of how American attitudes regarding poverty have combined with political and economic conditions to fuel concentrated poverty, particularly since Daniel Patrick Moynahan's 1965 report for the Department of Labor, see urban historian Michael Katz, *The Undeserving Poor: From the War on Poverty to the War on Welfare* (New York: Pantheon Books, 1989), His *The Price of Citizenship: Redefining the American Welfare State* (Philadelphia: The University of Pennsylvania Press, 2001 and 2008), and his essay with Mark J. Stern, "Beyond Discrimination: Understanding African American Inequality in the Twenty-First Century," in *Dissent* (Winter 2008), are essential resources for understanding the historical roots of the contemporary urban landscape, as is Thomas Sugrue's *The Origins of the Urban Crisis: Race and Inequality in Postwar Detroit* (Princeton, NJ: Princeton University Press, 1996), and *The New Urban History* with Kevin Kruse (Chicago: University of Chicago Press, 2006).

William Julius Wilson is widely hailed for his *socioeconomic analysis* of the relationship between unemployment and interpersonal facets of concentrated poverty in *The Truly Disadvantaged: The Inner City, the Underclass and Public Policy* (Chicago: University of Chicago Press, 1987), and *When Work Disappears: The New World of the Urban Poor* (New York: Vintage Books, 1997). He most recently examined the socioeconomic structures of racism and cultural practices in *More Than Just Race: Being Black and Poor in the Inner City* (New York: W.W. Norton and Company, 2010).

For an *ethnographical* study of cultural conditions that perpetuate social immobility within inner-city communities, see Loïc Wacquant, *Urban Outcasts: A Comparative Sociology of Advanced Marginality* (Cambridge,

UK: Polity Press, 2008). Elijah Anderson offers a Philadelphia-specific ethnographic study in *Code of the Street: Decency, Violence and the Moral Life of the Inner City* (New York: W.W. Norton and Company, 1999). Buzz Bissinger's *A Prayer for the City* (New York: Vintage Books, 1997) offers a narrative account of urban poverty in Philadelphia in the 1990s, highlighting throughout its roots in the rise and fall of Philadelphia's industries in the late nineteenth and early twentieth centuries.

Gloria Albrecht offers a *theological analysis* of urban poverty in "Detroit: Still the 'Other' America" in *The Journal of the Society of Christian Ethics* 29, no. 1 (2009): 3–24, as does Warren R. Copeland in *And the Poor Get Welfare: The Ethics of Poverty in the United States* (Nashville, TN: The Abingdon Press, 1994). See also David Hilfiker, *Urban Injustice: How Ghettos Happen* (New York: Seven Stories Press, 2002), and David Mitchell, *Black Theology and Youths at Risk*, Research in Religion and the Family, Black Perspectives 5 (New York: Peter Lang, 2001).

For *Philadelphia-specific history*, I relied extensively on Russell F. Weigley, ed., *Philadelphia: A 300-Year History* (New York: W.W. Norton and Company, 1982). The historical narrative account by Bissinger offered helpful neighborhood-specific context, and Steven Conn's *Metropolitan Philadelphia: Living the Presence of the Past* (Philadelphia: University of Pennsylvania Press, 2006) provided an important discussion of the historical connections between city and suburb. A volume of essays edited by Carolyn Adams and others, *Philadelphia: Neighborhoods, Division, and Conflict in a Postindustrial City* (Philadelphia: Temple University Press, 1991), was invaluable for its historical data and statistics. In terms of the city's racial history, see James Wolfinger, *Philadelphia Divided: Race and Politics in the City of Brotherly Love* (Chapel Hill: University of North Carolina Press, 2007). E. Dibgy Baltzell paints a fascinating picture of the implications of Philadelphia's Quaker origins in the city's politics, economics, and culture in *Puritan Boston and Quaker Philadelphia: Two Protestant Ethics and the Spirit of Class Authority and Leadership* (Boston: Beacon Press, 1979). Sam Bass Warner's *The Private City: Philadelphia in Three Periods of Its Growth* (Philadelphia: University of Pennsylvania Press, 1968) was also insightful for following the thread of privatism throughout the city's history. For the history of the Fair Hill neighborhood, see a document prepared by Patrick Kidd for the Historical Preservation Studio at the University of Pennsylvania, available in PDF format online through the Philadelphia Church Project, http://www .phillychurchproject.com/. Philadelphia also features prominently in

Charles R. Morris's *American Catholic: The Saints and Sinners Who Built America's Most Powerful Church* (New York: Random House Books, 1997).

Finally, several independent research institutes offer *current demographical data on Philadelphia*: The Brookings Institution Center on Urban and Metropolitan Policy's analysis of the 2000 census data, "Philadelphia in Focus: A Profile from Census 2000," available at http://www.brookings .edu/reports/2003/11_livingcities_philadelphia.aspx, and their Metropolitan Policy Program (http://www.brookings.edu/metro.aspx); The Metropolitan Philadelphia Indicator Project (MPIP), "2010: Where We Stand—Economic Indicators for Metropolitan Philadelphia," retrievable at http://mpip.temple.edu/index.php?q=node/39; The Pew Charitable Trust's Philadelphia Research Initiative (http://www.pewtrusts.org/ our_work_category.aspx?id=244) and The Pew Center on the States 2008 report, "One in 31," retrievable at http://www.pewcenteronthestates .org/news_room_detail.aspx?id=35912. A 2006 report for the Philadelphia Affordable Housing Coalition, "Closing the Gap: Housing (Un)Affordability in Philadelphia" by Amy Hiller and Dennis Culhane of the University of Pennsylvania provides a wealth of statistics that link housing insecurity with income insecurity: http://repository.upenn .edu/cplan_papers/1/.

Part Two

Murals
Painting *Philia*

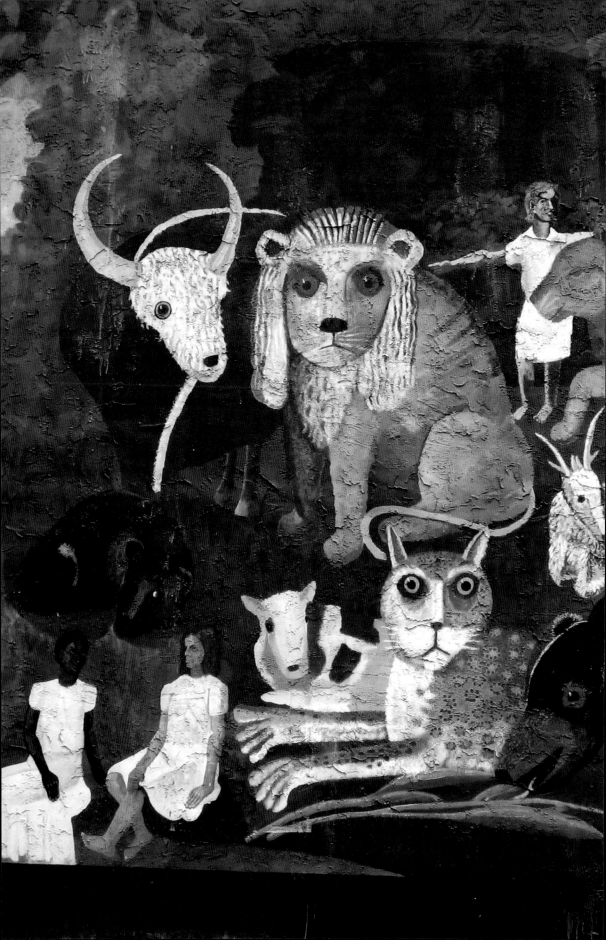

Peaceable Kingdom

There is nothing necessarily extraordinary about an artist and practicing Quaker from the Philadelphia metro area painting a rendition of Edward Hicks's *Peaceable Kingdom*. After all, Hicks (1780–1849) himself was a Quaker familiar with Philadelphia, and the various renderings of the vision of justice from Isaiah he painted in the 1830s, often invoking the lore of William Penn's treaty with the Lenape Indians under a grand tree on the banks of the Delaware, were iconic for his Quaker abolitionist peers and adorn the homes of Quakers to this day.

But what if that contemporary artist were a direct descendant of Hicks? And what if he decided that a two-story external wall of a row home would be his canvas? And what if that wall stood just a few short blocks from a cemetery where his muse and his abolitionist friends are buried? And what if the image that descendant of Hicks painted were to juxtapose the vision of the peaceable kingdom that inspired the abolition movement with a contemporary vision of a peaceable neighborhood in a still racially segregated city? And what if teens from that neighborhood, now one of the most economically challenged in Philadelphia, helped that relative of Edward Hicks in bringing that image to life?

Those, in fact, are the extraordinary details of *Peaceable Kingdom*, painted by Charles Hankin in the Fair Hill neighborhood of North Philadelphia in 2001. And they speak to the ways in which community murals are painting *philia* throughout the City of Brotherly Love.

Peaceable Kingdom invokes the vision of justice from Isaiah (11:6-9). The biblical passage, often read in the Advent season as Christians await the in-breaking of the reign of God in the person of Christ, instills in us a sense of just how radically different the world might be if we were truly to "live in right relationship" with each other and the created

Peaceable Kingdom, Charles Hankin, 2001, © Philadelphia Mural Arts Program.

world, the basic definition of justice in the Hebrew Bible and in Jesus' parables and actions in the gospels. Just as the lion will lie with the kid, Philadelphians of different races will be good neighbors to each other. An ecological consciousness will allow communities to prosper in the cool shade of trees for which many of the city streets are named. A sense of civic harmony and stability will emerge out of the wilderness of Penn's Woods and the chaos of inner-city life. It reminds passersby of the exhortation at the conclusion of that chapter in Isaiah: "They will not hurt or destroy on all my holy mountain; for the earth will be full of the knowledge of the LORD as the waters cover the sea."

Isaiah's vision of justice is inescapably rooted in the imagination—as are most of the ethical concepts in biblical texts with connections to the peaceable kingdom of God. Forgiveness, love of enemies, the equal distribution of material goods, and the table fellowship of discipleship all point to social relationships that define the kingdom, a reality Christians both hope for in the next life and are commissioned by Christ to build in this one. Many of these mandates, however, seem increasingly impractical and impossible in our day and age, especially

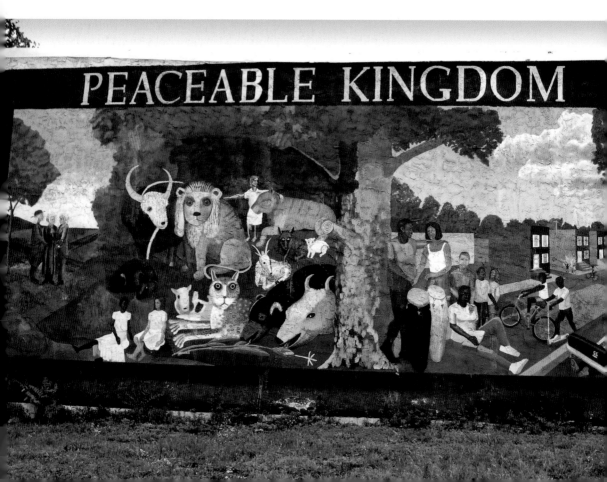

when the mythical power of religious images like Isaiah's are diluted by postmodern sensibilities, when the temptation to surrender to the status quo overpowers collective commitment to meaningful change, and when three generations of social inequality render problems like urban poverty a seemingly inescapable reality. So it is only through the imagination that we are able to see the reminders of what dances on the periphery of our experiences. With imagination we ponder images of the peaceable kingdom and recommit ourselves to seek after them. Just as Martin Luther King Jr. called the nation's attention to his dream of this same holy mountain and the just relationships among persons that would flourish there, we know that without a vision or fantasy of the kingdom to agitate our imaginations we are unlikely to commit ourselves to the moral tasks necessary to achieve it.

Painting *Philia*

"The moral life is more than thinking clearly and making rational choices," explains Christian ethicist Stanley Hauerwas. "It's a way of seeing the world . . . a progressive attempt to widen and clarify our vision of reality." Rev. Carnell Smith, pastor of Gate to Heaven Ministries, which is home to *Songs of Hope* (Donald Gensler, 2002, see p. 87), captures this well: "When I minister, I paint a picture in the minds of the people to demonstrate my point. What we are trying to do with the Gospel is to relate people to some sort of event that has already taken place—paint a picture of the past and the present so I can see where I'm going in the future."

The vision of *Peaceable Kingdom* is transformative precisely because it is an expression of beauty. "Beauty does not passively work on us," explains Robin Jensen, "but stirs us up to strive for this union. While we strive, we are transformed: as we progress toward the goal, we are gradually shaped in its own image." In this section, we will consider the ways in which community murals like *Peaceable Kingdom* are particularly well suited for forming and transforming individuals and communities. They not only tell us what justice is about but also give all who participate in creating them and all who pass them by a sense of what justice might look and feel like. To that end, they impact how we go about doing justice in metropolitan regions like Philadelphia.

Chapter Three
Painting Walls

For folks at Klein Jewish Community Center in Northeast Philadelphia, mural making is a kind of *mitzvah*—an activity that keeps the commandments of the covenant, particularly those focused on caring for the neighbor. At least that was their impetus for offering up one of the walls of their center for a mural as part of a unique "Mitzvah Mania" day of service sponsored annually by the city's Jewish Federation. But after brainstorming and listening sessions with folks at either end of the life spectrum whom Klein increasingly serves—the elderly and preschool children—about their understanding of the Jewish tradition and the work of the JCC in incarnating it, *mitzvah* emerged as a theme for the piece that was eventually painted by more than one hundred people connected to Philadelphia's Jewish community. It's captured in the lines of a short poem by Rabbi Hillel, written in Hebrew and English, at the center of the mural: "If I am not for myself, then who will be for me? And if I am only for myself, then what am I? And if not now, when?"

"This is simplistic but sums up the fact that religion deals with the personal, as well as your relationship to the larger universe and your relationship to other humans," explains lead muralist Shira Walinsky, whose own family roots lie in Northeast Philadelphia's Jewish community. "At the dedication there was a Holocaust survivor that spoke and that was very powerful because she didn't talk so much about the mural as much as about the need to continue our traditions. Which is exciting."

"The quote—'if not now, when?'—is the whole response to community action," explains Lisa Sandler, a point person at Klein JCC for the mural-making process. "I might be OK, but my neighbor might not

L'Vor D'Vor: detail, Shira Walinsky, 2009, © Philadelphia Mural Arts Program.

be." This sensibility is significant for folks at Klein, currently the largest senior center in Philadelphia, located in a once blue-collar neighborhood that has seen a new influx of immigrants from Russia and India struggling in a postindustrial economy. "While you look at the maps of Philadelphia County, we're technically considered the third wealthiest [district] in the county," Sadler notes. "But we also have a significant group of working poor, so by having a senior center and having a pantry, home delivery meals program, and produce garden, we try to make things as affordable as possible."

L'Dor V'Dor (Shira Walinsky, 2009; see p. 51), Hebrew for "from generation to generation, symbolically captures Klein JCC's *mitzvahs*, both to its increasingly elderly members as well as to a culturally diverse neighborhood—both significant changes since they opened their doors in 1975. Walinsky intended the image to remind viewers of a *ketubah* or Jewish marriage contract that, along with the rainbow that arcs across the top of the mural, symbolizes God's intergenerational covenant with Israel. While filled with flowing and flowering images that remind Walinsky of a henna tattoo, a creative nod to the culturally diverse community that views the piece, the symmetry of the image is intended to call to mind a *bima*, the altar that houses the Torah in the synagogue. Below the rainbow at the center of the image, the cross section of a deep red pomegranate with its 613 seeds reminds the community of the 613 *mitzvahs* of the Torah. The pomegranate also serves as the *ner tarnid*, or the sanctuary lamp, a symbol that functions in Judeo-Christian sacred spaces as a reminder of God's eternal presence and promise.

Perhaps most significant for the folks at Klein JCC, the mural provides the backdrop for the center's produce garden, which makes fresh food available through their pantry and meal delivery program. The fluidity of the image's central symbols—even down to the detail of traditional and modern Hebrew calligraphy—also underscores Klein's commitment to serving an intergenerational and multicultural community.

"It's thought-provoking," says Sandler. "Some people say the piece framed by the garden gate sort of looks like a mosque or a symbol from Christianity. When I look at it, I see the Bahá'í Gardens in Haifa. And there are many Near Eastern influences too."

This intent to reach beyond the cultural boundaries of religion is its own *mitzvah*, and one germane to interfaith muralism, as we will see in the final section of the book.

"There probably is never enough [community-based art in religion]," Walinsky opines. "It's just amazing how wonderful and powerful religion is and yet how divisive it can be at the same time. And so there

should just be more of this, more attempts to be inventive visually. The great things murals can do is bring together different viewpoints and allow people to come together around a common goal that is concrete that most people can get on board with because it is not threatening the way other things [about religion] are threatening."

Looking back on the experience, Walinsky, who is familiar with the challenges and opportunities of working with religious imagery, having collaborated with other faith communities in the city (see chapter 15), relished the opportunity to work in such a familiar tradition and geographical context. "I have been invested in looking at other people and other ethnic groups and other neighbors and it felt as if this mural was significant, largely because of my parents and grandparents," she recalls. "Sometimes you can get excited about things outside of what you know but there is also a lot to be said for exploring where you are and what you are about."

If not now, when?

Painting Community

"Our sense of moral community is often established by the images that guide our perceptions and emotions," the late Christian ethicist Bill Spohn once wrote. "Who counts for us morally depends upon whom we notice." His observation underscores the significance of community muralism in Christian ethics, both in deconstructing master narratives about the history of urban centers and values that bolster voluntary alienation, as well as in revealing new ways of understanding urban poverty and the urban poor. It is hard not to engage the symbol of the ghetto critically, now that thousands of Philadelphians are emerging "from behind the mask" of concentrated poverty through the more than thirty-five hundred murals that dominate the cityscape. With this art, these folks have become what Pope John Paul II might call "artisans of their own humanity," fashioning a multidimensional and richly textured approach to cultural identity as well as to a variety of issues in their neighborhoods. These walls are also unmasking the deleterious attitudes metropolitan residents have about their inner-city neighbors, fashioning in their place virtues of solidarity and justice.

Philadelphians are not necessarily innovators in this regard. From paintings on cave walls in Lascaux, France, dating back thirty-two thousand years, or the decoration in Egyptian tombs, or the illustrative frescoes that adorned internal and external walls throughout the Roman Empire, walls have long provided canvases for human self-expression. Since the end of the nineteenth century, however, communities have

earnestly taken paintbrushes to walls in order to challenge the masks forced on them by those in the dominant culture or to make visible the mask through which the dominant culture views them in order to recon- struct a more authentic identity that can better respond to what's going on in their communities. "A mural is so much more than a painting on a wall," insisted Jane Golden, executive director of the Philadelphia's Mural Arts Program (MAP), at the dedication of *All Join Hands: The Visions of Peace* (Donald Gensler, 2006; see p. 106). "A mural becomes a catalyst for positive change in a community."

Muralism is first and foremost a genre of public art, since as art that is painted directly on interior or exterior walls, murals are created in public, often under the watchful and inquisitive eye of the community, and easily accessed by the public at large. Just as good muralists have to integrate murals into the distinct features of the walls on which they paint—doorways, windows, cracks, changes in texture—good murals are also woven into the social fabric of the place where they are painted, engaging in some way what has transpired or goes on in that space. Murals tend to be of two persuasions—those that bolster collective iden- tity and those that challenge it. The preponderance of murals created through the Works Progress Administration in the 1930s reflects the former: beautification projects bolstering public spirit by portraying civic values in civic spaces. At its peak in the 1930s the WPA paid an hourly living wage to five thousand artists who produced 2,250 murals and thirteen thousand sculptures for public buildings across the country. These artists were given tremendous artistic leeway since the goal was employment and beautification, but designs were approved either by those who owned or operated the buildings and public spaces where their work was exhibited or through jury systems, as well as by unilateral decision makers. In many ways, these pieces became precursors of what iconic American muralist Eva Cockcroft calls "urban-environmentalist" murals that intend to renovate economically depressed areas by raising aesthetic consciousness rather than addressing political problems.

Mexican muralists Diego Rivera and José Orozco stand in the tradi- tion of muralism that challenges collective identity and in many ways mark the earliest roots of modern community muralism insofar as they were largely uncommissioned and their works challenged the domi- nant culture with alternative memories of the past and perspectives

on the present. Their murals became became visual rallying cries for marginalized people.

And yet, *community* muralism distinguishes itself from other forms of public art, including the WPA murals and even the work of iconic Mexican muralists in several ways. If public art is democratic in its appeal and access, then community murals are the most democratic form of public art since they are both commissioned by communities and exhibited in their public spaces. Nevertheless, community murals are quite different from public art that is commissioned by civic authorities or private individuals and completed by artists with little, if any, connection to the exhibition space. Community murals are done for, if not in direct collaboration with, communities. Community murals use the "vernacular" of a particular culture or event in a particular neighborhood as their muse and the "vernacular space" in communities as their gallery. Art historians generally agree that it is their connection to the local—real people facing real issues—that gives murals their aesthetic impact.

Second, since more often than not these same communities are not accurately represented in or even embraced by those in the dominant

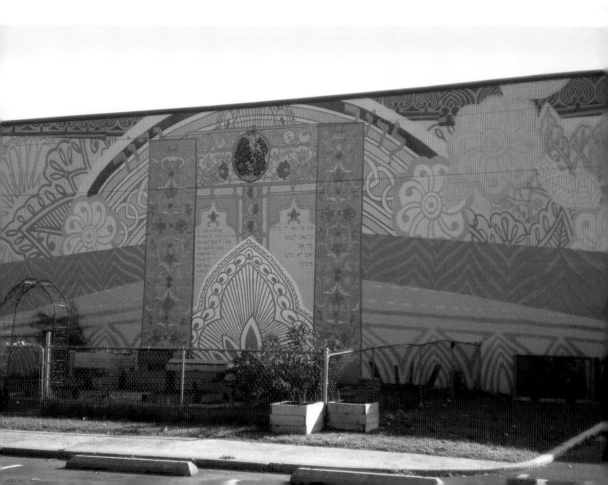

culture and have little access to institutional art, community murals are rarely art for art's sake. Rather, community muralism seeks after particular objectives: building communal identity through storytelling, memory, and visions of the future; breaking through monolithic appropriations of culture that often denies difference or relegates the construction of culture to either social elites or to consumer-driven media; raising consciousness and sparking public discourse around issues impacting the community; resisting projections of outsiders by visually promulgating an alternative identity. In *Toward a People's Art*, scholar Ben Keppel notes that muralism resists " 'cultural homicide' which decides what attributes of community can be recognized or celebrated as truly 'American' and that which cannot and must be ignored."

Finally, the process of creating community murals—which at the very least involves a community meeting to discuss designs and dedication ceremonies that formally integrate murals into the landscape of the neighborhood—fosters the values and practices that make a participatory democracy viable, particularly in communities that are isolated from the cultural, economic, and political spheres of influence. These practices include embracing difference, engaging isolated constituencies, creating space for divergent opinions and positions to be heard, making decisions through consensus, revitalizing public discourse. To that end, mural making often transforms those who paint murals as well as the concrete canvases on which they work. Appealing to her personal experiences as a muralist, Cockcroft notes, "We have been transformed by this intense experience, not only into mural painters, but also transformed in our view of ourselves and our neighbors, of art and of the artist's place in society." Philadelphia muralist Cesar Viveros-Herrera puts it this way: "I see every mural as a learning experience—I need to learn from the spiritual needs of people by interacting with them. Their emotion, pain, happiness. In every project is my own lesson, my own test, my own opportunity to learn more. It helps me to learn what is next."

Certainly, community muralism shares many of the objectives of other long-standing forms of artistic expression in urban subcultures, from the elaborate lettering of graffiti or spray can "throwups" and the guerilla art of now-famous artists such as Banksy and JR who stealthily stamp or paste up their marks in urban places around the world to the social commentary of hip-hop and the embellishment of tattoos. Like other artistic expressions arising from an organic street culture, murals adapt familiar art forms in order to call attention to the unfamiliar; create expressive platforms for voices and issues that go unheard; politicize ordinary spaces or claim forgotten spaces; jar the public out of com-

placency; mock, resist, and reject mainstream culture; and ultimately create something unexpected in places where nothing new is thought possible. And yet, community muralism remains a distinctive facet of the quickly evolving urban street culture through a commitment to privileging many voices rather than that of a particular artist or group, seeking community buy-in in a democratic process of creativity, moving beyond individualistic or sectarian self-expression that often toys with criminality, and insisting that the community and not the artist are what ought capture the public's attention. Community murals make good art and engaged citizens.

Muralism and Social Change

Although there is very little scholarship on community muralism, most art historians and practitioners agree that the evolution of this expression of public art in the United States is best understood as an organic movement that spans cities across the country and evolved through five phases, mostly determined by the political and economic climate, from the late 1960s up through the decade following the terrorist attacks of 9/11.

It is only fitting that community muralism would originate in the decade of "movements"—civil rights, antiwar, feminism, and gay rights, to name a few—that each in its own way challenged the foundation of American culture and public life in monolithic Cold War sensibilities that many citizens experienced as stifling if not unjust. Artists in particular wanted to resist a culture of fear of difference and an avoidance of inevitable conflict brewing under the superficial façade of postwar prosperity. They sought to unleash the creative and socially transformative possibilities inherent in the expression of distinct cultural identity. Community organizing and political activism provided them a way to bypass the institutionalism and authority that harnessed the American creative spirit and to move beyond the elitist museum space and audience in order to connect with people in the streets. *The Wall of Respect*, painted on a semi-abandoned two-story building at Forty-Third and Langley on the south side of Chicago in 1967 by twenty-one African American artists who were members of the Organization for Black American Culture, is recognized as the iconic origin of community muralism and reflects the distinctive features of its first phase: images initiated by groups of artists from racial and ethnic groups excluded from the art industry on "neglected" sites in neglected neighborhoods with the input and support of the local community.

Community muralism therefore begins with a community of artists seeking authenticity in a "collective act" or "event" of mural making and the recognition that authenticity comes from taking seriously the experience of the people of communities on the margins. Clusters of similar "walls of respect" as they came to be known sprang up in Chicago (*Metafísica* in 1968 and *Wall of Truth* in 1969) and other cities around the country (*Wall of Dignity* in Detroit and *Freedom and Self-Defense* in Boston in 1968) as *Wall of Respect* muralists were invited to assist other artists' collaboratives in their own search for authenticity.

"To be a good muralist you need to be a sociologist, a community organizer, a social worker," explained Jane Golden at the dedication ceremony for *The Open Door* (Jonathan Laidacker, 2008; see p. 165) on the Church of Philadelphia in South Philadelphia. "You have to have an ear to the ground to learn what is really going on in the community. It is an art form in and of itself to be a good muralist."

The economic downturn of the mid- to late 1970s marks a second phase of community muralism and one that in some ways reflects the

motivation and content of WPA murals done forty years earlier. First, government funding made available through the Comprehensive Employment and Training Act, the Neighborhood Youth Corp, and Supplemental Training and Employment Program trained some public artists who worked collectively but now also independently with a variety of disadvantaged populations to bring art to their schools, community centers, and neighborhoods. In addition, an Inner City Mural Program funded through the National Endowment for the Arts (NEA) made more than $100,000 available to community arts groups working with ethnic minorities as well as municipal governments to support community arts programming for marginalized populations. This gave rise to what Cockcroft calls "urban-environmentalist" murals that reflected the priorities of urban planners and municipal architects to address economically depressed areas and populations by "making art available to the general public, improving the looks of the city and supporting artists." They are primarily aesthetic in purpose and can often

L'Vor D'Vor: detail, Shira Walinsky, 2009,
© Philadelphia Mural Arts Program.

unintentionally or intentionally camouflage the social problems that lie just below their visual surface. Perhaps to mark the bicentennial, 1976 saw the first National Murals Conference that brought 150 muralists together. Scholar Jack Prigoff notes that this phase expanded the democratic nature of community muralism by involving untrained people from the community in the creative process while at the same time a new "localism" that celebrated the distinctiveness of particular communities dampened their socially critical content. Rather than tackle national problems that seemed intractable in the midst of economic hardship, murals through much of the 1970s were "almost affirmative and almost never critical or based on conflict or visual tension."

The late 1970s through mid-1980s brought with it the third phase of community muralism, which is recognized more by what was not painted than by what was. Federal funding for artists, collectives, and the NEA were largely discontinued and collectives of muralists were forced to seek private funding for much of their work. The muralists who wrote *Toward a People's Art*, for example, noted in 1977 that "this mural movement [was] grossly under-patronized and [relied] on local community support and the initiative of artists." Disappearing funding had two effects, in addition to precluding new works. First, in order to be more effective in raising funds, some muralist collectives transitioned from artist-driven to administrator-driven organizations. Second, in order to meet the aesthetic sensibilities of private donors, the content of murals transitioned from politically critical or locally conscious to "more universal, less specific topics" in more permanent and expensive media, such as mosaic and sculpture. By the end of the millennium, however, the dramatic turn in the economic tide brought with it a resurgence in government and private funding, both individual and corporate, and therefore a boom in the number of walls being painted. The availability of funding flowing through administration-heavy arts collectives established earlier in the 1980s, however, marks the fourth phase in the movement. Muralist and coauthor of *On the Wall: Four Decades of Community Murals in New York City* Janet Braun-Reinitz notes that in many cities, Philadelphia most notable among them perhaps, "murals had become almost completely institutionalized—that is, organizations, not artists, controlled imagery and critical politics were shunned in favor of affirmation." This lent itself to urban-environmental murals, particularly in Philadelphia, as city mayors took advantage of federal funding for urban renewal and saw muralism as a viable means of blight removal and encouraging economic investment.

The terrorist attacks of 9/11 changed many things in American cities, among them community murals. Walls in neighborhoods around the five

boroughs of New York City and beyond became visual memorials to those who died as well as touchstones for a renewed and perhaps equally narrow national identity to which community muralists first responded in the late 1960s. A description by authors of *On the Wall* indicates a range from "simple American flags or the Statue of Liberty, torch raised high, to more sophisticated versions of the same themes, often including in flowing script the phrases 'United We Stand' and 'One City Indivisible.'"

African American and Latino/a Muralism

Although muralism is often associated with Mexican culture, it is important to note the African American roots of muralism in the United States and the visible signs of that culture on walls around the country. "In many respects, African American murals, with their very public personae, help to establish a visual rebuttal to the racist, derogatory, and insulting imagery so often used by upper-class groups that want to maintain power and position at the expense of the African American community," explains Jack Prigoff in his book, *Walls of Heritage, Walls of Pride: African American Murals.* "Given limited access to the more formal art venues, African American artists chose the streets and other public places to create images that challenged negative messages."

An examination of artistic expression in the African American community reveals similar expressions of a lived aesthetic that resists the "colonization" of the black self throughout American history. Perhaps more so than other groups, the arts are an expression of freedom for African Americans, a subculture in which, in the words of bell hooks, blacks "set their imaginations free" in order to resist the forces of domination, reclaim an authentic sense of self separate from the "Euro-centric gaze" and reinvent communities undermined by the structural violence of racism. The spirituals are evidence of this struggle for liberation—both of bodies and imaginations. In these "religious classics" we hear and feel the way that beauty functions as a form of resistance rooted in a sense of human dignity that refuses to accept the dominant culture's estimation of the self. Artistic expression represents a subversive ability to be nourished by an awareness of God's liberating presence in the midst of the ugliness of bondage. "People who have not been oppressed physically cannot know the power inherent in bodily expressions of love," such as clapping, singing, dancing, explains James Cone, the father of black liberation theology. "Freedom was the body in motion, emotionally and rhythmically asserting the right to be," Cone continues. "'Jesus' then was not a thought in their heads to be analyzed in relation to a related

thought called 'God.' Jesus was an experience, a historical presence in motion, liberating and moving the people in freedom."

Many of Philadelphia's murals reflect "Africentrism" that explores elements of African heritage that can be lifesaving for the immediate neighborhood and the community at large. Consider, for example, the beauty of the African-inspired sky-scape in *Born Again* (Cliff Eubanks, 2000; see p. 178). They also reflect what womanist theologian M. Shawn Copeland indentifies as the commemorative, celebratory, and critical elements of black spirituality, perhaps most evident in *Steppers* (Cavin Jones, 1996; see p. 90). Several murals also offer visual expressions of black liberation theology through which communities turn to the wisdom of their particular experiences as African Americans in order to affirm the central messages of the gospel: freedom from personal and social sin through relationships rooted in the liberating struggle for justice. Christ's blackness in *Born Again*, for example, is not symbolic merely of Christ's solidarity with those who are victims of structural violence but rather of the community's sense of participating in the liberating mystery of an incarnational, crucified, and resurrected God who is not colorblind but attentive to the struggles of the marginalized.

Murals in the *barrios* of major American cities not only stand in a rich tradition of muralism, most notably that of Mexican muralists of the early twentieth century, but also in a larger materialistic or embodied aesthetic of popular or lived religion in which God and God's justice is not simply an intellectual exercise but a lived reality in *lo cotidiano*, or the everyday. In home and outdoor altars, visual devotions to Our Lady of Guadalupe stamped on walls or tattooed on bodies, or performative installations of *Viae Crucis* that move throughout neighborhoods, we find tangible and embodied experiences of God. Of particular note is the companionship of God in Christ, whose preferential option for the poor is not intellectualized but rather experienced in the faith and hope of the Latino/a community. The lived aesthetic sensibilities of this faith community illuminate a resilient hope that springs from a sense of God's accompaniment of the people in the neighborhood. Since they grow out of this sensibility, murals created in and for Latino communities serve as symbols of hope because in them God's love is made evident. They are also expressions of discipleship, since through them the community creates a space that integrates devotional practice with an attention to the needs of the neighborhood.

For more about the ethical implications of African American and Latino aesthetic sensibilities and to situate Philadelphia's murals more completely in these rich artistic traditions, see the appendix.

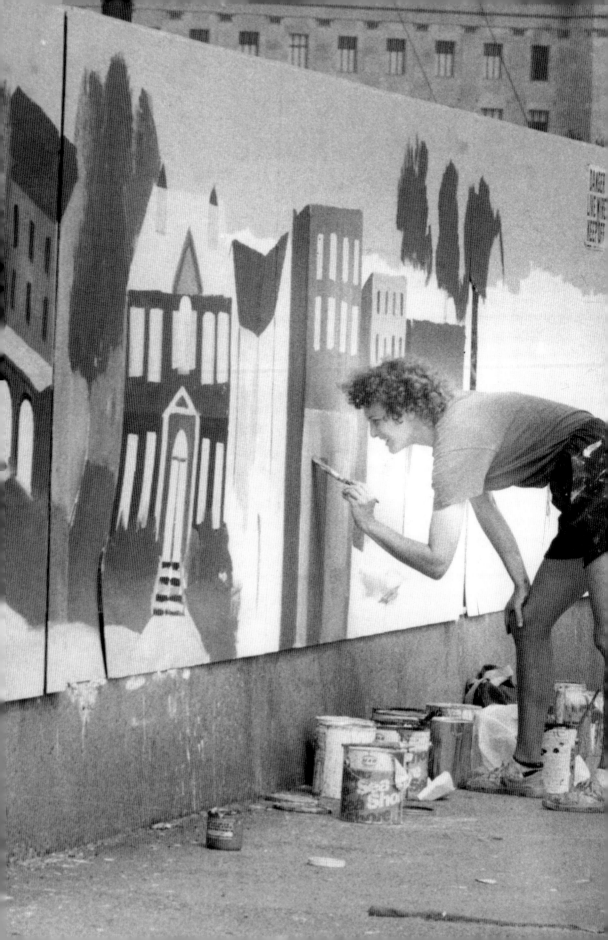

Chapter Four

Painting Community

There was a lot on the line in that civic experiment in the summer of 1985. For muralist Jane Golden, forced to retreat from a vibrant career painting walls in Los Angeles by an unexpected diagnosis of lupus, the project promised a professional and personal resurrection in the city closest to her network of support in South Jersey. Do the job well, and she would land a full-time job in the mayor's office doing community art. For her crew—nearly one hundred teenage casualties of the mayor's war on graffiti—the undertaking offered a possible alternative to fines and sentencing and a potentially viable outlet for the things that compelled them to tag in the first place. Put down the spray can, pick up a paintbrush, and who knew what might happen next?

The conditions were far from ideal. The six hundred–foot stretch of six-foot-high corrugated metal running on either side of the Spring Garden Street bridge baked all day in the July and August heat, making the surface more suitable for grilling than painting. The bridge itself was a busy one, connecting the Mantua Section of West Philadelphia, an economically challenged neighborhood, with the top of the Benjamin Franklin Parkway, the gateway into more affluent Center City. Heavy vehicular traffic confined the painters to the sidewalk and only added to the heat. And then there was the timeline: design and paint a mural nearly a quarter mile long in three weeks.

Golden literally worked from dawn to dusk, seven days a week, staying just ahead of the painters behind her with her sketching, to see the project through. In the end, the mayor's office liked the finished

Jane Golden painting *Life in the City*. Urban Archives, Temple University, Philadelphia, Pennsylvania.

product, which featured people and faces, familiar and fictional, in hues of blue and red. But more important, Philadelphians liked it—or as Golden recalls, they liked the kids who worked on it. "People loved it," she explains in the first of two books that she has coauthored on the movement. "The kids were seen as heroes. I remember people pulling over and stopping traffic on the bridge, beeping and waving, and the kids taking bows. Really, it wasn't about art, it was about the fact that kids were doing something productive for their community."

Life in the City (Jane Golden, 1984), the first of more than twenty-five years' worth of murals in Philadelphia, reflects the fundamentals of the city's distinct approach to mural making: using art as a way of channeling the moral agency of self-expression, building relationships with others by opening up new ways of perceiving what is going on around us, and galvanizing a sense of collective civic responsibility.

"Kids have a hunger, but no opportunity," Golden remembered of those early days in the 1980s at a lecture on restorative justice at Villanova University in 2008. "That is our responsibility. Change isn't going to happen because something occurs in their lives but because we, the adults in their lives, eventually give them a leg up."

Needless to say, Golden landed the job. More significant, however, were the accomplishments of many of the young artists she initially worked with through the Philadelphia Anti-Graffiti Network (PAGN), "kids with talent that had gone unrecognized," she explains. "These young men became my colleagues. It was about *them*. People began to see *their* lives reflected on walls around the city."

Life in the City: Art on the Walls of the City of Brotherly Love

If muralism has features that distinguish it from other forms of public art, then Philadelphia's murals have features that distinguish them from other forms of muralism around the country. Interestingly enough, while known for the birthplace of many things in America— rugs and carpets, fire companies, botanical gardens, lager beer, city wage taxes—community muralism is not among them. Certainly, it had its own "walls of respect" in the 1960s and artists received CETA and NEA funding in the 1970s. The Philadelphia Museum of Art also sponsored the Environmental Art Program, an urban outreach initiative through which muralists Don Kaiser, Clarence Wood, and others painted more than one hundred murals to combat graffiti in the 1970s. It wasn't until 1984, just as the nation's economic tide began to turn, however, that the paint really started flying.

It was at that point that Jane Golden, a muralist with degrees from Stanford in art and political science and a host of murals to her credit in the Los Angeles area, introduced mural making into an amnesty program for graffiti taggers. In exchange for fines or jail time, and rather than simply whitewash their tags only to create a blank slate for the next tagger, wall writers were offered formal training in mural making through the Philadelphia Anti-Graffiti Network (PAGN).

Soon these young people began to identify with their mural art rather than their graffitied signatures, largely because Golden and a small cadre of artists incorporated the young people in every stage of the mural process—from brainstorming designs and prepping walls to judging the authenticity of images and organizing dedication ceremonies. By 1991, PAGN had completed one thousand murals throughout the city and thirty-six of the wall writers involved in PAGN since its inception had joined its ranks of paid muralists. As mural painting and not merely eradicating graffiti became their clear purpose, Mayor Ed Rendell initiated the Mural Arts Program (MAP) in 1996, partly under the Department of Parks and Recreation and partly in the nonprofit world, where it resides to this day.

Being a latecomer to the mural scene has had its upshots for Philadelphia, most notable among them the possibility of establishing a "city agency nonprofit hybrid" mural organization with support of the mayor's office as well as cultural, business, and, most important, neighborhood communities around the city. So while the muralism movement in other cities in the 1980s and early 1990s was in the hands of a variety of consortia of artists or small nonprofits—often competing for limited governmental or private funds and working independently of each other—Philadelphia's muralism movement has been cultivated by a single entity. MAP channels artists, supplies, and funding into city neighborhoods that express an ever-increasing desire to paint their walls. The organization then works with a variety of neighborhood constituencies, municipal departments, social service organizations, and the private sector to reinvest the human, cultural, and social capital these images generate back into the communities that create them. Today MAP has a $6.5 million budget (the majority of which comes from private and corporate funders) and involves more than thirty-five hundred Philadelphians every year—from neighborhood block captains and public school students to corporate responsibility departments in city businesses and incarcerated felons.

So what makes murals in Philadelphia different from others around the country?

Leveraging the assets of the creativity of three hundred muralists, the visions of more than one hundred communities, the energy of thirty-five hundred citizens of varying ages, and more than $6 million in city and private funding each year makes large-scale mural projects—in terms of physical size and complexity of theme and design—possible. We will consider the theological and ethical significance of several of these projects in the next chapters. Having dedicated themselves to building relationships of trust in various communities for the last twenty-five years, particularly those on the margins and among marginalized neighbors in those communities such as truant students or ex-offenders, MAP can now marshal the social and human capital necessary to bring together a variety of constituencies, often groups with little productive or creative interaction with one another, to work together on a mural project. Cops and teenagers, criminals and victims of crime, teachers and students get pulled out of their respective comfort zones and into creative space where their engagement with each other gives rise to an image that serves as a signpost of their commitment to deeper understanding or shared values.

A second distinctive feature of muralism in Philadelphia is the fact that despite the growing size of its administrative staff and increasing reliance on private funding, neighbors continue to be the driving force—political, cultural, and creative—at every stage of the mural-making process, from selection of the wall and theme to the details of the dedication ceremony. "The artist paints the mural but the community creates the vision," explains Golden at the dedication of *The Journey: Viet Nam to the United States* (Shira Walinsky, 2008; see p. 232). Although they would not call it this, MAP practices a kind of visual or artistic preferential option for the poor, which insists that folks in marginalized communities not only deserve art and the various personal and social benefits that come with it but also should be in the position to determine what sort of art they want, where they want it, and how it will function in the community. In order to accomplish these goals, relationships between MAP and neighborhoods, between muralists and community members, and among community members themselves need to be created long before scaffolding goes up or paint is applied. So muralism in Philadelphia involves building up the communal social trust via a variety of strategies familiar to community organizing: knocking on doors to get signatures for the application process, neighborhood meetings to brainstorm possible themes and designs and to build consensus, collaborating with other communities or constituencies from across the city, painting with folks from the community, throwing a block party to dedicate the mural.

 As their self-understanding continues to evolve with the assistance of the folks in communities and the variety of social service agencies with whom they work, MAP increasingly understands what they do as a viable response to the various causes and effects of urban poverty we examined in the previous section. In a 2010 report by the National Endowment for the Arts, MAP was the only mural program recognized as an exemplar for what they call "creative placemaking," which brings together partners from "public, private, non-profit, and community sectors" to "strategically shape the physical and social character of a neighborhood, town, city, or region around arts and cultural activities." According to NEA, Philadelphia's approach to muralism serves the "livability, diversity, and economic development" components of building strong neighborhoods. Murals enhance social trust among neighbors, improve the immediate environment of many neighborhoods, and bolster public safety. They enhance property values and tax revenues that can be reinvested into neighborhood infrastructure. They revitalize Philadelphia's many retail corridors that were once the economic lifeblood of whole communities. MAP offers employment, particularly to at-risk citizens, and, as we will see in the final chapter, murals create space for multicultural self-expression and for retelling the American story in a city where it all began. Also, murals serve as visual anchors that resist market-driven urban renewal efforts that have not always benefited neighborhoods of color. With the help of a mural, the neighborhood is a space that is stamped with the visual identity of those who created it and binds these persons together in a way that empowers them to be participants in change and not merely the collateral damage of progress.

 Although we will explore some of these ideas in the chapters that follow, Golden claims that the variety of mural initiatives "show[s] alternatives to the often difficult daily rounds of urban life, especially in poor parts of town" and the process of creating them "suggests how to build those alternatives." In addition to partnering with one hundred communities throughout the city each year to create neighborhood murals, MAP also integrates murals into four social justice initiatives that focus on resisting concentrated poverty. The Big Picture program, an after-school program offered in conjunction with the school district of Philadelphia, involves more than twenty-five hundred students ages ten to eighteen in various aspects of mural making, from design and painting to poetry and mosaic work. The Mural Corps program, an intensive artistic training and mentoring program for at-risk youth ages fourteen to twenty-two, connects budding muralists with lead muralists working on murals throughout the city and offers them paid apprenticeships.

The ArtWORKS! after-school program targets delinquent or truant students and uses mural making as a way to reintegrate these young people into communities and social networks. The Restorative Justice program works within the criminal justice system to bring victims and perpetrators of violent crimes together in the restorative process of mural making. This program rehabilitates nearly three hundred incarcerated Philadelphians each year, paints talismans of healing and nonviolence in their communities, mentors juvenile offenders during and after their incarceration, and provides meaningful employment to adult ex-offenders.

The final characteristic of the mural movement in Philadelphia is the sheer number of projects that have earned it the NEA designation of "The City of Murals." If there is any truth to Janet Braun-Reinitz's claim that "the most universal result of a successful mural project is the public's desire for another mural," then it is safe to say that Philadelphia has been successful. At the time of this publication, thirty-five hundred murals adorn walls around the city, involving more than twenty thousand Philadelphians over the past twenty-five years in the relational process of making them and enticing twelve thousand visitors each year into neighborhoods previously disconnected from public life of the city.

As we will see in the following chapters, the distinctively relational and rehabilitative approach to mural making at every phase of the process has earned Philadelphia a reputation as having the preeminent civic mural program in the United States and the singular moniker as the "mural capital of the world."

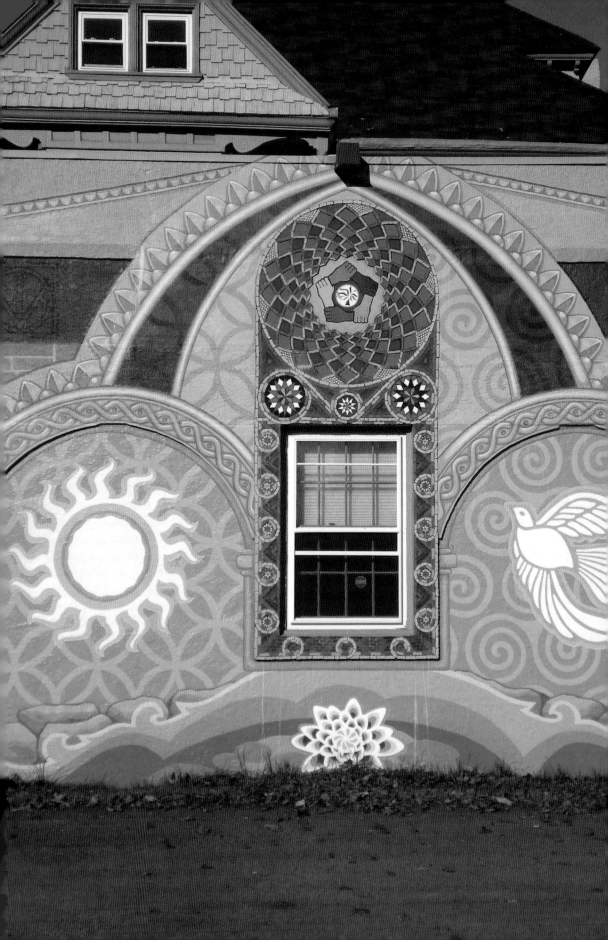

Chapter Five

Painting the Signs of the Times

The ability to read the signs of the times is practically an unspoken prerequisite for daily life in the Mount Airy section of Northwest Philadelphia. The neighborhood has received national acclaim in both popular and scholarly presses for its residents' commitments to racial and economic integration, a legacy that dates back to the antebellum period when neighbors participated in the Underground Railroad. It was tested by the seemingly unstoppable hypersegregation of Philadelphia in the 1950s and 1960s. Mount Airy still provides a sharp contrast to the city's other segregated neighborhoods, and its various neighborhood associations and civic initiatives—from the food cooperative to the oral history project—continue to imagine new ways of living as an intentionally multicultural community.

Walking Together (Paul Downie and David Woods, 2009) reminds the neighborhood that religious organizations have assisted residents in reading the signs of the times and, in fact, led the charge for racial integration in the 1960s. The mural, prominently displayed at the crest of one of Germantown Avenue's many hills, celebrates the fortieth anniversary of the Neighborhood Interfaith Movement (NIM), a "grass-rootsy" collective of nearly sixty faith communities from the neighborhood who remain committed to building a racially, ethnically, religiously, sexually, and ecologically diverse neighborhood.

"NIM was started by people who felt out of their religious values that integration, racial acceptance, and racial harmony back in the '60s

was extremely important," explains Rabbi George Stern, who grew up in Mount Airy and served from 2002–11 as NIM's executive director. "Several religious leaders and laypeople said, 'We need to be engaged [in the process of racial integration] because if it is not controlled in some way, this can destroy the neighborhood.' They quoted sacred texts but more importantly, they studied together, and did interfaith activities like integrated seders. So in this way they *knew* more of the people they worked with."

"We have a shared history in Mount Airy that people are proud of," says former NIM board member and Mount Airy resident Betsy Teutsch who was involved in community meetings to brainstorm the mural's design and contributed to the image's Jewish symbolism. "Religious communities have been coming together to stabilize the community and NIM's goal is to emphasize our shared traditions of service and faith."

While other artists might have seen the wall's five windows as a challenge for creating a cohesive image, muralist Paul Downie and mosaic artist David Woods used the architectural design of the building to capture the spirit of NIM's social ministry, which maintains distinct portals through which religious neighbors read the signs of the times while providing an open space where they share a unified commitment to building a vibrant Mount Airy. Each of NIM's affiliate congregations is represented by one of the wall's five windows, replete with symbols done in glass and clay tiles—saffron flowers for the Eastern religions, the first ten letters of the Hebrew alphabet for Judaism, a stained-glass window for Christianity, and ornate patterns and Arabic lettering for Islam—as well as in individual clay tiles that run along the far edge of the image created during community paint days. The middle of the five windows depicts NIM's logo—a tree with roots and branches—as well as a hexagon of interlocking hands of different colors.

"Sacred space is a theme of NIM," explains Downie. "It is sacred not because of a static thing that happened there or a static sense of rules that govern it. It is sacred because it is universally safe and allows for fluidity—where energy flows, not where it is constricted."

Stern notes that the mural provided NIM yet another opportunity to do interfaith work in a way that complements the organization's annual celebrations and rituals and celebrates their citywide work with childcare providers and in long-term care facilities. "We understand justice as fairness and social equality," he explains, pointing out that the words "justice," "service," and "faith" appear in all of the languages spoken on the streets of Mount Airy and in its sacred spaces: English, Spanish, Latin, Greek, Hebrew, Chinese, Arabic, Sanskrit. "Good things

can come out of religious organizations and we want NIM to be known as a place where people get along and do positive things for the community."

"I believe that this kind of work has the potential to bring people into community with one another," Downie explains of why he enjoys working with religious communities in the mural-making process. "I have come to conceptualize the projects as opportunities for coming together, for creating unity, rather than focusing on a shared past. Religion is a cultural institution and as is the case with all cultural phenomena, it changes over time. I believe we are entering a turning point for religion, where some old standards are beginning to break down and younger generations are asking tough and salient questions about faith traditions. I think muralism will prove an excellent medium to explore the religious changes in the coming years, and I'd love to be part of that process."

Murals as Urban "Classics"

In light of what we've explored in terms of the sociospatial contexts of murals and the distinctively communal process that creates them, murals are urban "classics," as Catholic theologian David Tracy understands the term in his own classic, *The Analogical Imagination: Christianity and the Culture of Pluralism*. "When a work of art so captures a paradigmatic experience of [an] event of truth, it becomes in that moment

Walking Together: detail, Paul Downie and David Woods, 2009, © Philadelphia Mural Arts Program.

normative," he explains. "Its memory enters as a catalyst into all our other memories, and, now subtly, now compellingly, transforms our perceptions of the real."

What specifically about community murals, particularly those painted on sacred space or that incorporate religious imagery, makes them a classic? To answer that question we need to consider facets of the images themselves and the effects they have on those who paint them and on those who encounter them. Tracy suggests that classics are works that pose provocative or attention-grabbing questions that are worth asking and consciously draw people into the task of pondering them. Classics point toward or even participate in the truth insofar as they are constantly taken up by different people and contain within themselves an excess of meaning. Classics do not illustrate reality but rather interpret it. As such, classics generally spark some sort of dialogue, either within or among viewers, in an attempt to reach some sort of understanding.

Part of Tracy's criteria for a classic also involves its effect on those who create it. Since classics disclose some fundamental facet of truth, artists feel a sense of risk in birthing them—risk in closing the distance between the self and that truth, risk in losing control over that which is created, risk of being rejected by those not ready or willing to consider the essential things to which the piece might point. Often, artists describe a sense of giving themselves over to something that is greater than themselves in this process. Says Tracy, "Timidity is no longer possible. A courage to allow oneself to be played and thereby to play this game of the truth of existence must replace the fears and the opinions of the everyday. The artist does not know where the journey will lead; one must wager and risk."

Finally, the classic affects the viewer. It heightens a viewer's sense of his or her own finitude by demanding some sort of response from him or her. Classics confront us with limit questions—about the meaning of life, about the existence of God in a suffering world, about the reasonableness of hope, for example—and dare us to risk the heightened self-awareness that will come with our attempts to engage these limits. These images also "read" the viewer and make evident to him or her otherwise undisclosed desires, fears, frameworks of meaning, or methods of interpretation. In that way, an encounter with a classic becomes an event in the viewer's life, a moment in which that person participates more fully in reality through a heightened awareness of history, of the self, of the present circumstances, or of what lies ahead in the future. "The interpreter must risk being caught in, even being

played by, the questions and answers—the subject matter—of the classic," Tracy explains.

In his litany of characteristics of the classic, Tracy says it is "always retrievable, always in need of appreciation, appropriation, and critical evaluation, always disclosive and transformative with its truth of importance, always open to new application and thereby new interpretation." In the chapters that follow, these elements of the classic will become evident in Philadelphia's community murals. Perhaps most important for our consideration of them as urban classics, Tracy notes that the ethical demands of classics are unavoidable, since they make a "nonviolent appeal to our minds, hearts, and imaginations, and through them to our wills," and as such are "gifts that imply a command: a command to communicate by incarnating that reality [to which it points] in a word, a symbol, an image, a ritual, a gesture, a life." Given the rather estranged relationship between ethics and the arts that I explore in the appendix, we are not necessarily prepared to take up the ethical imperative of classics, particularly visual classics like those on the walls of Philadelphia. Engagement with murals, however, may prepare us as Tracy recommends.

Accepting the Commanding Gift of Community Murals

"Good art, unlike bad art or random occurrences," suggests Christian ethicist Stanley Hauerwas, "exists over against us in such a way that we must surrender to its authority. Both love and great art show us our world with a clarity that startles us because we are not used to looking at the real world at all."

The remainder of this book highlights the startling clarity that art created by communities and adorning the walls of the city of Philadelphia brings to the all-too-familiar problems of urban poverty. Residents of the inner city are painting the signs of the times as they experience them. Interpreting their images will require a certain set of ethical skills on our part, since, as Hauerwas states, we're not used to seeing the signs of the times this way. Let me identify three that will be essential for viewers to bring to their engagement of the images in the following chapters.

Imagination

Those who paint the signs of the times use their imaginations to do so. So it seems only fitting that imagination is required of those who attempt to engage their work. While this may seem obvious, the

capacity for imagination has not always been celebrated in Western ethical traditions such as Christianity where deductive reason, logic, linear thinking, and abstract philosophizing have long been prized. But the evocative and disruptive nature of classics depends on the imagination—what Tracy calls the "analogical imagination" or the ability to be "caught up in, even [played] by the questions and answers . . . of the classic."

From a humanist perspective, we can use the imagination to transcend limits of our physiology and wander unfettered throughout time and the cosmos. With the help of imagination we conjure relationships with unknown people and acutely experience otherwise foreign sensations. We can envision every unseen detail of the world or dramatically dream of alternate realities. Through imagination we find fresh perspectives on old ideas and renewed energy for tackling entrenched social problems. "Once we see our givens as contingencies," explains philosopher Maxine Greene, "then we have the opportunity to posit alternative ways of living and valuing and to make choices."

In more explicitly theological terms, imagination provides the primary means to encounter and be in relationship with a God who cannot be fully understood or experienced logically but also in the context of mystery that invites ever-deeper interior reflection and ever-expansive external engagement in the created world. Imagination is central to Christian anthropology. It is a capability through which we accept our inherent dignity that comes with being made in the image of a wildly imaginative and creative God; through it we express our freedom or our ability to build purposeful lives and to enter into meaningful and life-giving relationships with ourselves, with others, and with God. Through it we

Walking Together: detail, Paul Downie and David Woods, 2009, © Philadelphia Mural Arts Program.

respect the dignity of others when we imagine the world from their perspective or protect their own imaginative capability to chart the course of their respective destinies. Some even consider imagination a human right, given its centrality to living a distinctively human life, since so long as we are able to imagine our own futures we never fully succumb to the wills of others or the conditions of injustice.

Imagination is not merely oriented toward fantasy, although unfettered freedom to dream up new realities is an important contribution imagination can make to ethics. It is also an active way of engaging the world characterized by a willingness to acknowledge one's own socio-historical location and connectedness to others, to risk being confronted by symbols and be read by them, to be receptive to unexpected insights and seemingly contradictory interpretations, to engage in a dialectical give-and-take that pushes us to the limits of our own understanding, and to communicate with the wider community about its meaning.

The imagination in the Christian tradition has an unavoidable moral dimension, particularly in light of the Vatican II imperative to understand the moral life less in terms of evil actions that ought to be avoided and more in terms of the good we are constantly called to do. Christian ethicist Philip Keane points to the increasingly integral role of imagination in virtue ethics as well as its effectiveness in helping us to understand more concretely and engage more creatively the central principles that shape Catholic moral discernment. The imagination liberates us from the paralysis of being overwhelmed by the immensity of our social problems and unleashes a desire to become something more than we are or to participate in something greater than ourselves that can shake up our passivity. Imagination interrupts anxious futility with a restless confidence in knowing on an intuitive level that this is not all there is, since, to use international peace activist John Paul Lederach's language, "imagination is the art of creating what does not exist." Or, as Greene says, "It may be a new way of de-centering ourselves, of breaking out of the confinements of privatism and self-regard into a space where we can come face to face with others and call out, 'Here we are!' "

The transformative capacity of community muralism—both for those who create it and for those who view it—suggests that the capacity to imagine and to create are constitutive of what it means to be human. John Paul II says as much in his 1999 Letter to Artists, where he contends that to be made in God's image is to be a creator—to bring order to chaos, to reveal the inner beauty of all living things, to make

meaning out of dehumanizing suffering, to weave a luxurious fabric of social relationships, and to "save the world with beauty." It is through imagination that we are able to recognize the prophetic content of community murals, calling our attention to our complacency with the way things are and challenging us to more inclusive and socially critical frameworks of meaning and authentic ways of being. When we approach the murals with our imaginations fully charged, we appreciate John De Gruchy's sense that "it is not only the word of the prophet and the poet that challenges injustice, but also the work of the painter, sculptor and architect." In the case of community murals, these prophets are not individual artists but entire neighborhoods or faith communities whose ability to imagine lays bare the difference between what is and what can be.

Affections/Emotions

"The function of art is to identify and articulate a range of subjective patterns of feeling and to give objective form to feeling," explains Margaret Miles. Pope John Paul II alludes to the fact that art and beauty are rooted in the "sacredness of life and of the human person" and contends that the arts offer "an invitation to savour life and to dream of the future." Richard Viladesau speaks of the irresistible "theo-dramatic" beauty of God's love made evident in the cross or the artistry of God that anticipates the kingdom whose purpose is to stir the soul. Clearly, the arts tap into the emotions, dimensions of the self of which we are wary, particularly in ethical evaluations or decision making, because our culture of control, invulnerability, and civility tells us to avoid them at all costs. Whether the invitation to "give object form" to patterns of feelings, to "savor" one's existence, or to participate in the "theo-drama" of God's action, art, as artist and educator Karen Stone says, "has an ability to bore through to our center." And it is in this center, a place where we often fail to dwell in Christian ethics, that we find the insight and the passion needed to take on some of our biggest moral problems, problems like urban poverty. In order to receive the ethical gifts of the murals, of these urban classics, we need to embrace the subjective, emotive, and affective dimensions of our intellect.

As a component of a street subculture that does not participate in "high" or "institutionalized" art of museums or galleries and their

often-narrow construal of what counts as art, community murals become an ideal artistic site for viewers to resist the "disinterested" or "distanced" aesthetic that has shaped so much of our engagement with creative expression. This Kantian approach tends to intellectualize, objectify, or "look at" pieces of art using externally established criteria such as technique or form or method that separate artistic expression from the complexities of the political or socioeconomic reality. Such a rationalistic or intellectual approach short-circuits the equally important need to engage with or "look in" pieces of art to note their depth, ambiguity, and excess of meaning. It keeps us from noticing similar attributes in ourselves. Because the emotions and subjective experiences of communities give rise to community murals, they bypass theorizing and rationalizing and go right to the heart of the matter at hand and the heart of those who encounter them. While the muralists are certainly committed to working with their communities to create beautiful images—images that invite interpretation of a reality rather than merely illustrate it—they also recognize that capturing the essence of the community in their design is the imperative. This essence is rarely

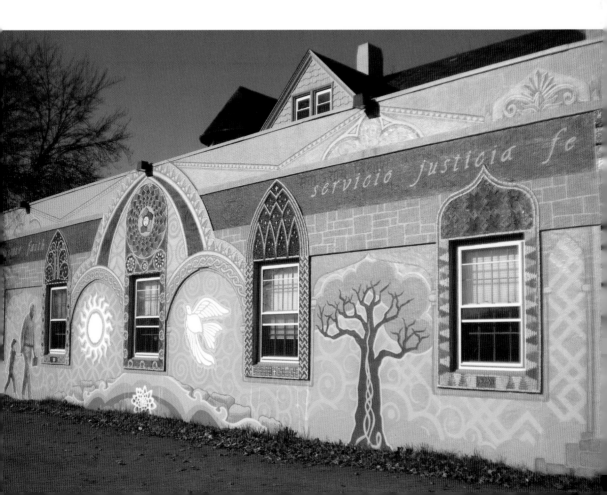

what community members think but rather how they feel. The primary question, then, when engaging a mural is not necessarily "What do you think of this piece?" or "What does this image make you think about incarceration, or gun violence, or urban gardens, or religious diversity in the neighborhood?" Rather, the primary question ought to be, "How does this mural make you *feel*?"

We need to bring emotions into our ethical reasoning around concentrated poverty for two reasons. We need emotions such as fear, anguish, confusion, and sorrow because they make our own vulnerability apparent to us, and it is only by entering more fully into that vulnerability that we will be able to resist the values in our culture that prevent meaningful relationality and perpetuate the various injustices of urban poverty we will examine in the chapters to come. Boring through to our emotional centers is also a way that we can enter more fully into experiences of communities for whom this kind of vulnerability is a given and not a choice. It cultivates the various other-regarding sensibilities that meaningful justice requires: empathy, compassion, solidarity. But we also need emotions to discover forms of moral agency beyond the familiar capabilities for reason or capacity for free choice, elements of an affective cognition that communities on the margins have developed as alternative means of agency after generations of oppression that denounced their rationality or denied their freedom of choice. Emotions such as anger, hope, and pride fuel a resilient agency that can serve as the antidote to the paralysis we often feel when it comes to taking on overwhelming moral problems like poverty.

Embodiment

"Art is unique in that it unifies the material with the spiritual," says Karen Stone. "It is embodiment." Community murals support this other dimension of the arts that tends to be overlooked by a disinterested ethic that retreats from embodied engagement into the rational mind or assesses as somehow less authentic art that is made from the materials of the everyday. Perhaps because they are not located in quiet galleries that can protect the senses from being bombarded, murals integrate embodiment into the artistic encounter. Those who create them physically and emotionally bump into one another as they paint cloth canvases that will be adhered to walls. Those who view them have to move their bodies in order to take them in, pacing back and forth amid the sounds, smells, and feel of the neighborhood. They hear the traffic, kids playing, cell phone conversations of passersby. They smell the exhaust fumes, the meat grilling in a nearby food truck or smoking at the corner BBQ

place, and the wild honeysuckle wafting from an overgrown lot. They feel the heat rise from the street or the bass of a passing car reverberate in the chest. This sensory overload is part of encountering one's body as one encounters a community mural and it serves an important purpose in ethics.

A heightened sense of embodiment renews our sense of being alive and being inherently social creatures. We become more aware of our bodies moving through different spaces across the face of the earth. We are faced with a deep sense of being connected to people we encounter in these spaces if only because our feet touch the same ground and our lungs breathe the same air. We begin to integrate outer experiences and inner insights: awareness of the physical space and the way we move through it is important for making us aware of unspoken codes that shape conduct among people in these spaces; physical contact with other bodies bumps us up against the limits of our stereotypes and assumptions of people who are different from us; sounds, smells, and tactile sensations fill in important gaps in our understandings of people and places that are unfamiliar to us.

We cannot underestimate the moral significance of the preponderance of bodies of color portrayed in Philadelphia's murals. Portrayals of black bodies by black communities resist the gaze of outsiders, a gaze that too often separates those bodies from the complex and historically situated "self" they contain. When visually expressed by those in the black community, that self is defined by capabilities and sensibilities acquired after generations of marginalization that the dominant culture continually fails to acknowledge: resilience, ingenuity, joy, wisdom, a sense of irony, authentic self-love, deep communal ties, and moral imagination, to name just a few. Reconnecting the black body with the black self through these images further empowers the black community to resist the things that have been done and are being done today to black bodies in the name of the Union, in the name of homeland security, in the name of family values, in the name of public safety, in the name of corporate bottom lines.

Finally, this prevalence of the black body in community murals functions as a way of engaging in the material world as it is and with material things, reminding us that our religious traditions and notions of justice that arise from them are often mediated to us through this material world and the bodies in it, not just through doctrine or appeals to abstract concepts that are constructs of the mind. Attention to our bodies becomes a way we can tactilely encounter God in these spaces, tactilely encounter justice—what it feels like, what it sounds like. "By denying

the flesh we may deprive our very souls of the visible Word, embodied in nature and art and perceivable only through physical means," says Karen Stone. "To deny the flesh, in a sense, is to deny the Spirit."

Painting the Signs of the Times

So, with these thoughts about murals—their situation in the culturally constructed symbolic space of the ghetto, the process that goes into their creation, their status as "classics" and the ethical sensibilities needed to engage them—let's take up the ethical charge to look at the real world of urban poverty through the wall-sized art we find there.

Bibliography

Introduction

An interview with Rev. Carnell Smith with Gate to Heaven Ministries on October 21, 2006, informs this introduction.

Stanley Hauerwas highlights the fundamental connections between art and Christian ethics in *Vision and Virtue: Essays in Christian Ethical Reflection* (Notre Dame, IN: Fides/Claretian, 1974), and Robin Jensen considers the arts and the formation of community values in *Substance of Things Seen: Art, Faith and the Christian Community* (Grand Rapids, MI: William Eerdmans Publishing Company, 2004).

Chapter Three: Painting Walls

Interviews with muralist Shira Walinsky on November 24, 2011, and Lisa Sadler of the Klein Jewish Community Center on December 8, 2011, provided information on *L'Dor V'Dor*. I gathered first-person accounts through an interview with muralist Cesar Viveros-Herrera, September 22, 2008, Jane Golden's public comments at the dedication of *All Join Hands: The Visions of Peace* on October 26, 2006, and from a story by Kathryn Levy Feldman, "The Big Picture," *University of Pennsylvania Gazette*, available at http://www.upenn.edu/gazette/0302/feldman2.html.

For a history of muralism in the United States and discussion of the relationship between this democratic art form and social change, see the previously mentioned *Towards a People's Art: The Contemporary Mural Movement* by Eva Cockcroft, particularly the Introduction by Ben Kepell, xvii–xlvi. James Prigoff highlights the distinct contribution of African American muralists, as well as distinct phases of American mural movements in *Walls of Heritage, Walls of Pride: African American Murals* (San Francisco: Pomegranate Communications, 2000). Janet Braun-Reinitz et al., *On the Wall: Four Decades of Community Murals in New York* (Philadelphia: University Press of Mississippi, 2009), examines the roots of mural movements in New York City.

Roger Gastman's *Street World: Urban Art and Culture from Five Continents* (New York: Abrams, 2007) vividly situates muralism within a broader aesthetic of street art. Gastman's *The History of American Graffiti*, along with Caleb Neelon (New York: Harper Design, 2011), provided important distinctions between muralism and other forms of wall art.

William Spohn offers an explanation for the role of images in forming communities in "Who Counts?: Images Shape Our Moral Community," available at www.scu.edu/ethics/publications/iie/v7n2/spohn.html. In thinking through the connection between black muralism and black theology, I turned to the following resources: bell hooks, *Art on My Mind: Visual Politics* (New York: The New Press, 1995); James Cone, *The Spirituals and the Blues: An Interpretation* (New York: The Seabury Press, 1972); and Cornell West's piece, "Catastrophic Love" produced by bigthink, available at http://www.youtube.com/watch?feature=player _embedded&v=3EYK4p0Byfw#at=11. For discussions of African American spirituality among Catholic theologians, see *Taking Down Our Harps: Black Catholics in the United States* (Maryknoll, NY: Orbis Books, 1998), particularly Shawn Copeland's essay. "Method in Emerging Black Catholic Theology," 102–19. See also a collection of essays edited by Dwight N. Hopkins, *Black Faith and Public Talk: Critical Essays on James H. Cone's* Black Theology and Black Power (Maryknoll, NY: Orbis Books, 1999). For a fuller examination of the ethical implications of an African American aesthetic, see the appendix, pages 301–5.

For aesthetics in Latino theology, Roberto Goizeuta's *Christ Our Companion: Toward a Theological Aesthetics of Liberation* (Maryknoll, NY: Orbis Books, 2009), as well as Alejandro García-Rivera's *Community of the Beautiful: A Theological Aesthetic* (Collegeville, MN: Liturgical Press, 1999) and *Wounded Innocence: Sketches for a Theology of Art* (Collegeville, MN: Liturgical Press, 2003) were influential. Ana Maria Pineda offers a theological exploration of murals and *retablos* that decorate and commemorate various Latino immigration routes and neighborhoods in "The Murals: Rostros del Pueblo," *Journal of Hispanic and Liberation Theology* 8, no. 2 (2000): 5–17, as well as "Imagens de Dios en El Camino: Retablos, Ex-Votos, Milgritos and Murals," *Theological Studies* 65 (2004): 354–79. For a fuller examination of the ethical implications of a Latino aesthetic, see the appendix, pages 305–9.

Chapter Four: Painting Community

For a full history of Philadelphia's murals, see Jane Golden et al., *Philadelphia Murals and the Stories They Tell* (Philadelphia: Temple University

Press, 2002), and Jane Golden et al., *More Philadelphia Murals and the Stories They Tell* (Philadelphia: Temple University Press, 2006). A full online catalogue of Philadelphia's more than three thousand murals can be accessed through the University of Pennsylvania's Cartographic Modeling Lab at http://cml.upenn.edu/murals/.

Many of the direct quotations from Jane Golden, MAP executive director, are public statements made at various mural dedication ceremonies, as well as in the local press (Joseph A. Slobodzian, "Exploring the Link of Art, Justice," *Philadelphia Inquirer* [October 3, 2007]; Vernon Clark, "A Mural That Goes to the Mountaintop," *Philadelphia Inquirer* [January 12, 2008]; Melissa Dribben, "Gracing the City," *Philadelphia Inquirer* [July 27, 2008], and "Parisians Look to Copy City's Mural Program," *Philadelphia Inquirer* [May 8, 2009]); the national and international press (Jon Hurdle, "A City Uses Murals to Bridge Differences," *The New York Times* [October 6, 2008]; "The Murals of Philadelphia," photo essay for *Time Magazine*, http://www.time.com/time/photogallery/0,29307,1649278,00.html; Lauren Silverman for National Public Radio "On Philly Walls, Murals Painted with Brotherly Love" [August 23, 2010]; Isabelle de Wavrin, "Bienvenue a Fresque-City," *Beaux Arts* [Julliet 2009]); and opinion pieces she authored ("Murals Can Offer Hope and Generate Change," *Philadelphia Inquirer* [October 12, 2008]; "Power of Art to Ignite Change— And Healing," *Philadelphia Inquirer* [October 17, 2010]). A full archive of press coverage can be accessed at www.muralarts.org.

Chapter Five: Painting the Signs of the Times

Several interviews between November 26 and 28, 2011, with artists and community members connected to *Walking Together* (Paul Downie and David Woods, 2009), inform my ideas here. These include Paul Downie and David Woods, the lead muralist and mosaic artist; Rabbi George Stern, former executive director of the Neighborhood Interfaith Movement; and Betsy Teutch, NIM member and neighbor.

David Tracy's previously mentioned *The Analogical Imagination* is essential for considering the ongoing significance of Philadelphia's murals, particularly chapters 3 and 4; "The Classic" and "The Religious Classic," pages 99–192. Karen Stone outlines a process for critical interpretation of art that implicitly illuminates the characteristics of Tracy's classic in *Image and Spirit: Finding Meaning in Visual Art* (Minneapolis: Augsburg Books, 2003). Margaret Miles's *Image as Insight: Visual Understanding*

in Western Christianity and Secular Culture (Boston: Beacon Press, 1985) makes for a good companion to Tracy as well.

Stanley Hauerwas's *Vision and Virtue* is helpful in pointing to the ethical implications of how we see reality. Those whose consideration of imagination and the arts were influential on my own ethical engagement of the murals include John W. DeGruchy, *Christianity, Art and Social Transformation: Theological Aesthetics in the Struggle for Justice* (Cambridge: Cambridge University Press, 2001); Maxine Greene, *Releasing the Imagination* (San Francisco: Jossey-Bass, 1995); John Paul Lederach, *The Moral Imagination: The Art and Soul of Building Peace* (New York: Oxford University Press, 2005); Phillip S. Keane, *Christian Ethics and Imagination: A Theological Inquiry* (New York: Paulist Press, 1984); and Pope John Paul II in his Letter to Artists (April 4, 1999), available at http://www.vatican.va/holy_father/john_paul_ii/letters/documents/hf_jp-ii_let_23041999_artists_en.html.

Daniel Maguire's approach to the agency inherent in creativity in *The Moral Choice* (New York: HarperSanFrancisco, 1984) was also helpful.

Part Three

Codes
The Impasses of Poverty

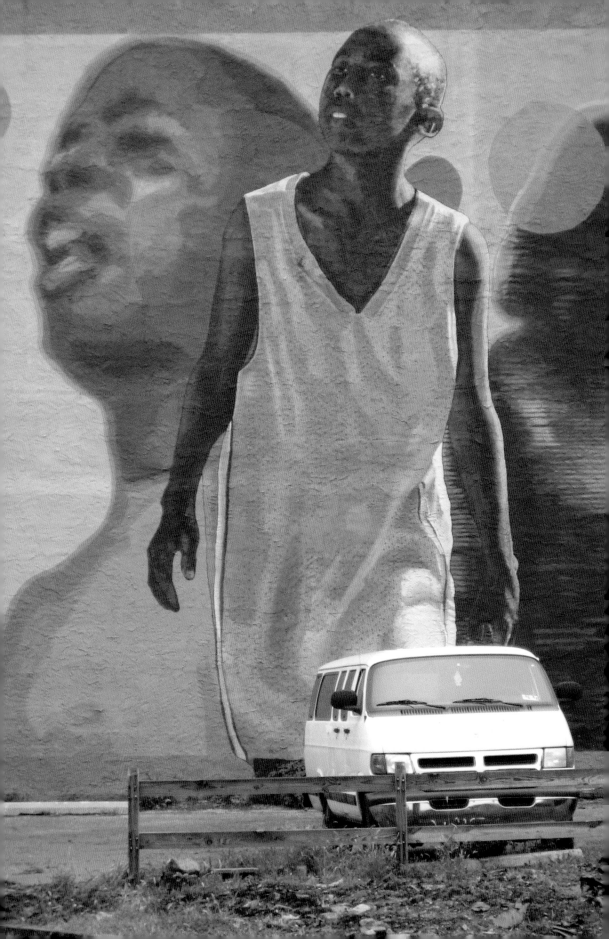

Songs of Hope

"Most of the young people in the city don't have positive role models," explains Rev. Carnell Smith, who founded the storefront church Gate to Heaven Ministries in the Mantua section of West Philadelphia nearly fifteen years ago. "If the ghetto is all you see, then that's the mentality you're going to have. This mural is a mural of hope," he explains of *Songs of Hope*, a four-story image in hues of blue and green that his congregation created with artist Don Gensler. The mural features a young boy, dressed in an oversized white basketball singlet, with an uplifted face gazing at something on the horizon. Ghosted figures of three other young people serve as a backdrop for the boy, their actions barely distinguishable. "The young man is stepping out; he's looking to the future," explains Rev. Smith. "The young man, by coming out, shows that he has hope. He has a goal and a vision in mind. One thing leads to another. With a positive outlook you will seek a positive or moral life."

According to Gensler, this isn't *Songs of Hope*'s only message. It also illuminates the limited ways in which persons perceive each other, a personal realization that Gensler reached after meeting with members of Gate to Heaven and worshiping with them several times. He recalls that he "began to wrestle with how we see people—personally, through TV, etc.—which often create a huge distortion." The lines running through the figures in the image's background capture that distortion, as well as a sense of being trapped behind someone else's narrow construction of who you are.

The ghetto mentality to which Rev. Smith refers, identified by urban anthropologists as the "code of the street," poses a real threat to the common good in contemporary America, given its grip on the consciousness of both urban youth and suburban adults. While we can certainly trace

Songs of Hope, Donald Gensler, 2002, © Philadelphia Mural Arts Program.

economic, political, and cultural factors that buttress the invisible walls that trap persons in growing pockets of poverty and shrinking pockets of wealth. But concentrated poverty has affective or dispositional causes as well. The contemporary ghetto arises from a variety of internal factors in the lived experiences of the urban poor that stem from living day-to-day in the pressure cooker of the structural violence and social stigmas germane to these places. These psychosocial factors are evident in a variety of markers of the ghetto with varying levels of visibility: isolation and alienation from civic activity, an unwritten code of conduct that precludes social mobility, the social indignities perpetrated by mass incarceration, a personally and communally destructive informal economy, and low levels of social capital or networks of relationships that foster personal and economic development.

Equally threatening to the common good is the "code of whiteness," a series of dispositions and practices espoused by those in the dominant culture that distort the way whites see themselves and their reality and preclude meaningful relationships with self and others. The values of white culture—autonomous individualism, heterosexual masculinity, personal and financial security, denial of embodiment and mortality, social stability rooted in meritocracy and reinforced by law and order, obsession with work and social advancement—construct the symbol of the ghetto and dictate how this symbol functions in suburbia. Obstacles to flourishing in neighborhoods like that of *Songs of Hope*, such as the drug economy, high rates of unemployment, racial profiling by law enforcement, and mass incarceration, are reinforced, if not set in motion, by the fear of others that lies at the heart of white culture.

These affective dimensions of urban poverty are often more difficult to diagnose and even more difficult to treat. Like parasites, these codes drain the imaginative capacities of otherwise healthy collective bodies and leave them vulnerable to the injustices of the status quo. We might best understand them as "impasses" or the cognitive dimensions that often fuel entrenched social problems, giving them the intractable quality of quicksand. The more we struggle to escape impasses the more submerged in them we become. Constance Fitzgerald, a Carmelite theologian, defines "impasse" as "a situation in which there is no way out of, no way around, no rational escape from what imprisons one, no possibilities in the situation." Bryan Massingale expands on Fitzgerald's

Songs of Hope, Donald Gensler, 2002, © Philadelphia Mural Arts Program.

ideas and describes impasse as a "sense of futility" or a feeling that there is "no way out" of social problems. It is the intuitive recognition that we have created these problems for ourselves.

How do we experience impasse? Fitzgerald explains it in terms of the physical and emotional sensation of "being squeezed into a confined space" between the past and the future where we constantly fight the temptation to "give up, to quit, to surrender to cynicism and despair." To experience impasse is to drown in an invisible riptide of "disappointment, disenchantment, hopelessness, and loss of meaning" that tears us away from communities of support and worldviews that otherwise anchor us in a coherent sense of self. Impasses suffocate us with a sense of being "unfulfilled, debilitated, constricted, empty." It is a kind of "numbness" that "expects nothing of the future" in which we resign ourselves to the predictability and familiarity of a present that never seems to end. Massingale describes experiences of impasse in terms of "floundering on the shoals of intergroup conflict, distrust, resentment and bitterness." Another Catholic ethicist, David Hollenbach, SJ, implicitly alludes to it in his claim that even those engaged in the struggle

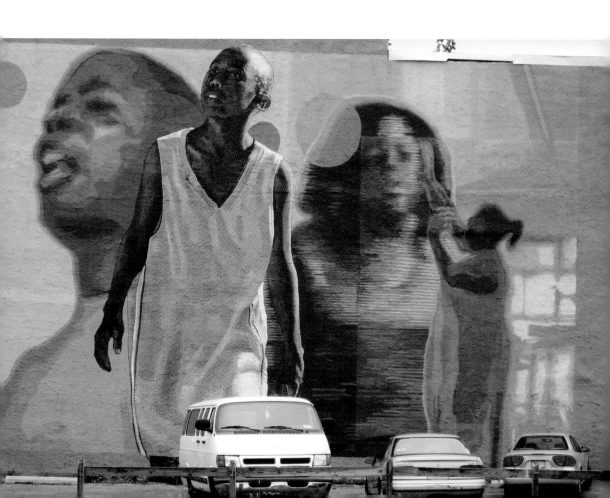

for justice "experience powerlessness or a loss of hope and energy." Impasse is a catalyst for guilt, lethargy, moral paralysis, social apathy, and alienation.

In many ways, *Songs of Hope* is a response to the affective and psychological factors of urban poverty that make it such an impasse today. "Most people don't know their purpose of existing," explains Rev. Smith of Gateway, "but for many people here there is no future."

The never-ending present of concentrated poverty is the result of two distinct and yet related impasses. One springs from circumstances of poverty where conditions of social marginalization give rise to a collective sense that a different future is literally not possible; the other stems from contexts of economic and social privilege where conditions of individualism and self-sufficiency give rise to a collective denial of human vulnerability and suffering. Both destroy the social fabric of life in community. This section explores the potential of community muralism to interrupt these dehumanizing mentalities by cultivating imagination, creative moral agency, and social responsibility on both sides of the city line.

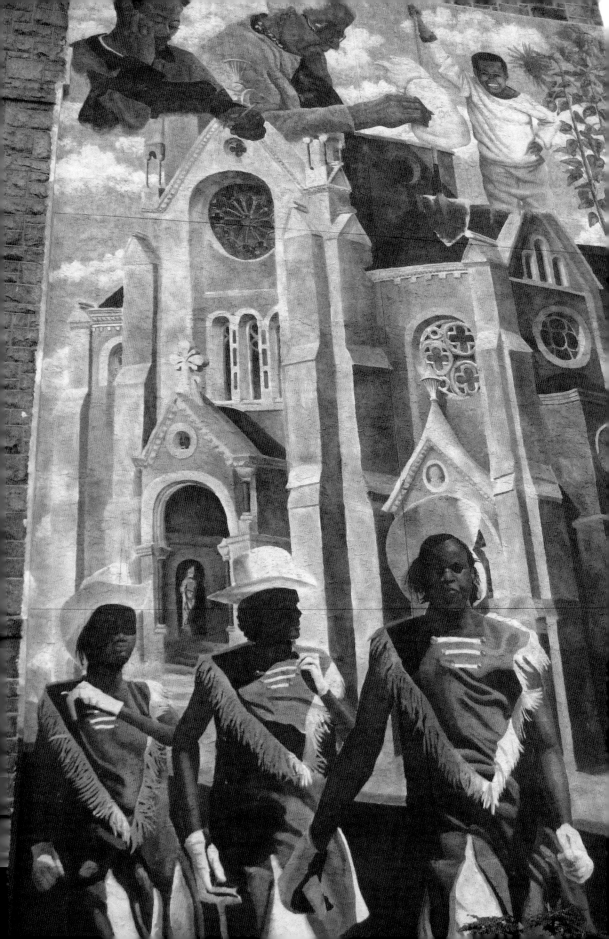

Chapter Six

Code of the Streets

The bookshelves in Mrs. Helen Brown's office on the ground floor of the former convent of St. Elizabeth's Roman Catholic Church on North Twenty-Third Street are filled with trophies won by the drill team she started in the St. Elizabeth–Diamond Street neighborhood of North Philadelphia in 1994. Far more precious to her are the graduation photos displayed at their bases and adorning her walls—images of her "North Philly Foot Stompers" as they are nationally known. They are the smiling faces of kids who beat the odds in her neighborhood. From her living room window, "Miss Helen," as she is called by all who know her, watched the social fabric of the community come apart as one social institution after another—including the Archdiocese of Philadelphia— withdrew their services and left residents to navigate unemployment, addiction, and a violent drug culture on their own. As Evelyn Johnson, grandmother to a Foot Stomper as well as another grandson killed on the streets, said in a *New York Times* feature on the drill team, "People had gotten so discouraged. They had lost hope. When a person is without hope, they don't do anything."

A four-story mural, *Steppers* (Cavin Jones, 1996), on the Church's former rectory, now a recovery house for former substance abusers run by Project HOME, a nationally recognized community development nonprofit that collaborates with neighbors to operate the St. E's community center where Miss Helen works, captures the resilient spirit of the Foot Stompers, who started banging out their beats on telephone books before there was any money for drums or uniforms. Now those

Steppers, Cavin Jones, 1996, © Philadelphia Mural Arts Program.

beats reverberate in the concrete canyons of Center City in Independence Day Parades and are met with hoots and hollers at the neighborhood's Annual Day block party performances each August. The mural visually testifies to the refusal of Miss Helen and her neighbors to allow their community to be swallowed up by what William Julius Wilson has coined the "eclipse of hope" in urban African American communities as a result of the "lived experience of coping with a life of horrifying meaninglessness, hopelessness, and (most important) lovelessness." Recall Rev. Smith's comment: the structural causes of the ghetto cultivate a "ghetto mentality." Like *Songs of Hope* across town, *Steppers* speaks to the urgency of rescuing urban youth from the code of the streets and the viability of the arts—whether singing church hymns, drumming, dancing, or painting—to do so.

Code of the Street

Urban historians and sociologists have been reluctant to examine the "culture of poverty" or a set of dispositions and actions that arise out of and reinforce an "enclosed and self-perpetuating culture of dependency" in what Wilson at one time identified as the "underclass." There are good reasons for this hesitancy. Insofar as an uncritical evaluation of the personal and collective choices that poor persons make reinforces the American tendency to individualize the causes of and responsibilities for urban injustice, this kind of analysis unfairly makes poor persons the scapegoats for their poverty. What's more, to the extent that such analysis implies "white culture" as the socioeconomic default or benchmark against which all other cultures are measured, and in so doing fails to examine the racial assumptions and biases of policy makers, the vast majority of whom are white, this kind of analysis calcifies racial biases and justifies the social abandonment of entire groups of people as undeserving of social welfare or public compassion.

Several sociologists, however, most notably William Julius Wilson, contend that we must examine the cultural conditions of urban poverty—which he defines as "the sharing of outlooks and modes of behavior among individuals who face similar place-based circumstances, or have the same social networks"—in order to understand the ways in which social and political structures and processes shape these factors and the ways in which the culture of poverty reinforces the isolation or dislocation of inner-city neighbors from the wider community. "It is important to remember," Wilson explains in *More Than Just Race*, "that one of the effects of living in a racially segregated, poor neighborhood

is the exposure to cultural framing, habits, styles of behavior, and particular skills that emerged from patterns of racial exclusion; these attributes and practices may not be conducive to facilitating social mobility."

After at least four decades of socio-economic isolation and dislocation, residents of poor urban communities are no longer simply marginalized from the common good. Many, particularly young people, actively and aggressively *alienate themselves* from life in the wider community where theologian David Mitchell suggests they believe "the rules of the game are written in a language that they cannot understand or speak, in which they are discriminated against and are not afforded an equal opportunity."

In an extensive ethnographic study of one North Philadelphia neighborhood, urban sociologist Elijah Anderson describes this alienation in terms of an all-consuming cultural "code of the street," a variety of countercultural and self-destructive values and practices by which inner-city youth reject a society that has rejected them. The code relies on "violence as a form of social control" in socially isolated neighborhoods. It promotes an alternative worldview and set of values and practices that initially emerge from the patterns of racial exclusion or economic dislocation that we examined in the first section: lack of educational opportunities, exclusion from the formal economy, limited public services, a dearth of green and recreational space, and involuntary segregation. Nevertheless, the code increasingly creates a collective identity rooted in what Anderson calls an "ideology of alienation" in which young people "actively live their lives in opposition to those in the dominant culture." For example, the code dictates violence and aggression as the only viable way to establish and constantly defend a sense of personal identity or "respect" rooted in impermanent things such as the estimation of one's peers or material possessions. It regulates interpersonal, familial, and social relationships in the midst of limited social resources and a lack of viable options for self-discovery and esteem. It navigates a dangerous and yet potentially lucrative informal drug economy that offers one of the only viable avenues for cultural mobility. Through it young people resist the values and practices of a wider culture, perceived to have abandoned inner-city communities or to deny participation through stereotyping and discrimination. Anderson notes that the code of the street affects everyone living in cities since "it puts the entire community on guard and encourages a defensive posture in many otherwise ordinary situations."

Elements of this ideology of alienation include rejection of persons, practices, or institutions that mirror or espouse white culture;

participation in the informal economies of drugs, stolen goods, and sex; a reversal of the Golden Rule where "might makes right"; refusal to rely on or cooperate with law enforcement; and reliance on violence to mediate social relationships. As a result, Anderson holds the code of the streets responsible for a variety of "deep and debilitating social pathologies in the black community" that preclude social mobility, including truancy, chronic joblessness, teenage pregnancy, addiction, threats to physical and emotional well-being, and criminality. "This culture, especially among the young, gains strength and legitimacy by opposing the dominant society and its agents," Anderson explains. "But such opposition produces ever more alienation, and lines become hardened, polarities develop. And people, particularly young black males, become demonized."

How is the code of the streets an example of impasse? Ultimately, this aggressive voluntary alienation from the dominant white culture not only arises from lack of material goods such as affordable housing or

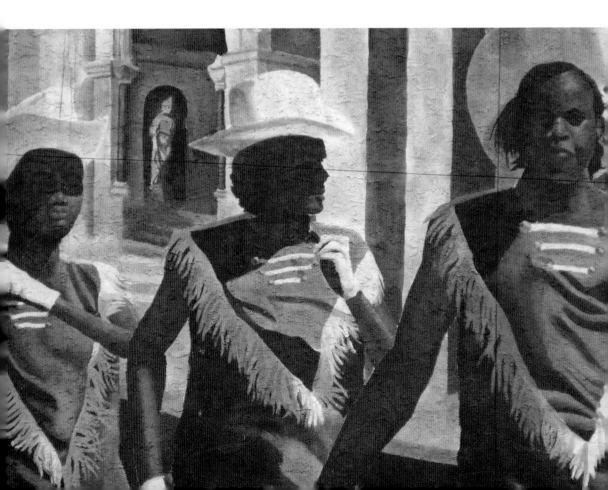

healthy food, or even intangible public goods such as education or clean air, but it also seeps into individual and collective identities as a result of a diminished capability to perceive oneself as a person of worth, to derive meaning from one's experiences or circumstances, to recognize others' well-being as important to one's own, to yearn to participate in something greater than oneself, or to dream of a different future. Mitchell describes the code of the streets in terms of an "economic and spiritual anxiety, the rage against society, and the deep sense of being alone and unheard."

Mitchell diagnoses this as a "Deconstructive Capitalist Personality Complex," which threatens the African American community by destroying the spirituality of the black community. It is nourished by a materialistic, destructive, and antisociety worldview that deprives African American youth of a sense of self, responsibility, and wholeness. It originates as a survival mechanism, since many believe that the code of the street is the only option for navigating essential relationships, and evolves into an entire way of being.

Consider a few features that reveal the affective dimensions of structural poverty.

First, the code of the street is an all-consuming and exhausting intrapersonal struggle for "respect"—the universally shared desire for an authentic sense of self-worth, for a feeling of control over one's environment, for the freedom to assert one's unique identity, and the ability to earn others' admiration and support. The dehumanizing conditions of poverty, however, make the struggle for respect a futile effort in inner-city neighborhoods. Poverty's continual assaults on young people's sense of worth and purpose, the limits it places on their future, and the competition for limited resources it fuels make "respect" a commodity to be traded, often in violent exchanges, rather than a gift freely given as a sign of mutual self-worth. Young people exact respect from others through practices of physical dominance that may earn them temporary security, but at a high cost, since, as Anderson says, "in this often violent give-and-take, raising oneself up largely depends on putting someone down." The "campaign for respect"—with its vigilant posturing and vigilante posses—creates a vicious and futile cycle that ensures that the very security and trust that young people seek in the midst of the unpredictability of poverty will remain beyond their reach.

Steppers: detail, Cavin Jones, 1996, © Philadelphia Mural Arts Program.

To that end, the outward practices of the code of the street are signs of inward experiences of alienation—not just from the dominant culture, but also from the self and from other people. The public mask of "respect" exacts a personal toll on those who wear it, since in order to follow the code, young people in inner-city neighborhoods must deny inherent aspects of what it means to be human. They are expected to despise vulnerability in others and themselves, to be suspicious of unexpected gestures of friendship, to reject mentors who are not "in the game," to deny inclinations to forgive or walk away from potential altercations, to move through their day always on the defensive, or to "go for bad" in order to maintain respect. This places many inner-city young people in a suffocating double bind where neither they nor the wider society afford them the freedom to discover who it is they want to become. "A boy may be completely 'decent,'" explains Anderson, "but to the extent that he takes on the presentation of 'badness' to enhance his local public image, even as a form of self-defense, he further alienates himself in the eyes of the wider society, which has denounced people like him . . . who threaten it." To alienate oneself from the desire for abiding friendship, much less from those life-sustaining relationships themselves, and then to be demonized by the wider culture and thus alienated from the social goods of life in community is particularly perilous for young people. Such a double bind cultivates distrust, bitterness, anxiety, and depression.

The code of the street also revolves around the often-disheartening effort to discern life's meaning and purpose in the midst of the chaos of the structural violence of poverty. It espouses violence as the most logical way to make sense of the chaotic suffering of social and economic marginalization, or to protect one's identity against social rejection or one's physical person from injury, or to keep the despair and anxiety of economic dislocation at bay. Since violence and aggression only disable more viable skills for building frameworks of meaning such as self-care or meaningful relationships with others, the code of the street perpetuates disillusionment, cynicism, and social apathy.

Moreover, since the code of the street deals in the social capital of the moment—the ever-elusive "respect" that young people seek—it perpetuates a sense of being confined or constricted to a present reality for which there is no foreseeable end. When it seems as though there is no way out, young people become inured to the dehumanizing circumstances of their lives, numb to the pain of losing friends to street violence, resolved to live up to cultural expectations that expect nothing of them. They lose the capability to dream of different possibilities.

"We have gotten the chains off our bodies and put them on our minds," observes Pastor Jeremiah Wright. The code of the street is both evidence of an incapacitated imagination. Given poorly funded public schools, record high unemployment, a lack of personal or professional mentors, and skyrocketing rates of incarceration, it is no wonder that many inner-city youth feel that to imagine a future that looks significantly different from their present circumstances is a laughable proposition. This not only negatively impacts their abilities to envision the long-term consequences of personal choices but also intensifies the confusing despair that comes with being trapped in the double bind of a life both determined by social forces and that you yourself have constructed.

Attention to the cognitive impact of urban poverty invites us to make connections between the alienation of inner-city youth and the consciousness of their suburban counterparts. Mitchell notes that the "Destructive Capitalistic Personality Disorder" at the heart of the code of the street is fueled by inner-city youths' unfulfilled desire "to experience the same sense of somebodiness and achievement" that other Americans crave. So long as that sense of self-worth and fulfillment are culturally defined according to the values and practices of consumerist capitalism, however, this will be a futile quest for all persons, including those with access to the material and intangible goods of life in community. Individualistic capitalism diminishes all persons' affective capabilities to imagine different futures, to acknowledge the worth of others, or to make meaning of their experiences. As such, it sustains the second impasse at the heart of concentrated poverty.

Stepping Out

Although we will consider how the process of community muralism is cracking the code of the street in the final chapter of this section, let's quickly consider elements of *Songs of Hope* and *Steppers* that highlight the cognitive affective dimensions needed to enter into and move through this impasse.

Both murals depict young people from the neighborhood in poses that suggest an intentional orientation to their immediate surroundings, either looking or marching forward toward a distant horizon, toward some sort of future. The present does not have a determinative grip on these children—they are shaped by it, as is indicated by the distorted images behind the young boy in *Songs of Hope* or the façade of the razed St. Elizabeth's Church in *Steppers*, but a future is interrupting that present and freeing these young people for a process of becoming.

These images also suggest the importance of supporting young people in their search to find their own beats and to walk to them. The muse for *Songs of Hope* was the empowering energy of the Spirit moving through worshipers in a tent revival that moved a young man to testify and sparked Gensler's recognition of the congregation's confidence that spirituality is the antidote to a ghetto mentality. Self-expression in drum and dance distinguishes the Foot Stompers from their peers, giving them a sense of purpose and the chance to participate in something that is greater than themselves. Essential to this process is exposing young people to resources within their own neighborhoods that reflect the cultural and religious traditions that exist there, whether acknowledged by the dominant culture or not—in these cases, the liberating spirituality of the spirituals of American slave religion or drumming in West African culture. The irresistible lure of the Spirit or the beat of the drum empowers these young people to resist the wider culture's assessment of them.

Murals create a platform for them to articulate that sense of self, perhaps for the first time, and in so doing begin to break open the socially constructed symbol of the ghetto from within and without.

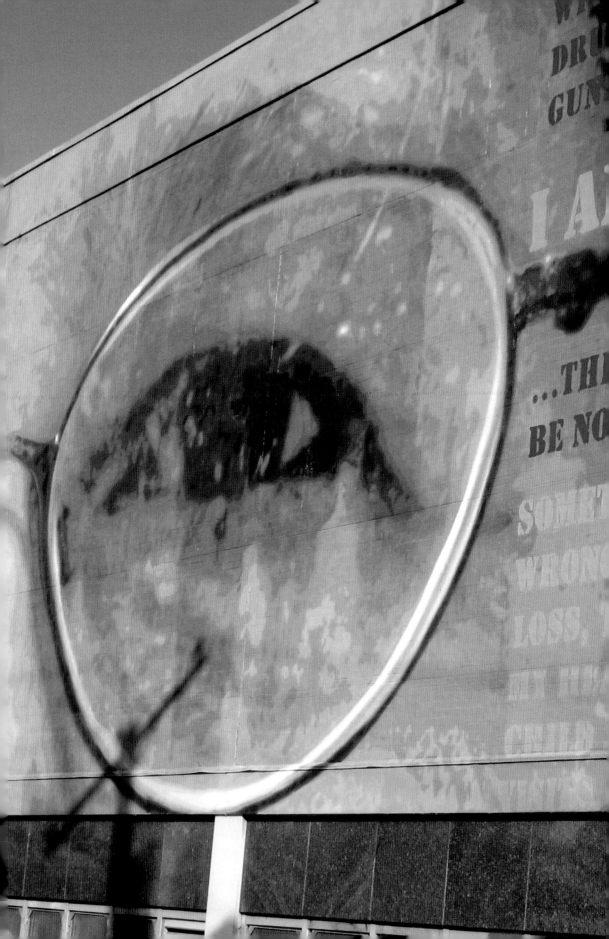

Chapter Seven

Code of Whiteness

All Join Hands: The Visions of Peace (Donald Gensler, 2006; see p. 106) runs the length of Benjamin Franklin High School at the corner of Broad and Spring Garden Streets. The image of three giant faces with piercing eyes is significant for its location, as well as its namesake (we will discuss the mural's content in section 4). At the turn of the twentieth century the intersection was home to Baldwin Locomotives, which employed twenty-five hundred laborers who could turn out a steam engine in twenty days. Today, Broad and Spring Garden is the gateway to either gentrification or ghettoization, depending on the direction you gaze as you stand before the mural. The cultural causes for both can be traced to the school's namesake.

Entrepreneur, inventor, statesman, moralist, diplomat—Benjamin Franklin is considered the quintessential American and, for the folks at home, the quintessential Philadelphian (except perhaps for Rocky Balboa whose status is as iconic as Franklin's for similar reasons). Franklin's "rags-to-riches" story is what Steven Conn describes as "poor boy made good, a parable of what is possible in America, where success is not determined by birth but made through hard work and sober habits." Although he overlooks Franklin's commitment to building voluntary and civic associations that facilitate any rags-to-riches transformation, cultural historian E. Digby Baltzell offers a different take on Franklin's legacy for Philadelphia: "Benjamin Franklin, in his autobiography, modifies the Calvinist ideal of devotion to a calling in a fixed status hierarchy to produce a later American ideal of individual moneymaking and mobility as a sign of secular salvation according to the gospel

All Join Hands: The Visions of Peace, Donald Gensler, 2006, © Philadelphia Mural Arts Program.

of success." Perhaps unknowingly supporting this characterization, *New York Times* columnist David Brooks recently called Franklin the Founder of American "bourgeois identity," which drives middle-class values of "industry, prudence, ambition, neatness, order, moderation and continual self-improvement."

These values would have been solidly in place in Philadelphia's Iron Age from 1876 to 1905 when Baldwin Locomotive at Broad and Spring Garden was just one outfit securing Philadelphia's economic place at the center of the nation's industrial age and ensconcing local giants of industry in an insular and inward-gazing upper class. "Domestic bliss and material comfort, those ultimate goals of middle-class Victorians," writes Baltzell. "This is what Philadelphia settled for. What it wanted, and what it got." Cultural historians of Philadelphia have noted the ways in which the ethos of exclusive self-investment and civic complacency among the city's elite at the turn of the century influenced subsequent generations. As Sam Warner Bass puts it, Philadelphia was a city "wallowing in contentment, conformity and conservatism . . . safe and sound, prosperous and potbellied. This was the image Philadelphia liked to present, what Philadelphia now stood for."

The historical processes of gentrification and abandonment within cities have roots in the dispositions and values that lie at the heart of the self-understanding of white or Euro-American America that fueled and now justifies the radical socioeconomic inequality between geographically proximate communities. "The reality of the ghetto as a physical, social and symbolic place in American society is, whether one likes it or not," warns Loïc Wacquant, "being shaped—indeed imposed—from the outside."

The Code of Whiteness in Penn's "Greene Country Towne"

Although painstakingly intentional in founding his city, William Penn was Philadelphia's first suburbanite, Conn notes, since he built his own estate well north of the city along the Delaware River. And in many ways, Philadelphia was always a metropolitan area—and not merely a city—since the relationships of mutual dependency between rural farmers and craftsmen, and the urban infrastructure for exporting their goods made any boundary line between city and suburb nothing more than an arbitrary geographical demarcation. Nevertheless, the dramatic shift in postwar America from cities to suburbs is perhaps the most significant change in American history. Philadelphia provides a great case in point. Kevin Kruse and Thomas Sugrue identify the im-

plications of the "suburban ascendency" on city dwellers: dislodging financial, political, and social capital from urban centers; shifting political focus and investment away from cities and their issues toward suburban agendas; new patterns of social relationships characterized by isolated and exclusive lifestyle enclaves governed by distinct municipalities; and the inescapable power of middle-class bourgeois values of domesticity, self-sufficiency, free market capitalism, and whiteness in shaping these relationships.

In suburban America, the values and practices of white privilege give rise to an impasse that serves as the moral equivalent of the inner-city code of the street. Whiteness shapes a ubiquitous and normative culture in which whites internalize our racial normativity and superiority to the extent that we are not aware of how our racial identity conditions our internal dispositions and external behaviors, as well as social institutions and systems. This is a privilege that people of color do not enjoy. This blindness to racial identity is a key factor in the production of white culture and the protection of white privilege. Like the code of the street, white privilege espouses a worldview, a set of socially constructed dispositions and a series of practices that shape intra- and interpersonal dynamics within affluent communities, as well as interactions among persons across economic boundaries. In fact, the two reinforce each other, since the code of whiteness perpetuates the sense of alienation that drives the code of the streets and precludes life in community for whites and people of color alike. Invoking Bryan Massingale's understanding of impasse, its various affective dimensions also render otherwise good-intentioned moral agents "vulnerable to disillusionment, cynicism and despair" around complex issues such as concentrated poverty.

When speaking of whiteness or white privilege it is important to note that "whiteness" does not refer to a set of physical traits. Rather, it points to a particular social location and set of cultural attitudes and practices that award varying levels of advantage to whites and reinforce the collective sense that whites are superior and our experiences are normative. When understood this way, whiteness or whiteliness is a way of being in the world that is only fully enjoyed by an elite minority of light-skinned persons, but since it is the cultural norm, whiteness is sought after by the majority of people on the planet, including most whites. For example, Philadelphia's history reveals that Italian and Irish immigrants, the majority of them Catholic, were not considered "white" by "native" European Philadelphians, at least until they gained positions of influence in business and government and were able to channel political social capital away from other minority groups precisely on the basis of their nonwhite

status. We see this today in the protectionist attitudes of working-class whites who resist integration of neighborhoods and schools in the name of protecting their property values and social mobility despite the fact that they themselves do not enjoy all the privileges of more affluent whites.

How does whiteness constitute a social "code" similar to the code of the streets we just examined? First, it is a framework of meaning or worldview that tends to understand and organize reality in binary and hierarchical categories—mind over body, reason over emotion, male over female, public over private. This is hardly an inclusive or flexible way of perceiving and organizing social relationships. Moreover, this framework of meaning understands white persons, specifically heterosexual white males, and their cultural preferences and practices as the default, the norm, or the benchmark against which all others are perceived, measured, and assigned value. From the earliest days in America the claim that all men were created equal applied to Euro-American landowners only.

Second, the code of whiteness espouses a set of values that shapes persons' perceptions of themselves and their world—suspicion of vulnerability or weakness, a preference for social stability anchored in meritocracy and the protection of self-interests, a sense of justice rooted in law and order, admiration for hard work and self-sufficiency, and heterosexism. These values, in turn, encourage a set of practices that organize human relationships around the protection of the freedoms and entitlements that come with privilege and make it the most prized form of social capital in affluent communities.

In comprising her now-famous list of nearly fifty practical examples of "skin privilege," Peggy McIntosh, one of the first sociologists to identify white privilege, defines "white privilege" as "a right, advantage, or immunity granted to or enjoyed by white persons beyond the common advantage of others" or a metaphorical "invisible knapsack" of resources that assist whites in life's journey. These privileges include the ability to ignore one's racial identity in a variety of situations if one so chooses; to find one's race predominantly and, more often than not, favorably represented in the media; never having to be the spokesperson or representative for one's racial group; and never experiencing racial profiling. These privileges also espouse a set of practices that protect or reinvest in them, such as obsession with work and productivity, distributing social goods and bads according to meritocracy, continual investment in personal and financial security, and wariness of others who are different from the cultural norm. All of these preclude meaningful care of the self and of the neighbor.

Finally, the code of whiteness features a public confidence in our moral goodness or the sense that white people—as individuals and

as a collective—are not complicit in the injustices that pervade the experiences of persons and groups of color. The inability for whites to see white culture at work in our lives, much less the lives of others, comes from white ways of knowing, or, more precisely, "not-knowing." Philosopher Barbara Applebaum suggests that at the heart of whiteliness is a willful ignorance about the impact of one's social location on one's perceptions or the inability to identify sufficiently the values and practices of whiteness at the heart of a variety of "-isms" that sustain violent social inequity (androcentrism, sexism, heterosexism, ethnocentrism, nationalism, agism, classism). White culture espouses a defensive posture that psychologically protects whites from realizing our complicity in racial injustice. It does so by sustaining a kind of "relentless readiness to ignore consideration of one's ignorance" mostly because whites want to understand themselves as morally good people. It also precludes other ways of learning and knowing such as listening and engaging vulnerability, and is reluctant to move away from individual liability toward collective responsibility.

The enclavish, insular, and defensive posture of Philadelphia's suburbanites reflects the privatism, elitism, and cultural value of whiteness in the city's socioeconomic and cultural roots. These values give rise to the false assumption that social inequity—for better and for worse—was the result of market forces and individual choice and not political and civic commitments of white Philadelphians. Appeals to the protection of personal or private investment—of home property values, of businesses, of student performance—in an attempt to resist efforts to integrate neighborhoods, business districts, or schools are an expression of "investments in whiteness" that maintain the privileges of whites, often garnered through state intervention, while at best stifling and at worst hijacking the opportunities of people of color.

The changing racial identities of and tensions within suburban communities reveals that the parameters of "white culture" constantly shift in order to exclude new groups of people assumed to be threats to the economic viability and moral values of the elite. Isolationist and defensive dispositions and practices of whiteness consolidate economic and social capital in the suburbs. "As suburbs hoard their resources, shielding them from cities, they become central agents in the reproduction of segregation and poverty in America," explains urban historian Michael Katz. "The invisible walls the suburbs erect to keep poor people within city limits concentrate poverty and increase the burdens on the welfare state, while suburban legislators wield their political power to reduce the public benefits that their exclusiveness helped make more necessary."

The Impasse of Whiteness

So how is whiteness an expression of impasse and, more important, how is this impasse connected to concentrated poverty? Mary Elizabeth Hobgood suggests that since its central value is autonomous individualism, whiteness makes authentic self-love difficult for most whites. The code of whiteness cultivates a voluntary isolation and loneliness that presents significant challenges to the human capability for authentic relationships with self and with others. Like the "campaign for respect" that constructs identity in the code of the streets, the "campaign for privilege" espouses its own practices of self-abnegation and disempowerment, all of which stem from a defensive posturing required to protect the privileges of whiteness. Equating work with productivity or the increased capacity for consumerism, for example, creates an overworked, stressed, and unhealthy corporate workforce, not to mention the economic dislocation of low-wage workers. Denial of embodiment and physical needs breeds loneliness and a variety of psychological disorders that in turn feed the addictions that drive the informal drug economy of inner cities.

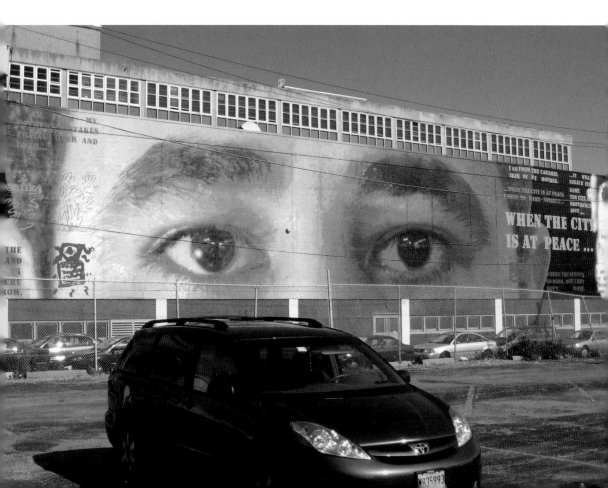

This same denial of self also wages war on dependency and vulnerability, rejecting everything but a pull-yourself-up-by-your-bootstraps approach to success and social responsibility. Suspicion of emotional or sexual intimacy confines people in narrowly constructed gender roles that bolster the often-violent practices of patriarchal heterosexism that disproportionately affect poor communities—through pornography, rape, domestic violence, and sexually transmitted disease. Constantly protecting privilege against the ceaseless threats of others fuels a distrust that exhausts fellow-feeling, traps whites in defensive enclaves, locks up people of color, and grows the bottom line of the incarceration industry.

The willful ignorance of white complicity makes it possible for citizens in the metropolitan area to deny our inherent connection to those in inner-city neighborhoods. Ignorance of a shared history is evident in the ways we fail to acknowledge that the very federal policies that made suburban homeownership possible for so many whites also contained blacks in city neighborhoods, or that a mixture of public and private investment continues to build physical and social infrastructure in suburbs. White ignorance of the economic connection between people in the inner city and suburbia is evident in the invisibility of the cadre of service-industry laborers who travel on public transit to the far reaches of the metropolitan area to clean office buildings or serve food in shopping malls. It is evident in the metro area substance abusers who keep the drug economy in North Philadelphia flush with cash. It comes into sharp focus in the incarcerated Philadelphians whose detention at Graterford prison alone generates more than $4 billion for the metropolitan area, anchoring the economy of one of Philadelphia's "ex-burbs where it stands." Ignorance of the educational ties between the inner city and the metropolitan area becomes evident in terms of public and private investment in the 25 institutions of higher education that enroll tens of thousands of students from the metro area but not necessarily from its urban core. These same institutions rely, nevertheless, on laborers from this urban core to clean classrooms, feed students, and keep campuses safe. Suburbanites are ignorant of the ecological connections among citizens in the metropolitan area in terms of vehicular commuter traffic and land development that threatens the air quality and waterways that form the city's borders.

Refusing to acknowledge the connection between the urban core and suburban fringe also rejects a sense of responsibility for what happens to

people who move within these spaces. "Suburbanites refuse to acknowledge—much less pay for—all the ways in which their lives depend on a healthy city," observes Conn. "Many simply want the city to provide them with recreation and cultural opportunities while resolutely closing their eyes to any sense of shared responsibility or common destiny."

Constance Fitzgerald claims that Americans "are not educated for impasse, for the experience of human limitation and darkness that will not yield to hard work, studies, statistics, rational analysis and well-planned programs." Since whiteness encourages the need to control or dominate one's environment, the code of whiteness tends to approach social injustices with a problem-solving mentality that favors rationalism and deductive reasoning at the expense of emotion, intuition, or imagination. Rather than take the risk of entering into the quagmire of impasses or surrendering to the potentially overwhelming reality of human suffering, people of privilege often skirt around the edges of social injustices with a logic or intellectualism that protects us from the emotional magnitude of these problems as well as our complicity in them. While this intellectualism may anesthetize people to the pain of reality, it also intensifies it. Brother Henderson of St. Gabriel Hall, a partner with the Mural Arts Program's restorative justice initiative, puts it this way: "In the US we are a very word-oriented society. Some of the visual, feeling, and tactile elements of humanity are repressed and this leads to a blindness to some of the richness of our humanity."

In a similar vein, those who practice the code of whiteness are often preoccupied with the future—future earning power, future educational opportunities or business ventures, the future of the next generation or of investment portfolios. Because it operates with a selective memory of the past, however, the code of whiteness traps even affluent people in an unending present haunted by injustices of the past. By not fully remembering the histories of people whose suffering made the privileges of whiteness possible—native peoples, slaves, Jews, women, sharecroppers, immigrants—the code of whiteness breeds an ignorance that ensures that the past will repeat itself in the future. When the future is nothing but an extension of the past, then one is in the midst of the darkness of impasse. A sense that history continues to repeat itself, despite one's best efforts to defend against it, creates a sense of being constricted to a present reality for which no meaningful change seems possible.

All Join Hands: The Visions of Peace, Donald Gensler, 2006, © Philadelphia Mural Arts Program.

Ultimately, the pathologies of the code of whiteness stem from the denial of very basic fears—of a loss of control, of the loss of privilege, of the reversal of one's fortune, of others and their suffering, of the self and its suffering. A fear of death binds these denials and imbues them with a futility that fuels impasse. Rather than accepting these fears as inherent to the human condition and surrendering to the mystery of being created in the image of a God who also accepted fear, the denial of the code of whiteness drives a variety of manic behaviors that exhaust and gradually destroy those who futilely engage in them. Roberto Goizueta notes that despite outward appearances of health, stability, and happiness, the suburbs are dangerous places in America. "To scratch that well-manicured surface," he notes, "is to discover the silent desperation that manifests itself in myriad of self-destructive ways, from chronic depression, to every conceivable form of addiction, to destroyed and destructive relationships, to suicide." Moreover, the denial of death justifies the denial of people who remind the privileged of this inescapable reality. "We run from the weak, powerless, vulnerable, wounded persons in particular," notes Goizueta. "They are the mirrors of our own souls, whose very existence threatens our sense of invulnerability, security, control."

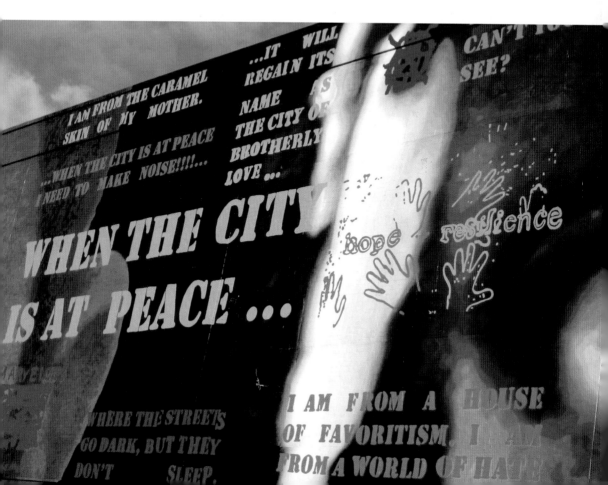

The Interruptive Power of the Gaze

All Join Hands: The Visions of Peace (Donald Gensler, 2006) on Benjamin Franklin High School is not only significant for its location on a school named for one of the greatest Americans to turn his back on the injustice of racism or for its location at the gateway to the ghetto or gentrification. The mural itself, created in collaboration with the School District of Philadelphia, the Department of Human Services, and the editorial board of *The Philadelphia Inquirer* in an attempt to create a citywide dialogue about youth violence, reveals ways through the impasse of the code of whiteness.

The three giant sets of eyes—belonging to people of different racial identities, ages, and genders—gaze piercingly at passersby and potentially heighten the self-awareness of one's own identity, potentially one's racial identity. This is a necessary exercise for whites who, precisely because we move in a culture of white supremacy, are often unaware of the way that we become white in a white culture. This is a privilege not enjoyed by people of color, who must always wrestle with the majority racializing them as "nonwhites." Racializing white consciousness, or helping whites to become aware of the ways in which our racial identity is also socially constructed and shapes the way we perceive the world and respond to people and events in it, can challenge complicity and transform defensive appeals to moral innocence into active commitments to social responsibility.

Poems written by students in school and in a residential facility for adjudicated youth and stenciled throughout the mural in varying sizes and colors speak to what it feels like "when the city is at peace." A thread that connects these self-expressions is an invitation to the wider community to move away from defensive claims of innocence where youth violence is concerned and, rather, acknowledge that urban youth—their troubles and their futures—are indeed in the hands of those who pass before these eyes. They are children of the city—young citizens born into socioeconomic conditions that predate them by at least three generations and fledgling Philadelphians in need of guidance, mentoring, and loving affection. "I come from you, can't you see?" one inquires.

It is in accepting the invitation to enter into meaningful relationships with the stranger—be that the self or another—that the codes of the street and whiteness can be cracked. We turn to that now.

CAN YOU
SEE?

silence

HOUSE

I AM

HATE

ONCE

Chapter Eight

Code of Creativity

"I didn't know how to come into this community as an outsider and do a mural about drug addiction," recalls muralist Don Gensler of his initial approach to the community at Gateway to Heaven and the mural he was commissioned to paint with them. "But I went to a tent revival twice a week where I experienced people connecting through song. It wasn't just the content of the song; it was emotions, the pain and the joy. One particular song jumped out at me. Spirituality as a way through addiction naturally presented itself to me."

Spirituality—what biblical scholar Sandra Schneiders defines as a lifelong intentional project to reach out beyond the self in love—was the key that unleashed Gensler's creativity precisely because it was a source of healing and empowerment for the Gateway congregation. So too it can serve as the antidote to the codes of the street and whiteness. The arts become an important vehicle for cracking the codes.

Cracking the Codes with Creativity

To gain a viable purchase on the slippery slopes of concentrated poverty, we need to crack the codes of the street and whiteness by identifying their commonalities and mutual dependencies.

Both codes are responses to what persons living in the not-so-dichotomous contexts of concentrated poverty and concentrated wealth perceive as the unchanging givens in their lives. Surprisingly, they push against similar constraints: competitive markets, whether formal or informal, in which the never-ending struggle to maximize social

All Join Hands: The Visions of Peace, Donald Gensler, 2006, © Philadelphia Mural Arts Program.

capital, whether respect or privilege, plays out; enclaves of socioeco-nomic similarity with constrictive social roles and narrow definitions of success; the constant need to be in control and to dominate; binary worldviews that make it impossible to engage the messy contradictions of life; cultural values that demonize those who are perceived as differ-ent. Cracking the code will involve changing perceptions of reality so that these conditions are not merely givens but human constructs that can be reconstructed through imagination and creativity. "The ques-tion of outlook is key here," notes Elijah Anderson in *Code of the Street*. "My experience [with urban youth] suggests that simply providing opportunities is not enough. Young people must also be encouraged to adopt an outlook that allows them to invest their considerable personal resources in available opportunities."

Moreover, the code of the street and the code of whiteness dehu-manize those who participate in them by gradually diminishing the distinctive features of what it means to be human. Both are suspicious of relationships of interdependence, leaving people feeling isolated and lonely. Both numb the poor and the privileged to the depth of their sor-row and pain and make it impossible to discern meaning in their lives. Both stubbornly refuse to surrender to the mystery of human finitude, which exhausts residents of ghetto and gated communities alike in their struggle for control or against the inevitability of death. Both fixate on the present and preclude liberating moments of transcendence that come with imagination. Cracking them requires rejuvenating peoples' capabilities for tender self-care—love of bodies and emotions, accep-tance of dependency, courage to wade into the dark waters of suffering, imagination that unlocks the future. Self-love will make love of others possible.

Finally, both the code of the street and the code of whiteness culti-vate a series of manic behaviors that preclude life in community and short-circuit new ideas with a circular logic that justifies the demoni-zation of those on the other side of city boundary lines. In choosing to play the game of the streets rather than the game of privilege, inner-city youth reject the knapsack of white privilege they know they will never be permitted to carry. This makes it possible for whites to claim that urban youth have freely chosen their social immobility and justifies their own choice to gate themselves off from the violence that urban youth have created for themselves and, as we shall see in the next chapter, lock up urban youth at astonishing rates. Likewise, the code of whiteness wrongly leads people of privilege to believe that access to the items in the knapsack of privilege is all that is needed to overcome structural

obstacles to social mobility. They entirely forget to address the enormity of these obstacles: inadequate public services such as education and recreation, lack of living wages for the limited employment opportunities available, degradative treatment in prisons and lack of services upon reentry. This charitable and unreflective approach to social change precludes people of privilege from critically examining the worldview and practices of privilege that sustain social inequity and justifies urban youths' suspicion of any white attempts to save them from the streets. This stalemate is the ultimate expression of impasse. What is needed to break it open is a new kind of privilege—the privilege of intentional communication that can engage new ways of relationship.

The arts can decipher the codes of these impasses.

Painting through Impasse

If we are going to get at the complexity of the social injustices that sustain the impasse of concentrated poverty, then we must take the risk to enter into it precisely as an impasse. "There is a way out of impasse," explains Massingale, "but it is not the path of avoidance or escape. Our faith declares that it is only by entering into the agony of the world's crucifixions through an embrace of the cross that the world can be healed." Fitzgerald notes that we must squarely face the finitude and powerlessness we experience in impasse in our minds as well as in our flesh if we have any hope of passing through them, because it is only in taking this risk that we realize that the spiritual darkness in which they blanket us is not the same as death.

Recall muralist Don Gensler's shift in thinking that led him to see "spirituality as a way through addiction." Such an insight requires that we intentionally shift from left-brained to right-brained thinking, a cognitive move that is particularly difficult in the light of the impasse of concentrated poverty. The general disillusionment and moral ambiguity of impasses render them immune to responses that lead with characteristically left-brain approaches that favor deductive reasoning, linear thinking, statistical analysis, and logical argument. We simply cannot master or dominate impasses by reasoning our way through them. Moreover, the code of the street and the code of whiteness often thwart holistic, tactile, nonverbal, intuitive, and imaginative processing associated with right-brained thinking. The codes have paralyzed the right sides of our brains. The arts, therefore, have a particularly essential role in the difficult work of entering into the impasse of concentrated poverty.

"Mural art is a powerful tool for people who have emotionally died," notes Brother Henderson, particularly in terms of its power to resist the word-oriented disposition in American culture. "It can put the death of life into a prospective that you can feel by seeing it. Then you can have a conversation that is healing and positive rather than more destructive and violent."

Reading the "Signs of the Self"

Christian ethicists, particularly Catholics, are familiar with the imperative to "read the signs of the times" in order to determine what ought to be done. But as we discovered with the impasse of concentrated poverty, responses to this crisis must begin with a "reading of the self" if we are to clear the affective hurdles that exist between knowing what ought to be done and actually wanting to do it. "The struggle Christians face as they prepare to act is an inner struggle between fear and daring, between hope and despair, rather than a struggle to know what justice demands," notes David Hollenbach, SJ. "It is as much an affair of the heart as it is of the mind." Moreover, in the case of concentrated poverty, we have seen that social problems are external manifestations of inward states of being. Fear of rejection, a desire to control the future, avoidance of meaninglessness, distrust of others, alienation, and loneliness distract all persons from the difficult but lifesaving task of knowing and loving the self. The self of the ghetto and the self of the gated community have to take the risk to discover and love themselves if people in both communities are to respond in a way that will break through the stalemate of concentrated poverty. In other words, they have to learn how to love themselves into ethical action. Muralist Ras Malik put it this way: "Healing can happen for the black community and for the white community. We all need it. Whatever I need you need and vice versa."

The arts or encounters with humanly created beauty facilitate this loving and healing process in several ways. First, the arts offer a way of entering more fully into impasse because beauty becomes a kind of amulet against the paralyzing meaninglessness and "bottomless pit–ness" of impasse. Because it jump-starts right-brained thinking, the arts sidestep the urge to approach impasses from a left-brained rationalism that at best keeps us suspended on the surface of impasses and maintains their status as "givens" in our realities. Instead, the arts strap us into the emotional life vests needed to wade into the turbulent waters of impasse. "We humans reflect the oneness and connectivity of nature," explains Cesar Viveros-Herrera, a lead muralist on two of Philadelphia's

first murals that brought together victims and perpetrators of crime in the creative process of mural making. "We need to become more and more like that every day—to learn how to minimize the impact of what caused you pain, to spend less and less time and energy on things that hold us down, or that don't let us get to the next stage."

Often, encounters with beauty bring us face-to-face with emotions that we have long submerged for fear that they would overpower us: alienation, sorrow, powerlessness, guilt, regret, self-hate. "These kids have suffered trauma," explains Greg Ensanian of the young people he works with in the Mitchell Program for adjudicated youth. "And unless you deal with that trauma you will not get them out of the street code that says 'what you did to me I can do to you.' If a kid has trouble expressing himself in words, he can express these things in art. Art allows us to see symbols that then allow you to see a variety of emotional states."

This is the object of art, according to Margaret Miles: "to objectify feeling so that we can contemplate and discuss it." Maxine Greene suggests encounters with the arts "make perceptible, visible and audible that which is no longer, or not yet perceived, said and heard in everyday life." The arts help us to name these deep-seated facets of ourselves and create a safe space outside of ourselves in which to engage, if not express, them. The arts enhance our emotional literacy and expand our consciousnesses, making it easier to "read the signs of ourselves" as well as those of other selves. Moreover, the seemingly unchanging "givens" of our realities against which we feel powerless become dynamic "contingencies" that we can engage through multiple interpretations and shape with ever-evolving meanings. Fitzgerald suggests that this moves us from the dark side of impasse to the dawn side where the light of deep self-understanding illuminates new possibilities by "restoring the sense that something can be done in the name of what is decent and humane." "I think a lot of artists are practitioners of spirituality," explains muralist Malik. "They know how to project a feeling with a certain color or angle or view and this can teach a lesson. Artists and muralists are conduits for a creativity that can inspire a whole group of people."

In addition to bringing to the surface the dark facets of ourselves that we deny or reject, the arts also move us from codes of self-denial to covenants of self-love. As such, beauty can be understood as a verb synonymous with loving the self. Beauty reminds us of dimensions of what it means to be human that the codes of the street and whiteness reject: acknowledgment of our limitedness and a refusal to be defined

by them, a desire to participate in things greater than ourselves and to know that we are greater than even our own estimations of ourselves, a longing to communicate the ineffable experiences of our lives and to have those expressions of self be understood by others, a desire to be of importance to others. In short, by awakening us to these forgotten dimensions and bringing them to bear on the impasses that smother us, beauty enhances our capacity for affirming relationships, first with the self and then with others. "From my mother and others along the way I have learned that beauty is a statement that one cares about others and about one's self," explains feminist ethicist Susan Ross. She and others suggest this is possible via a variety of lifesaving characteristics that beauty or the arts imbue in us and inspire us to share with others: empathy, generosity, respect, creativity, energy, awe, and responsibility. Finally, encounters with beauty can pull us over the hurdle of fear that stands between knowing what we ought to do and actually doing it, widening the impasses of concentrated poverty. As an expression of the divine, beauty is irresistibly attractive and compelling. It evokes a response from us, often against our resolve to remain unflappable or our fear of risking action. The arts help us overcome our fear of acting for the sake of the good, for the sake of the other, for the sake of our self because they awaken us to a deep desire for the good that we simply cannot resist.

Again, Philadelphia muralist Ras Malik's observations of working with young people underscore these points. "Art is about seeing, projecting and relating. It's about relationship with others. When you stifle creativity you cause a lot of problems. We need to mentor young people, to allow them to have their creative moment. Sometimes we have to wrestle creativity out of young people but the creative moment expands out and their whole person is improved."

Communicating Dangerous Memories

Recall that both the code of the street and the code of whiteness prevent the future from interrupting the present, whether by being obsessed with the past, as is the tendency with the code of the street, or denying it, as in the case of the code of whiteness. In either situation, "the past" determines "the now" and diminishes the essential human capability for imagination. The arts can release us from this stranglehold of the present by surfacing memories that make the future a palpable possibility. German political theologian Johann Baptist Metz identified the "remembrance" of dangerous memories of suffering as the only

way for European Christians, particularly Germans, to enter into the impasse of the Holocaust in the decades following World War II. Surfacing these memories and experiencing their retelling was the only thing that could possibly create a connection between Jews and those who permitted their near extinction and, as such, prevent the future from being nothing more than an extension of the present.

Community murals provide a way of communicating memories that the wider culture has forgotten or refuses to fully remember—the genocide of native peoples, African slavery, Jim Crow, white flight, and the trauma of war. They make it possible to recall memories in ways that are difficult to ignore or that cannot be easily dismissed. There is a propheticism in the artistic expression of persons on the margins as they often foresee both a different future as well as the conditions that will prevent that future from materializing. This capability for remembering and communicating memories is essential for empowering persons and communities disabled by generations of concentrated poverty. It enables people to make meaning of suffering, both past and present, and to articulate an identity that challenges stereotypes that are invoked and justified by selective memory.

Recall the spirituals, for example, as a living public record of both memory of suffering and resilient hope for the future that nourished African slaves and their decedents through the perils of slavery and its ongoing aftermath. It is no wonder that such songs became the muse for Gateway to Heaven's *Songs of Hope*. The same is true of *Healing Walls* (Cesar Viveros-Herrera, 2004), a pair of murals done by victims and perpetrators of crime. "I painted it with the sole purpose of painting pain so that these people know that they are never alone and that there are people with them in *this* life," explains Cesar Viveros-Herrera, lead muralist on this project and one of the first to go into Pennsylvania prisons to work with inmates. "They knew, no matter what happened, there was a testimony to people who want to live life to the most and up to the last moment. When you give to others, you give to yourself. You give yourself the experience of giving to others and this is key to healing."

These memories are also an important antidote to the amnesia that keeps people of privilege trapped in an equally dehumanizing present reality of denial. They challenge the myths that defend the self-abasing values and practices of the dominant culture—freedom and self-sufficiency, equality rooted in equal opportunity, justice that is color-blind, the social stability of meritocracy and heterosexism—and reveal their detrimental impact on all persons, not simply those for whom these myths have rung false. Communicating them in the context

of the arts creates fissures in the collective identity forged by the values of whiteness through which the wisdom of deep pain and regret might seep. By acknowledging others' pain we begin to name our own and to establish a solidarity rooted in fellow-feeling and responsibility.

The arts bring new dimensions to the tradition of dangerous memories that protect the radical alterity of the future from the profanity of the present. They recall these memories in tactile and even confrontational ways that mere verbalization or spoken narrative alone cannot capture. Through the arts, we unexpectedly encounter memories in bodies in motion, in the refrains of a melody, and in sacred or profane spaces. Moreover, symbols express the often-ineffable dimension of human suffering and evoke ongoing interpretations that give dangerous memories a radical inclusivity that keeps them alive. By tapping into the depth of emotion, the arts foster an equally deep fellow-feeling that gives people courage to face difficult pasts together.

Cultivating Paradoxical Curiosity

Recall Anderson's prognosis of the code of the street. Cracking it will require city and suburban residents to embrace a new outlook that simultaneously perceives the complexity of issues of concentrated poverty and at the same time can see beyond these complexities to the simple solutions that are before us. Left-brained thinking makes it difficult to stand in this seemingly contradictory space, since it tends to simplify complex realities by imposing a binary "either/or" framework, which we discussed in the previous chapter.

In his experience as an international peace activist, John Paul Lederach ardently believes that the arts provide a new way forward by cultivating a paradoxical curiosity within those trapped in the stalemate of conflict or impasse. "Paradoxical curiosity," he explains, "sustains a permanent inquisitiveness that vigilantly explores the world of possibilities beyond the immediate arguments and narrow definitions of reality." It does so by approaching realities with "an abiding respect for complexity, a refusal to fall prey to the pressures of forced dualistic categories of truth, and an inquisitiveness about what may hold together seemingly contradictory social energies in a greater whole." Such an approach to curiosity can be developed only through engagement with others in the context of artistic creativity, since it is here that we understand the true meaning of imagination, as well as the value of multiperspectival ambiguity: "the art of creating what does not exist." So what does paradoxical curiosity bring to the impasse of concentrated poverty?

First, it further muddies the already muddled water of impasse so that we might become comfortable with contradiction, ambiguity, and the potentially creative tension we feel when the various parts of our reality do not seem to fit together as a whole in the framework that we have constructed for ourselves. Paradoxical curiosity suspends our inclination to move unreflectively or reflexively to judgment or evaluation or action. It carves out a "a personal and social space that gives birth to the unexpected," says Lederach, something unexpected "whose every birthing changes our world and the way we see things." In this way we see the road ahead no longer in terms of "narrow, shortsighted or structurally determined dead-ends" but rather in light of unexpected bends or bridges that we wrongly assume are impossible to build. Paradoxical curiosity triumphs over a defeatist logic that has been internalized on both sides of the impasse of concentrated poverty. The very fact that the collaborative work of mural making goes on in inner-city neighborhoods—and that murals continue to be painted despite the fact that socioeconomic markers of poverty have not significantly changed—suggests that those who paint them incorporate paradoxical curiosity that empowers them to birth something new.

The arts provide the catalyst for paradoxical curiosity since they help us to make meaning of the complexity of our lives; they do so in a way that resists a false simplicity that comes with binary thinking. The arts do not simplify with stereotypes, ideologies, platitudes, or utopias but rather call our attention to the complex beauty of nuance, shades of color, shadows, subtle gestures, underlying tones, symmetrical asymmetry. The ambiguity and contradiction that come with the arts, in Lederach's opinion, help us to "see the big picture better" so that we might find "the elegant beauty of simplicity." Activities associated with the arts or creativity make it possible to wade into complexity and contradiction without fear of losing or denying self, losing sight of an integrated whole, becoming overwhelmed or emotionally exhausted. "Be attentive to image," Lederach advises. "Listen for the core. Trust and follow intuition. Watch metaphor. Avoid clutter and busy-ness. See the picture better. . . . Imagine the canvas of social change." In many ways, muralist Don Gensler embodied these practices of paradoxical curiosity in working with the Gateway to Heaven community on their mural. He suspended judgment and immersed himself in their community in order to be attentive to the experience that would present the big picture of that community.

Finally, paradoxical curiosity focuses our attention on preexisting webs of relationality. Part of seeing the complexity of our social reality

involves actually seeing, and perhaps even encountering, the people in it. Doing so reveals to us the profound web of relationship that connects all people—even those one would otherwise see as untrustworthy or even as enemy. This is what allows simplicity to cut through the complexity; the simple recognition that we are all people struggling through impasse raises the possibility of being in relationship with each other in new ways as the most viable way to the dawn side of those impasses. These relationships feed the heart and the soul for the hard work of bringing out change in difficult circumstances. Viveros-Herrera invokes this idea when he notes that the most significant changes that murals make in neighborhoods where they are painted are impossible to measure empirically, since they usually come in the form of personal choices against violence or against social irresponsibility. "You don't see the crime that doesn't happen," he prophetically notes.

Incarnating Hope

"This mural is a mural of hope," explained Pastor Smith of *Songs of Hope*, the four-story mural his congregation created with artist Don Gensler that opened this section of the book. "The young man is stepping out; he's looking to the future. He has a goal and a vision in mind." As the signature image for this chapter, and indeed this book, *Songs of Hope* also conveys its central message. Collective artistic expression like muralism provides a way through the affective dimensions of entrenched social injustices such as concentrated poverty. The arts bring us face-to-face with hope in unexpected places and in provocative ways. The brand of hope they imbue, one that is resolute in insisting that a different way is indeed possible, nourishes those who risk an affective approach to justice.

Impasses remind us that justice is not only an intellectual calculation of the mind and the brain but also a desire or longing of the heart and body. As we will see in the next chapter, justice is not simply about access to tangible or intangible goods or the unfettered exercise of human rights. It is a vision of human relationships, like the vision that captivates the young boy of *Songs of Hope* in which we all matter to each other and, therefore, constantly reframe our worldview and social values to make space for that mutuality. If this is the case, then the work to bring that vision to fruition needs particular kinds of sustenance—states of the heart that sustain people in keeping this vision before them and moments when we tactilely experience its incarnation in the here and now.

Public art like muralism does precisely this. Murals carve out public space, alternative "staging areas," to use Anderson's term, where people come together to contemplate and work through the dynamics of their relationships with themselves and with others. Street corners, empty lots, playgrounds, courthouses, hospitals, libraries, and prison yards—once places where violent "campaigns for respect" in the code of the street and code of whiteness were waged—are now civic spaces where the social capital of mutual respect is generated and reinvested in the community. As we will see in more detail in the final section, they become what Lederach describes as "centers that hold": relational spaces that provide a sense of identity, pull people into community, and send them out to participate in social change with "know who" knowledge rather than "know how" knowledge. Standing before these concrete canvases where meaningful social change has happened, where justice has been created and tactilely experienced, all citizens feel what Hollenbach names as "sense of confidence, hope, energy and magnanimity"—states of the heart that can sustain them in the risky work of engaging impasse and knitting back together communities ripped apart by the structural violence of poverty.

Also, the arts incarnate hope by breathing transcendence back into souls weary from the unchanging worlds of the streets and of whiteness. Murals radiate wonder and amazement in the context of otherwise ordinary cityscapes. They evoke silence in the midst of the busyness we generate to distract ourselves from people and things that really matter and blow the winds of change into the doldrums of a present reality that seems to have no future. They spark the imagination and creativity, the tools we need to live as if there is more to living than getting through another day, as if we can indeed transcend our limits, as if we can sing songs of hope, and these songs—whether visual, musical, performative, or poetic—will indeed be the antidrug, the anti–racial profiling, the antigang, the anti–white enclave. Murals ensure that while people might violently continue to deny their inherent connections to their neighbors, there is a cadre of citizens who creatively embrace those connections and use them to remain as firm in their resolve to beautify the city as others may be in giving up on it.

Code of Humanity

Murals instill within people on either side of the city line courage to surrender to the mystery of being human rather than to succumb to the temptation of controlling its unpredictability or to be defeated by its

inevitable suffering. As such, they provide new images and language for God that reject the constructs for the Divine that emerge out of the impasse of the code of the streets. God is no longer warrior, memorializer of the dead, vengeful judge, guarantor of prosperity, or puppet of white culture who is absent from urban neighborhoods as the code of the streets would lead some to think. Nor is God an exacting employer, a hovering parent, a therapist, a talisman for security, or the provider of social stability that the code of whiteness tends to invoke. As we will see in the final section, muralism conveys a sense of the sacred in the public square that invites self-reflection and participation in what God is doing in the world.

Bibliography

Introduction

Several interviews inform this entire section, including (in order of appearance): Rev. Carnell Smith with Gate to Heaven Ministries on October 21, 2006; Brother Brian Henderson of St. Gabriel's Hall, September 18, 2008; muralist Donald Gensler, January 10, 2007; muralist Ras Malik, June 6, 2007; muralist Cesar Viveros-Herrera, September 22, 2008; and Greg Ensanian of the Mitchell Program at St. Gabriel's Hall, September 23, 2008.

Constance Fitzgerald presents the idea of impasse in her essay, "Living with Impasse," in *Women's Spirituality: Resources for Christian Development*, ed. Joann Wolski Conn (Mahwah, NJ: Paulist Press, 1986), 287–311. See also her plenary address to the Catholic Theological Society of America, "From Impasse to Prophetic Hope," *CTSA Proceedings* 64 (2009): 21–42. Bryan Massingale develops the ethical implications of impasse in "Healing a Divided World," *Origins* 37 (August 2007): 161–68. David Hollenbach, SJ, implicitly engages this idea in "Courage and Patience: Education for Staying Power in the Pursuit of Justice," in *Justice, Peace and Human Rights: American Catholic Social Ethics in a Pluralistic Context* (New York: Crossroad, 1988).

Chapter Six: Code of the Street

Stories of the North Philly Foot Stompers come from a personal interview with Helen Brown, February 12, 2007, as well as a *New York Times* article by Sara Rimer, "First Steps to Reclaim the Streets Are Joyful, Precise and Loud" (January 12, 1998).

For sociological examination of cultures of poverty, see *More Than Just Race: Being Black and Poor in the Inner City* (New York: W.W. Norton and Company, 2010), especially pages 42–68, as well as Loïc Wacquant's chapter, "Stigma and Division" in *Urban Outcasts: A Comparative Sociology*

of Advanced Marginality (Cambridge, UK: Polity Press, 2008). In *Code of the Street: Decency, Violence and the Moral Life of the Inner City* (New York: W.W. Norton and Company, 2000), Elijah Anderson describes the tension between "street" and "decent" families in inner-city communities. Particularly helpful in my chapter was David Mitchell who explores the spiritual dimension of the code of the street in *Black Theology and Youth at Risk* (New York: Peter Lang, 2001). See also an informative essay by Jeremiah A. Wright Jr., "An Underground Theology," in *Black Faith and Public Talk: Critical Essays on James H. Cone's Black Theology and Black Power,* ed. Dwight N. Hopkins (Maryknoll, NY: Orbis Books, 1999), 96–102.

Chapter Seven: Code of Whiteness

For the *historical roots* of a culture of whiteness in Philadelphia, see E. Digby Baltzell's *Puritan Boston and Quaker Philadelphia: Two Protestant Ethics and the Spirit of Class Authority and Leadership* (Boston: Beacon Press, 1979), a fascinating examination of the distinct religious values and frameworks of meaning that gave rise to two distinct colonies in the Americas and subsequent generations of Americans in these places. Steven Conn unknowingly names attributes of whiteness and white culture in his discussion of the suburban attitudes and relationship to the inner city in *Metropolitan Philadelphia: Living the Presence of the Past* (Philadelphia: University of Pennsylvania Press, 2006), as does Sam Bass Warner in *The Private City: Philadelphia in Three Periods of its Growth* (Philadelphia: University of Pennsylvania Press: 1968). The contemporary take on Franklin comes from David Brooks, "Ben Franklin's Nation," *The New York Times* (December 13, 2010). Thomas Sugrue examines these ideas in *The New Urban History* with Kevin Kruse (Chicago: University of Chicago Press, 2006); as does Michael Katz in *The Price of Citizenship: Redefining the American Welfare State* (Philadelphia: The University of Pennsylvania Press, 2001 and 2008).

Resources for understanding the cultural phenomenon of whiteness and white culture include: Peggy McIntosh, "Unpacking the Invisible Knapsack," available at http://www.amptoons.com/blog/files/mcintosh.html; Ruth Frankenberg, *The Social Construction of Whiteness: White Women, Race Matters* (Minneapolis: University of Minnesota Press, 1993); Birgit Brander Rasmussen et al., *The Making and Unmaking of Whiteness* (Durham, NC: Duke University Press, 2001); Terrance MacMullan, *Habits of Whiteness: A Pragmatist Reconstruction* (Bloomington and Indianapolis: Indiana University Press, 2009). See also a documentary film, *Race: The Power of Illusion.*

Philosophers who have done important work in this area include Charles Mills, *The Racial Contract* (New York: Cornell University Press, 1997); George Yancy's collection of essays titled, *The Center Must Not Hold: White Women Philosophers on Whiteness in Philosophy* (New York: Routlege, 2010); and Barabara Applebaum, *Being White and Being Good: White Complicity, Moral Responsibility and Social Justice Pedagogy* (Lanham, MD: Lexington Books, 2010).

Theologians are also beginning to take this up. See Kameron Carter, *Race: A Theological Account* (New York: Oxford University Press, 2008); James Perkinson, *White Theology: Outing Supremacy in Modernity* (New York: Palgrave MacMillan, 2004); Jennifer Harvey, Karin A. Case, and Robin Hawley Gorsline, *Disrupting White Supremacy from Within: White People and What We Need to Do* (Cleveland, OH: The Pilgrim Press, 2008); and *Interrupting White Privilege: Catholic Theologians Break the Silence*, ed. Laurie Cassidy and Alex Mikulich (Maryknoll, NY: Orbis Books, 2008). In Catholic systematic theology in particular, those demanding a racialized white consciousness include contributors to the *Theological Studies* volume dedicated to "Catholic Reception of Black Theology," 61 (2000).

For analysis within Christian ethics, Mary Elizabeth Hobgood's examination of the negative impact of unearned privilege on whites in *Dismantling Privilege: An Ethics of Accountability* (Cleveland, OH: The Pilgrim Press, 2000) is invaluable. Bryan Massingale, "What Is Racism" in *Racial Justice and the Catholic Church* (Maryknoll, NY: Orbis Books, 2010), examines facets of white culture and the "white soul." Dennis Ford implicitly explores whiteness in the context of a "middle-class ethic" where abundance, comfortability, and a lack of social problems hinders the ability to acknowledge the neighbor in need as neighbor in "Developing an Indigenous Ethic for the Middle Class," in *Perspectives in Religious Studies* 10, no. 2 (1983): 111–22. Roberto Goizueta implicitly speaks of whiteness in his discussion of the fear-driven values and dispositions of the suburbs, *Christ Our Companion: Toward a Theological Aesthetics of Liberation* (Maryknoll, NY: Orbis Books, 2009).

Chapter Eight: Code of Creativity

Sandra Schneiders challenges the cultural dichotomy between religious and spiritual people in "Religion vs. Spirituality: A Contemporary Conundrum" in *Spiritus* 3, no. 2 (Fall 2003); Matthew Fox invokes elements of this creative spirituality in *Creativity* (New York: Tarcher,

2004). David Hollenbach, SJ, alludes to the significance of the affective dimensions of the self in justice commitments in his chapter "Courage and Patience: Education for Staying Power in the Pursuit of Justice," in *Justice, Peace, and Human Rights: American Catholic Social Ethics in a Pluralistic Context* (New York: Crossroad, 1988). Margaret Miles, *Image as Insight: Visual Understanding in Western Christianity and Secular Culture* (Boston: Beacon Press, 1985), offers ethicists some great insights for thinking through the way the arts might sharpen the "perceive" or "observe" facet of the praxis of social ethics. Likewise, *Releasing the Imagination: Essays on the Arts, and Social Change* by Maxine Greene (San Francisco: Jossey-Bass, 1995) and John Paul Lederach's *The Moral Imagination: The Art and Soul of Building Peace* (New York: Oxford University Press, 2005) open up new possibilities for the role of imagination in the evaluative step of that praxis. For a feminist approach to the relationship between artistic self-expression and active commitments to justice, see Susan Ross, *For the Beauty of the Earth*: *Women, Sacramentality and Justice* (New York: Paulist Press, 2006). Finally, in terms of the art as a way of communicating dangerous memories, see German Catholic theologian Johann Baptist Metz's treatment of this concept in *Faith, History and Society: Toward a Practical Fundamental Theology*, trans. J. Matthew Ashley (New York: The Crossroad Publishing Company, 2007).

Part Four

Prisons
From Degradation to Restoration

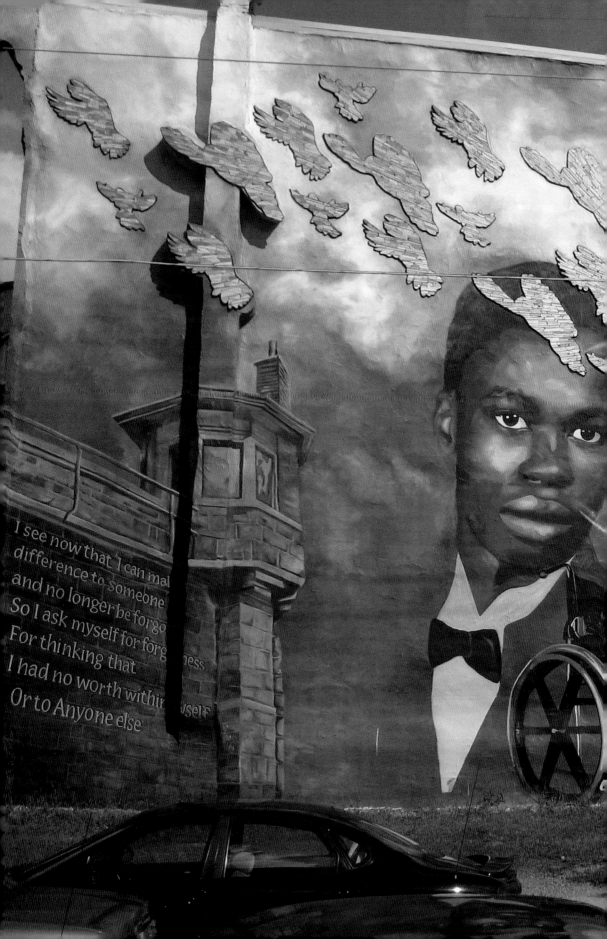

Forgiveness

In 2006, a group of teenagers shot Kevin Johnson for refusing to "give up" his Allen Iverson jersey. Although sentenced by his assailants to life in a wheelchair as a quadriplegic, Kevin refused to condemn them to the retributive justice of the code of the streets that would have justified—in fact, demanded—that he exact revenge in order to maintain his reputation, one of the only forms of social capital in inner-city neighborhoods. Not long after Kevin died from complications from his injuries, lifetime inmates in the State Correctional Facility at Graterford, adjudicated youth from St. Gabriel's Hall—including one involved in Kevin's shooting—and Kevin's mother, Janice Jackson-Burke, created *Forgiveness* as a memorial to his countercultural choice not to perpetuate violence.

Murals such as *Forgiveness* (Eric Okdeh, 2007; see p. 137), and more than twenty others like it throughout Philadelphia created by perpetrators and victims of crime, interrupt the seemingly endless cycle of violence on the streets and within the prison system. Art done "on the inside" but exhibited on walls "on the outside" offer a viable alternative to the prison-industrial complex that is destroying urban communities by further criminalizing the incarcerated, destabilizing their families, draining public funds for services that prevent incarceration, and reinforcing suburban stereotypes of urban crime and criminals. In the case of those connected to the *Forgiveness* project, murals offer provocative images that capture the courage needed to risk a new way of being in relationship with others that can begin to heal a city wounded by violence at among the highest rates of any city in the country.

Kevin's mural strikes a chord in all who encounter it in a way that the parable of the Prodigal Son—evoked in lead muralist Eric Okdeh's

Rembrandt-inspired image of the young man turning toward a loving embrace—would have spoken to first-century Jews living in an occupied territory of the Roman Empire. Kevin's was a radical action that flew in the face of the socially entrenched approaches to responding to wrongdoing that often maintain the injustices of the status quo. Just as the Prodigal's father in Luke's parable rejects the cultural mores that would have justified him in condemning his son to his freely chosen exile in poverty and embraces him instead, Kevin Johnson rejected the powerful code of the street with its justified retaliation and aggressive posturing in order to publicly forgive his assailants and interrupt a cycle of violence that would have sucked many of his peers into its vortex of retributive violence.

That Kevin's story and mural received the media attention it did also sheds light on some troubling flaws in our understanding of forgiveness. Cultural expectations for forgiveness far exceed individual choices to forgive. Several factors preclude us from meeting our own expectations of forgiveness. In a culture that increasingly values personal security we are afraid to risk the kinds of encounters that authentic forgiveness demands. In their public appeals for forgiveness that rarely incorporate those impacted by their wrongdoing, politicians and celebrities have eviscerated public confidence in meaningful forgiveness. Despite the pervasiveness of structural injustice and social suffering, we rarely consider forgiveness in more public, relational, horizontal, or social terms—whether as a public process of seeking repentance for social sin or as a collective commitment to a certain way of being in the world. Through its restorative justice initiatives, the Mural Arts Program (MAP) is taking up that work—painting with three hundred inmates and two hundred juveniles each year in five prisons and detention centers throughout the Philadelphia metropolitan area to produce six to eight installations annually. It partners with a variety of agencies and nonprofits connected to the prison system to reduce rates of incarceration and recidivism by changing the lives of people inside the prison system and attitudes of those "on the outside."

The criminal justice system, particularly as it operates in poor urban communities, provides irrefutable evidence of just how vacuous the practice of forgiveness in North American Christianity has become. An overview of the prison-industrial complex provides the landscape in which Kevin Johnson and those who painted his memorial embraced forgiveness. It makes their witness to forgiveness and their commitment to restorative justice through the arts that much more compelling and prophetic.

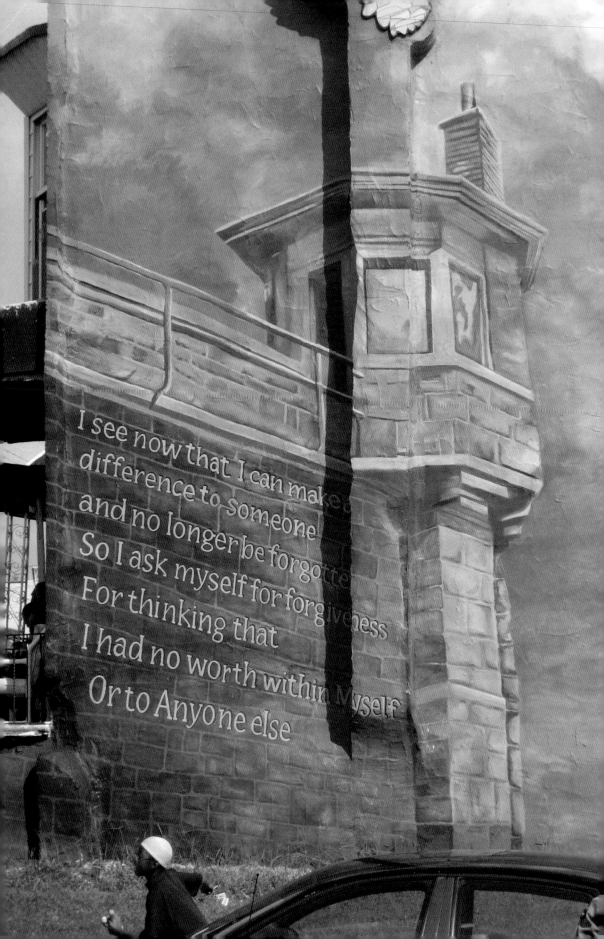

I see now that I can make a
difference to someone
and no longer be forgotten
So I ask myself for forgiveness
For thinking that
I had no worth within Myself
Or to Anyone else

Chapter Nine

The Complex

Kevin Johnson made a conscious choice to resist a culture of "un-forgiveness" that permeated his urban existence, a culture that suggests it is better to stick to the familiar territory of "an eye for an eye" retri-bution that maintains the social order—in this case the expectations, social roles, and power dynamics of the code of the street—than to risk stepping out of that code to find new ways forward after crime or violence. But this culture of unforgiveness is not limited to inner-city neighborhoods. It permeates spaces outside the ghetto where that same commitment to "an eye for an eye" retribution maintains another social order—in this case, the expectations, social roles, and power dynamics of white supremacy that would rather lock people up at alarming rates than find new ways forward after crime or violence. This unforgiveness fuels a $55 billion-a-year prison industry that bolsters the bottom line of private companies while simultaneously creating an "undercaste" of those caught in its tentacles who are barred from full participation in society in the process. Kevin's choice to forgive and the witness of the incarcerated men and boys who created the mural that memorializes his choice make us aware of this symbiotic culture of unforgiveness inherent in both the code of the street and the code of whiteness. By "unforgive-ness" scholars mean a disposition and set of practices through which people refuse to relinquish their positions as either perpetrator or victim and resist exploring the depth of their pain or injury or the demands of justice with either the person who has wronged them or whom they have wronged. Unforgiveness fails to situate an act of wrongdoing into a larger context of broken persons and communities and refuses to risk new ways of being in the context of crime and violence.

Forgiveness: detail, Eric Okdeh, 2007, © Philadelphia Mural Arts Program.

The prison-industrial complex—what sociologist Angela Davis defines as a matrix of bureaucratic, economic, and political interests that encourage increased spending on incarceration compounded by what Michelle Alexander identifies in her book *The New Jim Crow: Mass Incarceration in the Age of Colorblindness* as a system of "laws, policies, customs and institutions that operate collectively to ensure the subordinate status of a group defined largely by race"—depends on this unforgiving disposition. Those who participate in the complex do everything they can to cultivate an unforgiving stance—in the psyche of perpetrators and victims, within prison walls and in communities on the outside, in ghettos, and in suburbia. To understand Kevin's prophetic witness as well as the content of *Forgiveness*, we need to understand the incarceral context in which he and incarcerated muralists risked forgiveness.

An Unforgiving Prison-Industrial Complex

Forgiveness is not a priority of the criminal justice system in the United States. If it were, we might have difficulty satisfying the voracious appetite of the prison-industrial complex that continues to metastasize quietly throughout the criminal justice system and local economies. The complex disproportionately affects the poor, particularly African Americans, eroding the social infrastructure of urban communities, and ensuring that people who live there—increasingly women and children—become part of the prison pipeline. David Hilfiker prophetically notes, "With the deterioration of the social safety net, the prison has become our social policy: our employment initiative, our drug treatment program, our mental health policy, our anti-poverty effort, and our program for children in trouble."

According to a study conducted by the Pew Center on the States released in February 2008, there are 1.6 million Americans incarcerated in state and federal prisons, 763,000 more held in local jails, and more than 5 million on probation or parole. This means that one in thirty-one people in this country are either incarcerated or living "under some form of correctional control." While the United States only constitutes 6 percent of the world's overall population, Americans make up 25 percent of the world's prisoners.

Incarceration in the United States is not color-blind. A staggering one out of fifteen African Americans are behind bars; they constitute half of

Forgiveness, Eric Okdeh, 2007, © Philadelphia Mural Arts Program.

the prison population. Although they represent only 7 percent of the population, African American men constitute 37 percent of incarcerated Americans, which means that one in nine African American men is behind bars. In fact, the United States now incarcerates more black men than the South African government did in 1991, leading Alexander to conclude that "we have not ended racial caste in America; we have merely redesigned it."

The total number of women incarcerated in the United States exceeds the total prison populations of France and Germany. African American women are the fastest growing demographic in prison; in the years between 1980 and 1997 the rate of their incarceration doubled that of men, and between 1985 and 1995 that rate grew by 190 percent. Three-quarters of women who are incarcerated are mothers, and two-thirds of their children are under the age of eighteen. One in fourteen African American children currently has a parent who is incarcerated.

Children are also among the ranks of incarcerated Americans. As of 2000, more than three hundred thousand youth are incarcerated in

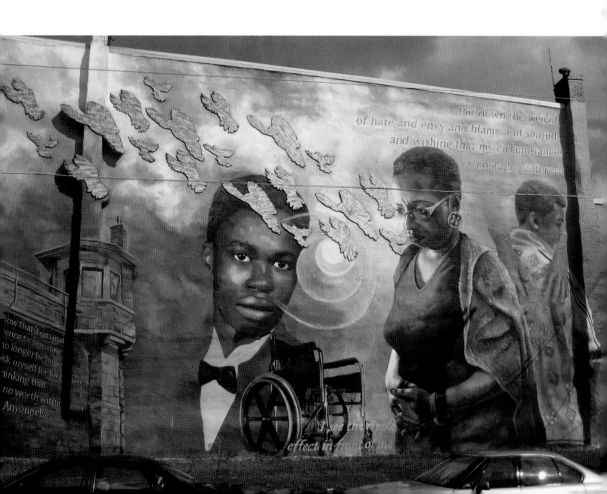

juvenile detention facilities prior to adjudication; more than sixty-five thousand have been committed to state institutions as a result of adjudication, and more than sixty-five thousand spend time in one capacity or another in adult institutions. The majority of incarcerated youth in this country are African American. While African American youth between the ages of ten and seventeen comprise only 15 percent of the total US population, they represent 26 percent of juvenile arrests, 32 percent of delinquency reports to juvenile courts, 41 percent of juveniles detained in delinquency cases, 46 percent of juveniles in correctional institutions, and 52 percent of juveniles referred to adult criminal court after juvenile hearings.

According to the National Institute of Corrections, the Commonwealth of Pennsylvania's Department of Corrections "manages" nearly forty-four thousand inmates in twenty-six prisons and fourteen community facilities. Philadelphians constitute 70 percent of that population. In fact, the Justice Policy Institute reported in April 2008 that Philadelphia, the first city to build a "modern" prison in 1829, had the highest incarceration rate of any county in the country. At that time, there were 9,440 jailed or incarcerated persons in Philadelphia, and experts claim that 70 percent of that population is African American. One-fifth of all juveniles who have been tried as adults in this country are Philadelphians.

What accounts for the fivefold increase in the incarceration rate in this country between 1973 and 2006, as well as its disproportionate impact on people of color, particularly African Americans? Scholars note a convergence of several contributing factors in the mid-1970s, both structural and psychological, that best describe the drive to incarcerate as a *complex*. Both types of factors reveal the limits of forgiveness and provide the background against which more creative approaches to punishment such as community muralism are emerging.

The Legal and Political Complex of Incarceration

The aggressive application of mandatory long-term sentencing sparked by the Rockefeller laws in New York City and the war on drugs that began in earnest in the 1980s, particularly in urban communities, caused rates of incarceration to skyrocket. Consider, for example, that drug arrests rose from five hundred thousand in 1980 to 1.2 million in 1989; those arrested during that same period were four times as likely to be convicted in light of mandatory sentencing laws. Drug offenders comprised 8.6 percent of state prison populations in 1985 but 22.7 percent in 1995, representing 45 percent of the increase in arrests. As of

2000, drug-related criminals represented 23 percent of inmates in state prisons and 60 percent of inmates in federal prisons. Although statistics reveal similar rates of drug use among Euro- and African Americans, the latter represent the majority of those convicted of drug-related crimes, if only because law enforcement tends to target urban communities where drug sales and usage is often more public and because African Americans are likely to be sentenced more harshly than their white counterparts. Until 2010, sentence disparity between crack and powder cocaine was 100:1. While the US Congress reduced that ratio to 18:1 in July 2010, the new policy is not retroactive and African Americans still constitute 80 percent of federal crack cocaine sentencing.

Second, in the last three decades politicians at every level of government have leveraged the political capital that accompanies tough-on-crime campaign platforms. We can see this with the emergence of the public prosecutor in American criminal justice, an elected official initially established to counter inherent subjectivity in private criminal suits but who is increasingly accountable to public opinion, whose concern with crime and confidence in social welfare programs significantly shifted in the mid-1990s.

The Economics of the Complex

Incarceration has become a lucrative private industry. The increased rates of incarceration predicate a boom in prison construction. In his comprehensive research, Christian ethicist James Logan notes that in 1923 there were sixty-one federal and state prisons; by 1974 there were 592 prisons, and by 2000 that number had grown to 1,023. The economic activity connected to the US prison system approaches or exceeds $100 billion, bringing employment to economically depressed rural areas and cheap labor to a variety of local and global companies. In 1995 the government spent $2 billion on building new facilities; each $100 million spent in this way requires a commitment of $1.6 billion over the next decade in operations alone.

Research has yet to confirm the economic growth that prisons supposedly bring to communities that have not fared well in postindustrial economic climate, a justification often invoked by those in private industry with a vested interest in the continued expansion of the American carceral state. Regardless of future expansion, the billions spent by states on incarceration each year lures the potential investment of a variety of private interests, such as the American Corrections Corporation, which oversees the $1 billion in services provided or products made by prisoners, for example, or develops the technology and resources that

can help state and federal prisons streamline prison management and make incarceration more cost-effective.

Increased levels of incarceration drain public resources for other social "goods" necessary for a vibrant common good to abound. At least five states allocate more tax dollars to incarceration than public education. According to a study by the Pew Center on the States, during the last twenty years, corrections spending has increased by 127 percent on top of inflation, while spending on higher education has increased only 21 percent. In fact, for every dollar the Commonwealth of Pennsylvania spends on higher education, it spends eighty-one cents on incarceration. In a classic example of the drain that incarceration places on already strained city budgets, the Department of Corrections, whose budget was $250 million in 2008, was one of the only in-budget lines in the City of Philadelphia that received a 2 percent bump in 2009. Funding for programs that prevent crime, contribute to rehabilitation on the inside, and assist ex-offenders on reentry into their communities has been and will continue to be cut in order to better incarcerate more people.

The Affective Complex of Incarceration

The tentacles of the prison-industrial complex are also entangled in our collective psyche. It is hard to ignore the cultural values of whiteness, so deeply rooted in the American consciousness, at work here. The values of autonomous self-sufficiency, personal security and social stability, defensive consolidation and protection of assets, and law and order justify our tendencies to perceive those who are different from us as threats to our personal safety and security as well as our inclination to wage a cultural and governmental war on dependency or vulnerability. These values also justify our tendency to demonize those who fall through a tattered social welfare safety net as "Public Enemy Number One" in "zero tolerance" crime policies and our obstinate commitment to punish them with a lockdown approach to corrections. As reflection of the inability to acknowledge complicity endemic in white culture, we refuse to take into account the social context of wrongdoing and instead hold individuals alone accountable for their own actions. We justify an unforgiving stance toward criminals by absolving ourselves of collective accountability for conditions that may have contributed to or influenced their personal choices.

The cultural value of whiteness also cultivates a proclivity for a reward-and-punishment model of forgiveness. As a result, many contemporary expressions of forgiveness fail to pay sufficient attention to the interior dynamics of this practice—memory, emotions, passions,

physical and psychological pain, visions of ourselves, and dreams for our families and communities. These things not only provide important insights into the unfolding consequences of wrongdoing but also offer viable pathways to rehabilitation and healing by illuminating common denominators in human experience and cultivating a sense of fellow-feeling that makes meaningful forgiveness possible.

Whites look to the law to provide a moral calculus that determines what winners and losers owe others in a competitive environment and to restore balance or reassert control over aspects of their lives. To that extent, criminal justice serves as an expression of what Denise Brenton names "contemporary feudalism" in which "the most powerful, the most aggressive, the richest, the best educated, the most 'cultured,' the 'best religion,' the 'Whitest', the 'head of the family,' the top of the food chain, or the higher rungs on the great chain of being dictate what counts as justice for everyone else, creating wounds that take generations to heal."

The shift toward more retributive and even vengeful models that exact punishment from prisoners, at the expense of more rehabilitative approaches to corrections that prevailed in the criminal justice system through most of the twentieth century, also mirrors white attitudes regarding the poor and social welfare that have emerged in the last three decades. In other words, "making prisoners pay" by treating them as less-than-human in a variety of ways or making them feel socially inferior, most basically by refusing to invest in their rehabilitation, has become the hallmark of punishment in the United States. Additionally, politicians and the media manipulate the value of personal security by stoking our collective fear of violent criminals for polling and rating purposes, creating attitudes and policies that ultimately stoke unfounded racial fear and conflict. In 1982 less than 5 percent of Americans thought crime was the most significant problem facing the country; in 1994 that number was just below 45 percent. Rates of crime remained relatively the same during that time period, proving that fear to be largely unfounded and irrational.

Finally, pervasive rhetoric of terrorism renders the breaching of borders—whether personal, cultural, local, or national—a criminal offense. Heightened surveillance of homes and businesses, the abdication of civil liberties, and the policing of civic spaces all in service of "homeland security" justifies the inclination to incarcerate rather than rehabilitate, educate, or employ persons who either undercut the common good or are alienated from it. Furthermore, Michelle Alexander and Marie Gottschalk each note that public opinion polls regarding criminals and models of punishment suggest that the incarcerated are the only

social group that it is permissible to publicly hate; this also reflects the lockdown mentality of the prison-industrial complex in which prisoners must be not only incarcerated but also punished with vengeance the likes of which we have not seen since the days of Jim Crow. That MAP does not publicize its work with prisoners as widely as its work among other city populations, for fear of jeopardizing their municipal or private funding, reflects the power of public consciousness around the incarcerated.

In short, private and public expressions of unforgiveness reflect the logic, dispositions, values, and practices of white privilege that are increasingly evident in Christianity in the Age of the American Empire or what some call the *Pax Americana*. Insofar as it reinscribes the imbalance of power and privilege in personal social relationships, approaching forgiveness as a privilege only exacerbates the diminishing impact of wrongdoing on perpetrators, victims, and the wider community.

The prison-industrial complex impacts the psyche of the incarcerated as well. During imprisonment and even upon their release, incarcerated individuals experience what prison physician and activist John May considers "further incarcerations." "On the inside" they are exposed to the physical and emotional trauma of disease, physical and sexual assault, retributive degradation, and the diminishing effects of a pervasive "lockdown consciousness." In addition to carrying many of these traumas with them "on the outside," ex-offenders also face significant obstacles in reintegrating themselves into communal life. They struggle to find meaningful employment, affordable housing, health care, and substance abuse treatment programs. Women deal with the additional challenge of being separated, often permanently, from their children and other networks of support. Gottschalk notes that incarceration brings with it "civil death" since prisoners are denied the right to vote and, in many cases, that right is never restored to those convicted of violent felonies. Most are denied access to federal welfare programs, most notably federally sponsored grants for higher education. In short, exposure to the dispositions and practices of degradative retributive punishment in prisons calcifies the code of the street mentality. Incarceration further alienates prisoners from themselves, from their families, and from social networks of support. These relationships are essential to breaking through a code of the street mentality and to break through the cycle of social immobility caused by concentrated poverty.

Logan argues that the affective dimensions of the prison-industrial complex preclude the clear thinking needed to address the many contradictory facts of incarceration. For example, while some offenders

have damaged their communities to various degrees, 84 percent of the increase in incarceration since 1980 has involved nonviolent offenders. Moreover, despite evidence that substance abuse treatment programs in prisons can significantly reduce criminal activity related to drugs, the vengeful approach to criminal justice refuses to fund rehabilitative initiatives. This means that only about 10 to 13 percent of the 70 to 85 percent of addicted prisoners actually receive substance abuse treatment. In addition, as the war on dependency continues, prisons increasingly fill in the gaps in social welfare programs "on the outside," exacerbating the social immobility that often fosters criminal activity in the first place. Finally, in addition to threatening the dignity of all involved in retributive punishment, on a pragmatic level, scholars note that it simply does not deter crime. The massive scale of incarceration, particularly in poor communities where economic and social opportunities are already severely diminished, belies the social stigma of going to prison. Moreover, retributive punishment is counterproductive, since in the absence of rehabilitation wrongdoers are immersed in a culture more violent than that on the outside. If estimates that two-thirds of those currently incarcerated are nonviolent offenders are correct, then prisons only create more violent persons who bring a "lockdown consciousness" to their communities upon release, further preventing social mobility and increasing susceptibility to criminal activity. Recidivism statistics support this claim. For example, each year thirty-five thousand previously incarcerated Philadelphians reenter society; two-thirds of them will shortly be rearrested and fourteen thousand returned to jail.

Interrupting the Complex and Forgiving with the Arts

In an interview with *Philadelphia Inquirer* reporter Natalie Pompillo shortly before *Forgiveness* was to be dedicated in November 2007, Kevin Johnson's mother, Janice Jackson-Burke, acknowledged that her desire for retribution at times overwhelmed the more demanding commitment to forgiveness she had made on Kevin's behalf. Even after participating in the process of creating her son's mural memorial—meeting face-to-face with adjudicated youth and incarcerated adults to discuss how to visually capture the significance of Kevin's choice to forgive—she admits that she wanted others to hurt as she did. "Then I said, 'I'm just going backward,'" Janice told Pompillo. "If I don't forgive, I'll be lying. And if people thought I was lying, they might think Kevin was lying. Kevin wasn't lying."

As we will see in the following two chapters of this section, the arts are a way of birthing the liberating emotion and practices of forgiveness with the potential to drain the pipeline of the prison-industrial complex. Art offers new worlds for perpetrators and victims to explore, and after being in those worlds, they do not inhabit the "real world" in quite the same way. Murals created by prisoners and victims of violence, then, become public testimonials to the truth of forgiveness, places where we can learn of the power of forgiveness and be renewed in our commitment to it. Philadelphia's community murals invite us into worlds where we discover the importance of a faith that not only does justice but also imagines forgiveness in the context of the pain and suffering connected with the personal and structural violence of the prison-industrial complex. In so doing, they challenge the way the symbol of the ghetto functions in the public consciousness.

Restorative justice murals like *Forgiveness* and the process of their creation invite all of us to ponder theologian Roberto Goizueta's notion of forgiveness: a willingness to risk a new relationship. These images provide a talisman for forgiveness in the context of urban injustices and visually capture a relatively unexplored trajectory in Catholic theology and ethics regarding forgiveness. Forgiveness involves the imagination, integrates beauty and justice, and presents alternatives to retributive or even "degradative" approaches to criminal justice.

"Restorative justice relies on key elements of art—imagination, creativity, communication, the whole person—and thus is especially appropriate for an artistic process," explains Howard Zehr of restorative muralism in Philadelphia. "What we are doing here is finding ways for people to find gifts within themselves that they can build on. . . . We are going to break the cycle of violence by providing an experience of respect."

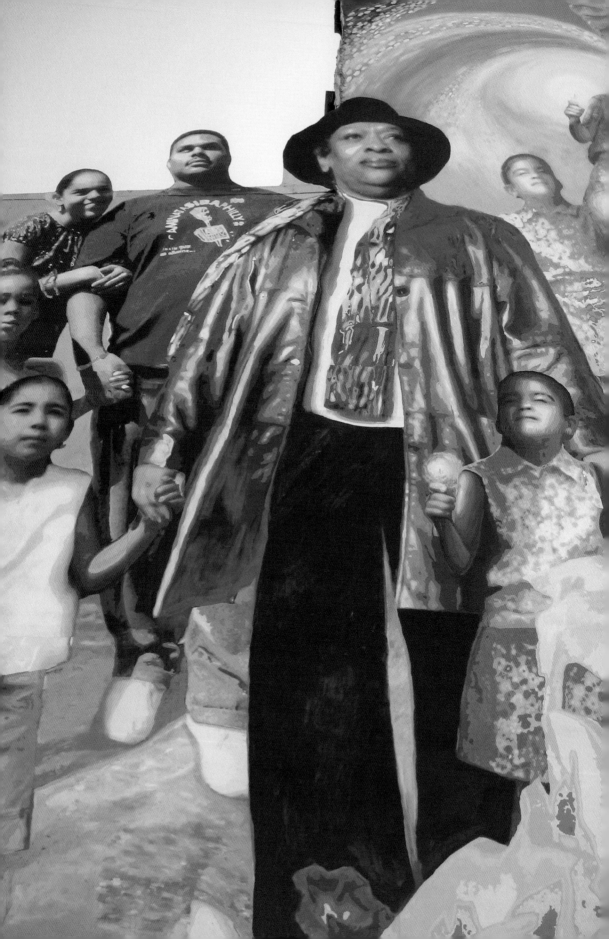

Chapter Ten

Forgiveness

The prison-industrial complex undermines the potential for forgiveness to interrupt the logic and practices of interpersonal violence cultivated by the code of the streets. It fails to interrogate the attitudes and practices of retribution that stem from our prevailing culture of whiteness. It fails to interrupt models of corrections for wrongdoers that serve only to make people more violent or wider cultural attitudes and irrational thinking about the causes of and responsibilities for urban crime. And, ultimately, it perpetuates a dangerously empty notion of forgiveness. So it is only with our faces turned toward the people whose humanity is diminished by the prison-industrial complex—like those who painted Kevin Johnson's mural—that we find new insights about Christian forgiveness that can rescue it from the retributive leanings of our contemporary culture. Incorporating elements of aesthetics into the process of forgiveness makes it possible for victims *and* wrongdoers to enter into this unfolding journey and to accompany each other along the way.

Elements of Kevin's mural provide visual clues to the elements of a meaningful forgiveness that can be the antidote to each of these codes and as such offer a viable alternative to degradative punishment. Kevin's empty wheelchair foregrounds a formal portrait of him that provides the mural's central image, giving the viewer a sense of what Goizueta calls a "wounded forgiveness" in which the hurt or violence is not forgotten but rather remains a focal point of future relationships. Kevin's forgiveness of his assailants, which happened from a wheelchair, remains a wounded forgiveness. Janice Jackson-Burke's anguished downward glance, her

Healing Walls—Victims' Wall: detail, Cesar Viveros-Herrera, 2004, © Philadelphia Mural Arts Program.

resolutely crossed arms, and her anxiously intertwined fingers visually capture the physical and emotional trauma she continues to experience. She is a living memory who calls to mind that forgiveness stands in the conflicted space between past and future. Disembodied hands reach out for a young man who stands with his back to Kevin but whose profiled face looks over the shoulder of a silken jacket decorated with dice. This image, evoking Rembrandt's famous sketches of the Prodigal Son, suggests that forgiveness involves welcoming back into the community those who have gambled with the lifeblood of that community—their very selves—and helping them make meaning out of their actions. A series of mosaic doves in white and glass tiles spiraling from Kevin's nose and mouth, perhaps symbolic of his breath, and flying over the walls of the prison, painted on the left side of the mural, evoke the kind of freedom that forgiveness might offer those struggling under the weight of being unable to forgive or being unforgiven. Finally, the mural's location on a halfway house for female ex-offenders surfaces the collective responsibility of society at large to truly accept their status as *former* offenders so that their criminal past might not determine their future.

Reimagining the Aesthetic Dimension of Forgiveness

The mural-making process interrupts the irrational and reactive logic that sustains the prison-industrial complex, whether the logic of the code of the street that demands revenge or "respect" through acts of aggression, or the logic of victims that exacts retribution or punitive punishment, or the logic of the market that fuels incarceration rates to boost profit margins. It does so simply by creating something new in the context of violent crime where nothing new seems possible. As biblical accounts of forgiveness indicate, this creativity is the essence of forgiveness. In fact, Christopher Marshall calls forgiveness a "*creative* act of love" that is not merely a reaction to an event in the past but a way of acting "anew" with an eye on the future. As he puts it, "forgiveness is a response to pain that does not merely *re-act*, but *acts anew*." Such a creative act imbues forgiveness with an aesthetic dimension that is evident in restorative justice murals.

Forgiveness that "acts anew" requires that we seek different or unfamiliar perspectives on the all-too-familiar circumstances of urban violence or of persons we presume to know by virtue of their status as perpetrator or victim in order to avoid equally familiar and predictable conclusions or judgments. Often the possibility of fresh perspectives is an objective of artistic expression: to offer the artist's point of view and

then evoke the multiple perspectives of viewers. Art becomes indispensible to forgiveness if we consider John DeGruchy's claim that one of its primary purposes is to create the "possibility of changing our perception and ultimately our lives." To that end, the imagination is particularly helpful in the context of resisting retributive justice insofar as it offers what Phillip Keane calls "playful suspension of judgment" that helps us make meaning out of the various fragments of our lives.

Because Philadelphia's murals are painted by communities and persons on the margins—neighborhoods dealing with drug addiction in North Philadelphia, truant students in the Philadelphia school system, lifetime inmates in Graterford Prison, or ex-offenders—they incorporate the perspectives of people who see and imagine the world quite differently. "The rowhomes in the mural's design provided a significant 'wow' factor with the neighbors," explained Eric Okdeh, lead muralist for *Restoration* (2008), painted by young adults in one of Philadelphia's after-school centers and by lifetime inmates in Graterford Prison. "People simply could not believe how well they were painted, and it really shocks them to learn that the work was painted by men, more specifically men serving life terms, in my prison class. With every mural, I find that 'reveal' to be a very significant moment of a project. It opens peoples' eyes, and causes them to think about exactly who these people are behind prison walls."

While creative forgiveness can never deny memories of the past, it slips the chokehold of the past that often drags preexisting social conditions into the future. Forgiveness leans into the mystery of the future and resiliently refuses to accept that new stories, new pathways, new relationships, and new beginnings are not possible. As a spiritual disposition that seeks a different future, forgiveness is an antidote to the desperation of the code of the street and the collateral damage of mass incarceration where the past bleeds into the present and day-to-day survival asphyxiates the future. In fact, muralism resuscitates the distinctive collective and corporeal spirituality inherent in the African American worldview that suggests that life, in the midst of the most horrific oppression and suffering, is worth living. Three particular aspects of aesthetics come to mind—the five senses, emotions, and imagination—and encounters with beauty or the arts can heighten their role in cultivating authentic experiences of forgiveness.

An Embodied and Tactile Forgiveness

Since it examines sense perceptions, aesthetics calls our attention to the often-overlooked tactile dimensions of forgiveness. Emphasis on

sight, touch, smell, taste, sound—particularly when it comes to giving voice to pain, being open to forgiveness, and establishing fellow-feeling in experiences of suffering—help to shift forgiveness from a logical righting of the scales of justice calculated with the rational intellect toward an arduous emotional odyssey that moves into and through pain and guilt with the heart and even the gut. Seeing the lines of loss or anger or guilt in another's countenance, hearing the tenor of hurt or regret in their voice, feeling the lead weight of loss or the flutter of fear in one's stomach, tasting the bile of grief or acid of adrenaline on the tongue—each of these are important tactile touchstones for acknowledging wrong that has been done. They make us present to pain and establish a meaningful empathy that might resist the temptation to deny the self and push the other away in despair, anger, or self-hatred.

Emphasis on human senses also reminds us that the most compelling examples of forgiveness throughout human history have been embodied, physical encounters among persons that seem to incarnate the difficult steps of forgiveness.

Goizueta suggests that we not underestimate the particularly fleshy elements of Jesus' forgiveness in his postresurrection visits with the disciples, the ultimate act of forgiveness in the Christian tradition. "Put your fingers here," he says to the doubtful Thomas, "and believe." That Christ lovingly invites the disciples to probe physically the bodily wounds of his torture and execution by the state—his hands, his feet, his side—and to hear in his voice and see in his face the emotional scars of their abandonment is what makes the gift of his forgiveness so generous, so cathartic, and so liberating. And once they relinquish their fear of this intimate face-to-face encounter, a fear that drove them to lock themselves away from Christ, and indeed the world, the disciples taste again the flavors of the last meal they shared before his death. They reconstitute the communion that will sustain them for the ministry that lies ahead. Goizueta suggests that the vulnerability in the wounded resurrection encounters—on the part of Christ who "refuses to cease suffering" by allowing his wounds to be probed and on the part of the disciples who turn to face Christ and tactilely acknowledge their guilt and shame—creates a radically new relationship between Christ and each one of them as well as among the disciples themselves. This relationship is steeped in a forgiveness that denies neither the physical

Healing Walls—Victims' Wall, Cesar Viveros-Herrera, 2004, © Philadelphia Mural Arts Program.

and emotional pain of the past nor the possibility of a future in light of this past.

Janice Jackson-Burke and the young man who took her son from her embody this wounded forgiveness. In fact, the prominence of Kevin's wheelchair is a visual reminder of a forgiveness that refuses to ignore the irrevocable pain one has caused. "Janice was killing herself with grief," said Eric Okdeh, the lead muralist for *Forgiveness*. "By letting go of it," through meeting with boys at St. Gabriel's Hall and men at Graterford and attending all the community painting days connected to her son's mural, "she was able to move forward. Muralism gives them [victims and perpetrators] purpose. It is not so much about the painting but the people."

Often, encounters with beauty or artistic expression serve as a conduit for these tactile encounters with the self and others wounded by violence or wrongdoing. It induces physical sensations such as quieted breath or quickened heart rate. It evokes vocalized gasps of astonishment, murmurs of awe, or a reverent stillness of bodies otherwise in constant motion. It sharpens our hearing, tuning us into subtle harmonies

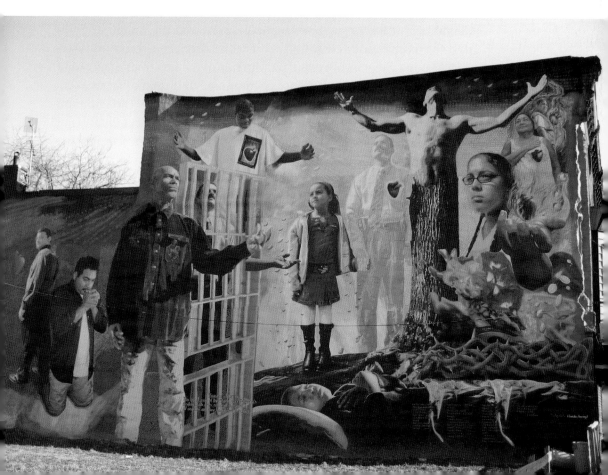

or intentional dissonances. In addition to emotionally moving us, the arts at times literally move our bodies by compelling a bodily participatory response, whether moving the body in time with rhythms or lending one's voice to the melody or straining to better hear a story being told or poem being recited. Frequently these corporeal movements are also collective—we do them with others and foster community, if only briefly. In these ways the arts or encounters with beauty circumvent the circular mental logic of revenge or retribution or of what Goizueta calls the "unbearable burdens of injustice" imposed on us. Instead, the arts enable forgiveness to pierce the physical and emotional boundaries we put up to protect ourselves from intensely penetrating experiences in order to more squarely face these things.

To that extent art mirrors the kind of participatory forgiveness that Goizueta says Christ invited his disciples to: the liberating and empowering graces of forgiveness come not to those who passively await forgiveness but rather to those who take the risk to seek it out actively with hands, eyes, and ears. And it is precisely this physical and emotional vulnerability that can release both victims and wrongdoers from cultural expectations of revenge, retribution, or unforgiveness.

Forgiveness and the Imagination

That literature is replete with examples of this embodied and lamenting forgiveness suggests that we often need the imagination to make it credible, not to mention achievable. Artist and community activist Maxine Greene suggests that "the role of the imagination is not to resolve, not to point the way, not to improve," but rather "to awaken, disclose the ordinarily unseen, unheard, and unexpected." Imagination awakens us to several often unseen, unheard, and unexpected facets of forgiveness. In order to resist a reactive logic, forgiveness requires the distinctively human capability for imagination or the ability to transcend the physical and emotional confines of the self, often with another person or situation serving as a muse, in order to contemplate something radically different. Persons involved in crime need to move beyond the roles they often assume for the sake of self-protection and self-preservation in order to become vulnerable enough to encounter the emotions, stories, and desires of others. They need to imagine a stranger's devastating loss rather than simply deny wrongdoing or a perpetrator's sense of self-consuming guilt rather than their own pain. They need to imagine the socioeconomic conditions of violence rather than the isolated event to which they are connected or the complex web of relationality that forever binds perpetrators and victims. These kinds of imaginative acts

are not an escapist form of denial. Imagination actually deepens one's emotional responses to crime and in so doing makes a fellowship of sufferings that can unlock chains of mutual bondage created by wrongdoing by imagining together new ways forward. Janice Jackson-Burke practiced this kind of imagination when she deepened her own pain by becoming vulnerable enough to accompany men and boys at Graterford Prison in painting a tribute to her son's acts of forgiveness. The arduousness of this journey is captured in her solemn image in *Forgiveness*.

Certainly, the imagination is necessary to establish fellow-feeling in the context of suffering when the pain these persons experience seems to seep from such different wounds. Incorporating the imagination into the deliberate processes of forgiveness can shift the relationships it seeks to cultivate—with the self, with others, and with the larger community—away from paralyzing preoccupation with personally sinful pasts or wrongs against us that preclude fellow-feeling in suffering. It can move us toward proactive commitments to creating something new and in which both parties have a stake. International peace activist John Paul Lederach sees "the capacity to give birth to something new" as the linchpin for meaningful healing and reconciliation because it can release persons from the static cycle of unforgiveness that keeps them from seeing situations and others with new eyes. This capacity depends in Lederach's estimation on the moral imagination through which we transcend the binary frameworks we often use to make sense of reality in order to acknowledge the web of relationships in which we are connected to all persons, even those we have hurt or those who have hurt us.

Artist and theologian Deborah Haynes insists that the imagination is a kind of "inventive power" or activity that cultivates activities that are essential to our life in community. This is particularly true for communities broken by violence or conflict. Imagination makes self-expression and engagement with others who are different from us possible. It breaks open lockdown mentalities with creative agency or freedom. It provides a way to enter into the complexity of crime and violence while not losing sight of the persons immediately affected by these things. Imagination imbues an emotional flexibility that enables us to lean in to our pain and the pain of others, making us more humane.

Finally, beauty offers a profound way to encounter the mystery of God in the midst of the suffering of violence. In his 1999 Letter to Artists, John Paul II commends their participation in several of the central mysteries of the faith, most notably redemption that brings wholeness and healing to relationships of alienation and pain. By exposing the hurt and the hope of our woundedness, the arts make us attentive to the

presence of a God who risked the same hurt and hope when he invited physical wounds to be poked and prodded.

Affective Dimensions of Forgiveness

The spectacularly provocative images in the murals unequivocally communicate to us that forgiveness is first and foremost a deep desire for something radically new, even if that desire seems futile, given insurmountable challenges and the complexity of these problems. Moreover, the creative process of muralism fosters the often-overlooked but absolutely essential emotional components of human reason and relationality that enable us to enter more fully into various dimensions of wrongdoing and forgiveness and, ultimately, to resist the potentially diminishing or degradative dynamics of wrongdoing and disingenuous forgiveness. The evocative energy of the murals—experienced by those who create them and those who encounter them unexpectedly in the streets—reveals that forgiveness is not an intellectual and episodic venture between consenting parties but an emotional, embodied, colorful, tactile, sensory process of creation that unfolds as people come together in the creative process and continues to unfold long after their work is complete. Therefore, it not simply is about the head but also involves the heart.

The integration of head and heart is obvious if we consider that the central question that the murals pose to those who paint and encounter them is not, What do you *think* about a particular image or the vision to which it points? but, rather, How does this image and its vision make you *feel*? When we stand before this wall-sized art, we are invited to explore our deepest values and emotions—the somewhat unpredictable aspect of our capacity to reason. Tapping into this depth of feeling opens us to desires, longings, laments, disappointments, and excitements, or what Denise Breton and Stephen Lehman identify as "the rich resources we possess to create a meaningful life" that are essential for resisting the diminishing facets of wrongdoing or the interior and interpersonal dynamics that continue to deny the essence of personhood. These emotions often bring a cathartic liberation to all persons impacted by violent crime: perpetrators who must be released from the bondage of their guilt and victims who need to be released from the bondage of their hurt. This helps to resist or even reverse the "diminishing" impact of wrongdoing by restoring a sense of agency, self-esteem, and frameworks of meaning.

"So much of what is troubling kids or what has traumatized kids gets locked in and creates a bubbling cauldron of toxic energy," explains Brother Henderson of St. Gabriel's Hall, a temporary home for

many of Philadelphia's juvenile muralists. "Many kids have a difficult time communicating through words but art does seem to give them a way to get this out. Given the chance to explain what they have done through art is essential. When you paint a picture of a story, that story can be shared and that is the first step in healing. In sharing comes the first step to being healed or reconciled enough that you can recapture a future horizon for your life."

Community murals evoke aspects of our humanity normally dismissed in public policy debates, urban development, and especially in the criminal justice system. They defiantly remind us what human beings are capable of and inspire in us an irresistible desire to make that capability a reality. As such, murals provide important physical and emotional space for people to understand themselves and others better. Eric Okdeh understands his primary role in restorative justice murals as making space for people to engage one another as they paint. "It's the job of the artist to engage people even in conversation," he explains. "I like bringing people together. It's an eye-opening experience. It's always under the guise of painting or poetry, but it can segue into people getting into their past actions."

Greg Ensanian, the director of the Mitchell Program, one of Philadelphia's residential programs for adjudicated youth, notes that mural making gives adjudicated youth a "sanctuary" where they can step out of the explosive context of the code of the street and experience a kind of liberation from the weighty cultural expectations that come with it. "Art allows kids to be kids," he observes. "It is a social thing and an innate thing. Play is so important and you need to know what it feels like to be a kid. Art can help with that."

For example, Amelia Crawford, a muralist involved in the *Forgiveness* project who herself discovered recovery through art while in a Philadelphia county jail, taught muralism to incarcerated persons and adjudicated youth, working with them to create beauty for their facilities and for communities around the city. At the time of our interview, she not only said that her work as an artist in prison "keeps her out of prison" but noticed a similar positive impact that mural painting has on her youngest students. "I tell my students, for two hours you are not an inmate, you are an artist. You can't mess up. Everything you do is right." Adding affective creativity into the rehabilitation process shifts the emphasis from merely taking responsibility for what one has done in the past and expands that responsibility toward a more constructive focus on what it is one hopes to be, what one hopes to contribute to the community in the future.

Forgiveness for the Social Sin of Whiteness

Murals in the "world's largest outdoor public gallery" cannot be separated from their particular contexts—in prisons, detention centers, family court, and neighborhoods—in one of the nation's most violent cities. The fantastic images on walls throughout the city raise awareness of the structural causes for broken social relationships and, like the wounded but resurrected body of Christ, they become a visual way of probing the various collective wounds we inflict on people in our extended communities. In so doing, muralism facilitates what L. Gregory Jones identifies as the hard work of forgiveness, namely, to unlearn sinful habits via attention to "the painful and affirming truth about ourselves" and to see what Breton and Lehman call the bigger picture "that considers persons in webs of relationships that go back for generations." The sins of white privilege make up the foreground of that collective self-portrait. Through encounters with murals and the process of mural making, we might interrogate the social sin of whiteness and creatively atone for it.

Peter Henriot defines social sin in terms of systems or structures that dehumanize or oppress others, situations that promote egotistical

self-interest, or apathetic responses to unjust suffering. As we examined in the third chapter, the practices of the code of whiteness fit each of these categories. Encounters with inner-city murals and the neighbors who paint them make plain the social sin of whiteness. For example, amazement at the beauty of this art illuminates an assumption on the part of many white suburbanites who take tours of the murals that poor people of color are not capable of such artistic expression. This stereotype denies the full humanity of people of color and, in turn, justifies the oppressive systems, such as the prison-industrial complex, that disproportionately affect them. Impromptu conversations with neighbors about murals in their communities illuminate as unfounded the fear of others espoused by white culture. It is this fear that fuels an isolating egocentrism and cultivates voluntary segregation. Both fuel the prison-industrial complex. The success stories of those involved in mural making while incarcerated or upon release reveal that the self-perpetuating logic of retributive justice is an irrationally apathetic response to violent crime. This is but one of the affective contributors to the impasses of the prison-industrial complex.

And yet, as we saw in the previous section, just as muralism offers a way into and through the impasses of concentrated poverty, so too does it provide a viable means of seeking collective forgiveness for the social sin of whiteness. First, by offering alternative perspectives on crime, punishment, and forgiveness, murals challenge the cultural default of whiteness that we identified in the previous section as one of the affective causes and symptoms of concentrated poverty. Murals such as *My Life My Destiny* (Cesar Viveros-Herrera, 2005), painted by men at Graterford Prison and boys at St. Gabriel's Hall depicting the various choices and influences in young people's lives, can "decenter" whites by pulling them out of the role of interpreting the piece and putting them in the vulnerable position of being interpreted by it. In this way, what passersby discover about themselves becomes just as illuminating as what they learn about the people who create the piece in the first place: the ignorance about incarceration, their own stereotypes of perpetrators and offenders, the privilege of assuming that justice is color-blind. The arresting beauty of the murals creates a dialogue "where one can learn from the artist and the work, where we allow the work of the art to speak to us and to direct our attention to dimensions of the world that we may

Healing Walls—Victims' Wall: detail, Cesar Viveros-Herrera, 2004, © Philadelphia Mural Arts Program.

never see." "We need to remember that this is how God sees them," Viveros-Herrera explains of the images of these young people. "The innocence of their faces should remind us that more kids like them could get lost along the way if we don't do something about it as a community."

Simply put, murals renew the capability of neighborly love among persons whose ability has been unknowingly compromised by the cultural values and practices of whiteness. It is no coincidence that muralism in Philadelphia, the City of Brotherly Love, makes *philia*, or the deep abiding love of friendship, possible. This expression of human love that the murals convey unabashedly proclaims, "You, your stories, and your visions matter to me, and I want my stories and my visions to matter to you." Because they are painted in public spaces, murals facilitate the struggle to acknowledge others' woundedness and, with their help, to acknowledge our own woundedness. It is this struggle that can free whites from the stranglehold of the dominant culture's preoccupation with denying mortality and all the self- and other-denying dispositions and practices that come with it. If whiteness and racism share a similar root in white denial of self-love, evidenced, according to Mary Elizabeth Hobgood, by whites' wariness of emotional and physical intimacy, bodiliness, and bodily needs, mural making resists this by making it possible to love the self again, and to love the self with stories of complicity and resistance, and visions of a future. Murals make it possible to make pilgrimages into neighborhoods where whites would otherwise never go; they make conversation among people possible; they teach new histories and recollect new memories. They liberate white culture from its denial of the self.

The Art of Forgiveness

In a short essay penned for the *Philadelphia Social Innovations Journal*, Jane Golden notes that in her more than twenty-five years of painting murals with the citizens of Philadelphia, "I have observed men, women, and young people who cycle through our courts, detention centers, and prison system as though this was how their lives were always destined to be—a world in which crime is the looming constant and opportunity a scarce and coveted resource." In addition to the important work of envisioning alternative futures for these folks, she notes that MAP has also worked to challenge wider metropolitan "assumptions about the creative abilities, capacity for good, and desire to do well among incarcerated individuals, observing how awe-inspiring acts of forgiveness can help mend the wounds of victims and their families, and how

cooperative art projects that engage inmates and ex-offenders with their former and future communities are among the most effective tools available to us in the fight against recidivism."

Robyn Buseman, who directs the restorative justice initiatives at MAP, explains it well. She says that projects such as *From Behind the Mask* or *Forgiveness* "ultimately provided a space where everyone, on both sides, could talk about restoring and healing their community. . . . The community and offenders can't exist in a vacuum; they have to understand each other."

We conclude this section with a look at muralism as an endeavor toward mutual understanding.

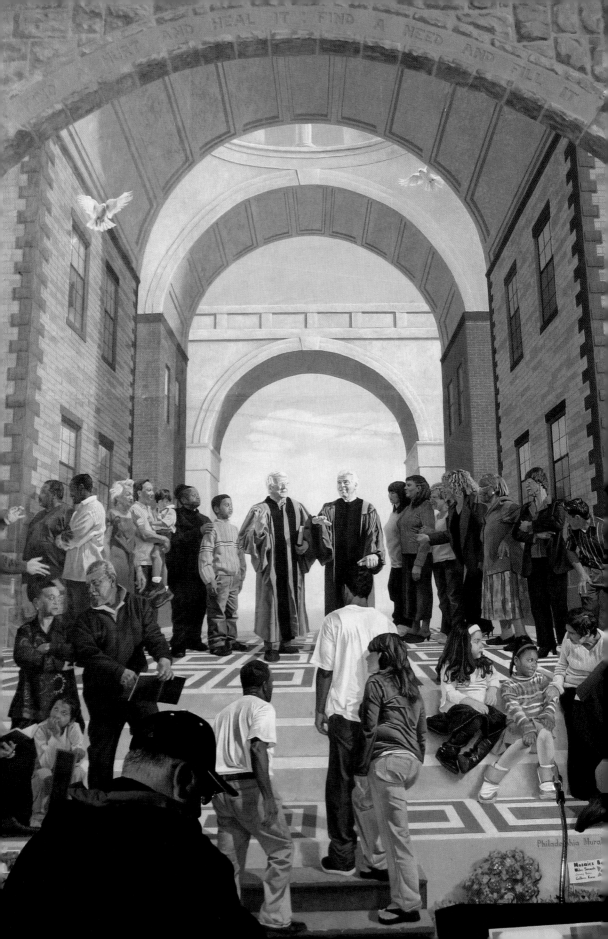

Chapter Eleven

Restoration

"Why did I have to get in trouble to get art?" Amelia Crawford provocatively asks over a cup of coffee in a café, ironically located across the street from the former Eastern State Penitentiary, one of the oldest prisons in America.

Crawford is one of three hundred thousand Philadelphians with a criminal record, the vast majority of whom struggle to find networks of support and meaningful employment. But because she "got" art through the MAP while serving her sentence in a Philadelphia jail, Crawford once made sure that adjudicated youth and incarcerated women get it too [in her position as a fully employed muralist in the MAP's Restorative Justice Program]. She is literally a poster child for MAP's initiative to reintegrate ex-offenders into communities they once harmed. She not only helped to design and paint *The Open Door* (Jonathan Laidacker, 2008; see p. 165), MAP's first mural that explicitly addresses the issue of prisoner reentry, but she is also featured at the center of it, walking up a set of stairs and toward the preachers of the Church of Philadelphia on whose wall the mural is painted.

"I think going into jails [to make murals] keeps me out of them," Crawford acknowledges of her work "on the inside." "It's the best therapy for me."

And yet she experiences a mixture of relief and frustration at seeing familiar faces in the places where she works. "I was relieved to see they were alive," she recalls of seeing twelve women with whom she once served time, "but angry to see that they are still in there or haven't found a goal and followed through."

The Open Door, Jonathan Laidacker, 2008, © Philadelphia Mural Arts Program.

In a way that echoes Crawford's initial question, Jane Golden chided those who gathered for the dedication of *The Open Door* in October 2008—congregants, representatives from the City's Department of Corrections, and neighbors—for our collective failure to keep people out of prisons: "Shame on us that something like art is denied to so many people."

In the last chapter, we examined how muralism fosters a more expansive way of thinking about forgiveness. In the final chapter of this section, we will think through the communal or collective demands of forgiveness in order to explore ways in which the arts can help us to move from retributive to restorative justice for folks like those twelve women Crawford encountered, dismantling the prison pipeline by healing broken persons and communities. *The Open Door*, the first mural in Philadelphia to call attention to the community's responsibility to welcome ex-offenders home, is ideal for this exploration. Painted by ex-offenders and the congregants of the Church of Philadelphia in South Philadelphia, the mural reflects what founding pastor Carmine DiBaise, "Pastor Dee" as he is affectionately known, sees as the next step for a faith community with a fifty-year history of active commitments to racial integration in South Philadelphia. "We want this community to know that we represent an open door," said Pastor Dee, "because church doors aren't always open."

"When people are incarcerated, it is our mission, our hope, and our charge that we restore those community ties or that we create them," said Philadelphia Prison Commissioner Louis Giorla at the dedication. "We have to take the initiative to reestablish lives and relationships that have been broken when people come into our custody. This is not just about painting murals but all of us grappling with issues like violence, crime, race, and gentrification."

From a Retributive "Eye for an Eye" to a Restorative Eye for Community

An economy bolstered by incarceration is one that also bolsters social impoverishment, not only for poor neighborhoods, but also for the wider public. The prison-industrial complex decimates the social infrastructure and social capital of inner-city neighborhoods, already marginalized by concentrated poverty. It also perpetuates fear-driven and racially biased dispositions and practices in the wider metropolitan community that preclude the *philia* or fellow-feeling needed for a vibrant common good that can interrupt the prison pipeline.

A retributive approach to criminal justice interrupts education and employment prospects. Degradative punishment in prisons calcifies a

"lockdown" consciousness on the inside that works in tandem with the code of the street on the outside, fostering dispositions and activities that contribute to incarceration in the first place. Moreover, Michelle Alexander speaks of the "invisible punishment" that comes with imprisonment and impacts ex-offenders far more dramatically than anything they endure on the inside: "Young black men today may be just as likely to suffer discrimination in employment, housing, public benefits, and jury service as a black man in the Jim Crow era—discrimination that is perfectly legal because it is based on one's criminal record," she notes. This invisible punishment all but guarantees that ex-offenders will return to prison and remain caught in what she calls a "closed circuit of perpetual marginality."

Retributive justice also impacts families, who make up the primary category in what theological ethicist James Logan identifies as the "invisible collateral damage" of the prison-industrial complex. Incarceration fuels financial and relational instability, given interruptions in employment and separation of families. Given the correlation between single-parent families and susceptibility to poverty, incarceration puts the 1.5 million American children under the age of eighteen with an incarcerated parent at risk of further socioeconomic isolation. Researchers also note that an imprisoned parent is a contributing factor to disruptive emotional and behavioral problems that make these young people susceptible to criminality themselves.

The "closed circuit of perpetual marginality" of retributive justice ensures that urban neighborhoods will remain little more than the containment areas described by Loïc Wacquant, as discussed in chapter 2: racially segregated and heavily policed reservations with few social services or networks of support—viable employment, rehabilitation centers, schools that are more than gateways to prisons, opportunities for social mobility— that keep people out of prisons or reintegrate them when they are released. And since it fosters vengeful retribution as a means of "managing" already vulnerable populations, the prison-industrial complex undermines social ties in the wider metropolitan community. Our willingness to convict people according to legal statutes that atomize crime and a penal code that explicitly rejects rehabilitation as a goal of punishment denies the inherent sociality of persons, prevents us from acknowledging the broader social causes for violent crime or drug abuse, and precludes a sense of responsibility for integrating ex-offenders back into our communities. That we are so willing to lockdown 2.2 million people in a way that diminishes the essence of what it means to be human calls into question the depth and authenticity of the fellow-feeling that supposedly binds those of us "on the outside" in our commitments to a good society. That our logic

of incarceration is so dominated by irrational fear and the bottom line of capitalism to the extent that we see no value in rehabilitating people who have been destroyed by the violence of poverty and racial bias points to a collective diminishment in our collective self-understanding.

Mennonite Howard Zehr, an early champion for a restorative approach to criminal justice, suggests that when we rely on the anonymous state to exact justice from perpetrators on behalf of victims, we deny meaningful encounters between these two groups. Victims serve as little more than "footnotes to the crime," and trials themselves focus on infractions of the law and not necessarily on the many relationships damaged or broken by crime or violence. The legal process assigns guilt that becomes a permanent feature of the wrongdoer's character and then attempts to restore the status quo by exacting punishment owed to an anonymous society. This undermines the accountability of wrongdoers, as well as the potential for forgiveness between them and their victims. The state's resources are spent on incarcerating the wrongdoer through dehumanizing practices rather than on programs to heal the victim or to correct the wrongdoer's moral character. These practices weaken

▶ Dedication ceremony for *The Open Door*, Jonathan Laidacker, 2008, © Philadelphia Mural Arts Program.

◀ Jonathan Laidacker painting *The Open Door*, 2008, © Philadelphia Mural Arts Program.

the self-worth, moral agency, and capability for fellow-feeling of both parties, and they reinforce wrongdoers' sense that violence is the only viable means of relating to others.

Perhaps most important, in seeking to restore the status quo, retributive justice also ironically fails to recognize the injustice inherent in that status quo, facets of life in the ghetto that the wider metropolitan community accepts as givens: inadequate educational resources or employment opportunities that strengthen the pull of an underground economy replete with illegal activity; whole communities of young people falling through the holes in the social safety net and drowning in the quicksand of gang life; a waning commitment to social welfare programs making the talismans of drug rehabilitation or reentry support increasingly elusive for those struggling against recidivism rates; racial profiling that erodes the social trust needed to maintain meaningful public safety.

Zehr suggests that restorative justice counters these facets of retribution with a commitment to resuscitating the capacity for relationship and putting people into relationship with each other. Orienting justice away from retribution toward respect is central to this task, as Zehr states in

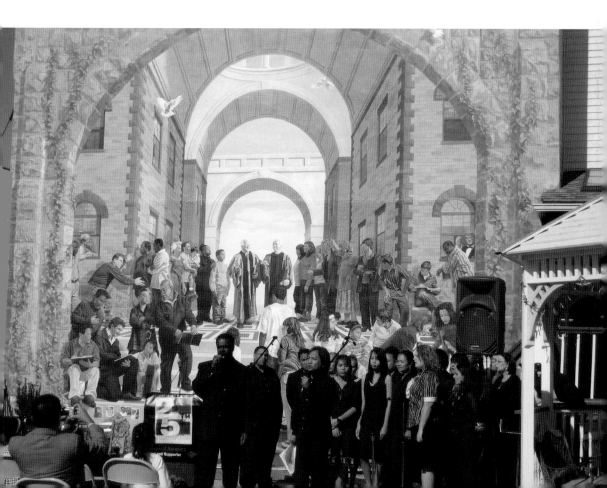

his *Little Book of Restorative Justice*: "respect for all, even those who are different from us, even those who seem to be our enemies." He notes that where retributive justice understands crime in terms of a violation of the state and laws, restorative justice sees crime as a "violation of people and relationships"; where the retributive approach determines justice via "blame" and "administers pain in a contest between the offender and the state," the restorative justice "involves the victim, the offender, and the community in a search for solutions which promote repair, reconciliation, and reassurances."

"If we think about restorative justice," said Golden at the dedication of *The Open Door*, noting that there were ten thousand people in custody in Philadelphia that day, "it is about forgiveness and about restoring self, community, and soul. And that's what art can do."

Restoring Those on "the Inside"

Since encounters with beauty are often experiences of grace, or God's gratuitous love, the beauty of the murals becomes a means of "reframing" justice with an eye for communion or for deeply abiding relationships with others. Collective creativity revitalizes a sense of communion that is destroyed by wrongdoing, by retributive justice, or by an overwhelming sense of complicity in social brokenness that paralyzes us. Rather than individualize the reality of crime, the murals call our attention to the "bigger picture" in which crime takes place—families traumatized by concentrated poverty, underdeveloped schools that keep children trapped in cycles of poverty, a prison system that does little to rehabilitate offenders, and a lack of both community support and viable options for those who return. In this way, murals provide an opportunity for people to begin to function as a community by naming these structural limitations, to entertain the ways in which they give rise to broken individuals who harm communities, and to begin to heal the wounds those crimes inflict.

"Paint a picture of a story and when that story can be told, that's the first step in healing," explains Brother Brian Henderson of St. Gabriel's Hall. "In sharing comes the first step to be healed or reconcile enough that you can recapture a future horizon for your life."

Telling stories through big pictures interrupts the cycle of carceral violence "on the inside" of prisons. Mural making in detention centers, jails, and prisons involves months of conversation and reflection before participants even pick up a paintbrush. This reminds us that authentic forgiveness begins with the often difficult, messy, and unpredictable pro-

cess of reestablishing relationships with self, others, and even the Divine that are severed by crime. Mural making puts forward a painstaking approach to forgiveness that entails a "complex process of 'unlocking'" criminals and their victims from the emotionally and physiologically damaging relationships of hostility and revenge that arise both from situations of personal violence, such as murder, as well as from structural violence, such as concentrated poverty. Encounters with people can create that kind of liberation. For example, Cesar Viveros-Herrera, the first muralist to work with inmates at Graterford Prison to paint a pair of *Healing Walls* (2004; see p. 151) that depict the inmates' and victims' respective journeys to healing, suggests that mural making can serve as the antidote to street violence: "Like coming to Mass or going to a block party, the more you connect with others the less you are willing to hurt another person." He suggests that in many ways, the beauty of the murals is the incidents of violence or crime that are avoided or do not occur because of the relationships that murals create within and among persons.

"I now see I can make a difference to someone and no longer be forgotten," reads a poem written by incarcerated muralists in Graterford Prison on an image of their permanent home in *Forgiveness*. "So I ask myself for forgiveness for thinking that I had no worth within Myself or to Anyone else."

Restoring Those "on the Outside"

In terms of healing communities "on the outside," community murals and the process that creates them refuse to separate individual crime from the larger context of broken communities and societies. They demand a collective commitment to forgiveness that focuses on repairing broken relationships on the social level and encourages the community to begin to take responsibility for crime, rather than leave it in the hands of "professionals" in the legal and criminal justice systems. Rehabilitation is something that communities need to take on for themselves, as well as for those who commit crime. "In our community, prisoners have a stigma," explains Pastor Rogers of Bible Way Baptist Church, home of *From Behind the Mask* (Eric Okdeh, 2009, see p. 5), a restorative justice mural that was considered in the first section of this book. "People think they are there for a reason and we should watch out. But we should not forget that they came from us and we want them to come home and stay home. Restorative justice is community righteousness."

The four sets of outward gazing eyes of *All Join Hands: The Visions of Peace* (Donald Gensler, 2006, see p. 106) on Benjamin Franklin High

School, designed and painted by students there and at St. Gabriel's as well as nearly one thousand other citizens around the city, provide the kind of reminder about which Pastor Rogers speaks. The eyes, nonverbally and piercingly, ask passersby what they are doing to curb youth violence in the city. Poetry written by students and stenciled throughout the three-hundred-foot mural calls our attention to the fact that these young people are a product of their families, of their neighborhoods, and of our collectively held social values; "I am from you, can't you see?" one poem provocatively asks.

"Muralism is calming," said Robyn Buseman who directs MAP's restorative justice initiatives, noting that on any given day in Philadelphia there are 120 young people between the ages of fourteen and eighteen in custody. "It gives them a chance to reflect more and think about what they're doing. Kids don't often stop and think. And then they go to an event out in the community for painting days and this creates a chance to challenge stereotypes and a level of interaction with different kinds of people."

This face-to-face interaction, as well as the public nature of the murals created by those in custody or on parole, can challenge the willful ignorance that most citizens invoke in a post–Civil Rights America that only recently elected a black president. As Alexander reports, there are more African Americans "under correctional control" than lived in bondage a decade before the Civil War. The evocative, reflective, complex, and critical images painted by prisoners and the self-effacing, inquisitive poetry written by adjudicated youth that accompany them challenge, if not flat out refute, the depictions of them in the media, in popular culture, and in political discourse that justify our collective denial of responsibility for them. Restorative murals invite those who create them and those who view them to move beyond fear of the other—the one someone has harmed, the true self behind the mask, the inmate or ex-offender—toward a willingness to hear stories, to share symbols, or to imagine new ways forward. The adjudicated youth who wrote a poem on the far right side of *Forgiveness* put it best: "To all whose lives are driven or constricted by fear, anxiety or panic, may you find peace and may that peace penetrate the entire world."

Restoring Broken Communities

"Healing [involves] things that bring us out of where we are into wholeness," explains Rev. Rogers. "We may not be capable of establishing a perfect system since our sense of justice is warped by 'What's in

it for me?' But making people feel welcome is one of those real needs. When we can get people to leave here taking Jesus Christ's words about letting their light shine seriously, that's real discipleship. In our world, how many churches are real salt?"

Restorative justice murals proclaim that the rehabilitation of people affected by violence depends as much on the commitment of the wider civil society to creating safe communities with economic, educational, and vocational opportunities as it does on incarcerated persons' individual commitments to personal responsibility, healing, and nonviolence. Furthermore, the process of their creation gradually instills within the wider public a sense that rehabilitation and forgiveness involve not only the successful reentry of ex-offenders back into society but also their reintegration into a wider community that itself needs to be rehabilitated.

"I really wish for the people behind the mural to be true to the appeal of the mural," explains Pastor Dee of *The Open Door*. "When I started the Church of Philadelphia, I wanted to open doors to all and I can't say it emphatically enough—we were the first and only church who were really integrated. Every church says they are integrated, but you don't always feel it in every church. This is automatically a church of love. But I want to press people to be so conscious of God's presence whenever we are together, that we don't know what might happen. We want to create an atmosphere so saturated with divine presence that they are healed. I want us to project that. This mural will be preaching forever."

Muralism unequivocally underscores that, when it involves the community, forgiveness entails restoration. It gives us a chance to be community in the midst of social problems and to rectify situations of social sin. Mural making opens up the possibility of offering support, expressing deep concerns and hurts, gaining a deeper understanding of the pains and hurts of others, and seeking healing through imaginative and embodied activities like painting together. The murals remind us that forgiveness is best understood as a radically social and public way of living together in the everyday routines of our daily lives, not something that we reserve for isolated interpersonal dealings or headline-grabbing events.

Opening Doors

How do we reintroduce restoration into the landscape of mass incarceration? Publicly exploring the harm that crime does—to the self, to others, to the community, and to the future—in severing the web of

human relationship provides an important starting point. So too can challenging the ignorance of Americans without criminal records when it comes to who is incarcerated, how they are treated in prisons, and the lives they can hope to lead upon release. Both of these steps require that we examine the brokenness within the web of human relationships that often sets the stage for further violations of those social bonds.

"I see more and more connections between Raphael's painting [*The School of Athens*] and what is going on here," said muralist Jonathan Laidaker of *The Open Door*. "The great philosophers were mentors and guides. Designing this from the ex-offenders' point of view, we realize that they look to the community and family members to act as guides or mentors to reinitiate themselves into the community. When crime happens we all lose. There is a cost to the taxpayer, a cost to public safety. But we lose one another. We lose part of our soul as a city. Crime eats away at the social fabric of our soul. And so painting this mural is not just a job but a moral imperative."

"We have to raise awareness of the way that we are dependent on and invest in the dehumanization of people and how to rehumanize prisoners as an unfavorable group of people," explained a Graterford inmate named Tom in one of the community meetings for *From Behind the Mask*. "How do we do this? We keep painting."

Bibliography

Introduction

Muralist Phoebe Zinman's short piece for the Mural Arts Program, *Visual Restoration* (Philadelphia, 2009), documents the history of its restorative justice initiatives through the voices of perpetrators and victims. Also telling is the documentary film codirected by Cindy Burstein and Tony Heriza called *Concrete, Steel and Paint* that explains the history and objectives of the city's first restorative justice murals, *Healing Walls* (Cesar Viveros-Herrera, 2004). Jane Golden writes an insightful essay on the history and contemporary trajectories of MAP's restorative justice initiatives for the *Philadelphia Social Innovations Journal*, "Mural Arts: A Solution to Healing and Restoring the People Who Go through the Criminal Justice System," http://www.philasocialinnovations.org/site/index.php?option=com_content&view=article&id=112:the-mural-arts-a-solution-to-healing-and-restoring-people-who-go-through-the-criminal-justice-system&catid=29:columns&Itemid=61. Natalie Pompillo's feature in *The Philadelphia Inquirer* about Kevin Johnson, "A Son's Legacy of Forgiveness," October 21, 2007, as well as an interview with lead muralist Eric Okdeh in April 2009 provided important background details.

Several interviews informed this section: muralist Eric Okdeh in April 2009; Brother Brian Henderson of St. Gabriel's Hall, September 18, 2008; Greg Ensanian of the Mitchell Program at St. Gabriel's Hall, September 23, 2008; muralist Amelia Crawford (name changed to protect her identity), September 22, 2008; muralist Cesar Viveros-Herrera, September 22, 2008; muralist Jonathan Laidacker, September 23, 2008; Pastor Carmine DiBaisi of The Church of Philadelphia, September 23, 2008; Robyn Buseman, director of the Restorative Justice Program at MAP, September 18, 2008; and muralists at the State Correctional Facility at Graterford, September 25, 2008.

Chapter Nine: The Complex

Several think tanks have examined the reality of mass incarceration. Most notable among them is the Pew Center on Study of the States,

"One in 100: Behind Bars in America," available at http://www
.pewcenteronthestates.org/; and "One in 3: The Long Reach of American
Corrections," available at http://www.pewcenteronthestates.org/
report_detail.aspx?id=33428.

Angela Y. Davis is a pioneer in naming mass incarceration as a "com-
plex." See "Race and Criminalization: Black Americans and the Prison
Industry," in *The Angela Y. Davis Reader*, ed. Joy James (Malden, MA:
Blackwell Press, 1998); and *Are Prisons Obsolete?* (New York: Seven
Stories Press, 2003). Marie Gottschalk, *The Prison and the Gallows: The
Politics of Mass Incarceration in America* (New York: Cambridge Uni-
versity Press, 2006), clearly maps the historical convergence of a va-
riety of factors that have given rise to the prison-industrial complex.
I also found Eric Schlosser's "The Prison-Industrial Complex" in the
December 1998 *The Atlantic Monthly* (http://www.theatlantic.com/
magazine/archive/1998/12/the-prison-industrial-complex/4669/)
helpful in naming its socio-political roots. Michelle Alexander argues
that mass incarceration is creating and containing an "undercaste"
of people of color in *The New Jim Crow: Mass Incarceration in an Age
of Colorblindness* (New York: The New Press, 2010). For a succinct but
thorough examination of the various effects of the prison-industrial
complex (physical and mental health, future employment, political
participation) on a variety of populations (women, children, people of
color, the urban poor) see a collection of essays edited by John P. May
and Khalid R. Pitts, ed., titled *Building Violence: How America's Rush to
Incarcerate Creates More Violence* (Thousand Oaks, CA: Sage Publications,
1999). David Hilfiker also examines mass incarceration in the context of
urban poverty in *Urban Injustice: How Ghettos Happen* (New York: Seven
Stories Press, 2003).

James Logan offers the definitive *theological examination* of the com-
plex in *Good Punishment: Christian Moral Practice and U.S. Imprisonment*
(Grand Rapids, MI: William B. Eerdmans Publishing Company, 2008).
See also Christopher D. Marshall's comprehensive overview of the
sources, strengths, and weaknesses of the retributive approach to justice
in contemporary Western societies in *Beyond Retribution: A New Testament
Vision for Justice, Crime, and Punishment* (Grand Rapids, MI: William B.
Eerdmans Publishing Company, 2001).

For *Philadelphia-specific statistics* regarding rates of crime and incar-
ceration, I turned to Pennsylvania data from the National Insti-

tute of Corrections, available at http://www.nicic.org/Features/
StateStats/?State=PAdrew, from a special 2007 series on "Violence"
by *The Philadelphia Inquirer*, accessible at http://www.philly.com/
inquirer/special/violence/. I also referred to Marcia Gelbert, "Housing
More Inmates at Holmesburg Prison is Explored," *The Philadelphia In-
quirer*, April 21, 2009, retrieved from http://www.philly.com/philly/
news/20090421_Housing_more_inmates_at_Holmesburg_Prison_is
_explored.html.

Chapter Ten: Forgiveness

Roberto Goizueta provides the central theme of forgiveness as a will-
ingness to risk a new relationship in "Reconciliation and the Refusal to
Cease Suffering" (New York: National Pastoral Life Center, 2006). See
also Kay Carmichael's *Sin and Forgiveness: New Responses in a Changing
World* (Hampshire, England: Ashgate, 2003); and L. Gregory Jones, *Em-
bodying Forgiveness: A Theological Analysis* (Grand Rapids, MI: William
B. Eerdmans Publishing Company, 1995). Geiko Müller-Fahrenholz's
The Art of Forgiveness: Theological Reflections on Healing and Reconciliation
(Geneva: World Council of Churches, 1997) explores the dimensions of
forgiveness from critical perspectives—that of perpetrators, that of vic-
tims, and that of the wider community. Also, I relied on Peter Henriot's
discussion of social sin ("Social Sin and Conversion," in *Introduction to
Christian Ethics: A Reader*, ed. Ronald P. Hamel and Kenneth R. Himes
[New York: Paulist Press, 1989], 123–35) to propose whiteness as a form
of social sin requiring a particular kind of forgiveness that aesthetic
encounter and engagement might facilitate.

Christopher D. Marshall's *Beyond Retribution: A New Testament Vision
for Justice, Crime, and Punishment* (Grand Rapids, MI: William B. Eerd-
mans Publishing Company, 2001) offered scriptural groundwork for
restorative justice, and John W. De Gruchy, *Christianity, Art and Social
Transformation: Theological Aesthetics in the Struggle for Justice* (Cambridge:
Cambridge University Press, 2001) provided generally the connection
between the art and social change informed my thinking about the
arts and the prison-industrial complex, as did John Paul II, Letter to
Artists (1999); retrieved from http://www.vatican.va/holy_father/
john_paul_ii/letters/documents/hf_jp-ii_let_23041999_artists_en.html.

In terms of roles of imagination and forgiveness, see Phillip Keane's
examination of the imagination in the various facets of social ethics in

Christian Ethics and Imagination: A Theological Inquiry (New York: Paulist Press, 1984); Maxine Greene's *Releasing the Imagination* (San Francisco: Jossey-Bass Publishers, 1995) on imagination and collective consciousness and community building. John Paul Lederach, *The Moral Imagination: The Art and Soul of Peacemaking* (New York: Oxford University Press, 2005), highlights the inherent relationality in the imagination, so essential for weaving back together relationships severed by violence.

Chapter Eleven: Restoration

I found statistics for prisoner reentry through Philadelphia Impact Services Corporation (http://www.impactservices.org/employment/reentry.php).

Previously cited works by Michelle Alexander, *The New Jim Crow*, particularly pages 137–72, and James Logan, *Good Punishment*, particularly pages 32–37 and 65–99, are prophetic in naming the destructive forces of contemporary incarceration on the incarcerated. My extensive quote from Alexander comes from page 175.

Writings by the "father of restorative justice," Howard Zehr, that continue to shape MAP's restorative justice initiatives include: *Changing Lenses: A New Focus for Crime and Justice* (Scottdale, PA: Herald Press, 1990), and *Little Book of Restorative Justice* (Beaverton, OR: Good Books, 2002). In addition to Christopher D. Marshall's *Beyond Retribution: A New Testament Vision for Justice, Crime, and Punishment* (Grand Rapids, MI: William B. Eerdmans Publishing Company, 2001), see also Denise Breton and Stephen Lehman, *The Mystic Heart of Justice: Restoring Wholeness in a Broken World* (West Chester, PA: Chrysalis Books, 2001).

Part Five

Beauty
Arts and the Body Politic

Born Again

On a chilly Saturday in late October, a group of undergraduate students and I climbed out of our university van in a Southwest Philadelphia neighborhood in order to visit *Born Again* (Cliff Eubanks, 2000), painted at the end of a long line of traditional Philadelphia row houses at the corner of Dickinson and Bouvier Streets. This fantastically colorful image features a woman with an upheld child who reached out to her. Both are silhouetted against a spectacular, African-inspired orange sky. The life of Christ, depicted as stained-glass windows from a Gothic cathedral, frames the scene. The nativity, crucifixion, and Mary are prominently featured, all with Afrocentric detail.

We exited the van with trepidation. After all, in preparation for our "pilgrimage" to Philadelphia that semester, I had explained that the muralist, Cliff Eubanks, had to hit the deck on the scaffolding while painting the piece back in 2000 when shots were fired somewhere in the neighborhood. Those bullets claimed the life of a child that day. A similar shootout occurred when Eubanks returned six years later to refurbish the piece. As we disembarked into the neighborhood, two young African American men were hanging out on the corner of a wooden fence in front of the mural. We were visibly nervous outsiders as we approached the image and acknowledged these guys.

After a quick nod in their direction, I launched into telling the story of the mural as I had learned it from Eubanks, aware that they were listening too. "Do you think that sun is setting or rising?" one of the two asked me, as I came to a pause in my script. Rising or setting? That question had never occurred to me.

"I always assumed it was a setting sun," I replied, somewhat taken aback by my assumptions, both about the image and the men on the

Born Again: detail, Cliff Eubanks, 2000, © Philadelphia Mural Arts Program.

street corner. "What do you think?" I replied, posing the question to everybody now looking closely at the background detail of *Born Again*.

What ensued was a classic exercise in visual hermeneutics, with different voices, in different dialects, with different perspectives chiming in with different responses. Although they had no direct connection to the mural, the two guys on the fence were our docents that afternoon, helping us to discover new meanings of the image that looms large in their neighborhood and to understand their reality with a bit more clarity.

Ironically, legend has it that Benjamin Franklin asked this same question about sunrises and sunsets after months of looking at a carving of the sun in the chair in which George Washington sat while overseeing the proceedings of the 1787 Constitutional Convention. Even in the bleakest and hottest of hours in Independence Hall, Franklin was confident that that sun represented a new day for those hammering out a new vision of the common good. In many ways, the poignancy of this question rings true for contemporary Philadelphians struggling with the personal and structural impact of concentrated poverty. The tragic irony that a child was killed as Eubanks tried to capture the hopeful vision of

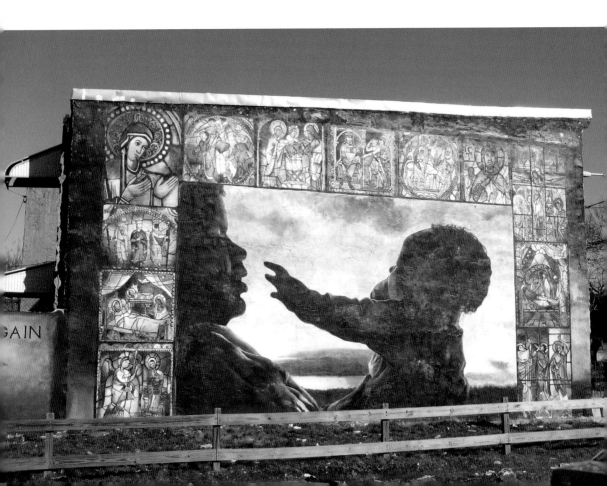

the women in the neighborhood who commissioned *Born Again* is not lost on him. "It is both a rising and a setting sun because the image is about death and rebirth. There is hope. There is a future. The child is much like the sunrise." Despite lengthening shadows, you hope for a rising sun.

For outsiders to this community, like my students and me, *Born Again* prophetically evokes a rising sun in this neighborhood—long dismissed by wider civil society as a haven for gang violence and a quagmire of chronic underemployment and addiction. The image announces the self-understanding of neighbors like those the students and I met on our pilgrimage in other forgotten neighborhoods around the city. The mural's symbols of love, family, and hope for the future—literally framed by the life and death of Jesus of Nazareth—serve as transformative symbols for anyone who encounters them. These symbols speak to those *in* this community whose experiences have not always been consonant with the spirit of this mural and yet who continue to resist a future that does not reflect a God of hope. It reminds the community that they are more than the dominant culture's estimation of them. It proclaims that their spirit cannot be trampled by generations of social, economic, and political marginalization. It recalls a God who knows their struggles as crucified peoples and whose resurrection kindles in them a stubborn hope.

Moreover, in an ironic twist of optimism, *Born Again* also prophetically reminds those *outside* of this neighborhood of the many structural injustices that impede the flourishing of this woman and child. The fact that the sun Eubanks painted may indeed be a setting one raises the specter of the dehumanizing effects of concentrated poverty and racism that dictate the social reality and relationships for many, like these two figures, struggling to survive in blighted and forgotten urban places. To that end, *Born Again* serves as a prophetic symbol of the role of perception in responding to the precariousness of life in inner-city communities. Whether the sun is rising or setting is not a rhetorical question.

Murals like *Born Again* illuminate how persons on the margins create and experience beauty and ways in which their understanding might link beauty more concretely with the common good, one of the central ideas in philosophical and theological traditions when it comes to living in right relationship with others. The creative intuition that muralism sparks can reconstitute the individual selves that ultimately constitute

Born Again, Cliff Eubanks, 2000, © Philadelphia Mural Arts Program.

our "body politic" or civil society. A healthy body politic is essential for a vibrant common good, particularly in contexts of urban poverty.

The French philosopher and theologian Jacques Maritain (1882–1973) was one of the first to articulate the Catholic approach to the body politic in the 1960s. By "body politic" he means the "organic fraternities and associations" where multidimensional selves come together to discern consciously and with reason how we ought to channel our inherent need for community in such a way that ultimately serves persons in their quest for both material goods and supernatural ends. Maritain's ideas became foundational for official church teaching on the relationship between the common good and democracy. "The common good," explains Christian ethicist David Hollenbach, "is not simply a means for attaining the private good of individuals; it is a value to be pursued for its own sake. This suggests that a key aspect of the common good can be described as *the good of being a community at all.*"

Interestingly, in addition to a passion for political philosophy, Maritain explored the role of the arts, particularly painting and poetry, in illuminating and cultivating "personality" and "individuality," the foundational components of his anthropology. Although Maritain himself did not connect the dots between his ideas on the arts and the common good, it is in his insights about "creative intuition" that we can begin to see the relationship between the arts and the body politic, or beauty and the common good. He notes in *The Person and the Common Good*, "When, against social pressures, the human person . . . fastens to the adamantive objectivity of beauty and truth, when it pays obeisance to God rather than to men, in these very acts it still serves the common good of the city and in an eminent fashion."

Exposure to beauty and participation in creating beautiful things is an overlooked aspect of the common good that should and can be retrieved. In this section we begin to understand the wisdom of Robin Jensen's claim that "art, after all, isn't something we merely do; it is the way we live and who we are." This artistic way of being is central for nourishing the body politic and ensuring that the sun continues to rise on communities struggling in the shadows of urban poverty. We will consider three things that muralism contributes to the body politic or the common good in metropolitan areas: lament, creative intuition, and an empowering common beauty.

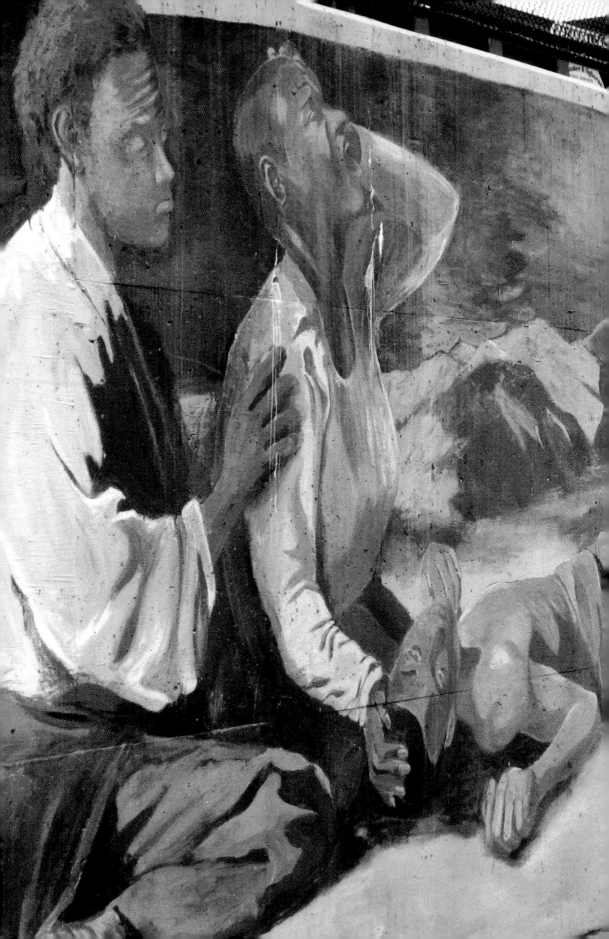

Chapter Twelve

Healing

The SEPTA bus terminal at Fifty-Fifth and Woodlawn in Southwest Philadelphia takes up most of the corner, and the surrounding sidewalk that abuts a containing wall sees quite a bit of foot traffic. It struck neighbor Sandy Spicer as an ideal place to create something to help her and her husband, Garnet, as well as a small but growing number of their neighbors, deal with their grief after the murders of their children on the streets surrounding the depot. After garnering neighborhood support, Spicer applied to the Mural Arts Program and soon she and members of an informal group she started, called "The Families Are Victims Too," were meeting regularly with Jewish muralist Barbara Smolen to design a mural that would be more than a living memorial to the dead but rather a space with images and messages that would serve the families left behind.

Smolen describes her meetings with the community as intense and emotionally draining, as family members shared stories of their deceased loved ones and what they needed in order to move forward. Neighbors rejected Smolen's initial designs because of their political overtones or for reducing their children to symbols rather than paying tribute to the lives they led and the resilience of their surviving families. So Smolen took a risk and allowed the mystery of the human spirit in the depths of suffering to be the muse for the piece, not knowing where this would take her or the community for whom she worked in the public process of painting the three-hundred-foot mural.

In order to respect the intimacy of their loved ones' losses, the dead only appear as fifteen small, black-and-white portraits strategically

The Families Are Victims Too: detail, Barbara Smolen, 1999, © Philadelphia Mural Arts Program.

placed among larger-than-life mourning angels and flowers, painted by children in one of MAP's after-school programs. The flowers' deep purples, reds, and oranges increase in lushness and intensity as one walks along the mural, capturing the progression "from sorrow to hope to a sense of serenity."

"It's not that life goes on and you pick up the pieces," explains Smolen of the progression of the colors. "The families' lives are forever changed. But it's more that their child's life and death have meaning. The color is vibrant and restorative and acknowledges this kind of intensity."

All are set against urban landscapes and charcoal-like renderings of people in anguish that evoke the drawings of twentieth-century German painter Käthe Kollwitz, who lost a son to World War I and a grandson to World War II. One of the central images is an urban pietà: a young person, covered in a red loin cloth, lies across the lap of a mother, whose upturned face is contorted in an anguished cry, as she is embraced by the child's father. An angel, with arms reached out to the slain person, gazes at the parents.

"The whole idea [of a pietà] was a little awkward for me," Smolen acknowledges. "Is it improper or sacrilegious to make a reference to the death of Christ and the death of a child in southwest Philadelphia?" she asked herself from the outset. But her intuition was affirmed by the countless interactions she had with passersby as she painted.

"One woman stopped me and said, 'That woman up there? That is the story of my life.'"

Precisely because the family members resisted politicizing their children's death and insisted instead on capturing the depth of their emotions, *The Families Are Victims Too* (1999; see p. 186) reveals to the wider community the kinds of dispositions and practices needed to resist the affective dimensions of poverty that can defeat the human spirit—the sense of meaninglessness, the endlessness of the present, fear that memories of people and events will be forgotten or that the grip of loss will never lessen. The mural publicly summons those who pass through that space, which has become sacred to the families of the victims, to risk tapping into depths of their own experiences of loss, to ponder their own vulnerability, to marvel at the resolve on the faces of the angels—one of them Sandy Spicer—and to commit more fully to family members who are alive. Doing so makes it possible to enter into solidarity with families for whom the mural has become a touchstone of moral agency that would otherwise go unnoticed by the wider community—accompanying family members to court appearances,

making funeral arrangements, maintaining a working relationship with the local police precinct, and gathering information for investigations. The mural simply reflects the resilience of a people whose lives have been forever changed.

The Arts and the Body Politic

So returning to Jacques Maritain's notion of the body politic, how does a mural like *The Families Are Victims Too* serve the common good? It all hinges on Maritain's understanding of the person and the way in which creative self-expression responds to the many threats to authentic personhood he identified. Writing in the middle of the twentieth century, in the post–World War II dawn of progress and prosperity and the growing darkness of the Cold War, he worried that the sun may have already begun to set on the global community in light of threats that both communism and democracy made to the person or "the self." Maritain felt strongly that both contexts fail to acknowledge the multidimensional aspects of the "self" that give rise to fully human lives, whether in terms of our abilities to achieve material ends, which he understood as the intrinsic good of civic living, or our capability to participate in what he called the "eternal good" or the spiritual goods connected with self-fulfillment. These overlooked elements of the self include the spiritual as well as the material, the emotional as well as the physical, the imaginative as well as the pragmatic, the fanciful as well as the rational, the relational as well as the autonomous. Without a deep appreciation for these facets of what it means to be human, persons can easily be valued according to either their contribution to the community or their level of freedom from it and perilously placed at the service of the state or the society or the economy.

Narrow understandings of the person, either as an instrumental part of the whole or as a self-sufficient individual set apart from the whole, also concerned Maritain, since both negatively impact civil society or "the body politic." Persons are at once the building blocks of society and its builders since, as he explains in *Man and the State*, "the people are the very substance, the living and free substance, of the body politic." Therefore, threats to the self also threaten the community. In an ideal society, "whole" persons, that is, persons who are able to achieve the material ends worthy of their individuality and the transcendent ends worthy of their personality, contribute to life in the larger "whole" of society. This "whole" society in turn contributes to the wholeness of the individuals who comprise it. So rather than thinking of community in

the more familiar terms of "parts of a whole," Maritain encourages a "wholes of a whole" strategy for building the body politic.

Ultimately, Maritain claims that unfettered progress and advancement that comes at the cost of the various dimensions of the self undermines the capability to ponder the common good, as well as the collective will to create it. We see evidence of his prediction in the context of urban poverty. Codes of the street and whiteness both deny personality or the capability for self-transcendence and relationality, and this in turn undermines the wholeness of individual persons who contribute to the larger whole of society. An overemphasis on individuality espoused by American democratic capitalism often ignores the social conditions that preclude persons from meeting the material needs that sustain their "individuality" and denies the failings of the "whole" of society in fostering the individuality and personality of the selves that comprise it.

So how does Maritain unknowingly address these concerns using beauty and the arts? To start, he closely examines increasing levels of self-awareness, intense subjectivity, or the "creative intuition" that artists often experience in the midst of the creative process. In *Creative Intuition*

he explains this intuition in terms of "the intercommunication between the inner being of things and the inner being of the human 'Self'" and suggests that our capability for such communication stems from our personality—our desire for knowledge of "what matters most in Things . . . and the secret significance on which they live." He highlights how artists in Western civilization have assisted humanity in advancing through various stages of heightened self-understanding: from the self as an object that triumphs over the natural world to the self as a relational subject grasped by the desire for relationship with something greater than ourselves, and even further to the self as a subject with the special capacity to cocreate with that being through distinctively human capabilities for suffering, memory, and imagination. This intercommunication of creative intuition effectively illuminates the often overlooked facets of human "personality" or "suprasubjectivity" so essential for personhood and, likewise, the body politic. By this he means the hints we receive that we are more than our physical bodies, that there is more to reality than that which we can tactilely experience, that we participate in something that is greater than ourselves and perhaps that we are most fully human when we do so.

These intuitions are particularly important for persons whose capacities for "suprasubjectity" have been compromised by the demands of day-to-day survival in the context of urban poverty. "When you paint a picture of a story," explains Brother Brian Henderson of St. Gabriel's Hall, "that story can be shared and in sharing comes the first step to [being] healed or reconciled enough that you can recapture a future horizon for your life."

Visible Laments

The Families Are Victims Too is different from many painted memorials in urban neighborhoods that commemorate the casualties of gang and drug wars with images and language that often glorify and validate the mores of the code of the street and ultimately protect citizens from the terrifying depth of human emotion—whether pain or hope. *The Families Are Victims Too* neither glorifies nor validates that way of life. It does not convey the rhetoric of optimism with political statements about guns or gangs or drugs, and it makes no appeal to an empty

The Families Are Victims Too: detail, Barbara Smolen, 1999, © Philadelphia Mural Arts Program.

sense of justice, either via a broken criminal justice system or distorted theology that only looks beyond this life to the next. Rather, the mural communicates the laments of family members left behind who forever live a tortured existence at the crossroads between life that goes on and death that never seems to end. *The Families Are Victims Too* is a visual lament that publicly expresses the devastation of neighbors who have lost family members to the violence of the streets.

What do I mean by lament and what civic purpose might it serve? Paul describes lament as the groaning of suffering people, "sometimes *too deep for words*" (Rom 8:23 and 26), for which the Spirit often intercedes. In Jewish and Christian sacred texts, laments are a communal spiritual practice that arises from simultaneous experiences of two disparate realities—one of suffering and the other of fulfillment. The depth of emotion they convey can only arise from stark experiences of being separated from God and an even stronger desire for reunion. Laments arise from people with a special capacity for God or whose socio-economic status renders them utterly dependent on God. Consider, for example, the groaning of the Israelites while enslaved in Egypt, the

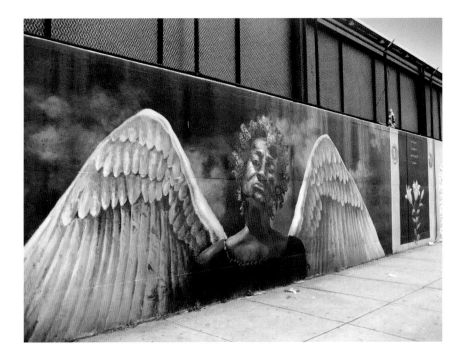

▲ *The Families Are Victims Too:* detail, Barbara Smolen, 1999, © Philadelphia Mural Arts Program. ▶

cries of the sick who called out to Jesus to be healed, or the wailing of the women of Jerusalem in the passion narratives. The depth of these persons' pain stems from an acute sense that it need not be, and their laments are public demands that their circumstances be changed.

To that extent, laments are public expressions of profound faith, prophetic in context and content. Theologian Bradford Hinze notes that laments ferment in contexts of "conflict between powers intent on destruction and desires and aspirations intent on the fullness of life and relationships that yield love and reconciliation in truth." Because they call attention to the stark contrast between the way things are and the way things could or should be, laments name a people's "unfulfilled aspirations" and prophetically refuse to let dreams of the future be extinguished. It is also important to note that we direct laments not only to God but also to others. They summon the wider community to take seriously the suffering of the present and to long actively for the future. Lamenting, therefore, is an important form of moral agency, particularly for people who have been oppressed or dehumanized by circumstances of injustice.

The arts offer a way of cultivating this capability that is underused in a culture that prefers intellect rather than emotion, reasonable discourse rather than impassioned action, logic rather than fantasy, deductive rather than inductive reasoning, and objectivity rather than subjectivity.

Laments help us to move beyond the many impasses of urban poverty discussed in previous chapters. Laments urgently interrupt our complacency with the status quo with the passionate demand of others who simply refuse to allow their sufferings to be ignored. Through their jaggedly raw expression of pain, they twist the heart in order to wring from it a kind of empathy that might develop into compassion. "Compassion and lament move me to risky speech and increasingly bold actions that seek to redress the evils that so shock and offend me," explains Bryan Massingale in his essay on impasses and social justice. "Compassion gives rise to a passion for justice."

Laments also disruptively carve out public space—both physical and metaphorical—in the present time in order to hold the past and the future in a tension that has the potential to transform reality. They are often not couched in logic or even in the language of the dominant culture in order to protect the depth of loss they convey from easy explanation or from being too quickly vanquished from the public consciousness. Rather, laments are offered in the language of metaphor, symbol, and even embodied performance that give the collective "eyes to see and to weep," to use Paul Ricouer's language. These aesthetic qualities make it possible for those who engage in this form of grieving or bereavement to refuse to move toward the future without ensuring that a truthful reckoning of the past is part of the future's memory. Consider, for example, the way in which Okdeh visually captures the lament of Kevin's mother, Janice Jackson-Burke, in *Forgiveness*.

Unlike more private expressions of grief, laments are a form of public discourse. Laments are an expression of what Rebecca Chopp calls "the poetics of testimony" or new forms of language, speech, and imagery that "speak of what, in some way, [has been] ruled unspeakable or not worthy of speech in the public." *The Families Are Victims Too* surfaces otherwise unspeakable things such as the violence of unrelenting unforgiveness, the victimization of family members, and the complicity of bystanders. Moreover, poetic testimony also incorporates an "ethical summons to attend to the other in a responsive fashion." As

The Families Are Victims Too: detail, Barbara Smolen, 1999, © Philadelphia Mural Arts Program.

a form of testimony, laments reimagine and embody public discourse with attention to telling the truth, evoking moral consciousness and social responsibility, and opening up new public space for a collective compassion that is transformative. "Human beings throughout history and across cultures and faith tradition have forged challenges and rituals for lament into a rushing river that cannot be held back," explains Nancy Lee in her book *The Lyrics of Lament*. "They have created compelling, beautiful and sublime expressions of sorrow . . . and in so doing have found the hope to join together in transforming society with calls for change and justice."

Ultimately, Massingale suggests that laments should precede every moral action, since they make it possible to *feel* more acutely the complexities of social suffering. The moral value of laments, in Walter Brueggemann's estimation, lies in their ability to shift collective consciousness. They interrupt comfortable complacency with an evocative longing for something different, a longing that can motivate action and orient social change. To that end, they are politically and socially dangerous.

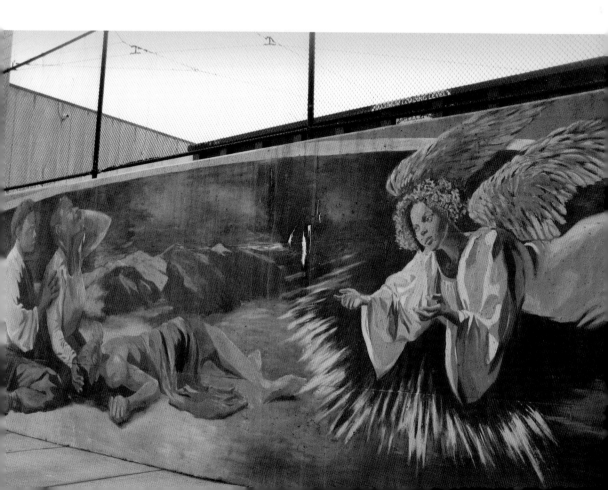

Clearly, many community murals serve as visual laments for those who create them. But muralism makes a unique contribution to this expression of mysticism, since these images transcend the limits of language-based laments in sacred texts to better capture the depth of emotion a community feels when standing at the crossroads of an assuredly oppressive present and a potentially liberating future. They reveal the depth of the community's pain as well as their refusal to be overcome by it. Murals issue a visual public summons to those outside the community, a call to social responsibility. But what do these visual laments offer to a body politic wounded and broken by structural poverty?

First, murals provide one of the only forms of lament in our public discourse in metropolitan areas. Borrowing the words of Hinze, murals, like laments, "bring public expression to those very fears and terrors that have been denied so long and suppressed so deeply that we do not know they are there." Surfacing these fears and terrors can break through the blockade of monolithic imperialism, which does not allow space for public expressions that contradict the carefully construed master American narrative which monopolizes our national consciousness. Doing so with such spectacular color and imagery allows us to "see more, hear more, feel more and think more" regarding our communal life together: the depth of human pain caused by structural injustices, the complexities and contradictions of metropolitan areas. Second, as was the case with visual remembrance, murals redirect our political engagement toward a concrete and practical vision of the future. These visual laments provocatively specify unfulfilled aspirations of neighborhoods and at-risk populations assumed for dead by the wider culture. Their visions of what might be shake those who pass for living out of our satisfied complacency with what is. They awaken those who encounter them to the pain and longing in our own lives, haunting us with the personal and collective dreams we too have yet to fulfill. With a flash of creativity they jolt persons who paint them and who encounter them back to life and life in community.

To that end, murals move the body politic beyond patriotic optimism toward civic hope. Optimism, in Bryan Massingale's estimation, seeks immediate gratification, is often easy or undemanding and transitory, focuses on the tangible, and can be compromising in the goals it seeks. Optimism abounds in the tropes of our public discourse, from the values of whiteness inherent in its Protestant work ethic to exclusivist invocations that God bless America. It shields us from the pain of our past and the arduous demands of the future. Hope, on the other hand, is an enduring and costly commitment to an intangible and yet palpable

goal, requires perseverance despite obstacles, is not easily satisfied, and refuses to compromise. "Hope," Walter Brueggemann explains, "is the refusal to accept the reading of reality which is the majority opinion." Murals are visual evidence of inner-city residents' departure with the opinion of the majority. As we will see in the following section, they challenge the empty optimism of our civil religion with hope characterized by brutal honesty about the past, vulnerability in the present, and risk for a different future.

Visual Healing

Laments heal precisely because they leave some wounds open so that their pain might prick the public consciousness and stir people to action.

"This was giving a public voice to people who are all suffering, who feel as though their child's death was just another death in the city," explains Smolen in retrospect. To do this with integrity and in a way that reflected the community's intentions for the piece required that she not back away from the pain—of family members, of passersby, and eventually of her own—as she painted their lament.

"I think the whole thing was hard for me because I put so much of myself into it; it was so emotional and so difficult and I felt like I was saying to the community, 'I'm helping, I'm helping.' But it was depressing at the end. I didn't go through what they went through; I'm trying to do my best, but no matter how great this painting is, the reality is, their son is still dead. But it was really gratifying when people stopped me to tell me their stories. I realized that the mural is very validating and that I was trying to say to people, the world can see what you are personally going through and this is my way of extending your experience out so that you don't have to feel alone. You can walk by and know that other people's eyes are being opened to what you're going through, the city of Philadelphia through the Mural Arts Program is standing behind you and we feel your pain. We honor your children."

Chapter Thirteen

Recovery

Like many Christian ascetics, Sr. Margaret McKenna felt compelled to journey into the desert in order to free herself from the trappings of "empire" and encounter God more dramatically on God's terms so that she might better live her mission as a Medical Mission Sister called to be "a healing presence in the heart of a wounded world." An abandoned property at Twenty-Third and Norris in North Philadelphia seemed to her to stand at the intersection of desert and the heart of woundedness in Philadelphia. To outsiders, it was nothing more than an urban wasteland when she arrived in 1998; with estimates that 70 percent of the population in North Philadelphia struggled with addiction. Drugs had sucked the life out of the community and a lack of support services ensured that drug dealers were the only rainmakers. But McKenna sensed God at work in this neighborhood and envisioned, with others, what biblical references to a "new Jerusalem" might look like in that neighborhood. That vision gradually became a holistic recovery initiative for the entire neighborhood, called New Jerusalem Laura, which seeks to "integrate the physical, psychological, spiritual, political, and social dimensions of recovery" in the daily lives of the community through relationships rooted in justice and reciprocity. "We are not so much a service institution," explains Margaret McKenna on the organization's web site, "as a community of people helping ourselves and our neighborhood to recover."

The cornerstone of this initiative is New Jerusalem Now, a residential recovery program that focuses on the personal conversion and social transformation that are essential for living drug-free lives. In 2001 clients and community members collaborated with Philadelphia's Arts

Recovery, Lynn Denton, 2001.

and Spirituality Center to create *Recovery* (Lynn Denton), a three-story mosaic depicting twelve images of what recovery means, on the side of the main house. "When things are right they are beautiful," says Margaret McKenna. "Recovery is about getting it right and then having a beautiful life. It's not just not doing wrong, but finding the joys that give you even better highs."

The "Sacramental Imaginary" and the Body Politic

Jacques Maritain asserts that the link between the arts and the common good rests in the human capacity for creative intuition that illuminates the self with "flashes of reality" that are "infinite in [their] meaning and echoing capacity." Imagination becomes the way in which we harness the insight and energy of those moments and channel them toward creative acts that cultivate whole persons and whole communities. Imagination is a capability distinctive to persons. It provides our primary means to encounter and be in relationship with a God who can not only be understood or experienced logically but also in the context of mystery that invites ever-deeper interior reflection and ever-expansive external engagement in the created world. It is a capability through which we accept our inherent dignity that comes with being made in the image of a wildly imaginative and creative God. We use the imagination to express our freedom or our ability to build purposeful lives and to enter into meaningful and life-giving relationships with ourselves, with others, and with God. Imagination makes it possible for us to respect the dignity of others when we imagine the world from their perspective or protect their own imaginative capability to chart the course of their respective destinies.

Even if he doesn't explicitly acknowledge as much, imagination is essential in Maritain's schema of the common good, particularly when it comes to the intuitive and collective process of discerning, creating, and generating communicable goods that make up the common good. In fact, it is these very aspects of imagination that lead Martha Nussbaum, a contemporary political philosopher herself influenced by the thought of Maritain, to go so far as to name the imagination a human right, given its centrality to living a distinctively human life. She contends that so long as we are able to imagine our own futures we never fully succumb to the wills of others or the conditions of injustice.

Charles Taylor, another prolific political philosopher, calls this collaboratively reflective process of groupthink about life in community the "social imaginary." By this he means "the ways in which people

imagine their social existence, how they fit together with others, how things go on between them and their fellows, the expectations which are normally met, and the deeper normative notions and images which underlie these expectations." In other words, the social imaginary is the collection of beliefs and values that we deliberately incarnate through reflective corporate practices. The social imaginary consists of multicultural and religiously plural communities imagining together alternative visions and then working together to bring those visions to fruition.

But as we have seen in previous chapters, a variety of intrapersonal and structural circumstances preclude this kind of collective reflective and imaginative activity, especially in metropolitan areas. The value of individualism inherent in both the codes of the street and whiteness relegates the imagination to a private and personal experience rather than a collaborative exercise in building community. In addition, the cultural similarities and narrow worldviews perpetuated by lifestyle enclaves—whether voluntary or involuntary—often preclude ingenuity or radically different possibilities for social relationships. A preference for pragmatic and practical solutions to social injustices often rejects imagination as nothing more than impractical fantasizing.

So where does that leave the imagination when it comes to the collective process of discerning and cultivating the communicable goods so essential to the common good? This is where beauty might bring what Taylor calls "enchanted" perspectives to the social imaginary, perspectives that can break through conditions that "buffer" the self against intuitions that there might be more to reality than meets the eye. Scholars in the Catholic tradition prefer the term "sacramental" when it comes to imaginative thinking. For example, theologian and novelist Andrew Greeley defines the Catholic sacramental imagination as "the way Catholics picture the world and God's relationship to it." It arises from the central beliefs of the tradition: that God is incarnate or present in the world, not mysteriously withdrawn from it; that ordinary physical objects can mediate or disclose to us God's extraordinary grace or loving presence; and that we can best understand God metaphorically and in the context of stories and narrative images. In either case, orienting the social imaginary toward the mystery of beauty, particularly its mysterious ways of cultivating a stirring sense of "the more" as well as strong ties among persons, imbues the social imaginary with enchanted or sacramental qualities that can address these many obstacles to imagining together life together. As such, the "sacramental imaginary"—the collective process of determining how we ought to live that is oriented toward the radically liberating possibilities of what might be—becomes

a critical component of the common good insofar as it functions as a collective virtue that incorporates a faculty for moral reasoning and practices essential for life in community.

Recall Maritain's claim that art itself is a virtue, since it exercises the underutilized emotive aspects of our intellect and it perfects our creative abilities so that we might become more fully human in embracing our "personality" and our "individuality." The sacramental imaginary adds a corporate or collective dimension to this experience of creativity so that communities might become "a whole of wholes" oriented toward a certain vision of the good life. By integrating the ethical orientation of the social imaginary with the sacramental awareness of the divine, the sacramental imaginary hones our moral awareness of the horizontal implications of our vertical relationship with God. In other words, it makes us better able to perceive the mandate to participate in God's ongoing justice in the world. Therefore, the *sacramental imagination* suggests that the pivotal moral question concentrated poverty presents to us is not what we as individuals should do to improve the bottom line, or what obligations we have to others as we haggle over budgets or business development strategies. Rather, we need to ask ourselves, as "wholes of the whole," who do we want to become as a community in light of our relationship with the Divine? This question is radically future-oriented and imaginative. It evokes a sense of creative responsibility as we collectively conjure an image of ourselves in the future and imagine what might be required of us to actualize that vision.

In addition, the sacramental imaginary is a kind of disposition that motivates action. Precisely because it is rooted in the imagination, it encourages a kind of analogous thinking that makes it possible to draw connections, to run threads of conversation out, etc. It underscores that often dispositions—openness to new ideas, patience with the creative processes, humility in rethinking one's dreams in light of hearing another's innovation—are absolutely essential mental faculties for living in community. Likewise, it helps us to see the common good too as a disposition and not simply an abstract norm or principle. We can see its power in forming particular kinds of communities with particular capabilities.

We might also approach the sacramental imaginary as a set of practices that make it possible for us to build authentic communities. It is a dialogical, creative, and relational process through which unexpected

Recovery: detail, Lynn Denton, 2001.

religious experiences, encounters, stories, images, or practices not only serve as a conduit for individuals to better understand and participate in the divine but also provide a set of collaborative practices through which otherwise disparate individuals can intentionally participate in creating a more just world. The sacramental imaginary becomes a particular kind of collective moral agency characterized by a desire to gather together in real space and in real time to share our dreams with others, to listen to wise stories that we will need to move forward, to express the deepest longings in our hearts, to review critically what "is" in order to more freely imagine what "might be." As such, it is central both to membership in community and for cultivating conditions of fulfillment in communities. This echoes David Hollenbach's claim in *Christian Ethics and the Common Good* that "without the kind of relationships that sustain social participation, individuals are unlikely to be able to even imagine that they have options among which to choose."

Creativity is one such practice. Through the sacramental imaginary we come to know experientially—and not just intellectually—that if we

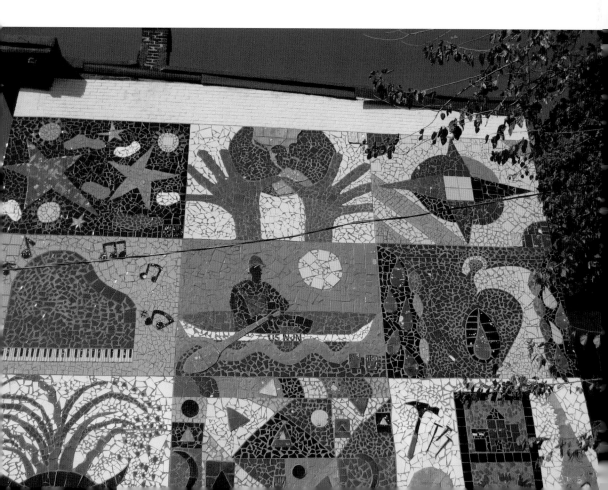

are indeed made in God's image and likeness then we do not simply react to the conditions of our lives but rather have the proactive capability to construct them by bringing new things, ideas, energies, perspectives into being in our current situation. Creativity, both individual and collective, serves as the minimum condition for life in community or a "common good" as well as an expression of fulfillment or authenticity via potential for wholeness, integration, or coresponsibility. John Wall makes this argument when he discusses what he calls "the creative moral imperative" in which we come together, in the midst of difference, to "create ever more profoundly meaningful and reconciled life in common." It underscores a notion of moral agency rooted in human persons as cocreators; it cultivates practices connected to creation, most notably the creation of selves with capacity to imagine others and to imagine with others. Moreover, it resists the isolating alienation that sustains the affective impasses around concentrated urban poverty. "Moral creation is a force of integration which connects the previously unconnected in the direction of greater and deeper unity," explains ethicist Daniel Maguire.

An Artistic Praxis for the Common Good

Through the *sacramental imaginary*, we accept the social responsibility of being made in God's image, namely, that our creative energies are to be focused on establishing and nourishing life-giving relationships within creation so that they once again might yield abundance. This is the mandate of building the kingdom of God—to make new again the life-giving and abundant promises of the covenant by using our respective gifts. The sacramental imaginary, therefore, brings a mystagogical element to the often language-dependent, analytical, and pragmatic "see-judge-act" praxis of Catholic social teaching and likewise the common good. This approach, first articulated at the turn of the twentieth century, encourages disciples to observe the world around them; to evaluate those circumstances using a variety of principles, including the common good; and then to respond in a way that is consistent with conscience and the teaching of the church. What gets lost in this pragmatism? Creative intuition, emotion, imagination, dreaming.

The arts, on the other hand, give us a way of exploring the transformative power of the mysteries of God, particularly the mystery of a creative God incarnate in human experience, as we engage in the activism of Catholic social ethics in our personal and public lives. This openness to mystery illuminates overlooked aspects of the three-part

praxis of Catholic social teaching and offers new elements to the praxis, which support the common good. With the help of the arts we more accurately perceive our reality through bodily and sensorial *encounters* with people and situations; we more affectively interpret that reality through participatory *engagement* that uses emotion, memory, and imagination; and we respond more effectively through *creativity*.

Consider these three mystagogical facets of the sacramental imaginary in the example of *Recovery*, a three-story mosaic mural of twelve images, each made from broken pieces of glass and tile. Members of New Jerusalem Now hoped that the piece would visually proclaim their mission to rehabilitate neighbors struggling with substance abuse as well as to rehabilitate the entire neighborhood struggling with poverty induced by addiction and the informal drug economy. Each of the twelve artists depicts an image that captures for him or her the essence of recovery or living with what Sr. Margaret calls "more authentic highs": boats, the stars, awareness of ecological unity, family, a home, geometric symmetry.

Artwork like *Recovery* attunes our perception of the connections between poverty and drug addiction not only by revealing otherwise hidden dimensions of human experiences of this intersection but also by pulling observers into these otherwise unseen or ignored dimensions. In this case, we move beyond intellectual observations of the relevant statistical data about rates of addiction, recidivism in drug treatment programs, number of drug-related arrests—all of which give us a sense of what is going on in this neighborhood—to encounters with the people behind this data. *Recovery* enables us to see more and in new ways by creating for us an encounter with persons struggling with addiction. We literally see their attempts to chase after more authentic highs by putting back together the shattered pieces of their lives into an image that also attempts to piece back together a neighborhood broken by structural violence of poverty. *Recovery*, therefore, moves us from observation to encounter, or from objective or at-a-distance "eyesight" toward a more passionate, embodied, and engaged "insight" into the reality we perceive. And our very act of perceiving this reality through beauty or the arts makes us participants in that reality: we are pulled into that which we perceive or observe, whether by virtue of the interpretations we offer, a heightened sense of self-awareness when we realize that a visual text is reading us, or shared emotional experience that connects us in some way to the people of that particular time and place.

Sr. Margaret explains this move from perception to encounter in terms of awakening. "Art wakes people up to each other's beauty, to

their own beauty, and to the beauty of the world." It is the awakening power of encounter that has the potential to move addiction and recovery from pragmatism to dreaming.

In terms of the second step of the praxis of Catholic social ethics, the arts encourage an interpretation or evaluation or judgment of that reality through affective, embodied, sensorial, and imaginative *engagement* with the image, the self, and others. Jensen calls this "somatic" knowledge in which "the whole body engages in the work of learning, evaluating, and communicating" in a "wordless" mode that in many ways mirrors God's self-disclosure in the incarnation. "God did not self-reveal in the words of Scripture alone," Jensen notes. "God also appeared in a visible, physical form, with weight and mass and color and texture."

Community muralism, for example, does not seek to present an intellectual argument or abstract concept or moral principle through which we try to interpret and respond to a particular event or situation connected to concentrated poverty. Through sacramental imaginary, we are not merely intellectual but also emotional, not merely cognitive but also intuitive, not merely deductive but also inductive. This is captured in Sr. Margaret's comment that beauty "awakens us to our joys," joys that are often best experienced in the context of healthy relationships whether with self, others, or God. Beauty cultivates these relationships, which she understands as pivotal for successful recovery from all addictions. Therefore, at its best, justice is not a mathematical calculus that determines what we owe others, a classic definition, but rather a desire to be in relationships with others where we figure "what is ours to do" and thrive on the high of actually doing these things together.

Recovery reminds us of David Hollenbach's warning that we can no longer "hedge our affective bets" through "emotional distancing" when it comes to analysis of social situations or realities. We must raise questions about how these conditions impact the spiritual dimensions of all persons, both urban and suburban. When we stand before murals such as *Recovery*, we begin to see and, in fact, *feel* the causal connection between white flight and hyper-segregation, between overdeveloped and underdeveloped schools, between the addictions of consumerism and rampant substance abuse, between the cultural defense of the second amendment and the homicide rate, between social stereotypes of young black men and skyrocketing incarceration rates. By helping us to engage in these realities, Robert Wuthnow suggests that arts help us to "place ourselves inside the consciousness of another" where we can experience the reality of social sin from very different places and in very different ways. "When people shift their perspectives so that

they finally understand someone else's reality, the work [of muralism] moves from arduous to inspiring," wrote Jane Golden in a *Philadelphia Inquirer* editorial. "Those moments of profound change are really the essence of what we do."

Finally, engagement with the visions and values of public art such as muralism shifts the emphasis in Catholic social ethics away from a pragmatic, deductive, or even quantitative "faith that *does* justice" toward a more humble, inclusive, and innovate "faith that *creates* justice." The former can often be understood in consequentialist or deontological terms, particularly if the role of faith-based ethics is to identify the most practical or realistic blueprint for social living in light of the mandates of the Gospel, to translate that blueprint into normative principles, and then to apply them using logic, intellect, deductive reasoning. Through community art such as murals, we come to recognize that justice is a collective vision that arises out of encounters with the mysteries of faith—captured in this case in fantastic images—that we collectively dream up and then seek after in relationships with others. In other words, moral life is not necessarily about doing things differently but rather imagining things differently.

High on Justice

The subtle distinction between these two approaches to social transformation—doing versus imagining justice—has a significant impact on the way we use the common good in the context of concentrated urban poverty. This sense of connection to others and the environment through creativity produces a thick "social glue" that can repair lives and communities damaged by trauma, violence, and addiction. It becomes a way of experiencing community, which Sr. Margaret sees as so essential for individuals, neighborhoods, and societies to recover from our many dehumanizing addictions. *Recovery*, for example, not only captures the various inner joys and beauties of this community but also serves as a public testimony to the importance of healthy communities in helping people overcome addiction. "Community motivates behavior, wakes people up to a new self-image, makes people aware of the repercussions of their actions and their responsibility to each other," she explains. "It gives people feedback about who they are and a chance to observe that they have things to contribute; in community they discover the ability to enjoy doing good work. In community we learn that justice in our own lives becomes the framework for justice in the world." We turn to that framework now.

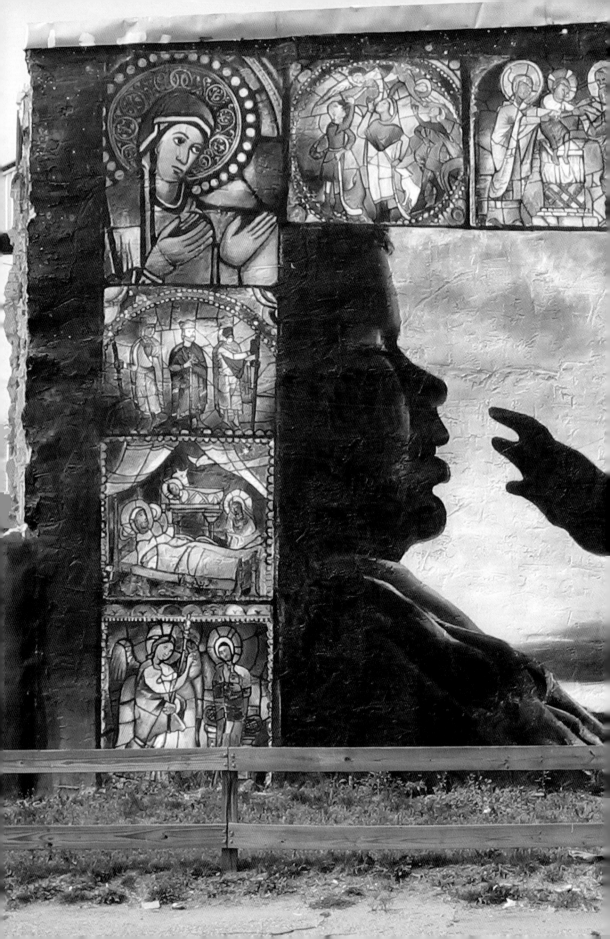

Chapter Fourteen

Flourishing

"I am really trying to suggest that the child represents hope for each family, because we are still talking about that black mother who lives in that community and the young mothers who pass by that wall every day," explained Cliff Eubanks who painted *Born Again*. "This is what you want your kid to evolve and grow into—someone of power and someone who can rise above all that is happening in the neighborhood."

To capture this, Eubanks designed an image with a variety of overlapping backgrounds. The deepest is the cosmos, upon which he layers central scenes of the life of Christ with particular resonances with the life of families in the community—families in crisis, children facing threats of violence, young men incarcerated by the state—which in turn frame a fantastic horizon with the aforementioned rising or setting sun. This layering captures infinite possibilities of the universe of the self—from a cosmological awareness of the infinite to a historical sense of a religious tradition that continues to unfold in the silhouetted figures in the foreground to the enticing mystery of the horizon at a pivotal point in the sun's journey around the earth. The mural stirs a sense of the possible, which Eubanks heard in the visions that women in the community had for the mural.

Born Again sparks a kind of intercommunicability that my students and I experienced while discussing the mural with folks from the neighborhood. Many of us that afternoon began to experience on an intuitive level the implications of the sun rising or setting on this community. Moreover, *Born Again*—and, perhaps more important, the process of its creation and its continuing power in the community—generates

Born Again: detail, Cliff Eubanks, 2000, © Philadelphia Mural Arts Program.

and distributes communicable goods that support the development of "whole" persons who contribute to the "wholes" of the neighborhood and wider community. It forms people for life in community, first by inviting them to contribute their various forms of "human capital" to creating the mural, such as their memories and stories, their ability to deeply listen to each other, their creative skills, their willingness to suffer with one another and also hope for better things in their community. The mural then serves as a visual touchstone of these important facets of human flourishing.

Dreaming and the Body Politic

Jacques Maritain's sense of the common good was rooted in the capacity to dream and, as such, this capacity is central to collective human flourishing. In our intuitions Maritain identifies aspects of moral reasoning that had been largely overlooked since the rationalism of the Enlightenment took hold. "At the root of the creative act," he argues, "there must be a quite particular intellectual process, without parallel in logical reason, through which Things and the Self are grasped together by means of a kind of experience or knowledge which has no conceptual expression and is expressed only in the artist's work." He argues that perhaps more than other moral agents, artists are able to recognize reason or intellect "both in its secret wellsprings inside the human soul and as functioning in a non-rational or non-logical way." It is important not to overlook the significance of this claim: Maritain embraces the intellectual or cognitive contributions of emotion, of imagination, and of wonder precisely because of their nonrational or illogical attri-

Born Again: detail, Cliff Eubanks, 2000, © Philadelphia Mural Arts Program.

butes. When we tap the "wellsprings of the human soul" we unleash a new way of perceiving and evaluating ourselves and our reality. He claims that he is talking here not of "inexhaustible flux of superficial feelings" or "cheap longings" but rather of an encounter with the "substantial totality of the human person, a universe unto itself," in which the person comes to understand the mystery of their being in a "flash of reality" that is "infinite in its meaning and echoing capacity." Muralist Ras Malik (1935–2007) puts it this way: "Even cave painters who had no artistic background injected spirituality into their work. An artist relates to his environment—trees, water, sky, sunsets, sunrises. . . . There arc so many heavenly things you can almost hear music. An artist needs to make that feeling and that is what you call creativity and that is going to take you into spirituality."

It is in moving beyond the logical, the rational, the abstract, the conceptual that creative intuition can reorient our focus on the common good beyond the aggregate good of individuals or totalitarian impositions of the good life or even the pragmatism of procedural approaches to justice. "Such an emotion transcends mere subjectivity and draws the mind toward things known and toward knowing more," Maritain explains, "and so induces a dream in us."

It is here, in the thought of one of its most fundamental proponents, that new possibilities for the common good as a "vision" emerge. What has the power to induce those dreams in us? Art. Through Maritain's notion of creative intuition, we can recognize art as a liberating practice that discloses truth—about the "self" of the artist, about the human condition, about life in community—in a way that suggests there are always deeper levels of meaning that can be explored and "inexhaustible potentialities for revelation" about all of these things. Therefore, the arts and those who participate in them are freed to break out of or through the defeatist mentality that accepts what is. With and through the arts, we are empowered to dream what might be.

If we approach the common good with these underused inductive moral faculties, we begin to understand it as an inspiring, attractive, compelling vision that sustains the very organic nature of the body politic rather than merely a pragmatic principle the body politic uses to construct society. In this way, the fundamental component of the common good becomes the capability for vision—for seeing more and responding more deeply to the desires that resonate in the depths of the self and the body politic.

Creative intuition, which harvests the knowledge that comes from the wellspring of the human soul, can help us to understand more

clearly the fundamental components of Maritain's approach to the common good. Primary among these is his notion of "communicable goods" that both create and sustain the common good by cultivating the personality and individuality of all members of society. These goods strengthen the bonds of the body politic against the fractious pressures of concentrated poverty. He explains that communicable goods are both material, oriented toward the physical needs of individuality, and spiritual, cultivating the dimensions of personality. These come into existence only through the collaborative efforts of persons in community to create and distribute them. His understanding of communication inherent in the artistic process can shed further light on the "communicable" attribute of the goods toward which the common good ought to be oriented. Maritain notes that insofar as it is "a meeting place where two minds [the artist and the beholder] become one," art is a form of communication. The same meeting of the minds generates communicable goods. The very possibility of their existence and functionality depends on an acknowledgment of the other, an acceptance of the intuition that the self is more than mere individuality and perhaps depends on others to develop the personality fully.

It is their communicability that connects these goods to beauty and makes them indispensable for understanding justice in the context of urban poverty. These goods are only possible when persons consciously enter into relationship with others, and their creation and redistribution only enhances such relationships. Goods such as health, friendship, education, safety, or nutrition are created by the whole but flow back on or are continually redistributed among the individual selves of society, enabling them to become more complete whole selves who perpetuate the cycle by coming together to perpetuate communicable goods. Beauty is an invaluable communicable good, since it heightens the subjectivity of the self. Beauty, therefore, makes the self more capable of relationship with others and guarantees that visions of the good continue to flow back on or reverberate within the community.

Finally, Maritain claims that "art resides in the soul and is a certain perfection of the soul." It is a virtue that strengthens the body politic by raising the "wholes" that make up society "to a higher degree of vital formation and energy." Art is a virtue that orients us for life in community, precisely because it becomes a way of embracing more fully our subjectivity or personality and understanding how this is best realized in relationships with, to use Maritain's words, "Things" and other "Selves." Art is a kind of ongoing process of spiritual formation, but one that is equally attentive to what is going on inside and outside

of the self and relentlessly attempts to capture and communicate ideas about these terrains. Robin Jensen explains, "Each act of creation is a spiritual exercise, strengthening or honing us in particular ways, making us more and more into whom we shall become and how we understand ourselves in relation to the rest of the created world." Muralist Cesar Viveros-Herrera, one of the first muralists engaged in restorative justice projects, captures this well: "You go into these neighborhoods, you meet with neighbors and they come to trust you. You have a chance to meet with lots of different persons—police officers, community organizers who all have stories. And they create a piece that is part of them and at the end is part of healing themselves and connecting with others."

Beauty and Justice as Flourishing

Contemporary scholars in aesthetics and in ethics are returning to the intrinsic connection between the beautiful and the good that was so clear in the minds of the ancient Greek philosophers. For Plato, beauty is a way to glimpse and perhaps understand the transcendental category of "the good"—goods that are higher and of greater value than the tangible and material goods that shape our social relationships, goods that keep us from being satisfied with the way things are. In addition, Plato thought that beauty is what makes this transcendental good so compelling and attractive to us. Beauty is what makes the transcendent or ultimate good seem fulfilling and therefore desirable. Simone Weil observes that "the contemplation of veritable works of art, and more still the beauty of the world, and again much more that of the unrealized good to which we aspire, can sustain us in our efforts to think continually about that human order which should be the subject uppermost in our minds."

Beauty or the arts introduces the category of *eudaimonia*, or flourishing—perhaps captured in the rising sun in *Born Again*—into the foreground of our visions of the good life or justice. According to political philosopher Martha Nussbaum, who intentionally stands at the intersection of classic Greek literature and economic theories of development in order to highlight the relationship between the wisdom that the beautiful can offer to us in our reflections on the good, flourishing is more than merely the removal of impediments to free choice or the exercise of liberty. It is also more than fair or equal access to material goods that make life possible, although it certainly involves both freedom for activities and freedom from want. Rather, flourishing is connected to the "activities, goals, and projects" of each person that are "awe-inspiringly above the

mechanical workings of nature" and that make it possible for persons to "shape his or her own life in cooperation and reciprocity with others rather than being passively shaped or pushed around by the world in the manner of a 'flock' or a 'herd' animal." Flourishing has a future orientation, since it is concerned with not only what people are able to do right now but, more important, how present conditions will affect who they are able to become. Nussbaum argues that flourishing involves activities that we understand as uniquely human—friendships, emotional and physical intimacy, recreation and imagination, storytelling and dreaming, authentic embodiment—which together make it possible for a person to decide for herself the ultimate end or goal of her life and then support her in finding the most fitting way for her to go about achieving that end. A capacity to dream and actualize a future distinguishes those who flourish from those who merely struggle to survive in the present.

Flourishing brings a tactile, embodied, and future orientation to justice. How? Let's consider beauty's connection to empowerment and participation, the cornerstones of the Catholic approach to the common good that also correlate to Nussbaum's central capabilities for flourishing. Empowerment cultivates our capability for practical reason, or "being able to form a conception of the good and to engage in critical reflection about the planning of one's life," while participation in life in community ensures that we regularly exercise our capability for affiliation, or "being able to live with and toward others" that involves "imagining the situation of another and to have compassion for that situation" and "to have the capability both for justice and friendship."

Beauty and Justice as Empowerment

Beauty instills within us a suspicion that despite evidence to the contrary the world is indeed a meaningful place and inspires us to get involved in it. "Even in my darkest hour, when I felt that I didn't have a future, I knew that art was inside me and that it would save me," recalls Viveros-Herrera. "I was doing things with my life, but I wasn't satisfied. I knew there was more." In *On Beauty and Being Just*, philosopher Elaine Scarry claims that beautiful things spark a desire to reproduce or replicate the beautiful things we see or to perpetuate the sense of "aliveness" they give us. She believes beauty has a "forward momentum," since we often try to replicate experiences of beauty by creating more of it. Beauty simply begets more beauty. Take communities in Philadelphia, for example. Through the inventive power of the imagination and the forward momentum that community muralism clearly triggers in

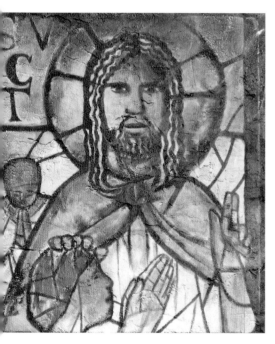
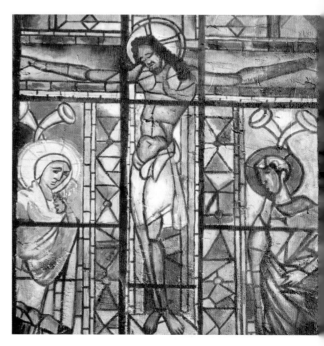

Born Again: detail, Cliff Eubanks, 2000, © Philadelphia Mural Arts Program.

neighborhoods around the city, given the sheer number produced each year, the murals help us to resist the temptation toward paralyzing guilt or demoralizing lethargy that often arises when we begin to think about the complexity of urban injustices or our egregious failure to bother to love our neighbors. Instead, they tenaciously empower us with a palpable desire to dream new possibilities, to enter into new relationships, to collaborate on new solutions. This tenacity is human flourishing.

Likewise, beauty gives us the resources we need to make meaning out of seemingly contradictory aspects of lives or realities or to deal with the threats to existence that all humans experience, some to a greater extent than others. To that end, John DeGruchy goes so far as to call access to beauty a human right because, at the very least, beauty "resists the principles of domination and death" and creates the possibility for social change by "supplying images that contradict the inhuman."

How is this possible? According to theologian John Haught, beauty empowers us to harmonize contrasting facets of the self or our social reality, to notice patterns of meaning among otherwise shattered fragments of experience, to build "narrative nests" that provide security and confidence, and to deconstruct narrowly told stories that deny full humanity to all persons. It is via our willingness to enter into "some power-bestowing narrative which patterns the moments of our lives" that we receive "courage" to face the threats to our existence and that we experience the "feeling of living in hopeful freedom." Feminist ethicist Susan Ross suggests that the power of beauty rests in its ability to promote self-care or self-love, which is absolutely essential to cultivating any kind of meaningful moral agency oriented toward the other. She turns to women's experiences of beauty as a practice of self-gift and generosity—an active expression of care of self and love of others—to argue that beauty is something we do for self and other.

In its abundant, generous, and generative qualities beauty empowers us for abundant, generative, and generous relationships with others. For example, Scarry believes that beauty inspires a desire to protect beautiful things from being damaged by attitudes or actions that deny or destroy their life-giving nature. Beauty invites us to become stewards of beautiful things or caretakers of the sense of aliveness or alertness that beautiful things instill within us. In other words, beauty calls forth a sense of responsibility. We see evidence of this kind of responsibility in the young people who resist the urge to tag or deface the murals, or who are attuned to the beauty of themselves or others and therefore resist the urge to resort to violence. Ross adds to this by noting that "real beauty does not exclude, rather it invites; real beauty does not

'count up' but rather flings its gifts to anyone who asks. . . . Beauty is always ready to give more."

Beauty as that which calls us to or opens us up for meaningful relationship with something greater than ourselves enhances our capability for meaningful relationships across the board. Jane Golden observes, "When you introduce beauty it makes people feel that they have a voice, that they can be part of the system of change, that there's potential, that redemption is possible."

Beauty and Justice as Participation

Beauty gives justice an embodied and tactile feel by cultivating in us a desire to participate in our immediate environment with our bodies and not simply our minds. It heightens our sensitivity to our own beauty and sense of dignity and worth. It stokes in us a desire to articulate our dreams and stories in a public way. It then provides an outlet for the agency that comes with caring for and cultivating something beautiful. Consider Ross's claim that beauty is not something we possess but rather something that we do. Likewise, flourishing is not a characteristic that we possess but rather something that we do and, as beauty suggests, that we do in relationship with other things and persons. Relationality or the capability for affiliation with self and people and things beyond the self lies at the heart of beauty's life-giving qualities.

Mural making forms people for life in community—or, more accurately, for participating in life in community—since it provides figurative and literal space for people to discover together what they recognize about themselves and their community, to appreciate collaboratively the gifts and talents and desires they share in common, to desire collectively for a different future, and then to go about bringing that vision to fruition by painting it on a wall and living it in the community. The coming together to dream and to share, and then to paint, is "doing" community rather than simply "being" community. Since muralism pulls people out of isolating individualism or exclusive enclaves, it bolsters the "social capital" of the neighborhood or the networks of relational trust, reciprocity, and even mutuality among individuals. Once established, social capital can bond communities together, bridge them to social resources, and link them to an increasingly wide web of persons.

Mural making embodies many of the positive attributes of a viable social capital that sociologist Robert Putnam identifies in his now-classic *Bowling Alone: The Collapse and Revival of American Community* cooperation in solving collectively shared problems, increasing physical and

psychological well-being that comes from deeply held relational trust, possibilities for community development and investment that is more likely to happen in communities where neighbors know and care for each other, a willingness to act on behalf of the whole and not just the individual that comes from a heightened sense of the interconnections among the community. By pulling various groups that make up civil society into this creative process—the police department, school district, faith-based organizations, social service agencies—the murals create a *common beauty* that irresistibly inspires our collective commitment to the types of goods needed to address both the *intrapersonal violence* of poverty that diminishes the *personality* of the self and the *structural violence* of poverty that diminishes the *individuality* of the self.

Creating common beauty becomes a way to identify the basic minimal conditions of life in community and to meet them in organic and relational ways. Therefore, the common beauty that the murals create reminds us that the common good is not something that we think about but rather something that we actually draft, dream, construct, craft, and hone in collaboration with one another. Doing so requires a context of a deep relationality that respects the inherent beauty in persons and communities.

Justice and the Rising Sun

When beauty informs us about the good life oriented toward flourishing and draws us toward it, we begin to realize that justice, traditionally defined as living in right relationship with self and others, is rooted in a deep recognition of the sacred beauty of the self and the other. Through encounters with beauty we also discover that justice channels the restless creative power to craft a life that resides in each of us, as well as our distinctively human ability to create new things where nothing new was thought possible. Justice becomes an experience and not simply a concept. Bryan Massingale puts it this way: "We act justly not because we are intellectually convinced, but because we are passionately moved." With the help of the beauty of Philadelphia's murals, justice becomes the deeply emotional, embodied, and sensorial experience of knowing, intuitively, that the sun is not setting but rather rising on human communities in metropolitan areas.

Bibliography

Introduction

Interviews that inform this section include: muralist Cliff Eubanks, February 10, 2007; muralist Barbara Smolen, September 2006; Br. Brian Henderson of St. Gabriel's Hall, September 18, 2007; Sr. Margaret McKenna, founder of New Jerusalem Laura, September 9, 2008; muralist Ras Malik, June 6, 2007; muralist Cesar Viveros-Herrera, September 22, 2008. Jane Golden's comments at the dedication of *All Join Hands: The Visions of Peace*, October 2006, as well as in an opinion piece, "Murals Can Offer Hope and Generate Change," *Philadelphia Inquirer* (October 12, 2008).

Jacques Maritain develops his notion of the person and its relationship to the body politic in *Man and the State* (Washington, DC: Catholic University of America Press, 1998); and *The Person and the Common Good* (South Bend, IN: University of Notre Dame Press, 1966). For his exploration of the self in the arts see *Creative Intuition in Art and Poetry* (Princeton, NJ: Princeton University Press, 1953). Robin Jensen's *Substance of Things Seen: Art, Faith and the Christian Community* (Grand Rapids, MI: William B. Eerdmans Publishing Company, 2004) is an excellent resource for examining the way that the arts form us for life in community. Finally, David Hollenbach's *The Common Good and Christian Ethics* (Washington, DC: Georgetown University Press, 2002) provides the Catholic perspective on the common good that supports many of my claims in this entire fifth section.

Chapter Twelve: Healing

Bradford Hinze develops the contemporary significance of lament in "The Prophetic Character of the People of God: Where Is the Prophetic in Contemporary Catholic Ecclesiology?" (paper presentation to the Catholic Theological Society of America, Cleveland, OH, June 2010). To some extent, Bryan Massingale implies laments as a way through

impasse in "Healing a Divided World," *Origins* 37 (August 2007): 161–68 as well as in his essay, "The Systemic Erasure of the Black/Dark-skinned Body in Catholic Ethics," in *Catholic Theological Ethics, Past, Present, and Future: The Trento Conference*, ed. James Keenan, SJ (Maryknoll, NY: Orbis Books, 2011), 116–24. Nancy C. Lee examines the connections between laments in the sacred texts of the Abrahamic traditions and contemporary expressions of the same in *Lyrics of Lament: From Tragedy to Transformation* (Minneapolis: Fortress Press, 2010).

Rebecca Chopp's idea of poetic testimony also reflects my application of lament to community murals, given that this genre includes a variety of communicative forms all designed to further develop the narrative identity that binds diverse persons in public discourse, including "poetry, theology, novels and other forms of literature that express how oppressed groups have existed outside modern rational discourse." See her "Reimagining Public Discourse," *Journal of Theology for Southern Africa* 103 (March 1999): 33–48. Walter Brueggemann's *The Prophetic Imagination*, 2nd ed. (Minneapolis: Fortress Press, 2001) served as my link from the poetic to the prophetic in light of his claim that prophets relied on imagination to interrupt the consciousness of empire that continues to paralyze the followers of YHWH in living out the covenant.

Chapter Thirteen: Recovery

For more information on New Jerusalem Now, see http://newjerusalemnow .org/hope_for_a_recovering_world/?page_id=3.

In addition to those previously referenced for the work on imagination and social ethics, political philosopher and human development theorist Martha Nussbaum lists imagination among her ten central human capabilities, which constitute a distinctively human life in *Women and Human Development: The Capabilities Approach* (Cambridge: Cambridge University Press, 2000). Charles Taylor identifies the imagination as something that ensures an element of the sacred will continue to permeate our secular age in *A Secular Age* (Cambridge, MA: Belknap Press, 2007). For his ideas about the social imaginary see *Modern Social Imaginaries* (Durham, NC: Duke University Press, 2004). Andrew Greely's *The Catholic Imagination* (Berkeley: University of California Press, 2000) is an excellent resource for engaging the Catholic sacramental imagination.

John Wall, "The Creative Imperative: Religious Ethics and the Formation of Life in Common," *Journal of Religious Ethics* 33, no. 1 (2005): 46–64; and Daniel Maguire, *The Moral Choice* (New York: HarperSanFrancisco,

1984); and Robin Jensen's *The Substance of Things Seen: Art, Faith and the Christian Community* (Grand Rapids, MI: Wm. B. Eerdmans Publishing Co., 2004), pages 1–26 proved helpful in thinking through the relationship between creativity and the common good.

Elements of what I name as a "theological-aesthetic praxis" come from Rolo May's description of the components of the creative act, which include encounter, intensity, engagement, and act, in *The Courage to Create* (New York: W.W. Norton and Company, 1975). See also Robert Wuthnow's ethnographical examination of the role of music in faith and community formation: *All in Sync: How Music and Art Are Revitalizing American Religion* (Berkeley, CA: University of California Press, 2003). To make connections to murals, I turned to Jane Golden, "The Power of the Arts: Murals Can Offer Hope and Generate Change," *The Philadelphia Inquirer* (October 12, 2008).

Chapter Fourteen: Flourishing

Jacques Maritain's *Creative Intuition in Arts & Poetry*, particularly pages 3–35, is essential for my argument in this chapter.

Simone Weil provocatively considers beauty a human right in *Simone Weil: An Anthology*, ed. Siân Miles (New York: Grove Press, 1986), as does John W. De Gruchy in *Christianity, Art, and Transformation* (New York: Cambridge University Press, 2001). In terms of connecting beauty and flourishing—or living a fully human life—Elaine Scarry's *On Beauty and Being Just* (Princeton, NJ: Princeton University Press, 1999) and Nussbaum's previously mentioned *Women and Human Development: The Capabilities Approach* both articulate the agency inherent in responses to encounters with beauty as does the previously mentioned discussion of art and moral formation by Robin Jensen in *The Substance of Things Seen*. John Haught's conclusions for the human capacity for meaning making when God is thought of in terms of beauty in *What Is God: How to Think about the Divine* (New York: Paulist Press, 1986) become evident when one approaches muralism as precisely that kind of agency. For distinctively feminist ways of justice that beauty evokes, see Susan Ross, *For the Beauty of the Earth: Women, Sacramentality and Justice* (New York: Paulist Press, 2006).

Essential for my argument about community art and the common good is Robert Putnam's treatise on decline of community life and social capital necessary for vibrant democracies in *Bowling Alone: The Collapse and Revival of American Community* (New York: Simon & Schuster, 2001), as well as Bryan Massingale's insistence on the affective dimensions of justice in the previously mentioned "Healing a Divided World."

Part Six

Holy Experiment

Religious Imagery in
the Public Square

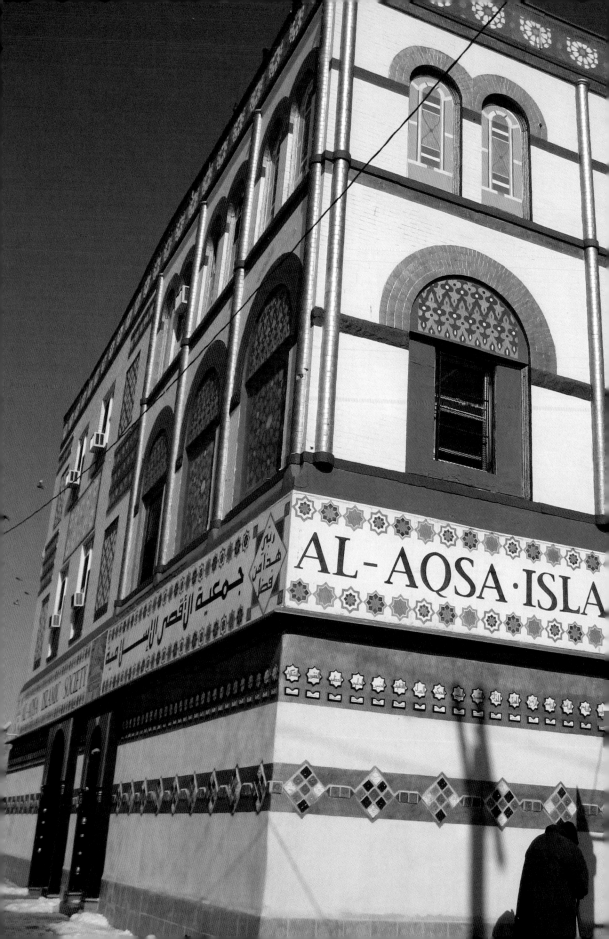

Doorways to Peace

Shortly after September 11, 2001, the more than 250 families of the Al-Aqsa Islamic Society, the largest Muslim community in Philadelphia and home to one of the biggest Muslim elementary schools in the country, found themselves at a crossroads. They could either ride out potential anti-Muslim backlash by remaining an anonymous presence in their North Philadelphia neighborhood, camouflaged in the former furniture warehouse that served as their sacred space for more than forty years, or they could step boldly into the public square in an attempt to fill a void in public discourse that dangerously allowed others to speak for them and their tradition. Emboldened by the fact that the anticipated violence never came, representatives from Al-Aqsa approached Philadelphia's Mural Arts Program (MAP) about arranging an extreme makeover.

"We'd come a long way," recalled Adab Ibrahim, the mosque's community liaison and a daughter of one of its founding members. "We were a sheltered community but we always wanted to build ourselves up and reach out to the wider community."

The next year brought a tremendous transformation, both within the mosque and without, as its members met with two muralists—a Jew and a Catholic—in order to discern how to capture in pattern and color the diverse interpretations of Islam they represented. "This was a big step for our community, to let a Jewish man and Christian woman do this work, to let other people touch our sacred walls," said Ibrahim. "Building up trust was the key issue in this project."

The Jewish muralist, Joe Brenman, a classically trained painter who lives in the neighborhood, expressed similar concerns, given his own hesitations about his faith, its relationship to Islam, and his misconceptions of Muslims.

"My intention with my murals is getting the artwork done and making it the best I can make it," Brenman acknowledged. "But I went

Doorways to Peace: detail, Joe Brenman and Cathleen Hughes, 2006, © Philadelphia Mural Arts Program.

into this project with a different intention, of making a change in attitude—of my own and the people I was working with." Listening to the prayers being sung inside the mosque everyday as he painted and speaking with members of Al-Aqsa in their comings and goings from the mosque facilitated that process of achieving a deeper understanding rooted in relationships of trust. "All of that uncertainty was a good thing," he concludes, "because it made everybody have to talk more and deal with these questions. It ended up being a good thing. I had to keep showing up, talking to the guys, building trust."

Cathleen Hughes, the Catholic abstract painter charged with the challenging task of designing the geometric patterns that would appeal to the aesthetic sensibilities of Muslims from so many parts of the world, as well as the religious aesthetic that prohibits visual representation of Allah, the Prophet, or any living creature, tapped her Celtic roots for inspiration. An awareness of the similarity in the two traditions—Celtic and Islamic—connected her more deeply to the project and kept her grounded when working on scaffolding fifty feet off the ground. It also became a point of unity with other traditions and cultures—Mexican, Jewish, Native American—that also rely on repetitive patterns to capture a sense of the sacred. *Doorways to Peace*, in her estimation, "gives recognition in a really positive way to a community, often in our current times, perceived in a one-dimensional way."

An intense process of regular meetings gave people opportunities both to speak and to listen and ultimately to develop a deep relational trust within the faith community itself, which features thirteen distinct nationalities. Taking steps to be a more public presence in their neighborhood led the community to discover an enthusiasm for their project among neighboring faith communities. Ibrahim expanded their parameters by incorporating classes from two elementary schools in North Philadelphia—one public and the other parochial—in a curriculum that examined the idea of peace in the Abrahamic traditions through art and poetry. The students' work ultimately made its way into three murals on the south side of the building, depicting their visual exploration of their shared values of peace, hope, and love. Once the painting of colorful geometric shapes in pastel hues began, more and more people from the mosque and surrounding community wanted to get involved. Before long, folks were hand rolling and painting the more than four hundred tiles—some with the ninety-nine names of Allah calligraphed in Arabic and English—that adorn

Doorways to Peace: detail, Joe Brenman and Cathleen Hughes, 2006, © Philadelphia Mural Arts Program.

the building. Al-Aqsa hosted several "community days" in the basement of the mosque for neighbors who also rolled and painted tiles. They not only reached out to the community but also invited others into their own.

Al-Aqsa now stands as a cultural landmark in Philadelphia. Brenman notes that on bright days the sun catches the mural's gold paint and the mosque literally glows. In many ways the light emanating from this space captures the spirit of this community, which has ventured out into the city in interfaith peace walks and community service projects and continues to welcome mural tourists into their sacred space. This mural and others like it move Americans beyond our national obsession with the conflict that occurs when faiths *collide* and instead reflects the transformation possible when faiths *create*.

Religion in Today's Urban Public Square

A final distinguishing feature of community murals in Philadelphia is the remarkable number of faith communities who have incorporated mural making into their community formation and social ministry

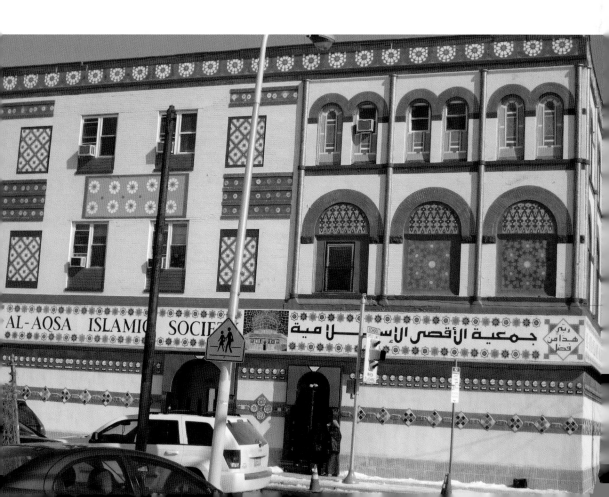

within and beyond their congregations. Murals increasingly offer ways for faith communities to get involved in the public life of the city. That congregants in Philadelphia's churches, mosques, temples, and synagogues want to contribute to public life should come as no surprise. Faith traditions, particularly the Abrahamic traditions, have long espoused the public significance of their central meaning-making symbols and storied moral codes. Kenneth and Michael Himes vehemently contend that "the one who retreats from the cares and concerns of his brothers and sisters because those concerns seem a distraction from God simply does not know what the word 'God' means in Christian discourse." That 25 percent of the more than three hundred annual applications to MAP come from faith-based communities calls attention to the creative vibrancy of American religiosity in this particular urban public square.

In many ways, this creative religious activity is germane to Philadelphia's public square. After all, Russell Weigly notes that William Penn's original vision was that the city be a "refuge for the persecuted, where the spiritual union of all Christians might be more than a dream." The diversity of Christian communities who found a home in Philadelphia by the 1780s, with memories of religious division and persecution still fresh in their collective consciousness, is evidence of the appeal and feasibility of Penn's vision: Anglicans, Baptists, and Presbyterians, Catholics populated the city as early as 1732, and Jews shortly thereafter in 1745, with the first synagogue erected on the centennial of the city's founding. Mother Bethel African Methodist Episcopal Church in the heart of the city is the oldest religious property of its kind in the country. "By the close of the colonial period," explains social historian E. Digby Baltzell, "Pennsylvania was, ethnically and religiously, more like modern America than any other colony."

Philadelphians are not outliers when it comes to vibrant religiosity. The Pew Forum on Religion and Public Life reports that 71 percent of Americans are absolutely certain in their belief in God or a universal spirit, 56 percent say that religion is very important in life, 37 percent attend weekly worship, and 58 percent pray at least once a day. Two-thirds of Americans who are active in social and political movements identify religious motivations for their commitments.

Yet not even a visionary like William Penn could have foreseen the contemporary challenges to his "Holy Experiment" in religious tolerance. Several arise from current socioeconomic conditions explained in previous chapters. Americans, particularly Philadelphians throughout the city's history, prefer the personal and the private spheres of the

home and the parish or congregation to the collective or public spheres of local government or citywide campaigns for social welfare. We face not only tension around issues of the separation of church and state but also, perhaps more pressing, the social implications of the segregation of the self from life in community. American Christians' preoccupation with issues of personal ethics such as reproductive rights and marriage, our move to privatize a variety of public services (energy, sanitation, education), and our declining rates of participation in collectives such as neighborhood associations, Catholic Youth Organizations, or bowling leagues provide the evidence for this preference.

Moreover, in a way that contradicts the spirit of the Founding Fathers, the nationalism that has shaped American identity in the decade following the terrorist attacks of September 11 has conflated Christianity and patriotism, religiously justifying violence and discrimination both abroad and at home in the name of securing the homeland and defending American freedom and values. Much as it did when it became the official religion of the Roman Empire, the collusion of Christianity with America in an Age of Empire gives rise to what Scripture scholar Walter Brueggemann calls an "imperial religion" that ultimately serves those in power, supports policies of oppression, and suffocates a longing for change with a paralyzing satiation with the status quo. It was precisely their outrage with the religious values that arise out of such a collusion of religion and the state that landed English Quakers in English prisons and ultimately convinced them to leave imperial Europe altogether.

On a related note, the various processes of globalization affecting American cities also impact religion and public life in America. Religion is just another commodity traded in the marketplace of ideas, where Darwinian survival-of-the-fittest logic and the values of whiteness monopolize religiously motivated citizenship. In an age of globalization, religions either are subject to consumerist desires for individual self-actualization that shun their intuitional frameworks or yield to the exclusivist postures of strident believers who think that religious pluralism is nothing more than an attack on their particular faith and therefore their communal identity. Evidence of the former can be found in the growing numbers of Americans, 16 percent according to the Pew Forum's 2008 "U.S. Religious Landscape Survey," who shake the confining bit of institutional religions and identify themselves instead as "spiritual but not religious" or "unaffiliated." The implications of more exclusivist stances manifest themselves in the various expressions of fundamentalism or "strong religion" embodied in some way in practically every religious tradition on the planet that at best seeks to separate

"true" believers from those who have fallen away and at worst to impose religious values on the wider society.

Finally, many faith-traditions today have experienced a dramatic decentralization of power since the latter half of the last century, a change that might actually be rather familiar to William Penn whose colony was little more than a hodgepodge of religious believers united not by religious or civil authority but rather by a single concern—a quietly righteous and prosperous life. Faith communities are increasingly "multi-centered" or anchored in local communities with distinct socioeconomic and cultural conditions. In some ways this multicenteredness reflects the spirit of the seventeenth-century Quakers. A growing number of today's believers seek after experiences of transcendence rather than a desire to dwell in the confines of institutional religion. This restlessness takes them across once-impassable denominational lines. Many also distrust authority figures as a result of hypocrisy and scandal, which continue to erode institutional religions. Moreover, as their numbers continue to dwindle, many of the monotheistic traditions struggle to articulate their relevance by engaging in the socioeconomic and cultural reality. And yet, as the manipulation of religious leaders and voters can attest, doing so comes at the cost of cultural distinctiveness and political co-option.

Walls throughout the City of Philadelphia offer a way into these confounding circumstances of religion in contemporary urban public life. Murals on Baptist and storefront churches, a Buddhist temple and Islamic mosque, a former Catholic convent and a Jewish community center all "build religion into the landscape," a phrase used by

◄ *Doorways to Peace:* detail, Joe Brenman and Cathleen Hughes, 2006, © Philadelphia Mural Arts Program. ►

Colleen McDannell to speak about the material nature of religious practice. They underscore the fact that religion indeed serves as a viable "placeholder" in multicultural and pluralistic communities.

Community murals that are created by faith-based communities or that incorporate religious symbols and images are not simply a representation of particular religious truth claims. Nor do they primarily illustrate the distinctiveness of the faith traditions of those who create them, or specific notions of the Divine as understood by a particular community. Rather, murals visually express the meanings of these truth claims, which are informed by the lived experience of particular communities. In turn, they shape people for life in urban communities where multiculturalism and religious pluralism are unavoidable. To use Catholic theologian David Tracy's words, these images do not "repeat" religious traditions as much as carry them forward in the midst of a new sociohistorical context—one defined by all the characteristics we have seen at work in contemporary urban America: individualism, consumerism, whiteness, and multicultural religiosity. In many ways, these factors make the beauty of Philadelphia's faith-based murals that much more arresting.

This final section explores the arts as a conduit for public theology, civil religion, and interfaith dialogue in urban contexts. It illustrates what happens when people of different faith traditions seek to *create* with one another in the public square rather than simply *clash* with each other there.

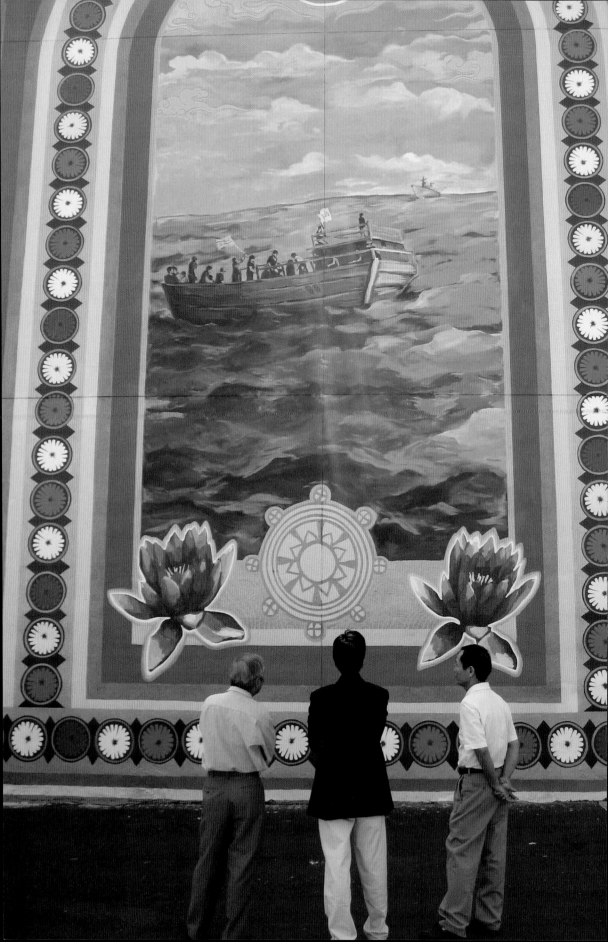

Chapter Fifteen

Visual Public Theology

"Everything we've done you can see today," said Edward Nguyen, founder of the Bo De Vietnamese Buddhist Temple, of the images in *The Journey: Viet Nam to the United States* (Shira Walinsky, 2007) at the mural's dedication on a five-story wall of the temple. The ceremonial drums had quieted and monks in saffron robes intermingled among community members, muralists and their student apprentices, and politicians in holding onto the bright red ribbon that was about to be cut. "I've been dreaming about this mural for many years," he continued, "and what it might mean for the next generations."

Members of the Bo De Buddhist Temple, blocks from a famous intersection in South Philadelphia and spiritual home to a growing Vietnamese community, discerned that their ongoing journey of immigration would be the central theme of their mural, since flight from Vietnam shapes the self-understanding of so many in their faith community, which was founded in 1994. Census data from 2000 indicate that more than six thousand Vietnamese immigrants now call Philadelphia home, making it the third-largest population of Vietnamese on the East Coast. In a 2008 report, the Brookings Institute named Philadelphia's metro area as a "re-emerging gateway city" since it has the "fastest growing immigrant population" of any of its peer cities, with 60 percent of those folks arriving after 1990, 39 percent of whom are Asian.

Their choice seems even more fitting, given the fact that in a former life their sacred space was home to the North Italian American Club, a place where Italian immigrants, like the father of City Councilman Frank DiCiccio, present at the mural's dedication, "could be proud of culture

The Journey: Viet Nam to the United States: detail, Shira Walinsky, 2007, © Philadelphia Mural Arts Program.

and perpetuate their traditions." Muralist Shira Walinsky and a group of aspiring muralists from high schools all over the city spent eight months meeting with members of the temple, "sharing their stories, their culture and the spirit of Buddhism . . . breaking down ideas and then trying to come up with symbols and then bouncing them back" in order to capture that image seared in individual memories and to convey what this faith community hopes to offer their neighbors. Since memories of the escape were so vivid, designing an image of the boat and the water that would resonate with all was not an easy task. But Walinsky surmounted the challenge with community and color.

"Where did you get that?" Nguyen recalls asking Walinsky in amazement when he reviewed her final design of the boat and the water, since there wasn't a single photograph to serve as her muse.

"Sometimes community is an empty term," she recalled of her eight months of collaboration with folks from the temple. "But they were really open and lived up to the term through their generosity and hospitality. They came together; families came together, and celebrated holidays and mourned together. Inviting us to be part of that experience remotely connected us to something so powerful and so beyond ourselves. . . . You want to get as much of the idea behind the story as well as their intention in telling it. Color can make a whole out of diverse images."

The vibrancy of faith communities like the Bo De Temple, engaged in community murals, speaks to the continued vitality of public theology, a distinctively American approach to bringing faith to bear on politics or public discernment about the good life and ways to procure it. Kenneth and Michael Himes define public theology as the attempt to discover and communicate the socially significant symbols, stories, and images of religious traditions so that they might be a resource for public discussion about the good life and its requirements. Public theology keeps faith relevant by reformulating beliefs in light of contemporary realities. It critically engages public policy, culture, and society and therefore represents one of the more viable strategies that communities of faith might use to "go public" with their values and commitments in a religiously plural and increasingly polarized public square. This approach to illuminating the public implications of faith resists the tendency to privatize faith commitments that occurs when we relegate faith to the private sphere or limit it to personal issues. Public theology identifies and communicates the social significance of the meanings of religious *symbols* using public reason, intellectual solidarity with others in the public square, and a keen awareness of social responsibility for

the good of *all*. It will use the particular symbols, stories, or doctrines of faith traditions to shape and critique public polity.

Public theology is increasingly crucial in urban contexts where the dramatic influx of immigrants, both legal and undocumented, fosters an uncritical nativism that shapes personal encounters and public policy with racial bias, where multiculturalism and religious pluralism easily lead to fragmentation that precludes collective action among faith-based organizations, and where the disposition and practices of the global economy dictate the discourse around urban poverty that disproportionately affects people of color. And yet a number of factors make traditional approaches to public theology—rational discourse, appeals to goodwill, engagement in public policy—increasingly rare.

Challenges to Public Theology

A variety of aspects of today's public square threatens the viability of public theology, particularly when it comes to engaging issues of urban poverty that we have examined in previous sections. Generally speaking, our hyper-individualized, privatized, and commercialized climate in contemporary American culture calls into question whether any kind of collective commitment to life in community is possible. We simply are not concerned with the public or common good, and even in the moments when we are so concerned, we have failed to habituate the public virtues that translate that concern into collective action. Catholic theologian Mary Doak explains that public theology in the United States has to deal with a "lack of public interest in clarifying a common good and with the widespread tendency to seek private resolutions for all public problems." Also, believers face a "catch-22 situation" when they attempt to bring their religious symbols and narratives to public discourse. The validity of their claims is questioned by both the wider culture for their seemingly nonrational foundations in religious traditions as well as fellow believers who claim that attempts to make religious principles palatable to the wider culture compromise their distinctiveness.

In addition, we must acknowledge the limitations of a discourse-based approach to faith and public life in light of the fact that discourse itself has fallen on hard times. We are increasingly aware of the ways in which language is socially constructed and excludes persons based on sex, gender, race, class, and religious identity. This is particularly true of the languages that sociologist of religion Robert Bellah claims dominate the American public consciousness—biblical, individual,

and republican—which have long denied the full humanity of certain groups in the process of shaping the nation's identity. In addition, reliance on debate or discourse can unintentionally exclude those without access to the places where this discourse usually takes place, whose methods of communication are not recognized by mainstream culture, or who simply cannot speak English (a growing number of inner-city residents). And while the technological advances of the twenty-first century might enhance connectivity, they have also deteriorated our ability for embodied, face-to-face dialogue in real time.

Also, a variety of civic "virtues" once touted as essential for life in community have morphed into civic "vices" in an increasingly privatized, consumerist, and fearful culture: tolerance of difference has become apathy for extreme social inequality, social responsibility for all is now translated as personal responsibility to self, civic-minded rhetoric has been transposed in a cacophonous key of ideology, neighborliness has deteriorated into enclavish exclusivity, and cultivating an "us" increasingly relies on a "them" to exclude, distrust, or hate. Moreover, Doak wonders if discourse is even possible since "evidence suggests

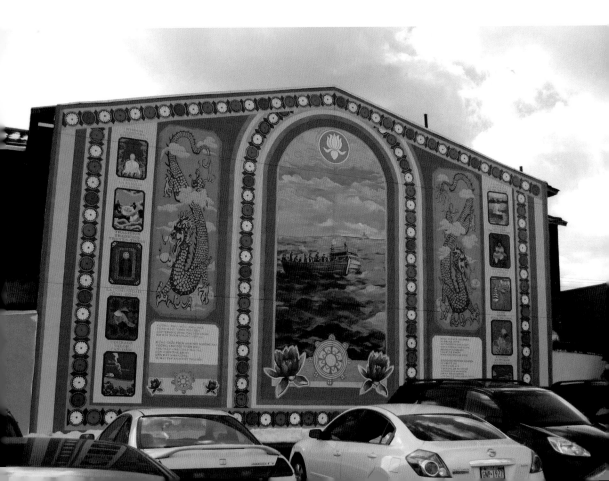

that the threat of terrorism will be used primarily to enforce greater homogeneity and to stifle rather than to invigorate public debate."

Since it attempts to make broad appeals to universal truth claims, using a natural law approach to moral reasoning, public theology tends toward abstract intellectualism or conceptualism. Appeals to human dignity justify demands for a common good or for human rights, but precisely what these ideas look or feel like, or precisely what constitutes experiences of human dignity, is unclear. As such, it fails to appeal to the increasing number of Americans who, in the estimation of Alan Wolfe, a sociologist of religion, "seek authenticity through experience rather than through ideas." Wolfe notes a turn toward the experiential in every faith tradition on the planet. People are less drawn to the truths, creeds, or doctrines of particular traditions and tend to favor experiences of self-transcendence that faith traditions facilitate. So long as it attempts to bolster dialogue through appeals to truth articulated in creeds and symbols, at the expense of experiential wisdom, public theology will be eclipsed by other approaches to faith and public life.

Finally, we must consider the specific challenges that faith in the *urban* public square present to public theology. In cities where wealth and poverty are concentrated in such close proximity to each other, the different ways that images and narratives of religious traditions function become increasingly apparent and often difficult to bridge. Communities of affluence, for example, invoke and apply the central principle of the "dignity of the human person," illustrated in a variety of New Testament parables, to issues of personal ethics such as reproduction, abortion, and marriage, while those in poorer communities use the same biblical texts and principle to evoke commitment to social issues such as employment, health care, and education. In addition, the alienation and isolation that accompanies the codes of the street and of whiteness erode social trust and preclude meaningful conversation. People in both groups are often predisposed to dismiss each other. Finally, as we saw in the second section of this book, after decades of population decline, older central cities such as Philadelphia are experiencing a dramatic influx of immigrants, both documented and undocumented, whose struggle for assimilation in a post–9/11 America differs significantly from previous waves of immigration and who present challenges to public theology in terms of language and engagement in religious traditions.

The Journey: Viet Nam to the United States: detail, Shira Walinsky, 2007, © Philadelphia Mural Arts Program.

Toward an Aesthetic Public Theology

In some ways these limiting factors have more than likely contributed to the faith-based mural movement in Philadelphia. With traditional avenues of discourse closed to them, faith communities turn to the walls of their sacred spaces or in their communities to articulate the public significance of the symbols and stories of their traditions. Cultural historian Colleen McDannell reminds us that religions are not simply ideas but lived expressions of truth that, when articulated through artistic expression, create a special opening for engagement that goes beyond language or discourse. To that end, they offer new possibilities for public theology.

Community muralism inadvertently responds to the catch-22 that hampers many contemporary believers by moving the focal point of public religious discourse away from foundational claims or their distinctive religious character and toward a particular reality—concentrated poverty or religious pluralism, for example—that affects secular and religious citizens alike. These images bring this common denominator into sharper focus and galvanize religious and civic commitment to address it. Frank Burch Brown notes, "The religious art that has the greatest significance is not necessarily the art of institutional religion but rather that art which happens to discern what religion in its institutional or personal forms needs most to see." Community muralism is precisely the kind of art that assists religious institutions and believers in perfecting their ability to see reality more accurately. As such, it illustrates an alternative mode of public theology. Community murals painted by faith communities bring the resources of various traditions to bear on a variety of social justice issues facing inner-city Americans—from adolescent drug use and incarceration to religiously motivated hate crimes and family violence. "When you look at a mural," explained Jane Golden at the dedication of *All Join Hands: The Visions of Peace*, "I urge you to think about it as a medium for discussion and connection. This kind of art can become a common ground from which we challenge the cycle of crime, poverty, and violence and overcome the fear and alienation they cause."

The arts, particularly community murals, bring what Doak has identified as a much-needed narrative focus to the discourse in which public theology is so invested. Murals share not just symbols or images from traditions but the stories of the faith communities who paint them and tales of how people experience or live out the imperatives of those stories or images. An emphasis on story, community, and color can avoid many of the previously mentioned dead ends in public theology.

The Journey: Viet Nam to the United States exemplifies these points. A boat filled with people being tossed on waves, a wheel of life, and a lotus flower are dominant images, framed by eight smaller symbolic representations of the values of the community: family, courage, tradition, culture, community, wisdom, journey, loyalty, and homeland. In recognition of their Mexican neighbors—formed by their own immigration stories and for whom these values have their own meanings—the community chose to communicate these values in Vietnamese, Spanish, and English. The giant lotus flower symbolizes new life emerging out of the muddy messiness of life and a need for greater self-understanding and understanding of others in the midst of religiously plural neighborhoods.

"We are living in an age where we have a need for spiritual growth, a desire for new knowledge, to understand our roots which are the source of our happiness," explained Edward Nguyen. "The lotus symbolizes a belief in religious freedom, in truth, compassion, and wisdom for all."

Muralism also shifts the emphasis in public theology from speech to action. More than simply invoking the familiar adage, "a picture is worth a thousand words," murals put people to work in the process of creating something out of nothing. Rather than simply convene citywide conversations on race, on education, or on youth violence, muralism commissions people to make abstract ideas come alive through symbol, color, and poetry. To make a mural requires that people come together, tell their stories,

The Journey: Viet Nam to the United States. detail, Shira Walinsky, 2007, © Philadelphia Mural Arts Program.

listen to others' stories, and put individual visions aside in order to come up with an image that captures the whole. Perhaps more important, they require that people embody the ideas they paint. To paint forgiveness, victims and perpetrators need to practice forgiveness. To paint a vision of one's congregation as a door that is open to all requires that congregants be welcoming to all in the community, particularly ex-offenders. Muralism fosters a kind of kinesthetic engagement that scholars recognize as increasingly important, given that, on average, we capture or process only a third of what is communicated in spoken conversation or dialogue.

The processes and products of muralism render public theology better able to attend to the changing dynamics of the urban and global public squares. Like public theology, muralism begins with a commitment to honest and humble dialogue and a basic desire to enrich public discourse about issues that affect all persons and not just particular communities. Unlike public theology, however, which relies on natural law reasoning in order to arrive at broadly construed and hopefully inclusive points, muralism incorporates the moral imagination to appeal to the goodwill of those in the public square. Doing so makes faith communities more effective in appealing to the underutilized affective aspects of human experience that can bind persons together—compassion, mutual respect, love for earth and children, human rights. And where public theology is limited by the confines of written and spoken language, muralism turns to imagination with its seemingly endless possibilities for ongoing interpretation. This makes faith communities who use murals more effective in communicating the significance of their respective faith traditions in political discussions.

To that end, as we noted in section 5, faith-based murals contribute to our social imaginary, which Charles Taylor describes as "the ways in which people imagine their social existence, how they fit together with others, how things go on between them and their fellows, the expectations which are normally met, and the deeper normative notions and images which underlies these expectations." They move our social imaginary beyond the limits of reason, which we often invoke to determine what is possible and instead remind us of the power of mystery and a sense of what might be. They incorporate nonverbal communication that moves beyond the confines of discourse and cultivate embodied and imaginative practices that are often ignored and yet essential for our communal lives together.

Journey from Private to Public

Faith-based community murals simply resist the temptation within religious communities to isolate themselves from the public square as well as the coercive segregation they sometimes experience when they do engage in public life. Murals create public space in the civic realm for telling and hearing stories of communities that make up the fabric of the city and explaining the contemporary significance of symbols or practices at the heart of ancient religions. They fill in holes in the collective memory of Philadelphia's immigrant past or point to chapters yet to be written and publically acknowledge the presence of faith-based communities as anchors in demographically dynamic neighborhoods, illuminating the contributions they make to civic life, whether through sharing their distinct culture or caring for the one-third of immigrants who live below the poverty line in Philadelphia.

"As Philadelphia shifts and neighbors experience economic and social change, we have to think collectively about how to hold onto the soul of the city," explained Jane Golden at the dedication ceremony of *Journey.* "We need to hold onto traditions and stories of the past before they are covered up by new communities. This mural says, 'We are here!' It is a way to create meaning in peoples' lives, to make Philadelphia a city where community really counts."

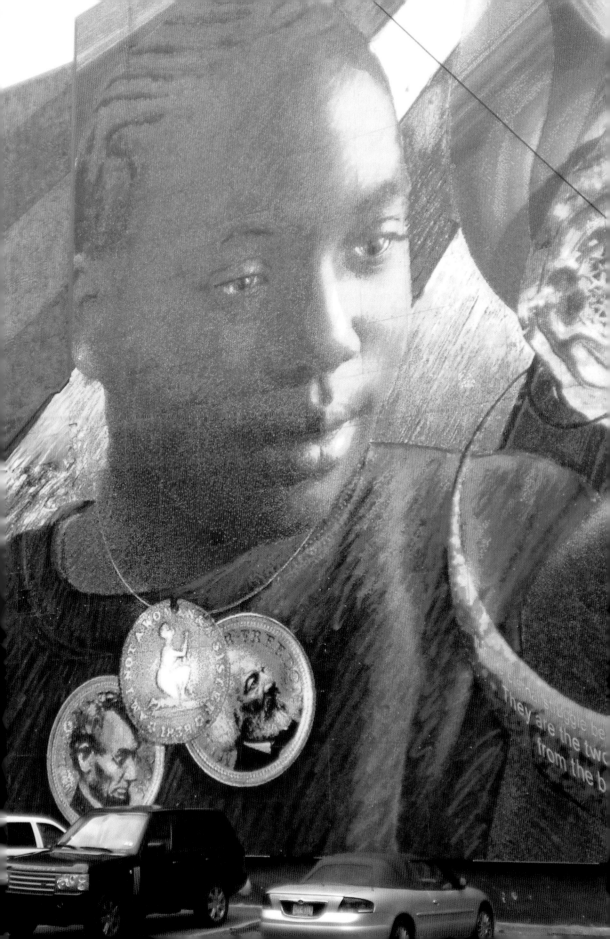

Chapter Sixteen
Visual Civil Piety

When Lincoln Financial, an international financial firm headquartered in Philadelphia integral to the city's twenty-first-century economic backbone, pledged funding for a public art project that would explore with students in city public schools the significance of Abraham Lincoln, few could have predicted the outcome. The image of this saintly figure and martyr in American civil religion is underwhelming in the one-hundred-thousand-square-foot mural done in nearly one million three-quarter-inch Venetian tiles just three short blocks from Independence Hall, sacred civil ground and a place where Lincoln himself made a significant address as president-elect in 1861.

That public art—statues, monuments, memorials—is a touchstone of American civil religion makes Lincoln's minor role in a mural about his legacy even more telling in terms of what community muralism brings to civil religion. In this mural we discover overlooked facets of the stories we tell and civic practices we embrace as "Americans": the death of countless Africans on their way to enslavement in the colonies and the resilience of their descendants in spite of dehumanizing bondage in the world's first democracy; the religious fervor that guided the abolitionist movement and the women who stood at its front lines; sensibilities and practices of African culture that remain distinct threads in a European garment. Perhaps as a reflection of the students' awareness of Lincoln's contested stance in relationship to slavery, the slain president appears only in a medallion around an African American child's neck (a young girl who worked on the project)—along with images of Frederick Douglas and Sojourner Truth. Symbols of slavery and the stripes of the

Lincoln's Legacy: detail, Josh Sarantitis, 2006, © Philadelphia Mural Arts Program.

American flag bleeding through the boards of a slave ship serve as a visual testimony of the dead of the middle passage and slaves whose experience is not commemorated in our nation's history—and, ironically, this testimony is offered just blocks away from Independence Hall. The talisman she holds is a West African symbol for spiritual protection; the blue flame that dances in the child's hand with an elder at its center who captures her gaze attests to the fact that legacies combine past and future. The expectant hope in her eyes and the colorful tiles point to the resilient joy of the African American community in Philadelphia.

"You can't be an American and not be affected by slavery," says the late Philadelphia muralist Ras Malik who frequently used religious imagery to capture the spirituality inherent in the process of mural making as well as in the African American community's process of meaning making. "It leaves a lot of subjects that are available to black artists or scenes that could be explored. There is a whole history and message right there on those walls. Our people need to know this."

Visible Piety and Civil Religion

"Religion" or "religiosity" has long been an element of the American ideal of *e pluribus unum*, our collective attempts to make one nation from many parts. In fact, regardless of religious affiliation, most Americans practice some form of "civil religion," which, like any religion, helps us to navigate the various boundaries of our social lives, be they economic, political, ethnic, or religious. Sociologist of religion Robert Bellah defines civil religion as the "apprehension of a universal and transcendent religious reality as seen in or . . . as revealed through the experience of the American people." Religious scholar and public intellectual Martin Marty considers Americans' shared civic sensibilities and practices as a "religion," since they reflect many of the components we recognize in most religious traditions: an ultimate concern (life, liberty, and the pursuit of happiness), myths and symbols that provide and sustain meaning (the first Thanksgiving or the bald eagle), sacred spaces (halls of government or national parks) and private devotions (flying the flag or hanging a photograph of the president in the living room), a moral code that supports communal identity (the Bill of Rights), behavioral practices (the pledge of allegiance or voting), and rites and ceremonies that bind the community together (inaugurations or parades). Mary Doak notes that civil religion "[invokes] religious beliefs and symbols in support of a country's values and practices" and as such seeks to create a "least common denominator" experience among increasingly

diverse persons and a shared experience of transcendence facilitated by civic stories, symbols, and monuments.

Civil religion relies on the arts to create and sustain this unifying sense of transcendence that gives rise to a sense of "the one." The arts articulate civil religion's ultimate concern (the rhetoric of Kennedy's or Obama's inaugural addresses), convey its central myths and narratives (the sense of frontier conveyed in *Hudson River Valley* paintings), commemorate its heroes (the Martin Luther King Memorial in Washington, DC), make the transcendent immanent (the eternal flame at the Tomb of the Unknown Soldier in Arlington National Cemetery), cultivate communal identity ("The Battle Hymn of the Republic" or "America the Beautiful"), and bolster emotions that motivate actions on behalf of national interests (marching bands in Fourth of July parades). Civil religion also turns to the arts to celebrate the rich cultural diversity of "the many" of the American experience: sculptures and profiles of native Americans adorn the capitol and coinage, epic films such as *The Godfather* capture the immigrant experience, Negro spirituals such as "We Shall Overcome" nourished the Civil Rights movement, or 9/11 murals in cities around the country remember the fallen. Therefore, the arts cultivate a "civic piety" or a devotional disposition and set of practices that inculcate a sense of the transcendent and bolster related values and practices. David Morgan contends that in some cases public arts foster a "visual" civic piety insofar as they are "practices, attitudes and ideas invested in images that structure the experience of the sacred," in this case, the experience of the nation.

Civil religion is palpable in American cities, especially those like Philadelphia, that physically hold the memory of saints and feast days connected to the nation's founding and bequeath their legacy to generations of residents. As such, it plays an integral role in shaping contemporary understandings of the central tenets and rituals connected to American citizenship: freedom and equality, tolerance and brotherly love. Nevertheless, like public theology, the vibrancy of civil religion is waning as it becomes increasingly more narrowly construed in our contemporary context.

The Decline in Civil Religion

Despite its pivotal role in shaping American identity throughout our history, many sociologists of religion claim that the term "civil religion" is increasingly out of vogue. "If there is any discussion of truly overarching civil religion," Arthur Farnsley notes, "it centers more on

religious abstraction, invoking patriotism, politics or the totemic significance of sports teams more than what we used to call religion." Like its public theology counterpart, civil religion in the United States faces a variety of challenges, many of which stem from the changing, and some would even say destabilized, role of "religion" in American culture: secularization or the declining dominance of religious frameworks of meaning and social order; the evolution of religion from a centralized "sacred canopy" that sheltered culture to a "sacred patchwork quilt" of localized subcultures that smothers any monolithic sense of "culture;" the increased collusion between religious expression and consumer choice or economic development; and the hypocrisy of religious leaders and communities with vested interests in political and cultural affairs.

Civil religion is further challenged when this at-times cynical uncertainty about religion is coupled with an equally cynical uncertainty about the possibility of "civility" or "civic virtue." Even the idea of "community" seems to be fading from the American experience. At the turn of the millennium—and in the midst of intensifying cultural pluralism, a new wave of immigration of both documented and undocumented persons, a War on Terror, and an economic downturn—what it means "to be an American" is a dangerously polarizing question. Sociologist of religion Robert Wuthnow notes that American culture is organized around two competing civil religions, each legitimized by our national creed, the Pledge of Allegiance. One emphasizes our religious identity as "one nation under God" and gives rise to heated conflict as to whose God we are organized under. The God of Christians? Which Christians? The God of Islam? Which Islam? Why God at all? The other strain of our civil religion emphasizes our political identity as a people committed to "liberty and justice for all." But this too comes with a set of contested questions. Are liberty and justice of equal value? Do we understand these ideas in private or public terms? Do we really mean to extend them to all? The tension between these strains—and within them—is fracturing American identity.

This trend toward divisive ideology is exacerbated by what Robert Putnam has identified as the disappearance of "mediating institutions" such as neighborhood associations, hobby groups, and bowling leagues that once honed the skills needed for life in community—friendship, empathy, openness to difference, and social responsibility. Without these collectives, we have seen the "social capital" or "social trust" that comes from civic engagement slowly depleted by cynicism. "If people trust each other," explains Quaker educator Parker Palmer, "they will come into community, they will generate abundance . . . abundance that

comes from knowing that we are willing to feed one another, knowing that we are in those generative relationships where when you need my support, I'm there to offer it as best I can and when I need yours, the same is true of you." Without the pull of life in community we are pressed into the isolating practices of hyper-individualism that deny both the intrinsic goods of life in community as well as a meaningful sense that the good of the whole is worth more than the individual parts. People no longer take each other at their word. We tend to look suspiciously on social welfare. We feel polarized by identity politics and suspect that our leaders are no less socially constructed than our consumerist desires. "Just like identity politics," notes Jean Bethke Elshtain, "the decline of civil society at once manifests and reinforces the increasing inability of American society to pursue a good that is common."

Finally, civil religion in the United States suffers from a severe case of amnesia, which I believe will be its ultimate undoing. We use the myths, rituals, codes, and creeds of our civil religion to forget the tragedies of American history and its victims: the genocide of Native Americans, a revolutionary Declaration of Independence that was not extended to African slaves, an economic supremacy built on slave labor and the unjust labor practices of the industrial boom, policies around homeland security that justified internment camps for Japanese Americans and the profiling of brown-skinned persons crossing borders, the use of atomic weaponry that exterminated 110,000 Japanese civilians, "equality" through segregation in Jim Crow laws of the South. As a result, some American citizens understandably refuse to participate in a civic religion or contribute to a civic community so compromised by voluntary ignorance. In such a fog of forgetfulness, civil religion is no longer about the common good but about protecting those who enjoy the spoils of empire in the *Pax Americana*. "Set the songs for a country, determine its stories, and you will have power," explains Martin Marty.

Limited memories of the past give rise to civic practices in the present that disproportionately disenfranchise people of color and preclude their contribution to collective dreaming about the future. A narrow civil religion excludes persons of color from contributing their own stories of origin that might bring moral ambiguity to American civil righteousness. It justifies changing immigration laws in the name of protecting the economic interests of "natives." It refuses to amend the constitution to deter gun violence, which disproportionately affects the urban poor. It domesticates the dangerous memories of central figures from underrepresented groups, softening the socially critical nature of their words and the prophetic witness of their lives.

Visual Remembrance

Muralism addresses the selective nature of our civic memory and our skewed collective memorializing by "remembrancing" persons and events. As someone familiar with this kind of cultural forgetfulness in Germany in the decades that followed World War II, theologian Johann Baptist Metz suggests "remembrance" as a way to resist denial couched as amnesia. More than simply remembering the past, remembrance is an actively embodied and communal practice of memory that pays particular attention to stories of human suffering so that we might see our present reality in a more accurate light. These "dangerous memories" of unjust suffering have interruptive power. They bring historical consciousness to civil religion as well as to what Metz calls a "mysticism of open eyes" that "makes visible all invisible and inconvenient suffering, and—convenient or not—pays attention to it and takes responsibility for it." They "break the spell of history as a history of victors" and "resist the flow of time" by reminding us of a future that we have forgotten, a future that is radically different from the present. That the word "remembrance" is incanted in the eucharistic prayer, "Do this in *remembrance* of me," is aesthetically significant. Remembrance "re-members" or puts back together the corporate Body of Christ broken apart by unjust suffering. It also reignites our capability for memory and imagination, since when we remember Christ we also remember the future that he promised.

Muralism offers contemporary faith communities innovative and liberating means for remembrance. Generally speaking, by incorporating historical consciousness into civil religion, murals offer an opportunity for faith traditions to acknowledge their participation in the tragedies of American history and to ask for forgiveness for these things. This humility not only restores the credibility of faith traditions but also liberates the moral imagination from entrenched or defensive stances against secularism in order to think about ways that religious traditions might contribute to responses to social injustices. It also makes for more authentic interreligious engagement when we acknowledge that a common denominator is compassionate commitment to neighbors.

More specifically, murals offer a particular method of remembrance. By visually portraying historical narratives—of individuals or communities—these images help us to remember the tragic or horrific features of civic memories in a way that encourages a more inclusive and accu-

Lincoln's Legacy: detail, Josh Sarantitis, 2006, © Philadelphia Mural Arts Program.

rate recollection. Since they use images that unleash the affections and emotions and invite a variety of interpretations, murals challenge the prevailing wisdom anchored in knowledge or authority that often calcify our memory into ideology or further alienate Philadelphians from our shared history. Recall Rebecca Chopp's idea from the third section of "the poetics of testimony" or "the discursive practices and various voices that seek to describe or name that which rational discourse will not or cannot reveal." Testimony, in her estimation, is "more tensive, more poetic, and more open to diversity" since it offers truth claims rooted in particular experience and evokes an ethical response or summons from those who witness to it. Murals are visual testimonies of remembrance since they meet Chopp's criteria of "telling the truth as [these communities] see it, as they experience it, and what truth means to [them]" so that we might imagine ourselves and others living differently in the future. The very fact that painting murals is a collaborative activity that increasingly involves otherwise divergent constituencies in urban communities speaks to the power of their invitation to create something new.

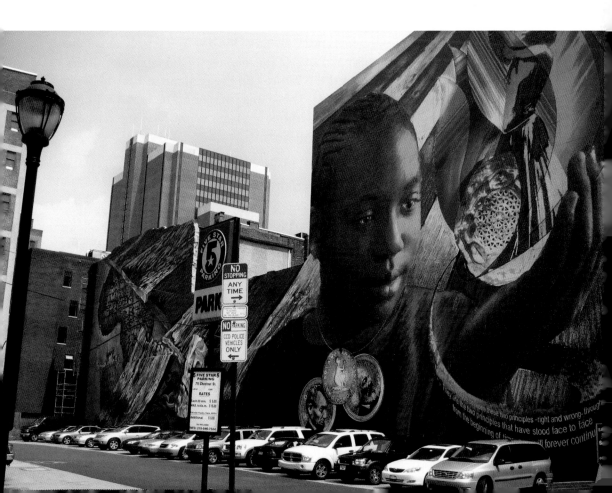

Perhaps most important, murals provide a viable means for re-membering black bodies in our civic memory. As Bryan Massingale put it to a worldwide gathering of moral theologians, "Black bodies are a structural reminder [of injustice] that haunt history." By remembrancing black persons throughout Philadelphia's history in colorful and multidimensional images, murals contextualize and "complexify" the one-dimensional and virtually colorless historical record of one of America's first cities. Remembering black bodies in our civil religion brings an important hermeneutic of suspicion to civil religion: if the stories of certain groups remain untold and isolated from our grand narrative, then that narrative is little more than a myth. Murals interject the prophetic presence of these black bodies into public spaces around the city, and in doing so, African Americans are no longer specters of history but embodied participants who offer specific contributions to civil religion. Murals inculcate a resilient sense of joy, or a joy character-ized by gratitude and expectation for the future, in our civil religion by remembrancing the experiences of black bodies in the past and in our current reality. This joy counters the joy of triumphalism, often the key in which we sing many of the hymns of our civil religion, which ignores the politics of oppression and dehumanization.

Also, remembrance of black bodies in community murals brings an intergenerational dimension to civil religion. When the experiences of black bodies are remembranced, civil religion does not simply remember heroes of the nation's past. Rather, the memory of these persons directs our imaginations toward the future and the generation of Americans who will inherit that future. These images remind us that a different future will not be possible without accurate memory of the past and commitment to action in the present.

Black Theology in Civil Religion

Lincoln's Legacy (Josh Sarantitis, 2006; see p. 245) exemplifies these points, since remembrancing black bodies is its implicit theme: remem-brancing the dead of the middle passage, remembrancing the embodied yearning for freedom that sparked and sustained the abolitionist move-ment, remembrancing that it was slaves themselves and not Lincoln who made it possible to live lives of dignity and freedom even in the midst of bondage, remembrancing the children of the City of Brotherly Love in whose minds and bodies that legacy lives. As such, it and countless other murals that remembrance the embodied experience of African American communities throughout Philadelphia's history and in the

contemporary context wordlessly incorporate essential elements of black theology into civil religion. As Katie Cannon says of the "critical truism" in the work of black women writers, Philadelphia's murals unearth the wisdom of "black folk who respectfully yearn to actualize the deepest possibilities of human existence" and do so on the walls of the city.

Murals that black communities create and the images they use to express their values and visions reflect the particular challenges faced by Philadelphia's African American communities in articulating a sense of identity, a notion of God rooted in that struggle, and theological principles that arise from the community's experience as black persons. To some extent this is the very praxis of black theology. Certainly, many black community murals reflect a similar model, particularly in proclaiming national and local black leaders, both past and present. Far more, however, reflect the contradictions of a history shaped by cultural genocide, a history written by a dominant culture, and a history of searching for authentic self-expression. Murals created by African American communities bring this sense of contradiction and moral ambiguity to civil religion. Many also integrate a variety of seemingly disparate images and symbols that passionately pull the viewer into the tumultuous, conflicted, and evolving sense of community identity. In *Lincoln's Legacy*, vibrant and swirling colors, the bleeding of past into present, and a symbolic reaching for the future reflect the complexity of the thick multiculturalism of the African diaspora and resilient spirit that refuses to be consumed by the dominant white culture. In so doing, the mural raises questions about the complicity of European Americans—from the days of the nation's founding to its present—in the dehumanizing oppression of people of color in the name of truths that, while fundamental to our national self-understanding, are far from self-evident for many Americans.

Therefore, unlike their counterparts in the ethnically European neighborhoods or historical districts—places where civil religion is constructed and uncontested—these murals reflect the black community's ongoing struggle to resist what Catholic womanist theologian Jamie Phelps calls the "continued institutionalized oppression, internalized self-hatred, and nihilistic despair" that we discussed in the third section in terms of black consciousness and collective identity. Murals amplify the wisdom and resourcefulness of the contemporary community in overcoming these obstacles to individual and communal flourishing. "The very fact that black people still exist in America is an example of unyielding faith in a power greater than humankind," says Warren Dennis, an urban minister and theologian. And yet, that power comes

from within: "It means, moreover, that hope for the African American lies in reclaiming these beliefs and values as instruction arising out of the community itself." Phelps identifies this as an "African world-view" that undergirds black spirituality, emphasizing the role of the community in articulating identity and ensuring survival, a lack of concern with chronological time in light of a preference for attention to the present, and a celebration of a "central life-force or power" that preserves and strengthens the community.

Many black community murals also reflect what Shawn Copeland calls the critical, commemorative, and celebratory praxis of black theology, a praxis that our civil religion in a post-9/11 reality might do well to adopt. Let's return to *Steppers* (Calvin Jones, 1996; see p. 90), displayed on the wall of a former Catholic convent adjacent to the lot where St. Elizabeth Catholic Church, once the anchor of this community, used to stand. One could interpret the mural's critical message regarding any false or stereotypical connotations of this community or of blackness itself on the part of outsiders. The mural also reflects critically on the failure of the Catholic Church to remain a physical and

Lincoln's Legacy: detail, Josh Sarantitis, 2006, © Philadelphia Mural Arts Program.

spiritual presence in neighborhoods most in need. At the same time, the depiction of the church, as well as an elderly woman at its highest peak, commemorates the various persons who have been the bedrock, memory, and caretakers of this community. Finally, the mural celebrates its namesake, The North Philadelphia Foot Stompers, who are clearly portrayed as resolutely marching into a hopeful future. To that end, *Steppers* visually expresses what James Cone identifies as a central goal of black theology: creating "a religious value system that encourages us to love blackness passionately and without compromise."

Visual "Storied Spaces"

Martin Marty believes that stories and the practice of storytelling might be the only things capable of preventing faiths from colliding in our multicultural and global reality, since stories simultaneously bolster and undercut personal and collective identity. "People tell and hear stories," Marty explains, "whenever they make efforts to find out and say who they are and whenever they listen for the signals that help them make sense of others." Telling and listening to stories lies at the heart of all virtuous practices. Philosopher Alasdair MacIntyre notes that as "story-telling animals" humans "can only answer the question, 'What am I to do?'" if we can answer "the prior question of 'Of what stories do I find myself a part?'" Discovering the plot line and central characters of the stories in which we participate is itself a virtue that civil religion tries to cultivate, since doing so weaves us into communities identifiable by the way they understand the past and respond to the future. Through stories and storytelling we practice virtues such as neighborliness, respect, resilience, freedom, and tolerance that ultimately make the common good, or, as we saw in the fourth chapter, the sum conditions necessary for life in community, possible. Marty contends that "the common good advances best when citizens freely choose the stories they tell and hear, the symbols to which they respond, and the practices they want to follow." Nevertheless, in light of the tensions arising from multiculturalism and religious pluralism in the United States, Marty adds "aggressive hospitality" to the list of civic virtues, which moves beyond tolerance of difference to embrace the different "other" in our communities.

As we have seen at various points in this chapter, murals are visible forms of "aggressive hospitality" that invite passersby into stories that shape the American identity and tell us of twists in the plot, of characters whose roles were not as minor as we may have thought, or of

alternative endings with new possibilities. But they carve out "storied spaces" throughout neighborhoods in Philadelphia, spaces that give citizens the physical and emotional room to risk the vulnerability that aggressive hospitality demands and the skills that hospitality in the midst of urban poverty requires.

For example, mural making and the images that arise from it increase social empathy for those beyond our immediate cultural enclaves, which is crucial for bonding communities increasingly fractured by differences in culture, race, religion, economics, and gender. As we saw in the last section, the ability to perceive our connections to others—especially those we consider enemy or alien—in a web of relationships that sustain us is the first step toward courageous acts of hospitality to these others. Since the images in many murals retell familiar stories in ways that shed light on chapters or themes that are unfamiliar or incongruent with our communal and self-understandings, they enhance our capacity for what international peacemaker John Paul Lederach calls "paradoxical curiosity." By this he means our ability to recognize and enter into the complexity and ambiguity of our social reality rather than to explain it in dualistic or binary ways. Those who practice paradoxical curiosity also approach reality with deep conviction that there is often more to our contemporary situation than meets the eye and with "an inquisitiveness about what may hold together seemingly contradictory social energies in a greater whole." Moving away from these narrow and artificially constructed categories with an intuition about "the more" allows us to see our reality and others who inhabit it in entirely new ways. Murals often help citizens to move beyond categorizing others as Christian or non-Christian, rich or poor, citizen or alien, black or white, urban or suburban, and rather tell stories about the commonalities that all persons share, stories that can sustain a sense of empowering unity through a celebration of diversity.

In addition, as we have seen in several chapters, murals performatively tell stories that illuminate the social suffering of various communities around the city and summon others to stand in solidarity with them. To that end, murals are transforming civic places into storied spaces of compassion. By making visible the often-invisible suffering of concentrated poverty, faith-based murals increase our civic capacity to feel others' pain and to avoid inflicting pain. Chopp sees this emotive self-awareness and response as expanding the boundaries of public discourse to include not only emotive and embodied ways of thinking about and responding to conditions of injustice but also more people in that collective endeavor.

Murals become placeholders for the sacred in the public square, spaces where the distance between "what is" and "the more" seems particularly luminal or thin. They evoke from us a sense of awe—at self, at others, at the created world—which is essential for the kind of relational trust that honors the integrity of our neighbors and is able to see the web of relationships in which we all live, move, and have our being. As literal and figurative spaces where people "experience fullness and richness," Philadelphia's faith-based community murals unequivocally proclaim that political philosopher Charles Taylor calls an "enchanted worldview" persists even in our contemporary secular age. When we encounter this art, we experience a sense of porousness that perforates the demarcated boundaries we establish between our intellects and our emotions, ourselves and others, our neighborhood and other communities, the real world and the realm of mystery. Community murals empower us to move beyond the boundaries of the "buffered self" via experiences of our interdependence with others, or an acknowledgment of beauty in unexpected places, or an awareness of our generative powers as creators, or the liberating realization that we can respond to social problems that seem to dictate the conditions of our existence. They become an enchanted space where all persons can participate in something greater than themselves.

Landmarks of Hope

"When kids walk by this wall I want them to look up and say, 'I did that,'" said Jane Golden at the dedication of *Lincoln's Legacy*.

The enchantment and collective activism that murals foster keeps religious traditions alive and morally relevant in the midst of secular sensibilities and conditions that suggest otherwise. Muralism enables faith communities to maintain an important balance between particular truth claims or doctrine and practices that contribute to a more common enterprise—practices such as the freedom for imagination, compassionate listening, and dreaming. It is important to note that communities of faith engaged in muralism do not necessarily create this art for the sake of their respective religious traditions, or even for the betterment of their personal faith, but rather to serve the wider community whose resources for making sense of the contemporary reality and for changing the dehumanizing aspects of that reality are increasingly impaired by the physical and emotional tolls of concentrated poverty.

Chapter Seventeen

Interfaith Creativity

"The main issue is that so many people didn't trust," recalls Adab Ibrahim of Al-Aqsa's early stages in creating *Doorways to Peace* (p. 223), the mural that serves as the focal point for this final section. "They feared that 'you don't get something for nothing.' 'People are going to be touching the sacred walls of the mosque,' they kept telling me. 'What are they going to do?'"

Ibrahim's comment attests to the risk that *Doorways to Peace* required of all who participated in the mural process. In today's religiously plural cities, it is not enough for faith communities to contribute their particular stories and symbols to public discourse or to independently practice virtues that might enliven civic piety. Believers inevitably and often unintentionally find themselves doing these things in concert with other believers from different religious traditions. Collaborating with "the religious other," particularly in the social context outlined at the beginning of this chapter, often raises a variety of perplexing questions that are "nonstarters" for many faith communities when it comes to "going public" with their faith: On what grounds ought we come together and how do we find that common ground? Where do we do this work and for what end? How do we maintain a distinctive identity while constructing a shared public platform? How can we trust others from traditions with a long history of tolerance for the injustices my community has born? What should we do about all of those points of disagreement?

As an expression of "visible religion," muralism makes it possible for urban faith communities to take up these questions and risk engaging

Restoration: detail, Eric Okdeh, 2008, © Philadelphia Mural Arts Program.

religious difference with intentionality and integrity. Archbishop of Canterbury Rowan Williams suggests that visible religion celebrates the capacity of religious symbols in public spaces to awaken the populace to a sense of the divine rather than relying on language-dependent truth claims to accomplish this. The former are dynamic and inclusive while the latter are static and exclusive. Collective interpretation of images is often more effective in fostering ecumenism and interfaith exchanges than intellectual wrangling over doctrine. A visible religion identifies shared visions of the common good and identifies practices—not simply verbal statements—that bring that vision into being. It is not wary of emotions that often drive wedges between religious communities but welcomes them as a common denominator of the human experience and a means of motivating shared commitment to certain values. Visible religion is available to believers on the streets and not necessarily controlled by those behind the pulpit.

"I think religion often feels like a closed or secretive area of public life," says muralist Paul Downie, one of a pair of muralists behind *Walking Together* (Paul Downie and David Woods, 2009, p. 75) done with the Neighborhood Interfaith Movement in Mount Airy that we examined in the second section. "It's sort of ironic, since the majority of people consider themselves part of a religion, and the majority of religions have a decent amount in common. Still, I feel like religion is kept behind closed doors a lot of the time. By doing public art projects around religion, I feel it brings religion and the ideas and issues surrounding it out into the open more. Over the years, my ideas about this work have evolved. I have come to conceptualize the projects as opportunities for coming together, for creating unity, rather than focusing on a shared past."

Visible religion is inherent in community murals created by faith communities, since their images actually capture their shared visions that nourish more complete understandings of what it means to be human or to live in community and not simply the set of beliefs or doctrine that distinguishes these communities from each other or sets them apart from the wider secular society. The images in faith-based community murals—angels, crucifixes, geometric shapes, doves, lotus flowers, families, trees, streams, bridges, doorways—transcend the limits of word-driven or word-bound interreligious dialogue and invoke the imagination as a viable method of communication across religious difference. They are attentive to the ways in which religious traditions—both alone but perhaps even more effectively in collaboration—might address any number of social injustices in civil society. "We didn't want to be so closed-minded as to be too religious," notes Rev.

Smith of Gate to Heaven Ministries of this community's decision against a specifically religious image in *Songs of Hope* (Donald Gensler, 2002; see p. 87). "I just wanted it to be positive. If the opportunity presents itself, pastors should get involved [in muralism] because we are trying to bring a message that the painting is doing much better. The church is praying and hoping we can bring security and understanding back to the problems of this entire community. You see history on walls and this puts questions in minds and brings stories out of people."

Murals also create physical space in the public square—whether neighborhood blocks, school yards, transit centers, or public libraries—for intentional religious pluralism that more than simply tolerates religious difference but actually engages it with the hope of discovering something new. It puts religious traditions at the service of a culturally diverse common good. Visible religion in the context of community muralism answers three important questions connected to interreligious dialogue: how ought communities of faith engage each other, what ought to be their common ground, and what ought be the outcome?

Contact Rather Than Concepts

Examples of interfaith community muralism indicate that effective interreligious dialogue begins with embodied contact among believers rather than with the various religious beliefs they may hold dear. The process of mural making begins not with a focus on the final product but rather with attention on the people who come together to create it. In other words, interfaith muralists do not begin with what Islam, Judaism, or Buddhism might have to say about poverty, violence, or religion in public life. Rather, they begin by listening to what their Muslim, Jewish, or Buddhist neighbors have to say about these issues in light of the way they impact a particular space in the community. In many ways the final product—the visual culmination of this engagement—is secondary, even from the perspective of the lead muralist.

Joe Brenman expressed concerns similar to those expressed by Ibrahim at the outset of the project and as work on the façade began to unfold. "School started again and more and more people were around all of the time," he recalls. "I would be outside working, putting up the tiles. Guys would come by and ask me why I was doing this, why I was here. I just tried to talk to them. Most people would say things like, 'I wish all Jews were like you,' which is hard to hear but at the same time they were being more honest with their feelings because most had a lot of

resentment and anger about their treatment in Palestine and Israel and probably didn't have opportunity to have conversations with Americans. Things never got too deep but we did talk about things a little bit. These were people who didn't have to talk to me—they could have just kept standing outside. I heard a lot of people say they were thankful that we were doing this; surprised that I would do this."

"Joe wanted people to know he was Jewish," Ibrahim remembers. "They called him '*il Joe*' or 'the Joe' and they really loved him. To let a Jewish man do this art work . . . he really changed a lot of perceptions and that was so transformative."

Eye contact, bodily movements that indicate deep listening or open-mindedness, physical gestures that convey sympathy, all suggest that interreligious dialogue is as much a tactile experience as it is an intellectual one. This emphasis on the senses and the body when it comes to how we ought to engage the religious other in interreligious dialogue offers a new category to the traditional exclusivist, inclusivist, and pluralistic approaches to interfaith dialogue. These more traditional approaches generally tend to focus on the personal and theological implications such

engagement might have for individual believers and religious traditions, at the expense of what might be learned through physical engagement.

As we have seen in previous chapters, muralism relies on first-person narrative exchanges in order to create visual stories that resonate with the immediate community but also speak to those beyond it. This integrates an autobiographical approach to interreligious dialogue that makes it possible for participants to reflect on their own tradition, whether in recounting the story of their experiences with it or listening to the story of another. Narrative forms people for life in community, and this is particularly true of religious narratives and communities. Whether as teller or listener of stories, interfaith muralism increases the likelihood that participants will approach their tradition and the tradition of the religious other with a heightened moral awareness of the way this tradition functions in the life of these persons and their communities, thus bringing a dynamic dimension to individual religious identity and expanding the reach of religious narratives beyond denominational lines.

The space where faith communities ultimately communicate their stories is significant. Murals call our attention to what feminist theologian Jeannine Hill Fletcher calls the physical spaces where religious identities are formed and the commonalities that begin to surface among divergent religious communities when space becomes a facet of their connection to each other. In other words, without denying the distinctiveness of the various dialogue partners, public art such as muralism reminds participants that persons experience some facets of poverty and violence similarly, regardless of religious affiliation. With these commonalities in mind, muralism makes interreligious dialogue an unavoidably public conversation about shared dimensions of the human experience in the context of urban poverty.

Empowerment, Not Power Over

The visual images that surface and are publicly expressed as a result of this embodied and narrative engagement with religious others offers new understandings of "truth" that resist equating it with power. The correlation between truth and power occurs all too easily in religious traditions and is often at the heart of religious divisions among

Restoration: detail, Eric Okdeh, 2008, © Philadelphia Mural Arts Program.

persons—whether reserving the power to articulate or explain the truth to a minority of persons, appealing to truth as the source of power to determine insiders and outsiders, or understanding the power of salvation in terms of assent to truth.

With the help of visual religion, truth becomes about the "how" of faith and not necessarily the "what" of faith. When expressed in an aesthetic key, truth can be articulated only symbolically, since we are never fully able to capture the full meaning or essence of the mysteries of faith traditions, most centrally the mystery of God. When truth is communicated and encountered symbolically, we are able to sidestep many of the power dynamics inherent in language and dialogue, which tend to privilege the dominant culture or those in positions of power in religious traditions and unavoidably lead interreligious dialogue down dead-end paths. An abundance of interpretations denies unilateral interpretations, ambiguity and contradiction challenge positions rooted in certainty, imagination and emotion resist exclusive reliance on reason and logic, and experiential wisdom of the body rejects exclusive reliance on the mind. One of the participants in *Restoration* (Eric Okdeh, 2008) offers a fine example. "This is the first time the Cambodian community has really been raised up in this neighborhood," he notes. "Before [the dedication ceremony] I thought, 'It's just one more mural painting.' I recognize today that its dimension is much greater than that. It is my first lesson on to build up the 'multicultural' in my heart."

With the help of the arts, we are better able to understand truth in terms of what religious doctrines mean to believers and how they function in their lives and not merely the content of the doctrines themselves. Truth is an ongoing experiential process of discovering meaning rather than definitive statements of absolutes. As was the case in a more aesthetic method of interreligious dialogue, the turn to experience also sharpens our focus on the persons who hold truth claims rather than simply the content of their claims. Since in the context of urban muralism these persons raise their voices from the margins of society and are often not heard in civic and ecclesial discourse, they bring often-overlooked communal perspective to our understanding of religious truth. What is true is also what is good for the community.

"It is the overlap in our webs of identity that draws us into relationships of simultaneous sameness and difference," says Hill Fletcher of the significance of this often-overlooked communal aspect of engagement with truth in interreligious dialogue. "Although we may not share the sacred stories of our neighbors, the multiplicity of stories that shape us provides resources for solidarity."

Rabbi George Stern implicitly points to this kind of collaborative power, or what he calls "faith-basedness," when he explains the rationale for the interlocking hands over the center window in *Walking Together* (p. 69), which ultimately became the logo for the Neighborhood Interfaith Movement. "If religion does not work with people, what good is it? There are a number of people in this neighborhood who are serious about their faith and they live out their faith in what they do. The hands symbolize 'doing' religion, that we are a people coming together, people of different ages, skin colors, and cultures in a place where people get along and do positive things for the community."

Aesthetic Solidarity

Muralism brings to public theology a kind of "aesthetic solidarity" that can complement the virtue of "intellectual solidarity" so essential for interreligious engagement to be effective. David Hollenbach, SJ, defines intellectual solidarity as "serious thinking by citizens" about their understanding of the good life in the midst of our multicultural reality and in the context of "an active dialogue of mutual listening and speaking across the boundaries of religion and culture." An aesthetic solidarity can complement the intellectual, verbal, and dialogical relationality of Hollenbach's approach with an emphasis on a more imaginative and nonverbal relationality that arises from collective commitments to perceive and cultivate the beauty of persons, communities, and the environment. By aesthetic solidarity I mean "a persevering commitment to become more fully human by risking the vulnerability that comes either with creative self-expression or with de-centering of the self that accompanies engagements with such expressions so that we might tactilely experience together in our bodies and hearts what it feels like when we are 'all really responsible for all.'" Aesthetic solidarity is a series of generative practices through which people of different religious traditions and socioeconomic enclaves learn how to imagine together, to create together, and to build together the kind of communities, city, nation in which they want to live. The African American novelist Toni Morrison captures what I mean here when she speaks of the internal and external "peace" that comes with the "dance of the open mind when it engages an equally open one."

Joe Brenman implies aesthetic solidarity in his description of the contagious enthusiasm for the Al-Aqsa project, both within the community and in the surrounding neighborhood, once relationships of trust were built. "As we started putting things up, the people from the

mosque were totally into it at that point and they were really enthusiastic. We had all of these meetings in the basement of the mosque and it was awesome because it was all women and kids, and these women would come wearing their traditional dress and almost nobody was speaking English, which was challenging to figure out what people were saying or what was going on because the thing was that they all wanted [Al-Aqsa] to look like their home country mosque, and there was an incredible amount of variety in that room. So we set up workdays in the basement and we told people to show up and we'd be there. People from all over the city were coming—from churches, synagogues, nonreligious people. They just wanted to be part of it."

Aesthetic solidarity brings important dispositions and practices to interreligious dialogue. It involves using right-brained thinking when perceiving and evaluating the other and contexts of social sin. Inductive reasoning, intuition, kinesthetic thinking, and fantasy bring to light the otherwise hidden or intangible dimensions of injustice but, more important, the sensorial knowledge we have in our bodies that can lead us to otherwise overlooked paths to justice. This is particularly important for engaging the affective dimensions of social injustices and for interrupting the circular logic that often yields less-than-optimal solutions.

In addition, because good art evokes a multiplicity of interpretations, aesthetic solidarity cultivates ambiguity, nuance, shades of grey, and even unsettling contradictions. This often breaks people out of narrow, binary, hierarchical, and increasingly polarizing ways of understanding themselves, others, or social circumstances so that different perspectives and insights might take hold. Aesthetic solidarity intentionally turns to the arts to create a nonthreatening physical and emotional space for people to share and hear impressions, to try on new perspectives, to read and be read by others, to engage difference. This open-ended ambiguity also breathes a sense of mystery back into situations previously controlled by particular frameworks of meaning or ideologies. It imbues within us what John Paul II called a "religious awareness of individuals and peoples" so essential for authentic human development.

Finally, aesthetic solidarity empowers those who engage each other through artistic expression. It physically, emotionally, spiritually, and intellectually moves them toward a vision or dream or longing. Often, the reason this vision is so compelling or this longing is so strong is because it is somehow rooted in basic truths about what it means to be human and insights about the good life. Moreover, aesthetic solidarity motivates creative acts—people come together and create something

new where new things seem unlikely or impossible. This is empowering because it unleashes one of the facets of being made in the image of God: not only to be creators but, more important, creators of goodness and beauty. In both of these ways, aesthetic solidarity fosters an *embodied experience* of living in right relationships.

Painting the Soul of the City

Muralism ensures the relevance of religion in the increasingly divisive public square because of its ability to creatively focus on what can be done about assaults to the common good, which just about every urban congregation in every faith tradition faces. This kind of nonverbal engagement saves the soul of the city. Murals create a sense of enchantment, particularly in the midst of neighborhoods where local residents and those from the outside assume that enchantment is no longer possible. This awakens an empowering sense of the transcendent within those who create this art and a humbling sense of the same within those who encounter it. Collective art such as this breaks through impasses of violence and apathy by stirring people with visions of a different future, the authenticity for which stems from the lived experiences that give rise to them.

This art brings together people of different religious and secular sensibilities in order to think critically about their beliefs or disbeliefs, to listen deeply to the wisdom of each other, and to dream collectively about a different reality. Murals created through an intentional process of dialogue, solidaristic listening, and nonverbal communication cultivate our shared human desire to encounter and be moved by beautiful things, to stretch the limits of our individual experience or abilities and to experience palpably ourselves as part of the whole, to transcend the limits of our finite being through the power of the imagination, and to liberate ourselves from the prevailing logic of the way things are with radically new visions for the way things might be. By lifting up these common denominators of human experience and cultivating nonverbal expression of our deepest values and most daring dreams, these murals become examples of an authentically pluralistic religious expression. They challenge binary worldviews within culture and even within theology—between sacred and profane, immanent and transcendent, word and sacrament, body and mind, men and women, city and suburb, whites and people of color—with a more constructive desire for shared practices that incarnate a multifaceted vision of life in community or a tactile sense of *e pluribus unum*.

Finally, they serve as new examples of "religious classics," in David Tracy's sense of the word, to the extent that the process behind their creation cultivates a set of liberating practices that empower marginalized communities for political participation and advocacy. This art relies on community organizing; discovering, sharing, and deeply listening to individual visions; social responsibility that comes with encounters with beauty. To that extent, they become what Tracy calls "liberating events" wherein "the actions of whole peoples whose disclosive, ignored, forgotten, despised story is at last being narrated and heard in ways that might transform us all."

"At the end, people said that there was a sense of hope accomplished. The community realized there is good from Americans," recalls Ibrahim of *Doorways to Peace*. "Our community is now ready for other things. When you do these kinds of things, doors open. To me, this is a well-educated peace because others can relate to it and everyone sees themselves differently. That is all a part of being part of a greater community."

Bibliography

Introduction

Interviews that inform this section include (in order of appearance): Adab Ibrahim, Community Liaison with Al-Aqsa Islamic Society, June 6, 2007; muralist Cathleen Hughes, February 16, 2007; muralist Joseph Brenman, February 17, 2007; Shira Walinsky, February 11, 2007; muralist Ras Malik, June 6, 2007; muralist Paul Downie, November 25, 2011; community member Rabbi George Stern, November 26, 2011.

I include comments from Jane Golden and muralist Shira Walinsky at the dedication of *Journey* (April 22, 2008) and *All Join Hands: The Visions of Peace* (October 25, 2006). Muralist Pheobe Zinman's *Visual Restoration: A Reflection on Two Years of the Albert M. Greenfield Restorative Justice Program* (Philadelphia: Mural Arts Program, 2009) is an important source in the final chapter.

As was the case in the first chapter, I used several histories of Philadelphia to explain the particular context of the public square in the City of Brotherly Love, most notably Russell F. Weigley, ed., *Philadelphia: A 300-Year History* (New York: W.W. Norton & Company, 1982), and E. Digby Baltzell, *Puritan Boston and Quaker Philadelphia* (Boston: Beacon Press, 1979). Tony Campolo's *Revolution and Renewal: How Churches Are Saving Our Cities* (Louisville, KY: Westminster John Knox, 2000) maps the challenges and promises facing urban churches as "lead institutions" in social change. In terms of current statistics on immigration, see the Brookings Institute November 2008 report, "Recent Immigration to Philadelphia," http://www.brookings.edu/reports/2008/1113_immigration_singer.aspx.

Michael J. and Kenneth R. Himes use Catholic doctrine and mysteries of faith to argue for the synergy between discipleship and citizenship in *Fullness of Faith: The Public Significance of Theology* (New York: Paulist Press, 1993). See also a collection of essays on this topic in *The Catholic Church, Morality and Politics*, ed. Charles E. Curran and Leslie Griffin (New York: Paulist Press, 2001). Colleen McDannell's *Material Christianity: Religion and Popular Culture in America* (New Haven, CT: Yale University Press, 1995) points out the ways in which that relationship is often mediated through religious art and religious culture and David Tracy's explanation of the "classic" in *The Analogical Imagination: Christian Theology and the Culture of Pluralism* (New York: The Crossroad Publishing Company, 1998) continues to inform my engagement of these images in this entire sixth section. Arthur Emery Farnsley,

Sacred Circles, Public Squares: The Multicentering of America (Bloomington: University of Indiana Press, 2004), maps and examines the impact of religious pluralism on American civic engagement. A 2008 survey by the Pew Forum on Religion and Public Life, "U.S. Religious Landscape Survey" (available at http://religions.pewforum.org/), captures a sense of American religiosity in the twenty-first century, as does Robert Putnam's book, *Amazing Grace*: *How Religion Divides and Unites Us* (New York: Simon & Schuster, 2010). Walter Brueggemann's *The Prophetic Imagination*, 2nd ed. (Minneapolis, MN: The Fortress Press, 2001) speaks about the theological significance of living in an age of empire on the religious consciousness and imagination of disciples.

Chapter Fifteen: Visible Public Theology

When it comes to understanding the ways in which Americans navigate their religious and civic identities, Robert Bellah's classic *Habits of the Heart*: *Individualism and Commitment in American Life*, 3rd ed. (Berkeley: University of California Press, 2007) remains invaluable, as does Alan Wolfe's *The Transformation of American Religion: How We Actually Live Our Faith* (New York: Free Press, 2003). The previously mentioned *Fullness of Faith* by Michael and Kenneth Himes engages this relationship in the Catholic tradition. For a state of public theology in the US context see Mary Doak, *Reclaiming Narrative for Public Theology* (Albany, NY: State University Press of New York, 2004). In terms of thinking through the civic aspects of religious artistic expression, see Frank Birch Brown, *Religious Aesthetics* (Princeton, NJ: Princeton University Press, 1989).

For Charles Taylor's discussion of the social imaginary, see *Modern Social Imaginaries* (Durham, NC: Duke University Press, 2004).

Patricia O'Connell Killen discusses the pedagogical significance of sight in "Gracious Play: Discipline, Insight, and the Common Good," *Teaching Theology and Religion* 4, no. 1 (February 2001): 2–8.

Chapter Sixteen: Visible Public Piety

For background on the *Lincoln's Legacy* mural project, see Philadelphia's public television station's series: http://www.whyy.org/artsandculture/lincolnlegacy.html.

For explanations of civil religion, see the previously mentioned classic by Robert Bellah, *Habits of the Heart*: *Individualism and Commitment in American Life*, as well as "Civil Religion in America," *Daedalus: Journal of the American Academy of Arts and Sciences* 96, no. 1 (Winter 1967). Farnsley's *Sacred Circles, Public Squares*, cited above, is also helpful. See also Martin Marty, *Education, Religion and the Common Good* (San Francisco:

Jossey-Bass, 2000). David Morgan points to intersections of civil religion with the arts in *Visual Piety: A History and Theory of Popular Religious Images* (Berkeley: University of California Press, 1998), as does Martin Marty in the eighth and ninth chapters of *The One and the Many: America's Struggle for the Common Good* (Cambridge, MA: Harvard University Press, 1997), where he explores the connection between telling the stories of religious traditions and American civil religion. Pivotal for Marty's argument is Alasdair MacIntyre's *After Virtue: A Study in Moral Theology*, 3rd ed. (South Bend, IN: University of Notre Dame Press, 2007).

In terms of challenges to a vibrant public life, see the previously mentioned Robert Putnam, *Bowling Alone*; Robert Wuthnow's *America and the Challenges of Religious Diversity* (Princeton, NJ: Princeton University Press, 2003); America Public Media's *Speaking of Faith*, "Repossessing Virtue: Parker Palmer and Economic Crisis, Morality and Meaning" (July 23, 2009), available at http://being.publicradio.org/programs/2009/rv-palmer/transcript.shtml; and Jean Bethke Elshtain, "Race and Civil Society: A Democratic Conversation," and Rebecca Chopp, "Reimaging Public Discourse," in *Black Faith and Public Talk: Critical Essays on James H. Cone's* Black Theology and Black Power, ed. Dwight N. Hopkins (Maryknoll, NY: Orbis Books, 1999), 205–17 and 150–66, respectively.

Johannes Baptist Metz discusses the significance of remembrancing in *The Emergent Church: The Future of Christianity in a Postbourgeois World* (New York: Crossroad, 1981). Bryan Massingale remembrances black bodies in the "The Systematic Erasure of the Black/Dark-skinned Body in Catholic Ethics, "in *Catholic Theological Ethics, Past, Present, and Future: The Trento Conference*, ed. James F. Keenan (Maryknoll, NY: Orbis Books, 2011), 116–24, as does M. Shawn Copeland in *Enfleshing Freedom: Body, Race and Being* (Minneapolis: Fortress Press, 2010). Walter Brueggemann unpacks the relationship between hope and prophecy in the previously mentioned *Prophetic Imagination*.

Katie Geneva Cannon explores the theological significance of the black experience in "Diaspora Ethics: 'The Hinges Upon Which the Future Swings'" in *Africentric Approaches to Christian Ministry: Strengthening Urban Congregations in African American Communities*, ed. Ronald Edward Peters and Marsha Snulligan Haney (Lanham, MD: University Press of America, 2006), 141–50; and *Black Womanist Ethics* (Atlanta, GA: Scholars Press, 1988). The definitive collection by black Catholic theologians is *Taking Down Our Harps: Black Catholics in the United States*, ed. Diana Hayes and Cyprian Davis (New York: Orbis Books, 1998). Of particular note for this chapter is an essay in that collection by Jamie T. Phelps, "A Search for Dynamic Images for the Misson of the Church Among African

Americans," pages 68–101. Warren L. Dennis explores the significance of black theology for urban ministry in "The Challenges of Africentric Ministry for Urban Theological Education," in Peters and Haney, ed., *Africentric Approaches to Christian Ministry*, as does Kelly Brown Douglas in *What's Faith Got to Do with It?: Black Bodies/Christian Souls* (New York: Orbis Books, 2005) where she argues that relationality pulls together justice, hope, and love, which James Cone identifies as the central theological principles of black theology in *A Black Theology of Liberation*. See also *The Courage to Hope: From Black Suffering to Human Redemption*, ed. Quinton Hosford Dixie and Cornel West (Boston: Beacon Press, 1999).

Recall Bradford Hinze's ideas about lament from chapter 12, "The Prophetic Character of the People of God: Where Is the Prophetic in Contemporary Catholic Ecclesiology?" (presentation to the Catholic Theological Society of America, Cleveland, OH, June 2010). Central to the transformative power of the arts to build relationships across difference is John Paul Lederach's notion of "paradoxical curiosity"; see *The Moral Imagination: The Art and Soul of Peacemaking* (New York: Oxford University Press, 2005). See also David Tracy's discussion of religious classics as "events" in *The Analogical Imagination*, p. 398.

Chapter Seventeen: Interfaith Creativity

Rowan Williams invokes the term "visible religion" to explain the contributions that religious make beyond divisive dogmatic statements or fundamentalist truth claims in order to defend religious expression in an increasingly multicultural public square. See "Christianity, Islam and the Challenge of Poverty," Archbishop of Canterbury Lecture, Bosnia Institute, Sarajevo, May 20, 2005. See also David Tracy's discussion of religious classics as "events" in *The Analogical Imagination*, p. 398.

For a feminist approach to understanding the relational dynamics of religious pluralism, see Jeannine Hill Fletcher, *Monopoly on Salvation? A Feminist Approach to Religious Pluralism* (New York: Continuum, 2005).

Fundamental to my reflections on solidarity are Pope John Paul II's articulation of this virtue in *Solicitudo Rei Socialis* (particularly no. 38), as well as David Hollenbach's development of it in *The Common Good and Christian Ethics* (Cambridge: Cambridge University Press, 2002). For the pedagogical applications of this idea, particularly in light of the transition from concept-based to contact-based learning, see Roger Bergman, *Catholic Social Learning: Educating the Faith that Does Justice* (New York: Fordham University Press, 2010). Toni Morrison's short National Book Award acceptance speech, published as *The Dancing Mind* (New York: Alfred A. Knopf, 1997), provides a purchase for me in articulating what I mean by aesthetic solidarity.

Appendix

Imagining the Signs of the Times

What follows is an attempt to situate community murals in Philadelphia, and other forms of artistic expression with inherent connections to a variety of social justice issues, in a larger conversation about the relationship between art and ethics that has been going on for centuries. It is intended to serve as a resource, not as a definitive work on theological aesthetics, to assist readers in their own exploration of these ideas. The themes and thinkers identified here are fundamental for those interested in the urgent project of constructively integrating the human fascination with the beautiful and our concern about the good in contemporary Christian social ethics.

Theological Aesthetics and Contemporary Christian Ethics

Aesthetics (the study of sense perceptions, beauty, and the arts) and ethics (the study of how we ought to live) have a latent but often undisclosed and unexplored relationship. Systematic theologian Richard Viladesau explains that theological aesthetics considers the ways in which humans have turned to beauty and artistic expression as a particular locus, place, or encounter in which we experience both ourselves and the transcendent more fully—what Viladesau describes as "a deep-seated 'yes' to being"—and communicate verbally and nonverbally the insights gained through such encounters about what it means to be human and how we ought to live.[1] "Art is an encounter of man with his world," explains systematic theologian Paul Tillich, "in which the whole man in all dimensions of his being is involved."[2] Since

1. Richard Viladesau, *Theological Aesthetics* (New York: Oxford University Press, 1999), 149.

2. Paul Tillich, "Art and Society," in *On Art and Architecture*, ed. John Dillenberger (New York: Crossroad, 1989), 27.

this experiential wisdom undoubtedly illuminates the ways in which the beautiful is related to the good, or the way our deepest desires can fuel an authentic flourishing, theological aesthetics undoubtedly incorporates ethics. "Each act of creation is a spiritual exercise," Robin Jensen further explains, "strengthening and honing us in particular ways, making us more and more into who we shall become and how we understand ourselves in relation to the rest of the created world."[3]

Contemporary Christian ethics has yet to embrace aesthetics fully as a method of ethical reflection, a source of moral wisdom, or as a means of ethical response. We rarely turn to the arts or to beauty in our attempts to follow the mandate of contemporary Catholic social teaching to read and respond to "the signs of the times." This is a significant shortcoming, given what I see as the threefold task for US Christian ethics at the dawn of the third millennium: (1) to examine critically the values of America in an age of empire with a historical consciousness that complicates our reality rather than simplifies it; (2) to pay attention to methods of ethics from the margins of American society where persons think about and respond to social injustices in different ways; and (3) to cultivate a meaningful solidarity in a culture that is defined by ethnocentrism, polarization, isolating technology, and an ever-growing gap between rich and poor. Reading the signs of the times as they are proclaimed in a variety of forms of artistic expression can be a way of taking up these tasks.

This appendix has three parts. First, I consider the reasons for the alienation between ethics and the arts in our contemporary context. I then identify openings to beauty and the arts in the four traditional sources of Christian ethics—(1) Scripture, (2) philosophical reflections on human reason and the good life, (3) the living Christian tradition, and (4) human experience of the beautiful—which challenge that alienation and offer important conduits for engagement between the arts and ethics. I conclude by identifying what has yet to be done in Christian ethics where the arts are concerned with the thought that readers will look to preceding chapters to fill in those gaps.

Ethics and Aesthetics: Strange Bedfellows

Despite the fact that most of the foundational and paradigmatic thinkers in theological ethics dabbled in aesthetics as a resource for encounter-

3. Robin Jensen, *The Substance of Things Seen: Art, Faith and the Christian Community* (Grand Rapids, MI: William Eerdmans Publishing Company, 2004), 10.

ing, understanding, and articulating ideas about the good life or justice, the study of sense perceptions, beauty in its many manifestations, and the fine arts remains a relatively peripheral concern in theological ethics, especially in the decades that coincide with contemporary Catholic social teaching. Even though art provides a window into the collective ethical soul of various historical points in time—the immanence of the Divine in medieval illuminated texts, the humanism of Renaissance portraiture, the social critique inherent in Modernist canvases—ethicists have not necessarily considered the moral value of the arts, whether in terms of moral formation, reasoning, or responses to injustices. While often associated with the True, particularly in theological contexts, Beauty's relationship to the Good remains somewhat uncharted territory in contemporary Christian ethics. Let me offer three explanations.

First, word, language, and text—and not necessarily image, musical note, or bodily movement—serve as primary sources for ethical evaluation. Aesthetics has been sidelined in Christian ethics due, in large part, to the association of image with idolatry throughout Christian history and the resulting tension between word and image in expressing truth claims.[4] "The religion of the Word made flesh has all too readily re-made the flesh into words of proposition and dogma," Michael Austin provocatively notes.[5] The Christian tradition has long preferred language as the ideal form of human communication. Creed, dogma, doctrine, and even sacred texts are all word-driven expressions of faith, which literally and figuratively provide the final word in moral discernment or ethical evaluation. But "language frequently makes us without stretching us" in John Dillenberger's estimation.[6] Insofar as language leaves our intuitive, imaginative, emotive, and mystical capacities underdeveloped, it limits us to rational, logical, linear, and deductive means of moral reasoning. This is particularly true in the context of Catholic moral theology and social ethics, where approaches to the moral life and social change are particularly word-dependent—whether on various interpretations of the words of biblical texts, the written guidelines of moral manuals or magisterial teachings, or the central principles of Catholic social thought presented in written papal or episcopal statements.

4. For a helpful overview of the history of the dichotomy between word and image, see Margaret Miles, *Image as Insight: Visual Understanding in Western Christianity and Secular Culture* (Boston: Beacon Press, 1985).

5. Michael Austin, *Explorations in Art, Theology and Imagination* (London: Equinox Publishing, 2005), 15.

6. John Dillenberger, *A Theology of Artistic Sensibilities: The Visual Arts and the Church* (New York: Crossroad, 1986), 232.

An ethical preference for written words also reveals the power dynamics inherent in Christian ethics. Those who control language about moral behavior and the good life have tended to reside at the socioeconomic and religious centers of power where ethical teachings are promulgated, thus making their ways of moral reasoning normative. The less language-dependent perspectives and practices of those on the periphery where moral teachings tend to be received are often considered deviations from that norm. And unlike those on the periphery, those with the power to articulate ethical teaching also have access to public discourse concerning morality and the good life, thus reinforcing their status as moral authorities and gatekeepers and undermining the development of the moral life that happens in other forms of collective self-expression and communication.

A language-driven theology alone is not necessarily sufficient for a living theology or a living faith, since it tends to prefer, in Margaret Miles's estimation, "subjective consciousness" as the ideal mode for reflecting on reality. In other words, we tend to privilege autonomous, disembodied, and rational approaches to moral reasoning at the expense of the experiential wisdom that arises from physical embodiment, relationality, and the tactile senses.[7] Christian Brother Brian Henderson, director of Saint Gabriel's Hall, a residential detention center for adjudicated boys from Philadelphia, suggests that as a result of living in "such a word-oriented society, some of the visual, emotional and tactile elements of humanity are repressed and this leads to a blindness to some of the richness of our humanity."[8] Words are also insufficient when it comes to capturing the deepest human questions as well as our most provocative insights and promising answers. We need images that can resuscitate our ability to see more accurately what's going on in our reality and provide avenues for understanding it before we try to make sense of it with words. We need, in Miles's words, "visual understanding."

A preference for empirical evidence and logical rationality in ethical discernment also limits the role of aesthetics in Christian ethics. This preference dates back to the Enlightenment, the high-water mark of confidence in the human capacity for reason to predict, analyze, dominate, and control the unknown through logic, rationality, linear thinking, and deductive argument. Roots of this preference reach back even further to the hierarchical dualism of Hellenistic philosophy out of which Chris-

7. Miles, *Image as Insight*, 17–26.
8. Phone interview with Brother Brian Henderson, September 8, 2008.

tian reflection on the good emerged. Consider the familiar pairings that give rise to hierarchical valuing in ethical thinking: immutable/mutable, infinite/finite, mind/body, intellect/emotions, sacred/profane. The skills and insights associated with the latter term in each of these dualisms are not given equal weight. In addition, many of the documents of Catholic social thought assume a binary or dualistic approach to understanding and presenting systems and structures of oppression, which belies the multifaceted complexity of unjust social relationships: the laborer/employer dichotomy, the East/West divide, the North/South approach to development, the tension between underdeveloped/super-developed persons, communism/capitalism, interpersonal/structural racism. As others have noted, the Catholic social tradition also tends to reflect a preference for universal principles deduced through an intellectual rationality abstractly applied, often at the expense of embodied practices arising from concrete circumstances. As evidence, consider the prevalence of deductive natural law reasoning that shapes much of contemporary Catholic social teaching.

A preference for reason, logic, and deductive reasoning that emerges from a disembodied and autonomous subject overlooks facets of cognition on the fringe of rationality such as affections, intuitions, or imaginative ruminations. Alejandro García-Rivera argues against this intellectual tendency in theological aesthetics, calling scholars instead to understand more fully the capacity of beauty to "move the human heart."[9] This seems to contradict Paul Avis claims that the "Christian lives supremely from the imagination," since God reveals God's self to the human imagination and that we rely on the imagination to understand, express, and interpret the revelatory nature of those encounters.[10] Theologians and ethicists such as William Cavanaugh, bell hooks, and Walter Brueggemann reclaim the centrality of the imagination in the moral life of individuals and communities as well as its usefulness in larger projects of social resistance and transformation.[11] Their work is

9. Alejandro García-Rivera, *The Community of the Beautiful: A Theological Aesthetics* (Collegeville, MN: Liturgical Press, 1999), 9.

10. Paul Avis, *God and the Creative Imagination: Metaphor, Symbol and Myth in Religion and Theology* (New York: Routledge, 1999), 6.

11. Stanley Hauerwas discusses imagination and virtue ethics in *Vision and Virtue: Essays in Christian Reflection* (South Bend, IN: University of Notre Dame Press, 1981); Ted Peters examines its connection to environmental ethics in "Creation, Consumation and the Ethical Imagination" in *Cry of the Environment: Rebuilding the Christian Creation Tradition*, ed. Philip N. Joranson and Ken Butigan (Sante Fe, NM: Bear and Co., 1984), 401–29; William Spohn develops a hermeneutics of the imagination in Scripture and ethics in *Go and Do Likewise: Jesus and Ethics* (New York: Continuum,

particularly important in our contemporary reality, where emotional ennui, political passivity, and comfortability with the status quo—perpetuated by first-world values of radical individualism, therapeutic consumerism, and whiteness—strangle our capability for imagination. Daniel Maguire suggests that creative imagination cultivated by the arts is the "supreme faculty" of moral persons, since through it we are able to find kairotic time for contemplation, to express the ineffable, and to "break out of the bondage of the current state of things."[12]

Moreover, these activities require a particular type of courage that Rollo May identifies in the willingness "to consider diverse possibilities, and to endure the tension involved in holding these possibilities before one's attention."[13] Art unleashes what Richard Côté identifies as the "gifts of the imagination," which can be useful in ethically responding to the dehumanizing and complex reality of urban poverty: sudden perception of the social causes of poverty, intuition about human interdependence, extratemporal vision that can see more accurately the past and present and more precisely envision the future, and a newfound ability to make connections among seemingly disparate things, such as gated communities and ghetto communities or between voluntary and involuntary hypersegregation.[14] Making meaning, exploring ambiguity, resisting stereotypes, contributing to visual memory, participating in storytelling, exposing joys and pains, creating something from nothing, all protect and nourish human dignity.

Finally, Catholic moral theology in particular has been obsessed with presenting the moral life as a series of negative admonitions against intrinsically evil acts or strict adherence to positivistic principles. Moral rules trump moral visions. The tradition of moral manuals, casuistry, auricular confession, deadly sins, and the more contemporary voters' guides are all evidence that believers are encouraged to follow moral *guidelines* rather than moral *visions* of the good life. Many pitfalls arise

2000). John Paul Lederach outlines the roll of the imagination in peacemaking through its capacity to weave a web of relationships that often includes the enemy in *The Moral Imagination: The Art and Soul of Building Peace* (New York: Oxford University Press, 2005), 26–27. Kathleen Caveny develops the role of ontic, empathetic, and strategic imagination in "Imagination, Virtue and Human Rights: Lessons from Australian and U.S. Law," *Theological Studies* 70, no. 1 (2009): 109–39.

12. Daniel C. Maguire, *The Moral Choice* (Garden City, NY: Doubleday & Company, 1978), 189–217, at 189.

13. Rollo May, *The Courage to Create* (New York: W.W. Norton and Company, 1975), 120.

14. Richard Côté, *Lazarus! Come out! Why Faith Needs the Imagination* (Ottowa, Canada: Novalis, 2003), 47–55.

when imagination and creativity are overlooked in the moral life. We become bound by blind obedience to external authority at the expense of cultivating activities associated with discernment that develop internal authority of conscience. We become preoccupied with what ought to be done in present time rather than take a longer moral view that considers alternative visions for the future. We acquiesce our freedom in refraining from certain actions rather than commit ourselves to good actions that freedom demands. Our moral agency becomes reactive to what we perceive as the givens of our circumstances, undermining our capabilities as proactive agents who can change those givens. Emphasizing moral convictions rooted in moral authority can be polarizing. "Our morality is more than adherence to universalizable rules," claims Christian ethicist Stanley Hauerwas. "It also encompasses our experiences, fables, beliefs, images, concepts and inner monologues."[15]

As an expression of creativity, the arts are a particularly important form of moral agency, both for individuals and communities. Matthew Fox claims that with our imaginations we participate in God's generative and redemptive energy, particularly if we consider redemption as that which "gives us permission to be creative, compassionate, and God-like. It is that which reunites us to the All."[16] Art effectively binds people together because it involves the opening and sharing of hearts rather than rational appeals to our intellect or emotive appeals to our fears. Insofar as imaginative creativity is constitutive of human dignity, as well as the collective capability for all persons to participate in God's generative activity in our midst, it is central to building vibrant individuals and communities. "The art of moral discernment may be the most important contribution that theological ethics has to make to the life of the Church," explains Christian ethicist William Spohn.[17]

Having said all of this, the Christian tradition does contain sources that unequivocally suggest that beauty and artistic expression should matter to those concerned with justice and that justice should matter to those concerned with the arts. Since these concepts and thinkers provide the foundation of what follows in the book, we turn to them now.

15. Stanley Hauerwas, *Vision and Virtue: Essays in Christian Ethical Reflection* (South Bend, IN: University of Notre Dame Press, 1981), 35.

16. Matthew Fox, *Creativity: Where the Divine and Human Meet* (New York: Penguin Putnam, Inc., 2002), 50 and 96.

17. William Spohn, "The Formative Power of Story and the Grace of Indirection" in *Seeking Goodness and Beauty: The Use of the Arts in Theological Ethics*, ed. Patricia Lameroux and Kevin J. O'Neil (Lanham, MD: Rowman & Littlefied, Ltd., 2005), 13–32, at 25.

Sources for an "Aesthetic Ethics"

The theological tenor of the Second Vatican Council in the 1960s and the Catholic humanism that emerged from the council was not only a watershed moment for ethics, given the affirmation of the church's responsibility to address suffering in the world and a return to biblical sources to shape that responsibility. It was also a turning point for ethics and theological aesthetics. The council fathers acknowledged that "literature and the arts are, in their own way, of great importance to the life of the Church."[18] They went on to say, "When man [*sic*] cultivates the arts, he can do very much to elevate the human family to a more sublime understanding of truth, goodness and beauty, and to the formation of judgments which embody universal values."[19] This "more sublime understanding" can resist the social sin of "social illiteracy" that prevents persons from "collaborating in a truly human manner for the sake of the common good."[20] In this climate of openness to culture, systematic theologians began to rediscover and cultivate the fertile ground between the arts and theology, whether as a viable locus of religious reflection and discourse among persons of faith or as a human capability that unites those with otherwise divergent religious and secular frames of reference.

In the spirit of the council's constitutional documents, Christian ethicists have identified four resources for ethical reflection and decision making. We can find traces of the ethical implications of encounters with beauty and the arts in each and in so doing build the foundation for an "aesthetic ethics" that overcomes the previously outlined limitations of an aesthetically apathetic ethic.

Revelation/Scripture

"If Catholic social teaching is going to form peoples' consciences, inspire their imaginations, and shape their lives, it must weave biblical theology into its presentations," notes biblical scholar John Donahue.[21] To some extent, if we were to follow Donahue's advice, then it would

18. See nos. 40–44 in *Gaudium et Spes* for definition of "culture" as well as directives for engagement with it.

19. *Gaudium et Spes*, no. 57, in David J. O'Brien and Thomas Shannon, *Catholic Social Thought: The Documentary Heritage* (Maryknoll, NY: Orbis Books, 2010).

20. *Gaudium et Spes*, no. 60.

21. John R. Donahue, SJ, "The Bible and Catholic Social Teaching: Will This Engagement Lead to Marriage?," in *Modern Catholic Social Teaching Commentaries and Interpretations*, ed. Kenneth Himes (Washington, DC: Georgetown University Press, 2005), 9–40, at 11.

be impossible not to incorporate aesthetics into our ethics. Scripture scholar Jo Ann Davidson estimates that at least 40 percent of the Hebrew Bible is written as poetry and that biblical scholars and theologians are only just beginning to appreciate the aesthetics inherent in the literary style, craftsmanship, and sequencing of biblical narratives. Moreover, the parables Christ used to teach his disciples his most important lessons give us a glimpse into his own imagination. More than one scholar acknowledges parables as a "literary art form requiring the imagination in order to grasp its meaning."[22] Given that the writers of Jewish and Christian Scriptures used more than twenty different Hebrew and Greek words to express "beauty" or "beautiful," it is safe to conclude, as Davidson does, that "in Scripture, God does not encounter the human creature exclusively through abstract concepts, but also as an Artist" whose goodness we are invited not to ponder intellectually but rather to "taste and see" with mind and body.[23]

Systematic theologians have articulated the theological significance of these many artistic attributes of God in Sacred Scripture: "potter" (Jer 18:6 and Rom 9:20-24), "master craftsman" (Prov 8), singer (Zeph 3:16-17), architect of the temple, and dramatic presence in a number of theophanies. But these attributes also have implications for the ethical principle of the *imago Dei* that lies at the heart of Christian anthropology. If we are made in the image and likeness of this artistic, innovative, creative God, then we too are artists and innovators and creators of goodness and beauty. Creative expression is a distinctively human trait precisely because it also characterizes the divine. The moral life, therefore, is not passive or reactive but active and proactive; it is about not simply keeping our souls clean by refraining from bad actions but getting our hands dirty in the messy but creative processes of social action; it is not about calculating how to distribute goods but about how to lavish them abundantly everywhere we move. In previous sections we saw the ethical ramifications for this kind of agency in breaking through a variety of consciousnesses that keep people from truly flourishing.

In addition, there are particular narratives in Scripture that underscore the contributions of natural and humanly created beauty for ethical reasoning and action, all of which underscore that beauty is not a peripheral concern to God; nor should it be to humanity. Seeking beauty will bring us into closer proximity with justice, and ethical actions that

22. Robert Alter, *The Art of Biblical Narrative* (New York: Basic Books, 1981), 12. See also John R. Donahue, SJ, *The Gospel in Parable* (Minneapolis: Fortress Press, 1990).

23. Jo Ann Davidson, *Toward a Theology of Beauty: A Biblical Perspective* (Lanham, MD: University Press of America, 2008), 11.

are most just are often compellingly beautiful and motivate us to act. These themes become apparent when we consider the beauty of creation, the covenant, and the cross.

Creation. There may be no other place in Scripture where beauty and goodness are more closely linked than in the accounts of God's creativity in the first chapters of Genesis where "And God saw it was good" is the anthem. Here we find characteristics of both beauty and justice: an orderliness and harmony in a web of interdependent life, overflowing abundance and superfluous surprises, a sense of inclusivity or at-homeness inherent in creation, a realization that each of the parts serves a purpose in the whole, and relationships rooted in tenuous sustainability.

Christian ethics often looks to the creation story for its anthropological significance. The *imago Dei*—being created in the image of God or being filled with the breath of God—provides the source of human dignity and likewise the ethical principles that stem from it, including human rights and the common good. Attention to beauty in these chapters, however, reminds us of the wondrous creative power of the divine and imbues ethics with a much-needed theocentric and even cosmic orientation. Jame Schaefer notes the ways in which patristic and medieval scholars such as Augustine, Bernard of Clairvaux, and Thomas Aquinas revel not in the human dimensions of creation narratives but rather in the mystery and splendor of the created world and God's providence and wisdom in creating it. Contemplating the God of Genesis can cultivate the dispositions and practices necessary for effective care of the created world: delight, the ability to see the big picture as well as attention to detail, abundant generosity, restful enjoyment. Contemplating this God might also give us the moral wisdom we need to make ethical decisions about the distribution of earth's resources, wisdom that comes from not just our intellect but also our sensorial engagement in the world. Doing these things is not simply a way of sustaining human life but also a way of loving and worshiping our Creator God. Reflection on the beauty of the incomprehensible cosmos and the attributes of an equally incomprehensible God who made it simultaneously humbles humanity with an awareness of our finitude. It can incite in us appreciation for the uniqueness of our own being in the midst of all of this incomprehensible grandeur.

Moreover, attention to beauty in the creation narrative reminds us of the marvels of everything that God has created and the ways in which created things mediate God's equally marvelous presence to us, again

downplaying the egocentric tendency in Christian ethics. "Beholding the natural environment through a sacramental lens should prevent us from using other species as mere stuff for our consumption and exploitation," explains Schaefer.[24] This is how mystics such as Hildegard of Bingen, Julian of Norwich, and Francis of Assisi understood beauty. "And I am the fiery life of the Divine essence," says Hildegard in the voice of Caritas, the third person of the Trinity:

> I flame above the beauty of the fields; I shine in the waters; I burn in the sun, the moon, and the stars. And, with the airy wind, I quicken all things vitally by an unseen, all-sustaining life. For the air is alive in the verdure and the flowers; the waters flow as if they lived; the sun too lives in its light; and when the moon wanes it is rekindled by the light of the sun, as if it lived anew. Even the stars glisten in their light as if alive.[25]

Or consider how Francis of Assisi underscores the relationality among all created things in the cosmos in light of their shared source of life in the Creator and Mother Earth in his Canticle of the Sun. Brother Sun and Sister Moon, Brothers Wind and Air, Sister Water, all offer praise to God.

Covenant. As is the case with creation stories, Christian ethicists often overlook the role of beauty in the covenant, whether that established between Yahweh and the people of Israel or between Jesus and all of humanity. In intellectually examining the moral imperatives in the Ten Commandments in Exodus, the law in Deuteronomy, or the love command in the gospels in order to determine how things ought to be, we tend to miss the sensorial experiences or almost uncontrollable gestures that seem to flow automatically from living in right relationship with God, others, and the earth. These signs indicate that we are on the right track when it comes to loving our neighbors as ourselves.

Yahweh's covenant with Israel, communicated in "theophanies"—majestic and even terrifying encounters that disclose direct revelation and yet maintain the Divine's ineffable nature—for example, is characterized by a freely given and lavish abundance. This abundance is

24. Jame Schaefer, "Appreciating the Beauty of the Earth," *Theological Studies* 62 (2001): 23–52, at 51.

25. Hildegard of Bingen, "The Holy Spirit as Caritas," in *Sister of Wisdom: St. Hildegard's Theology of the Feminine*, Barbara Newman (Berkeley: University of California Press, 1998), 69.

experienced in Yahweh's relational love for the people, the bounty of the earth, and the fertile relationships among the people that make them as strong as their weakest members. The people know in their bodies and their hearts when the covenant is being honored and often celebrate the experience of God's justice in songs of praise and with music and dancing. Yahweh instructs the people to build a spectacular temple whose irresistible beauty serves as a reminder of God's desire for the justice demanded in the covenant. The ecstasy the people feel in their close proximity to God in this beautiful place echoes the pleasure of living closely connected to each other.

Similarly, in the New Testament, the people are reminded of God's desire for a covenantal relationship with them in Jesus' healing ministry that restores people whose illness, deformity, or social status marginalizes them from community. Through the healing miracles, God again discloses to us that the beauty of justice lies in the power of human relationships of love to destroy the ugliness and contagion of social isolation. Whole bodies and minds rejoice as they are empowered to return to life-giving relationships with others. For our part, we are to respond to God's desire to love with love. Richard Viladesau notes the beauty in such acts of love in the example of Mother Teresa, who loved the least in their final hours. "A simple life of self-giving service to others can have a power and poetry; and love, particularly love of the most needy, is deeply beautiful."[26] In this way, we experience "theosis," becoming more God-like, precisely through aspiring after the relational beauty of the covenant.

Cross. We don't automatically associate the cross with beauty, and for good reason. Crucifixion was a torturous form of state-sanctioned execution that functioned to protect the interests of the privileged few in the Roman Empire. Christ found himself on the cross, serving as a warning against insurrection, because thousands of other outcasts, revolutionaries, and ordinary inhabitants of the empire had been crucified before him. Although traditionally a symbol for unpacking the theological implications of personal atonement and salvation, Christian ethicists have increasingly highlighted the significance of the cross in the larger scope of salvation history and atonement for social sin in an age of empire. In neither case has much attention been paid to the beauty of the cross.

26. Richard Viladesau, "The Significance of Art for Christian Theology," in *Chicago Studies* 41, no. 3 (2002), 236.

In his extensive scholarship on this subject from the days of the early church through the Renaissance, Viladesau notes that the cross reveals the paradoxical and even scandalous dimensions of the mystery of God's willingness to enter so completely into an experience of human suffering and death, an experience that can only be fully understood in terms of its ugliness and terror. "To speak of the beauty of the cross," he explains, "is to speak of a 'converted' sense of beauty. The cross challenges us to rethink and expand our notion of the beauty of God and indeed of 'beauty' itself."[27] Viladesau suggests that in the cross we find the ultimate symbol of God as an act of agapaic love, the kind of love whose profound beauty outshines the ugliness of rejection, of torture, of death. He notes, "If the crucified and risen Christ is the most profound and positive image of God, a God who is identified with the poor, the suffering, the dehumanized, then divinity is to be found not merely in what is outwardly beautiful and world affirming but also in association with powerlessness and death."[28]

The aesthetic sensibility of the African American community—scarred by the fiery brands of slavery, Jim and Jane Crow, segregation, and state- and community-sponsored violence—links the beauty of the cross more directly to acts of justice via the symbol of the lynching tree, which James Cone calls "the most horrifying symbol of white supremacy in black life."[29] While African Americans "sang more songs and preached more sermons about the cross than any other aspect of Jesus' ministry," Cone finds that its "conspicuous absence" from "American theological discourse and preaching is profoundly revealing."[30] He notes that "while the lynching tree symbolized white power and 'black death,' the cross symbolized divine power and 'black life'—God overcoming the power of sin and death."[31] The beauty of the cross, therefore, lies in its power as a touchstone of resistance within the African American faith community, manifested in a frenzied embodied response to God's liberation—clapping, dancing, singing—as well as in the courage to claim an identity over and against a violent and supremacist culture

27. Richard Viladesau, *The Beauty of the Cross: The Passion of Christ in Theology and the Arts, from the Catacombs to the Eve of the Renaissance* (New York: Oxford University Press, 2006), 9–10.

28. Richard Viladesau, "*Theosis* and Beauty," in *Theology Today* 65 (2008): 180–90, at 188.

29. James H. Cone, *The Cross and the Lynching Tree* (Maryknoll, NY: Orbis Books, 2011), 15.

30. Ibid., 25 and 30.

31. Ibid., 18.

that denies it. Via the lynching tree, a site of torture and death for hundreds of southern blacks, the cross is a sign of God's agapaic love that elicits and sustains an urgent commitment to justice in the here and now, the kind of justice that destined Christ for the cross and blacks for the lynching tree.

Finally, the Latino experience of colonial imperialism—economic, cultural, and religious—finds the beauty of the cross in its corporeality. Descendants of indigenous people scarred by the abuses of European empires in the seventeenth and eighteenth centuries and chattel of the American Empire in the twentieth century have a palpable affinity for the physical and emotional trauma Christ endured as a marginalized person in the Roman Empire in the first century. The resurrection of God's body—tortured and brutally executed at the hands of empire—reveals God's power to subvert empires and to side with the oppressed in witnessing to a society where all are seen as made in God's image. The subversive power of Christ's passion is not contained in sacred spaces or relegated to certain dates on the liturgical calendar but rather paraded through the streets in vibrant pageants and celebrated in Latinos' everyday struggles for justice in an age of empire. The cross evokes a tactile dimension to beauty and justice, since by touching the wounds of Christ, Alejandro García-Rivera claims, "there is an insight into evil itself that subverts it at its very roots for it offers a vision of humanity that is more beautiful than if the evil had not taken place."[32]

Human Reason/Philosophy

This source of ethics turns to the knowledge that we have accumulated through our capacity for human reason and invokes a natural law approach to responding to moral issues or social injustices in the Catholic tradition. In other words, we use reason to discern God's purposes for the world made evident in what we can observe in our reality and then determine, as best as we can, how to act in a way that is in accord with those divine purposes. Christian ethicist Thomas Massaro, SJ, explains it this way: "By closely observing the structures of nature, including our own bodies and the healthy instincts and inclinations built into our minds, we gain knowledge of the natural order God intends."[33]

Beauty has long been considered a disclosure of this natural law or divine ordering of things. Philosophers since Plato have tended to

32. Alejandro García-Rivera, *A Wounded Innocence: Sketches for a Theology of Art* (Collegeville, MN: Liturgical Press, 2003), 86.

33. Thomas Massaro, *Living Justice: Catholic Social Teaching in Action* (Lanham, MD: Sheed & Ward, 2000), 92.

consider beauty in one of two ways—either as a category of perfection toward which all beings orient themselves or as a facet of human experience that all persons share. Either way, beauty is essential for both discerning and interpreting the proper ordering of the world and the optimal orientation of human beings. Consider, for example, Simone Weil on this point: "The contemplation of veritable works of art, and much more still the beauty of the world, and much more that of the unrealized good to which we aspire, can sustain us in our efforts to think continually about that human order which should be the subject uppermost in our minds."[34]

Although the scope of this project does not permit me to do this with any depth or breadth, to understand the relationship between beauty and justice requires that we consider what a sampling of philosophers have had to say about the connection between the beautiful and the good. As in all things ethical, we must start with the ancient Greeks. Neither Plato nor Aristotle, two philosophers who greatly influenced Christian ethics, defined *to kalon*, or beauty, explicitly. Rather, in Drew Hyland's analysis, beauty "emerges" in the conversations the ancients engaged in as they searched for the connotations or essence of other ideas such as justice, *eros*, virtue, or the good.[35] Therefore, both Plato and Aristotle counted beauty among the finer or nobler "forms" or "ideas" that served as the source of knowledge and the compass for right living, the achievement of which served as the ultimate goal for human existence.

Plato. Hyland notes that Plato (429–347 BCE), unlike his successors from the modern period onward, largely associates beauty with the human body, which served as the reference point for evaluating and ranking the beauty of other things. In *The Phaedrus* he explains encounters with beauty with language that can only be associated with erotic love for one's beloved. Although he acknowledges that "there is something about 'beauty itself' that is not accessible to logos at all,"[36] Plato's inquisitive references to beauty, captured in the various questions pondered by Socrates and his compatriots in various settings in Athens, implicitly reflect the illusive and yet fundamental nature of this idea in Plato's understanding of life's purpose.

34. Simone Weil, *An Anthology*, ed. Siân Miles (New York: Grove Press, 1986), 94.
35. Drew A. Hyland, *Plato and the Question of Beauty* (Bloomington: Indiana University Press, 2008), 1–6.
36. Ibid., 25.

Dialogue in the *Hippias Major* attempts to offer a concrete definition of beauty, first by articulating a hierarchy of beautiful things—horses or gold for instance—and then identifying perhaps what some of the most beautiful things share in common: they are attractive; they shine forth; they make things around them beautiful. In the end, Socrates reveals this to be an exercise in futility, suggesting not only that it is impossible to clearly define beauty using words but also that it might be misguided to do so. Beauty is not necessarily a material or quantifiable thing but has something to do with the power of things to shine forth (important for understanding its connection to truth) and it cannot be clearly defined. It is something that extends beyond *logos* or our "discursive" capabilities, which reveals its connection to wisdom. "That is, no logos, and certainly not one concise enough to be called a definition, can capture the beautiful without remainder."[37]

The Symposium places beauty in a dialectical relationship to other things, most notably *eros*. It is worth noting that Diotima, a priestess and one of the only women to figure in Plato's entire corpus, articulates Plato's longest excursus on beauty. "Do you think," Diotima asks, "it would be a worthless life for a human being to look at [the beautiful itself], to study it in a required way, and to be together with it? Aren't you aware," she continues, "that only there with it, when a person sees the beautiful in the only way it can be seen, will he ever be able to give birth, not to images of virtues . . . but to true virtue, because he would be taking hold of what is true."[38] In this way, contemplation of the beautiful can lead to insights that shape our orientation toward the good.

Many discussions attempt to parse out the meaning and purpose of *eros*, only to illuminate that it is linked to physical and emotional desires for beauty—both material and immaterial—and our desire to create beauty ourselves, both material and immaterial. In its relationship to *eros*, beauty is that which makes us aware of what we lack and heightens our desire for those missing things so that we might become whole or experience more fully the good. It is here that Plato highlights beauty's connection to wisdom, or the desire for knowledge that comes from our awareness of what we do not know. The ascent to wisdom, for both increasing what we don't know and what we do know, is the good life. In his conversation with Diotima in *The Symposium*, Socrates reflects the creative dimension of beauty in light of what he calls his

37. Ibid.
38. Plato, *The Symposium*, 211e–12a, in Albert Hofstadfer and Richard Kuhns, eds., *Philosophies of Art and Beauty: Selected Readings in Aesthetics from Plato to Heidegger* (Chicago: University of Chicago Press, 1964), 76–77.

"soul pregnancy," which birthed a creativity that united him to the good in his pursuit of wisdom. Through its relationship to the good, we come to understand beauty in terms of both the end we desire and the way in which we achieve it. We know things to be beautiful because of their relationship to the good or happiness.

A desire for beauty without reason is dangerous since it can tempt us to be satisfied with a particular expression of beauty—a person, a poet, an idea—or merely to imitate that which we desire. This, along with the anthropocentric bias in Greek culture, explains Plato's reluctance to associate beauty with the arts, since the latter fosters mere imitation that limits the power of beauty to draw us toward more self-aware desires for the good. In essence, Plato considered most art to be nothing more than a copy of an original, light cast by the firelight on the walls of the cave with the power to keep us distractedly in chains. Moreover, he was suspicious of the power of the arts to stir equally distracting emotions that might preclude us from contemplating ideal forms with the highest level of our natures. He admitted that were he ever in the position to do so, he would drive poets and artists from the Republic. This dimension of the Platonic influence in Christian aesthetics, as in ethics, is perhaps most evident in Augustine. His own love/hate affair with beauty made him both restless for the Divine, whom he thought we might glimpse in encounters with beauty, and for the theater, which he resisted for fear that it stirred his baser emotions.

When infused with reason, however, Plato claimed that desire for beauty has the opposite effect. "Then he [the one who has had a singular experience with beauty] must realize that the beauty of one particular body and the beauty of other bodies is akin, and that if it is necessary to pursue beauty of form, it is irrational not to believe that the beauty of all bodies is the same."[39] A desire for the beautiful informed by reason, or the simultaneous awareness of the fact that what one desires is what one lacks, compels in us an ascent to increasingly nobler or beautiful things: a beautiful body can attune us to a beautiful law that can attune us to knowledge.[40]

Socrates's conversation along a country road with Phaedrus, a lover of rhetoric if not one of Socrates's most esteemed philosophical friends, describes in detail what Hyland calls "non-discursive" experiential encounters with beauty. In *The Phaedrus* Plato explains the ways in which experiences with beauty literally move human beings by healing the

39. Ibid., 210b.
40. Hyland, *Plato and the Question of Beauty*, 55.

parts of the human soul—the wings of the charioteer and two horses, one black and one white—damaged in our struggle for knowledge. In describing experiences of beauty, Socrates reports that: "a shudder runs through him, and again the old awe steals over him," and he experiences a "state of ebullition and effervescence bubbles up," a "feeling of uneasiness and tickling," "the sensible warm motion of particles which flow toward her" and "ceases from pain and joy."[41] Hyland notes that much like the sun, whose purpose is not to enable us to see it but rather to see more clearly the world around us, encounters with beauty, ideally in people we love, provide intuitional reminders of beauty of a higher order, namely, knowledge or enlightenment that leads to virtuous living.[42] That original source of beauty—ideally the "flashing beauty of the beloved"—is not denigrated but respected for the insight it sparks and its power to assist the charioteer in "taming and humbling" the horses, particularly the dark horse, "enslaving the vicious and emancipating the virtuous elements of the soul" so that it might be "light and winged for flight" with the gods. "Philosophic living [i.e., with an orientation toward the greatest goods with a heightened self-awareness of one's distance from it] and philosophic friendship [shared pursuit of union with the greatest of the gods facilitated through *eros* mapped out in *The Symposium*] are generated by, and so impossible without, the erotic experience of *beauty*."[43]

Hyland's examination of beauty in Plato's discourses challenges conventional framings of Platonic ethics: binary, focused on the immaterial, disregard for bodies, suspicion of the beautiful. Here we see the body as the locus of beauty; the creative process, which desire for beauty can engender; and a relationship between beauty and reason in heightening self-awareness and honing desires for the good. The point of encountering beauty is not to jettison the world in our desire to be united with beauty but rather an ascent to more virtuous living that becomes clear to us through experiences that remind us of our limits and yet foster a desire not to be determined by them.

Aristotle. Aristotle (384–322 BCE) develops Plato's ideas posed by Diotima in *The Symposium* regarding ways in which beauty fosters virtue. To that end, his treatment of beauty in *Nicomachean Ethics* and *Poetics* is

41. *The Phaedrus*, 246a–56, in Albert Hofstadter and Richard Kuhns, eds. *Philosophies of Art and Beauty: Selected Readings in Aesthetics from Plato to Heidegger* (Chicago: University of Chicago Press, 1964), 62.

42. Hyland, *Plato and the Question of Beauty*, 88.

43. Ibid., 87.

far more focused on the arts—human-made examples of beauty such as crafts, poetry, tragedies—than on beauty itself, in part because of the role of artists in exemplifying virtue that is central to his understanding of flourishing. For example, good carpentry is a result of carpentry done well; it is about both a particular end and a procedure by which one gets there. The proper end avoids excess or deficiency and involves doing something with excellence. Imitation is important here, particularly in the habituation involved in the arts and the dispositions and behaviors it can inspire in those who view it:

> When men hear imitations [of music, in this instance], even apart from the rhythms and tunes themselves, their feelings move in sympathy, since then music is a pleasure, and virtue consists in rejoicing and loving and hating aright, there is clearly nothing which we are so much concerned to acquire and to cultivate as the power of forming right judgments, and of taking delight in good dispositions and noble actions. Rhythm and melody supply imitations of anger and gentleness, and also courage and temperance . . . for listening to such strains our souls undergo a change.[44]

Just as craftsmen hone their craft in the image of an archetype or ideal form, human character is shaped by the form or end toward which we are oriented. "Every virtue or excellence both brings into good condition the thing of which it is the excellence and makes the work of that thing be done well," he explains in the *Nicomachean Ethics*.[45] Later in that text he goes on to say, "Every art and every inquiry, and similarly, every action and pursuit, is thought to aim at some good; and for this reason the good has rightly been declared to be that at which all things aim."[46] Aristotle even went so far as to identify the characteristics of beauty with "the mean" that is so central to his ethical theory. Beauty requires balance between extremes whether in terms of coloring, tone, or size. "The chief forms of beauty are order and symmetry and definitiveness," he notes in *The Metaphysics*.[47] Good artists seek the mean between excess and deficiency, and good works of art need nothing more and can do with nothing less. He also parses tragedies and poems according to

44. Aristotle, *Politics*, 1340a, in Hofstadter and Kuhns, *Philosophies of Art and Beauty*, 133.

45. Aristotle, *Nicomachean Ethics*, 1106B, in Hofstadter and Kuhns, *Philosophies of Art and Beauty*, 93.

46. Ibid., 1094b, 94.

47. Aristotle, *Metaphysics*, 1078a31–1078B, in Hofstader and Kuhns, *Philosophies of Art and Beauty*, 96.

these characteristics: symmetry, proportionality, and balance. These, he claims, are also characteristics of the good, particularly the goods of a just society.

Aristotle identifies the social value of the arts in stirring important social emotions and forcing us to make judgments about human flourishing. Greek tragedy, for example, offered safe space for citizens to embrace emotions such as pity and fear, from which they needed to be cleansed, as well as to foster emotions of empathy and compassion for those beyond their immediate circles of concern. "Tragedy is essentially an imitation not of persons but of action and life, of happiness and misery," he says in *Poetics*. "All human happiness or misery take the form of action; the end for which we live is a certain kind of activity, not a quality. Character gives us qualities, but it is in our actions—what we do—that we are happy or the reverse."[48] Both movements forge social bonds that make for more equitable distribution of social goods.

Kant. When the human subject, with the capacity for scientific discovery and self-knowledge, finally upstaged preoccupation with ideal forms or transcendentals or God in the eighteenth century, philosophers began to ponder the nature of beauty and human experiences of it with gusto. In fact, it was a German philosopher, Alexander Gottlieb Baumgarten, who coined the term "aesthetics" in 1750 to define the emerging discipline of sense perception, a source of empirical data and moral evaluation. Under the umbrella of aesthetics Baumgarten includes "the science of sense knowledge, the theory of the liberal arts, the epistemology of the lower level of knowledge, the rules of thinking aesthetically, and the rules of reasoning by analogy."[49] Beauty was seen as a catalyst for sense perception and the various cognitive activities that went with it, from imagination and fantasy to emotion and kinetics. Insofar as these capacities were seen as sources of insight, beauty became a moral category. Contemporary philosopher Daniel Herwitz notes that his predecessors began "to think of the experience of the beautiful as itself a kind of judgment, to conceive of the pleasure taken in beautiful things as the ground for judgment, indeed the judgment itself."[50]

48. Aristotle, *Poetics*, 1450A, in Hofstadter and Kuhns, *Philosophies of Art and Beauty*, 103.

49. Gottlieb Baumgarten, *Aesthetica*, 2 vols. (Frankfurt am Main, 1750–58), quoted by Umberto Eco in *The Aesthetics of Thomas Aquinas*, trans. Hugh Bredin (Cambridge, MA: Harvard University Press, 1988), 2.

50. Daniel Herwitz, *Aesthetics: Key Concepts in Philosophy* (New York: Continuum, 2008).

With so much at stake, beauty became a hotly debated philosophical concept. Although many philosophers have attempted to articulate exactly what beauty is, Immanuel Kant's (1724–1804) approach is perhaps the most influential for a Christian aesthetic ethic. Better known for his duty-based approach to moral decision making, Kant's four-part argument regarding beauty, spelled out in *Critique of Judgment* (1750), should be equally well read in circles of Christian ethics for several reasons. First, in a way that reflects his dispassionate categorical imperative, Kant insists that judgments about beauty must be universal or evaluations that all people would make using the same cognitive faculties if given the opportunity. The only way to ensure this universality is for us to take a "disinterested" stance toward beautiful objects as well as to any prior knowledge or likes or dislikes we may bring with us. What is pleasurable about beauty, therefore, is not the object or the way it makes us feel but rather the imaginative and reflective play the object initiates within us, a reflective activity that is "purposive" without having a specific purpose. As Herwitz explains, "I take pleasure in my own imagination in and around [the beautiful object] . . . in my own faculty of construction, not in the thing."[51]

This capability of cognitive, imaginative, and reflective play that beauty evokes is important for two reasons. First, Kant rightly recognizes it as an ability that makes us distinctively human. Contemporary feminist philosopher Martha Nussbaum acknowledges as much when she lists the imagination among her central capabilities necessary for authentic human flourishing. Moreover, Kant identifies the cognitive pleasure that beauty evokes as a common denominator among humans to the extent that Herwitz categorizes Kant's aesthetic as an "ought of togetherness." Beauty, therefore, is essential for establishing common bonds. In addition, Kant believed that this cognitive capability is something that humanizes us. The reflective process beauty sparks is less about the object that catalyzes it and more about the subject who encounters it. In other words, beauty reads us, awakening in us an awareness of our humanity. This makes us more human and therefore more capable of desiring and perhaps of doing the good.

Kant's contribution to the preceding chapters of this book cannot be underestimated. Certainly, he moves discussions of beauty beyond the suprasubjective "eye of the beholder" stances that often preclude meaningful evaluation of artistic expression. Although his disinterested gaze has been rightly recognized as the perspective of a Euro-American

51. Ibid., 62.

male, Kant's aesthetic still challenges cultural impositions of beauty
via the dominance of certain artistic tastes. The moments of cognitive
construction that he claims beauty evokes are morally significant for
community art, since it values the cognitive processes in creative acts
and not simply the end result. Perhaps most important, more so than
other ethicists, Kant opens up space in Christian ethics for the imagi-
nation. You can hear echoes of Kant in Philip Keane's description of
imagination: "Imagination is a playful suspension of judgment leading
us toward a more appropriate grasp of reality. . . . In its play, imagina-
tion looks for deeper and more appropriate unities in our experience,
unities and insights into truth which we might easily miss without
imagination."[52]

That said, we should not ignore the historical implications of a dis-
interested engagement with the arts that Kant, perhaps unknowingly,
cultivated. A disinterested stance is suspicious of many of the very
facets of human cognition that a turn to sense perception and imagina-
tive reflection contribute to ethics: emotion, bodily responses, desires,
a potential relationship between object viewed and viewer. Moreover,
it rejects the experiential wisdom of particular individuals who are
expected to exclude knowledge and insight that arise out of particular
contexts from their evaluations of beautiful objects. And as I previously
mentioned, Kant's disinterested stance reflects the autonomous ratio-
nality that contemporary scholars, particularly feminist ethicists and
ethicists of color, recognize as germane to a culture of whiteness.

Feminist philosophers. Iris Murdoch (1919–99)—a novelist, play-
wright, poet, and moral philosopher—was not immediately recognized
for her philosophical work during her lifetime, given the strong hold
that analytic philosophy had on the discipline. This grip didn't allow
room for a feminist's "deep suspicion of claims to universality" and
"a more complex psychology that acknowledges emotions and inter-
personal relationships" that she brought to the table.[53] Scholar Megan
Laverty notes that Murdoch understood moral wisdom in terms of
learning to enter into the ambiguity and contradiction of the human
condition, rather than to resolve intellectually the tension they create
or to mitigate it with principles and duties. Attention to ambiguity
makes us conscious of limits and aware of egocentrism, and both of

52. Philip Keane, *Christian Ethics and the Imagination: A Theological Inquiry* (New
York: Paulist Press, 1984), 83.
53. Megan Laverty, *Iris Murdoch's Ethics* (London: Continuum, 2007), 3.

these stances can more radically open us up to engagement with others. The arts are essential for raising this kind of consciousness, since truly great art "shows us the world, our world and not another one, with a clarity which startles and delights us simply because we are not used to looking at the real world at all."[54] In her treatise on Plato's understanding of art and beauty, *The Fire and the Sun*, Murdoch notes, "art is far and away the most educational thing we have. . . . Art is a great international human language, it is for all" and while it has "no formal 'social role' artists will automatically [serve society] if they attend to truth and try to produce the best art (make the most beautiful things) of which they are capable."[55]

Murdoch is Kantian in her insistence that our knowledge is shaped by our experiences and perspectives and that these experiences of the sublime offer flashes of insight as to the real or objective truth. We experience the sublime in the context of the everyday and our relationships with others. The ethical task is to examine these flashes of insight with the lens of the imagination, a tool that allows us to see things in our experiences that we might otherwise have missed and to envision things that are not there and should be, ultimately arriving at a humble shift in our understanding or way of perceiving reality.[56] In the end, this imaginative reflection is essential for virtuous living and for justice. "Miss Murdoch is not overly optimistic about the possibilities of achieving the good in this life," explains Stanley Hauerwas, "but she is sure that if it does happen, it does so only by the hard and painful effort of the transformation of our vision."[57] The task of ethics, in his reading of her, is the "progressive attempt to widen and clarify our vision of reality."

Elaine Scarry, a contemporary philosopher very much influenced by Kantian aesthetics, corrects some of these errant tendencies by underscoring the relational qualities of beauty that make it an ideal partner for justice. In her book *On Beauty and Being Just*, she puts a different spin on Plato's concern about the urge to imitate beauty. Rather than distracting us from the good, the desire to replicate beauty reflects what she calls a "forward momentum" inherent in beauty. This momentum is manifested in our desire to share what she names as beauty's many social goods through acts of imitation or replication. Beauty is lifesaving—"it quickens, adrenalizes, it makes the heart beat faster, it makes life more

54. Iris Murdoch, *The Sovereignty of Good* (London: Routledge and Kegan Paul, 1970), 65.

55. Iris Murdoch, *The Fire and the Sun* (New York: Viking, 1977), 86.

56. Laverty, *Iris Murdoch's Ethics*, 25.

57. Hauerwas, *Vision and Virtue*, 44.

vivid, animated, living, worth living."[58] It makes those who seek it "become beautiful in their interior lives," since, like Kant, Scarry acknowledges that beauty prompts deep scrutiny, judgment, and self-reflection that has the power to decenter us so that we might see ourselves and the world differently. Finally, beauty also fosters a sense of responsibility, since when we encounter beautiful things we often experience a desire to be sure that they are cared for, that no harm befalls them. "Beauty is then a compact or a contract between the beautiful being (a person or thing) and the perceiver," she explains. "As the beautiful thing confers on the perceiver the gift of life, so the perceiver confers on the beautiful being the gift of life."[59]

Perhaps not surprisingly, Greek philosophy grounds political philosopher Martha C. Nussbaum's academic and practical commitments to support the central capabilities of poor women in India and her advocacy for them and other underdeveloped populations at the United Nations. What is striking about Nussbaum's appropriation of Hellenistic notions of virtue, justice, and flourishing in our global economy, however, is the fact that Greek tragedies play just as important a role in her thought as more familiar political or ethical treatises. The Greek poets, she notes, relied on the medium of tragedy to expand and sharpen the wider society's sense of perception of vulnerability. By exposing audiences to radically different others wrestling with conflicts often not of their choosing, tragedies remind us of the inherent vulnerability of the human condition as well as the fact that social circumstances exacerbate vulnerability for many. The compassion they evoke via their power to move people emotionally might also move people to respond to vulnerabilities that preclude flourishing. Tragedy's central role, according to Nussbaum, "is to challenge the conventional wisdom and values" and "to disturb us," the "tragic spectators."[60]

She incorporates tragedy and tragic spectatorship into her development of ethics, since tragic questions can raise important questions often overlooked by those in positions to shape our political economy. Tragic questions unleash our imaginative ability to perceive what is going on in our social reality and to create upheavals in our presumed innocence in the causes of unjust suffering in our world. Exposure to the arts increases the moral faculty of what she calls the "narrative

58. Elaine Scarry, *On Beauty and Being Just* (Princeton, NJ: Princeton University Press, 1999), 24.

59. Ibid., 90.

60. Martha C. Nussbaum, *Cultivating Humanity: A Classic Defense of Reform in Liberal Education* (Cambridge, MA: Harvard University Press, 1998), 98–99.

imagination" or "the ability to think what it might be like to be in the shoes of a person different from oneself, to be an intelligent reader of that person's story, and to understand the emotions and wishes and desire that someone so placed might have."[61]

Tradition

Terrence Tilley notes that tradition, with its Latin roots in *tradere*, meaning "to carry," has two connotations. The first, *tradita*, focuses on the content of the faith that we carry, and the second, *traditio*, focuses on how we actually carry this content forward. In other words, religious tradition involves content—ideas, objects, rituals, and activities that ask and answer fundamental questions about who God is or what it means to be human, sometimes invoked with the term "orthodoxy," as well as the practices that pass these questions and answers from generation to generation, often called "orthopraxy."[62] As such, tradition is an important source of wisdom for Christian ethics, since it entails considering not only what scholars and communities of believers claim as central to the faith but also how they incarnate or actively participate in these claims from generation to generation. Tradition is both ideas and actions.

The *traditia* of beauty and the arts is rich since theologians frequently invoke beauty to explain the Divine, and Christians have created beautiful things—hymns, paintings, dances—to communicate their understandings and experiences of the same. Four theologians' particular engagements with beauty offer important insights for Christian ethics.

Augustine. "Do we love anything save what is beautiful?" asks Augustine, infamous fourth-century lover of what Plato would have considered less than beautiful things, in his memoir, *The Confessions.* "And what is beauty?" What is beauty indeed. Prior to his conversion experience, Augustine equated beauty with his emotional experiences in the theater, in the natural world around him that overwhelmed him with fragrances and tastes, and with his desire for knowledge of things eternal and immutable. After anchoring his restlessness in the Christian God, the unavoidable and overwhelming invitation to do so came to him in song; ironically enough, he equates all of these excitements and movements of his senses with the Divine. "Late have I loved Thee, O Beauty so ancient and so new, late have I loved Thee," he exclaims.

61. Martha C. Nussbaum, *Not for Profit: Why Democracy Needs the Humanities* (Princeton, NJ: Princeton University Press, 2010), 95.

62. Terrence W. Tilley, *Inventing Catholic Tradition* (Maryknoll, NY: Orbis Books, 2000).

"Thou didst call and cry out and burst in upon my deafness; Thou didst shine forth and glow and drive away my blindness; Thou didst send forth Thy fragrance, and I drew my breath, and now I pant for Thee; I have tasted and now I hunger and thirst. Thou didst touch me, and I was inflamed with desire for thy peace."[63]

Plato's influence on Augustine is perhaps nowhere more evident than in his understanding of beauty. His first work, "The Beauty and the Fitting," of which we have only reports since, like many beautiful things, it was not well preserved, attempted to distinguish the truly beautiful from things that merely reflect or point to beauty. Symmetry, proportionality, balance, and immutability were important characteristics. His "contemplative aesthetic" reflects his sense that, like a fourth-century mirror in which one would be able to see only a murky vision of the self, beauty could at best offer only glimpses of God; contemplating beauty could orient us to the world around us. His "incarnational aesthetic," on the other hand, reflects his sense that the material world too was imbued with beauty.

Thomas Aquinas. It is interesting that as one of the most prolific and significant theologians of the Christian tradition, Thomas Aquinas did not write an exhaustive treatise on aesthetics or beauty. Given his thorough treatment of so many other facets of Christian thought and practice, this lacuna is surprising, particularly in light of the fact that his educational training included literature, rhetoric, and music. In fact, there is evidence to suggest that he himself was a musician. Thomistic scholar Umberto Eco explains this gap in Aquinas's writing in terms of abundance. Aquinas was steeped in a medieval sensibility that would have articulated beauty as an intelligible expression of the Divine while at the same time attuning him to the beauty of the natural world and human-made creation. There is an allegorical facet to the medieval sensibility that created a sense of cosmic wholeness between the earthly and heavenly realms, as well as a taste for beauty in architecture, in vestments, and in music. Therefore, Aquinas does not offer a systematic treatment of aesthetics "because it came naturally to him to see the world in terms of its beauty; it was something spontaneous, effortless, and habitual. . . . It was a natural and everyday fact of life that the world was conceived of aesthetically."[64] Eco goes on to say,

63. Saint Augustine, *The Confessions* 10.27.38, ed. John E. Rotetelle (Hyde Park, NY: New City Press, 1997), 262.
64. Umberto Eco, *The Aesthetics of Thomas Aquinas*, trans. Hugh Bredin (Cambridge, MA: Harvard University Press, 1988), 116.

"For Aquinas, then, beauty was not just an abstract reality, known on the conceptual level but not experienced empirically." So while he may not have dedicated an entire thesis to the topic of beauty, Aquinas does rely on this transcendent category to explain the Divine and to further explain the good toward which human action should be oriented. To that end, these anecdotal references make significant contributions to Christian ethics.

Since Aristotelian philosophy plays such a significant role in the *Summa Theologiae*, particularly in the second of its three parts, where Aquinas considers humanity's relationship to God and our responses to God's love, many of his references to beauty in his various writings reflect the previously discussed tensions in Hellenistic philosophy where beauty is concerned: between physical and intangible beauty, between outward and inward beauty, and whether beauty lies in the usefulness of beautiful things. Moreover, he uses beauty to divinize the Greek concept of the transcendental or fundamental essence of things. In his *Commentary on the Divine Names* (1265–66), Aquinas describes God as "supersubstantially beautiful, beautiful beyond being" because "God gives beauty to all created being, according to the properties of each."[65] It is through beauty that God creates order and harmony, which make relationships among creatures possible; beauty, therefore, reminds us of the inherently relational nature of the Divine as well as of created things. "It is always the case that whatever creatures may have in the way of communion and coming together, they have it due to the power of beauty," explains Aquinas.

> Everything that exists comes from beauty and goodness, that is from God, as from an effective principle. And they turn toward beauty and goodness and desire them as their end. . . . And all things are and all things become because of beauty and goodness, and all things look to them, as to an exemplary cause, which they possess as a rule governing their activities.[66]

Aquinas's notion of beauty plays two important roles in Christian ethics. First, he associates the apprehension of beauty with a particular form of intellectual cognition that is often bypassed in light of our preoccupation with perceptions that arise out of our appetites, whether physical or emotional. Noticing beauty or beautiful things cultivates a "disinterested pleasure" or pleasure for its own sake in which more

65. Ibid., 28, quoting *Commentary on the Divine Names* 5.
66. Ibid., 28–29, quoting *Commentary on the Divine Names* 4.8.

instrumentalized ruminating is suspended or interrupted. Beauty offers a way of knowing and perceiving, particularly through our senses of sight and hearing, by opening up restful space for reflection and insight. "So it is clear that beauty adds to good a reference to the cognitive powers; 'good' refers to that which simply pleases the appetite, where a thing is called beautiful when the mere apprehension of it gives pleasure."[67] Through this reflective, disinterested pleasure reason is freed to ponder the essence of the Divine in the good and the true.

"Three things are necessary for beauty," he notes in the *Summa*: "first, integrity or perfection, for things that are lacking in something are for this reason ugly; also due proportion or consonance; and again, clarity, for we call things beautiful when they are brightly colored." He goes on to explain, "Beauty or handsomeness arises when clarity and due proportion run together. . . . So, beauty of body consists in this, that a person has well-proportioned limbs, together with a certain requisite of clarity and color."[68]

Aquinas's description of beauty, a reflection of his medieval sensibility and affinity for Aristotle, illuminates facets of his virtue theory. For example, his notion of proportionality speaks to the consonance the medievals saw in the created world, an ordering and symmetry that arose out of the laws of geometry and mathematics. If proportionality considered ordering on the cosmic scale, an ordering in which different parts worked together to form a unified whole, then integrity dealt with the right or proper ordering of individual objects or persons. Beings or objects had integrity if they embodied a balance between deficiency and excess and if disparate parts worked together in a larger whole. Aquinas associated clarity with light but understood light as a kind of luminousness generated from within that brings things into being. Clarity suggests that beautiful things do not become vibrant when light passes over them but rather are illuminated from within or are in themselves a source of light.

Beauty in Aquinas's thought reflects his virtue theory through an emphasis on fitting behavior, actions that are appropriate for the moral agent and the situation at hand, as well as a rightly informed or illuminated capacity for reason. Proportionality and integrity point to the importance of fit or "the mean"—the middle way between extremes—both in terms of creative acts and moral acts: "form and matter must always be mutually proportioned and, as it were, naturally adapted, because the

67. Aquinas, *Summa Theologiae*, I–II.27.1.3.
68. Aquinas, *Summa Theologiae*, I.39.8C.

proper act is produced in its proper nature."[69] Clarity points to the power
of reason, particularly given that Aquinas associates intemperance or
instances when desire is stronger than reason with ugliness because it
clouds the light of reason and leads to dispositions and habits that are
not fitting or appropriate.

Hans Urs von Balthasar. Swiss theologian Hans Urs von Balthasar
(1905–88) reprimanded his fellow theologians for casting aside the
aesthetic dimension of the Divine and revelation in what he deemed
as theology's futile attempts to become a more scientific discipline in
response to Modernism's critique of religion. In order to retrieve God,
and likewise truth, from being just an idea, he invokes experiences of
the performative arts—"quivering," "experiencing ourselves as being
moved and possessed by beauty, being taken up wholesale into the real-
ity of the beautiful"—all of which call our attention to the "theo-drama"
of God throughout history.[70] According to Oliver Davies, Balthasar
"breaks the link between faith and reason which has so dominated
modern theological apologetics" and instead asserts faith as a move-
ment akin to what we might "feel before the immense complicity of
meaning, expression and 'form' of a major work of art."[71] It is in these
dramatic and often beautiful events that God confronts us and we are
able to grasp and participate in goodness and truth, not merely as an
intellectual proposition, but as an affective movement of the soul. "All
of a sudden, revelation is demonstrated not to be a mere set of past
events, but a present ferment," he notes. "All of a sudden, it becomes
apparent that one can have no real idea of 'the truth' of this revelation
until one is caught up in it, relinquishing one's claim to neutrality."[72]

Balthasar did not agree with prevailing Kantian sensibilities that
somehow truth could be separated from form or that the object of our
aesthetic reflection is somehow distinct from the insights we gain from
contemplating it. His seven-volume *Glory of the Lord* maps out a Christo-
centric aesthetic since in the embodied form of Christ he finds the arche-
type or ideal "form" of beauty, characterized by *kenosis* or self-emptying

69. Aquinas, *Summa Contra Gentiles*, III.54.14.

70. Hans Urs von Balthasar, *Seeing the Form*, vol. 1 of *The Glory of the Lord*, trans.
Erasmo Leiva-Merikakis (Edinburgh, T & T Clark, 1982), 247.

71. Oliver Davies, "The Theological Aesthetics," in *The Cambridge Companion to
Hans Urs von Balthasar*, ed. Edward T. Oakes and David Moss (New York: Cambridge
University Press, 2004), 134.

72. Hans Urs von Balthasar, *The World Made Flesh*, vol. 1 of *Explorations in Theology*,
trans. A.V. Littledale and Alexander Dru (San Francisco: Ignatius Press, 1989), 205.

(relinquishing of desire to control and dominate), inexhaustible depth (pointing to depth of persons as well as to the human experience), super-abundance (God's gift of self to creation), and relationality (Trinity). In the subsequent five volumes of *Theo-Drama*, he also links "seeing the form" of God's self-disclosure in Christ, aesthetics, with acting in God's "theo-drama." Contemplate the beautiful form of Christ and you contemplate truth or the goodness of God; contemplate the truth and your whole being will be moved toward God, participating in the beautiful glory of God.

Balthasar's theological aesthetics makes at least two important contributions to an approach to ethics rooted in aesthetics. First, he encourages a Christocentric ethic, with an emphasis on an embodied perception of the "form" of God in Christ and then an equally embodied participation, as Christ's life reveals, in God's beautiful drama. It is through the enfleshed "theo-drama" of the life of Christ that we come to understand who God is and also better understand what it means to be human. We become more fully human by participating in God's unfolding work as Christ did: "quite humanly laboring in each situation to hear this calling to him from God, to give himself to it entirely, and thereby to discover the fullness of his personal identity."[73]

His aesthetic also underscores the importance of perception for moral discernment. It is the task of Christian disciples to "see the form" of God in the beauty of God's unfolding drama and then to accept the truth that form illuminates or shines forth. This is an ongoing process that gradually opens us to the depth of ourselves and stirs within us a love or *eros* that moves us ever closer to God. Proper perception of the glory of God in the theo-drama of Christ makes it possible for us to respond appropriately with love for God and for others. According to Ben Quash, "Theo-drama is *live* performance in solidarity with others of Christ's all encompassing mission to the world."[74]

David Tracy. What people have said about God and beauty, or even the artifacts they have created in attempts to articulate this, do not give a complete sense of the ethical role of beauty in religious traditions. "The symbol systems of a particular religious language are not merely handed down," explains Colleen McDannell; "they must be learned through doing, seeing, and touching. . . . Experiencing the physical dimension

73. Mark A. McIntosh, "Christology," in Oakes and Moss, *The Cambridge Companion to Hans Urs von Balthasar*, 33.

74. Ben Quash, "The Theo-Drama," in Oakes and Moss, *The Cambridge Companion to Hans Urs Von Balthasar*, 144.

of religion helps bring about religious values, norms, behaviors, and attitudes."[75] There is perhaps no better resource for Christian ethicists when it comes to mining the Christian "symbol system" with an eye for *traditio* than contemporary systematic theologian David Tracy. "Religion, like art," Tracy notes, "discloses new resources of meaning and truth to anyone willing to risk allowing that disclosure to happen."[76]

Tracy's "religious classic," which he describes as "any text, object, image, person, symbol, or event" that "so discloses a compelling truth about our lives that we cannot deny [it] some kind of normative status," not only makes *traditio* possible but also greatly expands our understanding of what might be included as a source of ethical reflection or wisdom.[77] As is the case with any authentic experience of art, Tracy suggests that when we encounter a religious classic, "we find ourselves 'caught up' in its world, we are shocked, surprised, challenged by its startling beauty and its recognizable truth, its instinct for the essential."[78] Religious classics confront us with limit questions—about the meaning of life, about the existence of God in a suffering world, about the reasonableness of hope, for example—and dare us to risk the heightened self-awareness that will come with our attempts to engage these limits. Similar to the reflective moments in Kant's aesthetic, "the interpreter must risk being caught in, even being played by, the questions and answers—the subject matter—of the classic," Tracy explains. Unlike Kant, however, Tracy believes that religious classics confront us with an excess of meaning, which continues to be revealed across time and space. The ethical demands of religious classics are unavoidable, since they make a "nonviolent appeal to our minds, hearts, and imaginations, and through them to our wills"[79] and are "gifts that imply a command: a command to communicate by incarnating that reality [to which it points] in a word, a symbol, an image, a ritual, a gesture, a life."[80]

In addition, Tracy's method of interpreting religious classics, what he calls the "analogical imagination," incorporates into Christian ethics many of the cognitive capacities we have been discussing in this appendix. This disposition and set of evaluative criteria, akin to those we

75. Collen McDannell, *Material Christianity: Religion and Popular Culture in America* (New Haven, CT: Yale University Press, 1995), 2.

76. David Tracy. *Analogical Imagination: Christian Theology and the Culture of Pluralism* (New York: Crossroad, 1981), 67.

77. Ibid., 108.

78. Ibid., 110.

79. Ibid., 177.

80. Ibid., 202.

employ when encountering and interpreting works of art, invoke the Catholic sacramental imagination—a mysticism that perceives the entire world as imbued with the sacred and seeks encounters with the divine in ordinary objects and experiences. It also implies the all too often underestimated claim that all language about God is symbolic and therefore continuously invites interpretation. Tracy suggests that approaching the tradition analogically makes certain demands on interpreters: a willingness to acknowledge one's own sociohistorical location, to risk being confronted by the tradition and be read by it rather than the other way around, to risk unexpected insights and seemingly contradictory interpretations, to engage in a dialectical give-and-take that pushes us to the limits of our own understanding, and to communicate with the wider community about its meaning.

Experience

"Experience is the actual living of events and relationships, along with sensations, feelings, images, emotions and insights that are part of this lived reality," explains Margaret Farley.[81] With this source, Christian ethicists begin with experience; analyze these experiences using the social sciences, such as economics, sociology, politics, or cultural anthropology; and then reflect on them, using the other three sources of ethics in order to determine how to respond.

Karl Rahner. To some extent, German systematic theologian Karl Rahner (1904–84) preceded Tracy in acknowledging the importance of believers' lived experiences of religious classics and not simply abstract theological concepts or categories. "If scientific theology is to be true to its own nature," Rahner notes, "it will have to reflect on the religion of the people much more than it usually does."[82] This ethical turn to experience is due in large part to Rahner's definitive theological turn to the "subject" in the middle of the twentieth century. "Theology should not merely speak about objects in abstract concepts, but it must encourage people to really experience that which is expressed in such concepts."[83]

81. Margaret Farley, "The Role of Experience in Moral Discernment," in *Christian Ethics: Problems and Prospects*, ed. Lisa Sowle Cahill and James F. Childress (Cleveland, OH: The Pilgrim Press, 1996), 134–51, at 135.

82. Karl Rahner, "The Relation Between Theology and Popular Religion," in *Theological Investigations* XXII, trans. Joseph Donceel (New York: Crossroad, 1991), 140.

83. Karl Rahner, "Art against the Horizon of Theology and Piety," in *Theological Investigations* XXIII, trans. Joseph Donceel and Hugh M. Riley (New York: Crossroad, 1992), 164.

In many ways, Rahner's transcendental theology is completely dependent on beauty or the sensorial experiences fostered by the arts. All persons are created with a "pre-thematic" awareness or apprehension of a communicative God who discloses God's self in the context of everyday human experiences of finitude. Art draws out of us that which is latent in us—a heightened sense of the infinite and our own finitude. Humanity is also created with the freedom to respond to that disclosure of God, both through love of God and love of neighbor.

Rahner's ideas about aesthetics are notable for their ethical implications. His claim that encounters with beauty protect the mystery of the self in relation to the divine brings a "mystagogical" awareness to theology, imbuing in it a poetic nature. This kind of theology he called poetic. "This means not only that theology should take account of feeling, beauty and art as aspects of religion and primarily religious language," explains Viladesau, "but also that theology itself should speak 'with feeling' and in images integrating the religious and poetic elements into its mode of disclosure."[84] When we look beyond what theologians "say" about beauty, or even what they say about "tradition," to the popular piety in which everyday believers "live" beauty, we can find the overlooked or marginalized "classics" in any tradition that not only reflect different cultural sensibilities but also point to a God at work in these cultural contexts and communities.

Feminist theological aesthetics. The category of human experience as a source for Christian ethics is largely credited to feminist ethicists and ethicists of color whose historical marginalization within the tradition and from the discipline of ethics has likewise marginalized experience from both. For example, the central thread of beauty runs through creative self-expressions of the tradition's earliest feminist theologians. Hildegard of Bingen composed music and painted imagery that captured a cosmological spirituality in the eleventh century that still speaks to Christians ten centuries later. The poetry of Sor Juana, considered the first feminist theologian of the Americas whose "auto sacramental" *El Divino Narcisco* used myth, metaphor, and symbol to break open the consciousness of indigenous peoples in the age of Spanish colonialism continues to trouble Christian consciences in our modern age of empire.[85]

84. Viladesau, *Theological Aesthetics*, 12.
85. See Michelle Gonzalez, *Sor Juana: Beauty and Justice in the Americas* (Maryknoll, NY: Orbis Books, 2003).

It seems only logical that we consider the ways in which encounters with beauty have long shaped women's experiences of the justice and the divine. And we have already done so to some extent in the previous discussion of feminist philosophers. It is improtant to note, however, that women have not necessarily had the opportunity to define beauty, however, either because they have been relegated to being objects of beauty, therefore incorporating them in the Platonic suspicion of the arts, or because their sociohistorical location has awarded them neither the time nor the privilege to theorize about it. If we look at women's experiences of beauty and the way they have attempted to define it for themselves, we will see much more clearly the connections between beauty and justice, primarily because beauty is something that women do; it is not simply something they think about. "Beauty for women is, rather, tied closely to the way one lives and acts," explains contemporary feminist ethicist Susan Ross. "It is interwoven into women's lives and is much less an ornament than a central thread: a practice, and not simply an idea."[86]

Ross is one of the few female theologians to define beauty using women's experiences—her own, that of her mother and friends and colleagues, and that of African women she has come to know through her research. She concludes that it is "a kind of ordering of material, intentional or not (as in nature), in a way that presents a unique vision or sensory experience of some dimension of the experienced world that gives the beholder pleasure and a sense of deeper meaning."[87] This reveals not only the relational nature that Scarry calls our attention to but also the different ways that persons are related. Beauty is something that we bring to the unique relationship we have with ourselves, most often through various acts of caring for our bodies and spirits. It is something that we offer to those to whom we are specifically related, since generous acts nonverbally communicate to others that they are "worth the time and effort to be cared for, with attention to details." We invoke beauty in navigating the relationships we have with all persons, particularly in our care for the earth, which is quite literally the common womb of our existence. To that end, women's experiences of beauty are inherently ethical. "When we fail to acknowledge and appreciate beauty—our own, another's, nature's—we are failing to give glory to God. We are failing to love our neighbor as ourself."[88]

86. Susan Ross, *For the Beauty of the Earth: Women, Sacramentality and Justice* (New York: Paulist Press, 2006), 65.

87. Ibid., 27–28.

88. Ibid., 31.

Black theology. The sociohistorical conditions of blacks throughout American history—from slavery to the Obama moment—give rise to a unique aesthetic sensibility that is at once religious in proclaiming divine justice and political in sustaining agency and resistance. W. E. B. Du Bois reflected in 1903 on the power of the black aesthetic, particularly via what he called the "sorrow songs" of the spirituals, to "make" the souls of black folk through the daring risk to plumb the depths of tragic suffering and sorrow and to risk a hope that such suffering would not have the final word.[89] According to James Baldwin, entering into the tragic nature of life protects African Americans from being ensnared in various phobias that arise when humans try to deny our tragic circumstances.[90] Awareness of the temporariness of this life heightens one's sensual experiences, making it possible to risk a meaningful despair without losing hope or to participate in joy without obliterating life's sorrow. Ralph Ellison suggests that tragic conditions of oppression and poverty created a particular kind of freedom and abundance in the black aesthetic: "rhythmic freedom in the place of social freedom, linguistic wealth instead of pecuniary wealth."[91] Contemporary scholar Cornel West similarly notes that the black aesthetic replaces self-reliance, a central value of American white supremacy, with self-integrity in response to the dehumanizing attitudes, practices, and laws such supremacy justified.[92]

Through the arts, the African American community throughout its tortured and triumphant history is able to hold this contradiction together without denying the creative tension it causes: enslavement and personal freedom, segregation and yearning for inclusivity, distinctively black and commonly human, nobodiness and somebodiness, separateness and solidarity. What West calls a "spiritual-blues impulse" "with its polyphonic, rhythmic effects and antiphonal vocal techniques, kinetic orality and affective physicality" flows through African American aesthetic and shapes other forms of American music.[93] "Afro-American music is first and foremost, although not exclusively or universally, a countercultural practice with deep roots in modes of religious transcendence and political opposition," West explains, making it particularly

89. W. E. B. Du Bois, *The Souls of Black Folk* (New York, Tribecca Books, 2011).

90. James Baldwin, *The Fire Next Time* (New York: The Dial Press, 1963).

91. Cornel West, "On Afro-American Music: From Bebop to Rap," in *The Cornel West Reader* (New York: Basic Books, 1999), 474.

92. Ibid., 464.

93. Ibid., 474.

appealing to groups of persons facing oppression or attempting to make meaning of their lives in the face of those who deny them that freedom.[94]

An examination of artistic expression in the African American community reveals similar expressions of a lived aesthetic that resists the "colonization" of the black self throughout American history. Perhaps more so than for other groups, the arts are an expression of freedom for African Americans, a subculture in which, in the words of bell hooks, blacks "set their imaginations free" in order to resist the forces of domination, reclaim an authentic sense of self separate from the "Euro-centric gaze," and reinvent communities undermined by the structural violence of racism.[95] In his most recent book, James Cone notes that "it was the blues and religion that offered the chief weapons of resistance" during the period of lynching in America between 1880 and 1940 that claimed nearly five thousand black lives, since both "offered sources of hope that there was more to life than what one encountered daily in the white man's world."[96] Part of that is an insistence in the black aesthetic sensibility toward truth telling, what Rebecca Chopp identifies as the "poetics of testimony"—that bears witness to history in nondiscursive formats that break through the monolithic culture of superiority and are not easily dismissed.[97]

The spirituals, the first distinctively modern American art form, are evidence of this struggle for liberation—both of bodies and imaginations. In these "religious classics" we hear and feel the way that beauty functions as a form of resistance rooted in a sense of human dignity that refuses to accept the dominant culture's estimation of the self and the subversive ability to be nourished by an awareness of God's liberating presence in the midst of the ugliness of bondage. "People who have not been oppressed physically cannot know the power inherent in bodily expressions of love" such as clapping, singing, dancing, explains Cone.[98] "Freedom was the body in motion, emotionally and rhythmically asserting the right to be," Cone continues. " 'Jesus' then was not a thought in their heads to be analyzed in relation to a related thought called 'God.'

94. Ibid.

95. bell hooks, *Art on My Mind: Visual Politics* (New York: The New Press, 1995), 4–8.

96. Cone, *The Cross and the Lynching Tree*, 12.

97. Rebecca Chopp, "Reimagining Public Discourse," in *Black Faith and Public Talk: Critical Essays on James H. Cone's* Black Theology and Black Power, ed. Dwight N. Hopkins (Maryknoll, NY: Orbis Books, 1999), 150–63.

98. James H. Cone, *The Spirituals and the Blues: An Interpretation* (New York: The Seabury Press, 1972), 128.

Jesus was an experience, a historical presence in motion, liberating and moving the people in freedom."[99]

Unlike the spirituals, which were collective expressions of resistance, Cone notes that the blues were individuals' attempts to claim an identity in the midst of "state-endorsed terror" of Jim Crow and lynching and to make meaning of the "absurd world of white supremacy" by creating defiant music that played in juke joints where blacks experienced in their bodies an intense freedom on Friday and Saturday nights.[100] West describes the blues as "autobiographical chronicle[s] of personal catastrophe expressed lyrically" or a "catastrophic love" that responds "to the monstrous and catastrophic" with a desire for freedom for all. In this way the blues are not merely an art form but a sensibility or way of being in the world that responds to "the catastrophic with compassion, not drinking from the cup of bitterness, not with revenge but with justice," West explains. "So the blues people in America have been the leaven in the American loaf. . . . [L]et that love inside of you be expressed even though it is hard for it to be translated into love or justice on the ground."[101] Josef Sorett notes the ways in which contemporary hip-hop artists, many of whom highlight the experiences of the "African Diaspora," particularly the experiences of "black youth living in the United States' post-industrial urban centers," stand in this prophetic musical tradition, at the same time using and abusing the power awarded them by the music industry. "For many hip hop artists, male and female, God-talk (Muslim and Christian) has represented a readily available avenue for articulating one's lyrical authority," Sorett notes. "In short, hip hop's range of religious sensibilities confirms the genre's preoccupation with power, both spiritual and social."[102]

The artistic sensibilities and proclivities of black women also reveal a distinctive way of living ethically within the confines of oppression. Womanist ethicist Katie Cannon rightly points out that "African American women are the most vulnerable and the most exploited people of the American society" since they struggle with dehumanizing racism *and* sexism. She calls attention to the literary tradition of black women to make clear the inadequacies of mainline Anglo-Protestant ethical

99. Ibid., 48.

100. Cone, *The Cross and the Lynching Tree*, 28.

101. Cornel West, video clip, http://www.youtube.com/watch?feature=player _embedded&v=3EYK4p0Byfw#at=11.

102. Josef Sorett, "'Believe Me, This Pimp Game Is Very Religious': Toward a Religious History of Hip Hop," *Culture and Religion* 10, no. 1 (March 2009): 11–22, at 11 and 18.

frameworks when it comes to accountability for slavery and segregation, and to celebrate the moral agency of black women who have passed the wisdom of "real-lived texture of Black life" and "action guides of the Black community" from generation to generation.[103] "Black women have created and cultivated a set of ethical values that allow them to prevail against the odds with moral integrity, in their ongoing participation in the white-male-capitalist value system," Cannon claims.[104]

She locates an "underground treasury of values" in the "cryptically described" experience of black women in their own literary tradition— from slave narratives and personal journals to political pamphlets and novels. These values include a commitment to the collective, respect for stories and oral histories, a focus on life within communities, affirming humanity and relationality, ingenuity in the face of adversity, and a wise pragmatism. In attempting to construct an ethic from the works of novelist Zora Neale Hurston, Cannon lifts up the inherently creative ways in which black women move through their daily lives, insights that might easily be missed in more traditional, that is, Euro-American Christian ethics: "The Black woman's very life depends upon her being able *to decipher the various sounds* in the larger world, to hold in check the nightmare figures of terror, to fight for basic freedoms against the sadistic law enforcement agencies in her community, to resist the temptation to capitulate to the demands of the status quo, *to find meaning* in the most despotic circumstances and *to create* something where nothing was before."[105]

Attention to the arts in the African American context reveals that the arts and ethics are two sides of the same vinyl record or protagonists in an ongoing drama, both inherently political in their power as touchstones for survival and of hope. Here we see the arts arising out of circumstances of nobodiness and in turn sustaining a particular way of being in the face of "the catastrophic"—one that responds with life-giving creativity that comes with truth telling about the tragic circumstances of the human condition. In the African American experience of beauty, the body is a locus of both oppression and moral agency in light of beauty's ability to stir the moral consciousness and raise awareness of the impact of the social reality on bodies—both oppressors and oppressed. Beauty calls for a contrast experience that prophetically points toward a vision of a more just society and sustains people in working toward it. Finally, beauty and the arts can racialize moral consciousness

103. Katie G. Cannon, *Black Womanist Ethics*, American Academy of Religion Academy Series Number 60 (Atlanta, GA: Scholars Press, 1988), 3–4.
104. Ibid., 76.
105. Ibid., 126, emphasis mine.

in a way that can make meaningful solidarity possible. "Artists," says Cone of African American musicians, poets, and visual artists, "force us to see things we don't want to look at because they make us uncomfortable with ourselves and the world we have created."[106]

Latino/a theology. Articulating the wisdom that arises from encounters of beauty in the context of non-personhood connects black theology with its counterpart among indigenous peoples in the Americas during the seventeenth through the twenty-first centuries. Increasingly, Latino/a theologians insist that the God-talk arising out of the experiences of colonized peoples of Central and South America in the age of empire (both European and American) is inherently aesthetic, since it refuses to separate notions of the Divine from life-affirming experiences of beauty, no matter how seemingly ordinary or insignificant. Exploring the fusion of the good with the beautiful in this strand of the Christian tradition has the potential to rescue the tradition as a whole, as well as the institutional church, from its current crisis of relevance, which many see as resulting from the separation of faith and justice.

Roberto Goizueta turns to the notion of beauty in the experience of the Latino/a community throughout history to discover overlooked ethical imperatives and resources for "countercultural resistance and social justice" in the aesthetic sensibilities of Christians on the margins. He claims that doing so recovers elements that Western theology has lost sight of, elements of faith and communion with the Divine that are givens in the experiences of God's immanence in the lives of colonized, enslaved, marginalized, and alienated peoples: "symbol, ritual, narrative, metaphor, poetry, music, the arts."[107] "Without the language and experience of Beauty and the beautiful, the Church will find difficult the expression of her faith," explains Alejandro García-Rivera, "much less her conviction of the dignity of the human person, and, even less, be a sacrament to the world."[108]

What are the central components of a Latino/a aesthetics? Most stem from the Latino expansion of the Vatican II imperative for *ressourcement*—a return to historical sources in order to better understand the tradition's contemporary significance—to include the experiences of those on the shadow side of history. According to mujerista theologian

106. Cone, *The Cross and the Lynching Tree*, 117.

107. Roberto Goizueta, "U.S. Hispanic Popular Catholicism as Theopoetics" in *Hispanic/Latino Theology: Challenge and Promise*, ed. Ada María Isasi-Díaz and Fernando F. Segovia (Minneapolis: Fortress Press, 1996), 261.

108. García-Rivera, *The Community of the Beautiful*, 11.

Michelle Gonzalez, the historical experiences of nonpersons, particularly women, often expressed symbolically, artistically, and ritually, have import for current situations of marginalization and economic oppression. She notes that designating "faith of the people as a source and norm for theology" brings important contributions to the theological enterprise: an emphasis on the particular as a way of discovering the universal, an accountability to the silenced and marginalized voices of Latino/a persons in theological discourse, and a rejection of a dualistic and hierarchical way of understanding the world.[109]

A Latino/a aesthetic is particular, tactile, and embodied. García-Rivera identifies a "symbolic-cultural analysis" in Hispanic theology that focuses not only on the structural imperatives for liberation but also on the identity of the subject in need of liberation—a subject shaped simultaneously by experiences of dehumanization and nonpersonhood at the hand of colonial and economic oppression as well as by palpable dignity and hope via encounters with the Divine. This seemingly dichotomous experience is captured in the community's religious rituals, stories, and symbols that often stand outside the church and even challenge it.[110]

García-Rivera describes the Latino aesthetic as an incarnational one in which beauty is passionately lived and consumed rather than passively studied in textbooks or observed in museums and concert halls. Through careful consideration of the corporal life of Christ—his embodiment, his affections, his relationships, the physicality of his suffering and resurrection—this aesthetic counters more abstract Euro-American metaphysics. "The God of Latinas and Latinos is one whose reality is inseparable from our everyday life and struggles," explains Goizueta. "Our faith is ultimately made credible by our everyday relationship with a God whom we can touch and embrace, a God with whom we can weep or laugh, a God who infuriates us and whom we infuriate, a God whose anguished countenance we can caress and whose pierced feet we can kiss."[111]

The move to the incarnational, corporal, and tactile complements the attention Latino aesthetics gives to the "little stories" of the people of God, their particular experiences of God's immanence in the everyday that bring fresh insights to the big story of God's ongoing plan of liberation and salvation. In home altars, visual devotions to Our Lady of Guadalupe stamped on walls or tattooed to bodies, *Viae Crucis* that retell the passion narrative through performative installations that move

109. Gonzalez, *Sor Juana*, 14.

110. García-Rivera, *The Community of the Beautiful*, 54.

111. Roberto Goizueta, *Christ Our Companion: Toward a Theological Aesthetics of Liberation* (Maryknoll, NY: Orbis Books, 2009), 81.

throughout neighborhoods, we find palpable and embodied experiences of God, particularly the companionship of God in Christ, whose preferential option for the poor is not intellectualized but rather experienced in the faith and hope of the Latino/a community. The lived aesthetic sensibilities of this faith community illuminate a refusal to separate the sacred and the profane, designate the significance of the body as the place where the sacred and profane and desires merge, and illuminate the intrinsic connection between the desire for God and justice.

All of these little stories together give rise to popular religion or the lived experiences of persons of faith outside of the institutional ecclesial and theological framework that allows experiences of the Divine to permeate everyday experience and ensure that Christianity is indeed a living tradition. In such a living tradition, symbols take on new meaning, since they are conduits for engagement with a God whose nature is inherently organic and relational and who is encountered "not in the parish, but in the home, in the neighborhood."[112] Goizueta insists that the many symbols and ritual expressions of Latino faith are not mere reflections of hope in God but "the very source of that hope" since they are signs of "God's activity in the world." "In the final analysis," Goizueta concludes, "it is not the rationality of theological arguments that will convince us of the truth of the Christian faith, but the beauty of those lives in which that faith is incarnated and made visible and palpable."[113]

Finally, Latino aesthetics refuses to bow to dichotomous thinking by celebrating the "mixed" identity, history, culture, and religious sensibilities of Latinos. Goizueta speaks of the reluctance to "deconstruct" in Latino theology, since such a move "results in a privileging of the immaterial and abstract explanation (whether theological, doctrinal, psychological or sociological) over the material and concrete" and "theoretical analysis over commonsense knowledge," ultimately rejecting the "performative and participative" fundamental truth at the heart of the Christian faith: the acceptance of and response to God's embodied love for persons.[114] As a result, Gonzalez claims that the Latino aesthetic sensibility is able to "speak of the diversity, messiness, and beauty of reality."[115]

Many of these ideas are captured in the theological and artistic engagement of what Virgil Elizondo points to as the "Guadalupan Encounter" in 1531; to this day, the implications of this encounter reverberate throughout the Latino imagination, and it manifests itself in

112. Ibid., 50.
113. Ibid., 3.
114. Ibid., 45.
115. Gonzalez, *Sor Juana*, 15.

myriad ways within Latino faith communities and neighborhoods and on Latino bodies.[116] For instance, Guadalupe has become an essential visual resource for illuminating an aesthetic that emphasizes "difference"—the distinctiveness of the experiences of indigenous peoples of the Americas and their descendants; the power of their cultural and aesthetic sensibility for challenging the norms of the occupiers, the powerful, the elite; the resilient agency of women in the Latino community, particularly in border communities and in the experience of immigration, which for women is often marked by sexual violence spurred by economic insecurity; and a uniquely powerful Mariology that privileges justice for persons on the economic margins rather than a pietistic one that disconnects divine beauty from divine justice.

Ultimately, Latino/a aesthetics heightens the Catholic sacramental imagination with the sense of the sacramentality of the everyday and the body; an awareness of the mixing or blending of ethnic and cultural identities that resists dualistic frameworks that still shape so much of ethical reflection; the incorporation of the lived experiences of nonpersons into theology that can save it from becoming, in Goizeuta's estimation, entirely too academic and therefore irrelevant to the people of God; and the importance of embodied and imaginative sources of practical reason—narrative, poetry, symbol. He prophetically notes, "If Tridentine Western theology stressed the fact that God is known in the form of the True (Doctrine), and liberation theology that God is known in the form of the Good (Justice), U.S. Hispanic theology stresses the fact that God is known in the form of the Beautiful."[117]

What Remains Unimagined

Despite this rich postconciliar resurgence in theological aesthetics, three lacunae persist when thinking through its application in Christian ethics.

116. See Virgil Elizondo, *Guadalupe: Mother of the New Creation* (Maryknoll, NY: Orbis Books, 1997); *The Treasure of Guadalupe*, ed. Virgil Elizondo, Allan Figueroa Deck, and Timothy Matovina (New York: Roman & Littlefield, 2006); Jeanette Rodriguez, *Our Lady of Guadalupe: Faith and Empowerment among Mexican-American Women* (Austin: University of Texas Press, 1994); Nancy Pineda-Madrid, "Guadalupe's Challenge to Rahner's Theology of Symbol," in *Rahner beyond Rahner: A Great Theologian Encounters the Pacific Rim*, ed. Paul Crowley (Kansas City, MO: Rowman & Littlefield, 2005), 73–85.

117. *Caminemos con Jesús: Toward a Hispanic/Latino Theology of Accompaniment* (Maryknoll, NY: Orbis, 1995), 106.

First, systematic theologians and ethicists captivated by arts have yet to articulate definitively or exhaustively the aesthetic turn to justice. More work needs to be done to illuminate the practical implications of aesthetics for the praxis of Catholic social teaching in general and the common good in particular. For example, although Pope John Paul II alludes to the fact that art and beauty are rooted in the "sacredness of life and of the human person" and contends that the arts offer "an invitation to savour life and to dream of the future," he does little to explicate the relationship between beauty and the common good beyond general allusions to the fact that it ought to serve "humanity as a whole."[118] Richard Viladesau speaks of the "theo-dramatic" beauty of God's love made evident in the cross or the artistry of God that anticipates the kingdom but does little to suggest what this might mean for confronting major social problems facing Christian disciples. Frank Burch Brown speaks of the socially critical role of art that reveals what is unjust or senseless but does not necessarily outline the kinds of responses that this propheticism requires among those who either create or encounter beauty or the arts.

Second, the relative few in theological ethics who have assisted systematic theologians with articulating the practical implications of theological aesthetics have tended to focus on the first component of the three-part praxis of Catholic social teaching, namely, perception. In this case, the arts serve as a way to make visible otherwise hidden contours of our social reality or to attune an otherwise distracted consciousness to the immanence of God, to the ethical imperatives of revelation, or to overlooked aspects of anthropology. Ethicists have yet to incorporate aesthetics into the remaining two facets of ethical praxis in the Catholic tradition—judgment and action. While Philip Keane offers a foundation for the arts as a normative ethics, given arguments regarding the necessity of imagination in Catholic approaches to moral reasoning, more needs to be done to integrate the affections, intuitions, and supra-rational cognition into our methods of evaluating possible responses to the signs of the times. Daniel Maguire and Nicholas Wolterstorff have begun to unpack the significance of artistic creativity as an expression of moral action, but that conversation needs to be moved beyond the arts and personal moral development toward critical analysis of the arts as both a condition for and experience of fulfillment, therefore invaluable for social transformation.

118. John Paul II, Letter to Artists (April 4, 1999), http://www.vatican.va/holy _father/john_paul_ii/letters/documents/hf_jp-ii_let_23041999_artists_en.html.

Third, very few Euro-American scholars engaged in either theological aesthetics or theological ethics have explored the relationships among beauty, justice, and the good "from below" or with specific attention to the sense perceptions of those on margins, to notions of beauty as defined by those outside of the academy or studio or gallery, or to artistic expression beyond "high institutional art" or "primary art objects."[119] This lacuna exposes an epistemology and methodology of whiteness pervasive in Catholic theology evident in a variety of ways: a persistent wariness of emotive expression, intimacy, or subjectivity that relegates the practice and wisdom of the arts, particularly the religious arts, to the private or sacred sphere; engagement of artistic sources with a detached reasoning or a Kantian "disinterested stance" that tends to focus on the mastery of technique or intellectual insight rather than the affectivity that comes with creating and encountering beauty; a preference for "aesthetic purism" that separates artistic expression from the complexities of the political or socioeconomic reality around it or the descriptive interpretation from normative interpretation; and even a narrow construal of what qualifies as a "classic" text or image.

Conventional articulations of theological aesthetics need to be interrogated by the impact of a collective failure to recognize the transformative work of the imagination in unexpected places or a reluctance to embrace diverse human experiences of beauty as a source of moral wisdom. This depends on a theological aesthetics that emerges via an "aesthetics from below" or one that explores sense perceptions, notions of beauty, and artistic expression from the margins, in order to interrogate the inherent epistemology and methodology of white privilege in Catholic social thought as well as theological aesthetics. That, in the end, has been the objective in this exploration on community muralism.

119. This is largely Colleen McDannell's argument in *Material Christianity*, namely, that like less than "real" sources or methodologies of theology, this type of art is either created or engaged by less than "adult" Christians.

Index

Images in Alphabetical Order